ALL HUMANS OUTSIDE

ALL HUMANS OUTSIDE

Stories of Belonging in Nature

TOMMY COREY

MOUNTAINEERS
BOOKS

MOUNTAINEERS BOOKS is dedicated to the exploration, preservation, and enjoyment of outdoor and wilderness areas.

1001 SW Klickitat Way, Suite 201, Seattle, WA 98134
800-553-4453, www.mountaineersbooks.org

Copyright © 2025 by Tommy Corey

All rights reserved. No part of this book may be reproduced or utilized in any form, or by any electronic, mechanical, or other means, without the prior written permission of the publisher.

Mountaineers Books and its colophon are registered trademarks of The Mountaineers organization.

Printed in China
Distributed in the United Kingdom by Cordee, www.cordee.co.uk

28 27 26 25 1 2 3 4 5

Design and layout: Jen Grable
All photographs by the author unless credited otherwise
Cover photographs, front, clockwise from top left: *Kam Redlawsk, Ben Mayforth, Joe Stone, Priyam Patel, Mirna Valerio, and Mary Mills*; spine, *Lolo Veloz*; back, *Virginia Delgado-Martinez photographed on the Manoa Falls Trail in Oahu, Hawaii*; last page, left to right: *Zachary Darden, Annijke Wade, Joanne Yeung, Emmeline Wang, Yvonne Babb, Geoff Babb, Wesley Heredia, and Channing Cash* (Photographed in Bend, Oregon; made possible by Vuori)

Library of Congress Cataloging-in-Publication Data
Names: Corey, Tommy, author.
Title: All humans outside / Tommy Corey.
Description: Seattle, WA : Mountaineers Books, [2025] | Summary: "A photography-driven celebration of diversity and belonging in the outdoors, featuring 101 individuals"— Provided by publisher.
Identifiers: LCCN 2024031973 (print) | ISBN 9781680517064 (hardcover)
Subjects: LCSH: Outdoor recreation—Psychological aspects—Pictorial works. | Nature—Effect of human beings on—Pictorial works. | Belonging (Social psychology)
Classification: LCC GV191.6 .C65 2025 (print) | DDC 796.5—dc23/eng/20240812
LC record available at https://lccn.loc.gov/2024031973

Mountaineers Books titles may be purchased for corporate, educational, or other promotional sales, and our authors are available for a wide range of events. For information on special discounts or booking an author, contact our customer service at 800-553-4453 or mbooks@mountaineersbooks.org.

Printed on FSC®-certified materials

ISBN (hardcover): 978-1-68051-706-4

An independent nonprofit publisher since 1960

In loving memory of my big sister, Tara—
Though time has kept us apart, I imagined your hand holding
mine as I made this book, as I have throughout my life.
I hope one day we are reunited, running through Deadfall Meadow.

Love, Tommy

CONTENTS

Author's Note 9

EMPATHY 11

Dani Reyes-Acosta	13
Eryn Roberts	15
Francis Eymard Mendoza	19
Bennett Rahn	23
Brandon Dale	25
Ricki Sanchez	31
Kam Redlawsk	35
Arthur Aston	39
Nicole Snell	43
Marcela Maldonado	47

FAMILY & ANCESTORS 49

Faren Rajkumar & Mohit Kaura	51
Chrisha Favors	55
Melody Forsyth & Ruby Forsyth	59
Gabriel Chillous	63
Jayne Henson	65
Scott Robinson	69
Anna Le	73
Emmeline Wang & Joanne Yeung	75
Frances Reyes-Acosta	79
Kamal Bell	82
Noël Russell	85
Gillian Larson	89
Matt Bloom	92

FORGING NEW PATHS 97

Mirna Valerio	99
Jimmy Flatt & Lydia Parker	103
Ash Manning	107
Dahlia Menelao	110
Anastasia Allison	114
Whitney Washington	117
Amelia Dall	121
Dezmine Washington	123
Kim Merrikin	127
Mary Mills	131
Divya Anantharaman	134
Brittany Kamai	138

HEALING IN NATURE 141

Ash White	143
Tasheon Chillous	146
Day Scott	149
Tara Myers	152
Dani Araiz	155
Summer Crider	158
Francisco Silva	161
Jesse Cody	165
Becca Moreno	168
Gabriel Vasquez	173
Shaynedonovan Elliott	175
Ann Yoshida	179

OVERCOMING 183

Ben Mayforth	185
Channing Cash	187
Josh Sheets	193
Annijke Wade	195
Jack Ryan	198
Kristen Wickert	201
Matt Tilford	205
Lolo Veloz	207
Kanoa Greene	211
DeVante Deschwanden	215
Kyle Stepp	218

BELONGING & IDENTITY 223

Richie Winter	225
Leah Kaplan	228
Christophe Zajac-Denek	231
Drew Hulsey & Sarah Hulsey	235
Caziah Franklin	237
Ashley Duffus	241
Jose Mendez	243
Erin Parisi	247
Jack Jones	249
Zachary Darden	253

CHANGEMAKERS 257

Beverly Harry & Autumn Harry	259
Joe Stone	263
Zelzin Aketzalli	267
Hector Rafael	270
Chev Dixon	273
Leo Chan Gaskins	277
Christopher Rivera	280
Geoff Babb	283
Virginia Delgado-Martinez	287
Mary Kate Callahan	291
Prince Asante Sefa-Boakye	295

COMMUNITY 299

Chris Greenwell	301
Mario Ordoñez-Calderón	305
Karen deSousa	308
Patrick Ramsay	311
Livio Melo & Jennifer Jacobsson-Melo	314
Alvin Garcia	319
Jordan Newton	323
Perry Cohen	326
Kava Vasquez & Mel Ramirez	331
Jahmicah Dawes & Heather Dawes	335
Priyam Patel	339
Wesley Heredia	343
Nicole Rivera Hartery	347

Behind the Lens: A Note from Tim Corey 351
With Gratitude 353
About the Contributors 355

AUTHOR'S NOTE

AS A KID, I HAD THREE MAJOR OBSESSIONS: photography, nature, and Oprah. While after-school television series like *Full House* and *Clarissa Explains It All* were my top-tier enjoyments, I couldn't wait to get home so I could eavesdrop on my mom watching my favorite program, *The Oprah Winfrey Show*. It wasn't just her interviewees' stories that fascinated me, it was the way she interviewed her wide array of guests from all walks of life—celebrities, criminals, politicians, everyday people—with compassion and empathy. Her endearing interview style made me want to become a storyteller.

In the spring of 2022, I found myself backpacking through the rock-walled canyons of the Gila National Forest. Four years earlier, I had completed my first thru-hike, walking the length of the 2,650-mile Pacific Crest Trail, where I discovered a deep sense of community with fellow thru-hikers. Every day since, I had daydreamed of a time when I could leave my "real life" and thru-hike again, this time on the Continental Divide Trail. While I was thrilled to be back in the wilderness, immersed in nature, I felt disconnected from parts of the long-trail community I had been yearning to reconnect with. A voice in my head urged me to pursue a different path—a project that would come to be named *All Humans Outside*, the results of which you now hold in your hands.

When I initially had the idea for this collection of portraits and stories, I believed that the unique ways humans connect to nature would be at its core. As time went on, through hundreds of interviews and eventually traveling the United States to photograph these 101 people, I learned that this endeavor wasn't just creative and fun—this project involved intense, humbling, and eye-opening research. What I found in my two years of visual and documentary exploration is something much more profound than the diversity of ways to enjoy the outdoors.

My first step was to identify people I wanted to interview by posting on social media seeking individuals with diverse identities—People of Color, disabled folks, individuals with varying body types, LGBTQIA+—and yet many people who replied to my requests directed me toward individuals who didn't match those identities. It seemed at times like the very narrative I was trying to dismantle still permeated people's perceptions of who qualifies as outdoorsy. This interaction revealed a crucial insight: we humans will go to great lengths to avoid being excluded. At our core, we all just want to belong, which I find beautifully humanizing. This book reflects that universal desire—the ways we seek connection and inclusion and how we can create spaces where everyone feels they belong. Each story in *All Humans Outside* is a testament to the ways individuals build communities and foster inclusivity, reminding us that nature and storytelling can bridge gaps and unite us all.

These stories recognize people or groups that inspired or brought that storyteller outdoors. In

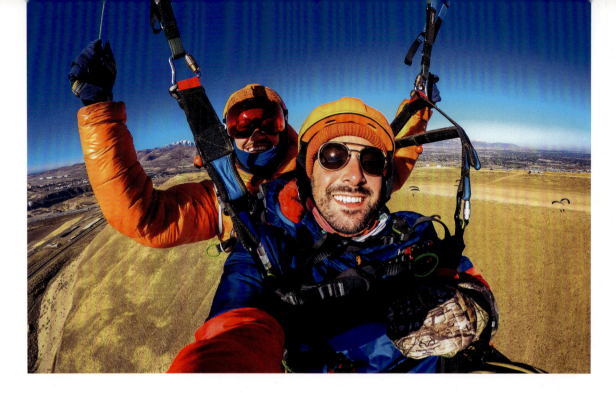

pay-it-forward fashion, these 101 humans have created community groups, nonprofits, resources, and charities—like Perry Cohen who founded the Venture Out Project so that other queer folks could connect in nature. That's the heart of building *community*. Christophe Zajac-Denek uses surfing to break the societal limitations placed on people with dwarfism, proving that adventure and self-belief aren't defined by height—that's *belonging*. Ann Yoshida's journey from a life-changing accident to founding Access Surf helped her discover her roots and connection to water and her ancestors, driving her to help others discover their own extraordinary lives through surfing—that's *purpose*. Kyle Stepp's journey through adversity—from childhood trauma to surviving cancer and losing his leg—has deepened his compassion, driving him to fight for others to have access to physical movement, ensuring that activity is a right, not a privilege—that's *empathy*.

I'm not an adrenaline junkie and I don't really try anything that involves a lot of risk. But an integral part of this project and photographing all these incredible humans was experiencing the outdoors through their eyes. Only then could I truly connect with and understand them, while capturing their unique affinity for nature. Photographing Jordan Newton near Salt Lake City, I went paragliding for the first time, and as this project unfolded, I continued to face new fears, all while connecting with people.

Sharing our stories is such a simple yet profound way to connect with others. I made this book to challenge everyone to tap into their innate empathy. It is my hope that we will choose to use our compassion to welcome others in, make space, and create communities where everyone can exist without judgment or ostracization. I hope there comes a time where people can simply exist in nature. Nature is humanity's universal language, binding us together across mountains and seas. Through my art and the inspiring words of everyone featured in *All Humans Outside*, I hope everyone sees that the outdoors has always been, and will forever be, a place where we all undoubtedly belong.

Empathy

DANI REYES-ACOSTA

MY PARENTS WERE INCREDIBLE INFLUENCES on my outdoor journey. They instilled a love for all things outside in my sisters and me from a very young age. I only came to understand, once I got older, that the range of experiences of being outside is much broader than the traditional definition the outdoor industry presents to us. Camping in your car, working in the dirt with your hands, or walking on the beach with your dog—these are all ways to be in love with nature, but my parents didn't talk to us about that. After years of introspection, I realized there are many ways to play, heal, connect, and grow outdoors.

Camping once a year with my family, going on walks with my dad and our dogs, and going skiing a couple times a year were foundational experiences that imprinted on me as I grew up—a privilege not everyone has. I came to understand that I had a place in the outdoors.

As a storyteller, athlete, and strategist, I use community building to help others think about how they view themselves in nature and as they commune with each other. I use media, events, public speaking, panel facilitation, and workshops that educate, inspire, and help redefine the narrative of what we're doing in these outdoor spaces. The way we view ourselves in this outdoor world is deeply informed by who and how the media tells us we should be.

Hearing stories radically different from our own, in the most beautiful sense, can open our worlds. As a child, I read many books to understand the world beyond the four walls I knew. Sharing stories beyond our experiences and understanding broadens our horizons. Part of that broadening is opening our minds to the possibilities of other worlds, which helps us understand that beauty comes in different forms.

Storytelling's power to create empathy relies on the approach the storyteller takes. And only ethical storytelling, a process by which a storyteller reaches outside their own lived experience to understand how their subjects and storytelling partners might move through the world, creates empathy. This process sometimes entails a lot of research. Ethical storytelling relies on the storyteller's development of a trust-based relationship with their character or subjects, as well as extensive personal work to dismantle systems of oppression.

The profound joy and elation of tagging a peak, climbing a sick line, or going for a long backpacking trip are all definitions of "success" in the outdoors according to outdoor media. But so much of

> By portraying stories that speak to a broader spectrum of unique experiences, I hope to share that there is more than one way of being outdoors, of being successful or failing.

our human experience gets left out of such a narrow definition—the struggle, sadness, loneliness, ambiguity, and everything between the binary of joy and loss.

So many stories told in outdoor media are rooted in objective achievement or the pursuit of joy. But when we show only the objective achievements (and the individual martyrdom that comes with those pursuits), we are erasing so much of what makes us human. By portraying stories that speak to a broader spectrum of unique experiences, I hope to share that there is more than one way of being outdoors, of being successful or failing. There are so many ways to be outside, and this truth can inspire us through relatable and human stories that celebrate all the ways we can play in nature.

ERYN ROBERTS

WHEN MY TWIN SISTER AND I WERE GROW-ing up, my mom had an exceptionally ineffective way of disciplining us when we were in trouble: she would often make us read a dictionary or the *Encarta* encyclopedia. When I was about eight, reading my "punishment," I stumbled upon "living organ donations," and for some reason, I became fixated on it. Inquisitively, I asked my mom, "Can I do this?!"

Unfortunately, it is recommended that you be at least eighteen and have your own health insurance to donate an organ in the United States. However, she never said no, so I kept that idea tucked away for a long time.

Eighteen years later, I was scrolling through Facebook one day and stumbled upon a reshared post from a stranger. The post was made by a woman named Michelle who was searching for a

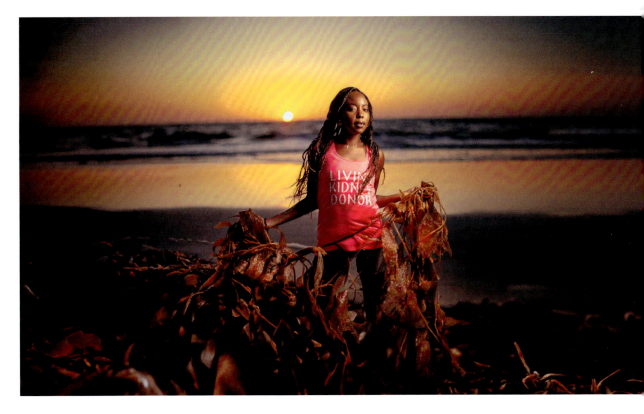

kidney donor for her father. Reaching back to that tucked-away plan, I messaged Michelle to ask about the process. Soon, I received some paperwork to fill out about my medical history, provided a blood sample, and answered questions about my interests and intentions behind donating my kidney. Following the interview process, I had to undergo rigorous medical testing to ensure I was healthy enough to donate.

I got the call that I was finally cleared to donate about a year and a half later, on the first day of a new job. I was tweakin' because of North Carolina's ninety-day probationary period before you can receive insurance through your employer. So, technically, I was no longer eligible to donate. That same day, I told my boss I was donating my kidney and asked for his support. He told me as long as I made it past ninety days, I would get my insurance and be able to take off as much time as I needed. I made it to that ninety-day mark and scheduled surgery on Day Ninety-One, which coincidentally was on my recipient Tom's seventieth birthday.

Who are we to say who deserves access to nature? I've had to combat these barriers in nature, organ donation, and society in general throughout my life to make sure that I am the Black face people see in predominantly white spaces to shift cultural perspectives and systemic disparities.

Over the years, I have come to realize how being a queer Black Woman donating to a straight white man signifies inequalities that exist in organ donation. White men are still more likely to get a donated kidney, even though nearly 60 percent of the individuals waiting on the donor list are BIPOC (Black, Indigenous, and People of Color), with half of that percentage being Black. We see these same barriers to entry for BIPOC in so many communities across the United States—nature included.

I've witnessed these inequalities consistently, especially during my upbringing in North Carolina, and they persist, even today in San Diego. I've experienced this while volunteering for a nonprofit organization that introduces Children of Color to surfing. Most of these kids have grown up in San Diego County but have never been to the beach. Even in the few times I volunteered, encounters with angry white individuals attempting to force us to leave were not uncommon.

Who are we to say who deserves access to nature? I've had to combat these barriers in nature, organ donation, and society in general throughout my life to make sure that I am the Black face people see in predominantly white spaces to shift cultural perspectives and systemic disparities.

Deceased organ donors can save up to eight people and enhance the lives of up to seventy-five more, while living donors can donate one kidney or part of a lung, liver, pancreas, or intestine. Thinking back, I'm glad I overcame the naysayers who questioned my decision to give my kidney to

a seventy-year-old man or asked if there was someone else more deserving. It always brings me back to the same question: Who are we to say who deserves what or how much? If one person in every ten thousand became a donor, the hundred-thousand-person waiting list would disappear. Because of my donation, Tom lived another two and half years. Before he passed due to complications from Covid, we said goodbye via FaceTime.

The phantom pain I felt when he passed away where my kidney had once been was a beautiful and stark reminder of not just what I had given but also the interconnectedness of humanity. As I continue advocating for equity, being seen in unexpected spaces, and reflecting on my organ donation experience, I am certain that everyone deserves the right to live a healthy life, access quality medical care, and connect with the profound beauty that we all share as equals.

FRANCIS EYMARD MENDOZA

SOME PEOPLE MAY LIKE TO BELIEVE THAT WE live in a fairy-tale society where anyone can be outdoors without fear. What a lot of people don't see are the layers of intergenerational trauma inflicted on BIPOC over many generations. Research suggests that about 95 percent of the Native American population was killed following 1492, the year Columbus arrived in the New World. In addition to the horrors of slavery and segregation that Black folx experienced, many BIPOC were forced to become survivalists, creating a long-standing, deep-rooted fear of the outdoors and the people who stole it.

I moved to Turtle Island (the Indigenous name for North America) from the Philippines with my family when I was five to escape economic persecution when Ferdinand Marcos declared martial law. Today, I live on Tamien Nation, Ohlone, Muwekma, and Confederated Villages of Lisjan land, also known as Fremont, California, the fourth-largest city in the Bay Area. That name comes from John C. Frémont, a US army general who committed horrendous massacres against Native Californians throughout the 1800s. When I reference places in the United States, I intentionally use the names of the Indigenous land they're on because so many parks, cities, and even large wilderness areas bear unethically titled monikers, usually the names of white colonizers.

Many barriers I have faced when recreating outdoors have been personally internalized cultural expectations. As a Filipino immigrant, I straddled the line between first and second generation because I spent most of my childhood in America yearning to assimilate but also hold on to my culture. Up until now, at almost fifty, I have struggled with doing both.

What resonates with many Filipino adults in the United States is that their parents discouraged them from going outside. Our parents slept outdoors in the Philippines, which, to them, most likely connotes being poor and unhoused. It's a kind of trauma response to having to survive outdoors that tells them they shouldn't be outside. Many Filipino parents expect their children to grow up and become doctors, lawyers, and businesspeople. Immigrant parents want to make sure their kids have a better life, and these careers usually provide some semblance of security. Despite these expectations, I followed my passion for nature and became a park ranger and naturalist.

> My job is to flip the script by not just focusing on our intergenerational trauma and fear of the outside but also by celebrating the liberation and joy we feel in nature—a spirited current flowing through the veins of our history.

A naturalist works in environmental education, whether through fieldwork, exploration, or research, to better understand the natural world and serve as a great steward of the land. My job specifically puts me in a consulting position, where I talk to local schools about ways they can provide outdoor access to children in those communities. This early education helps mitigate climate change by creating empathy for the planet and encouraging sustainable practices at a young age.

The Philippines consists of more than seven thousand islands, with about two thousand inhabited. My work is very personal to me as a Filipino

because island folx are the ones who will be affected by climate change first, especially those who are impoverished and unable to relocate because of rising sea levels.

My work as a naturalist has allowed me to create safe spaces for those who come from marginalized identities, whether that's BIPOC, LGBTQ+, or disabled folx. My family was able to relocate to Turtle Island to seek economic stability and opportunity, and many families like mine are still immigrating despite the trauma, family separation, and ravages of migration. These intersectional identities are often separated not just from a white-dominated society but also from the nature that surrounds it.

Stereotypes, prejudice, and discrimination have deterred many of these individuals from enjoying nature holistically. Being Black, Indigenous, or any People of Color strongly connects us to our past, future, heritage, and ancestors. My job is to flip the script by not just focusing on our intergenerational trauma and fear of the outside but also by celebrating the liberation and joy we feel in nature—a spirited current flowing through the veins of our history.

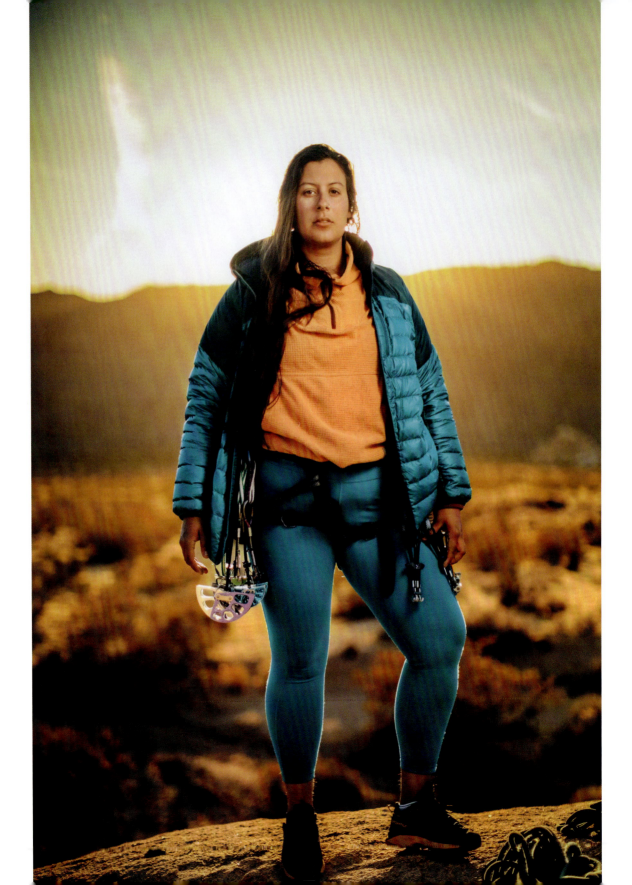

BENNETT RAHN

ABOUT A DECADE AGO, I WAS WORKING AS A social studies teacher at a middle school with an outdoor program, where naturally all of my coworkers were outdoorsy. The colleagues I spent the most time with were into the climbing gym, so I started going with them and got hooked immediately.

Climbing allowed me to turn off my brain and be embodied in a very specific way that I craved, which helped me with my body dysmorphia. When I'm climbing, I cannot disassociate. Being in the moment, in my body and in nature, helped me not think about how I am perceived.

When I started to get heavily into climbing, I started noticing I was usually the only fat person in the climbing gym or at the crag. I saw this craving from others who looked like me to see people who looked like us. Ultimately, I realized I needed to inspire people in big bodies to enter climbing, but I also desperately needed to change the rhetoric of this sport.

My story isn't groundbreaking. I pass as a white person, I'm a cis woman, and my queerness isn't visible—in fact, I only started speaking about it publicly because I was so tired of men sending me dick pics.

Even as a fat woman, I am still considered a "small fat." Yes, I do face discrimination in this body; however, I have found ways to maneuver around much of the scrutiny that keeps other fat people out of outdoor spaces. I use the phrase "gateway fat," which basically means that I try to be the largest person in specific technical spaces. This way, I can show what fat bodies are capable of and other fat people can see that climbing is possible for them.

Sometimes I wonder if my voice is necessary in the climbing world. However, my proximity to privilege has allowed me to gain access to these spaces. I then use that access to prove how much diversity we can invite in and to be a dissenting opinion to the dominant thought. It's like wearing a "wolf suit" into the wolf pack. In addition to physicality, my true strength in climbing is taking complicated, challenging, gritty subjects that are hard to talk about without feeling a lot of pain and suffering and then putting them in front of people with privilege in a way they can see them.

> This way, I can show what fat bodies are capable of and other fat people can see that climbing is possible for them.

This is what I mean when I say "gateway": I listen to people who share my complicated oppressed identities, share their words in the privileged spaces I occupy, and bring those perspectives with me in a wolf suit that makes me palatable to those who might not understand.

The climbing industry's inequities can be convoluted, much like a climbing route. It takes

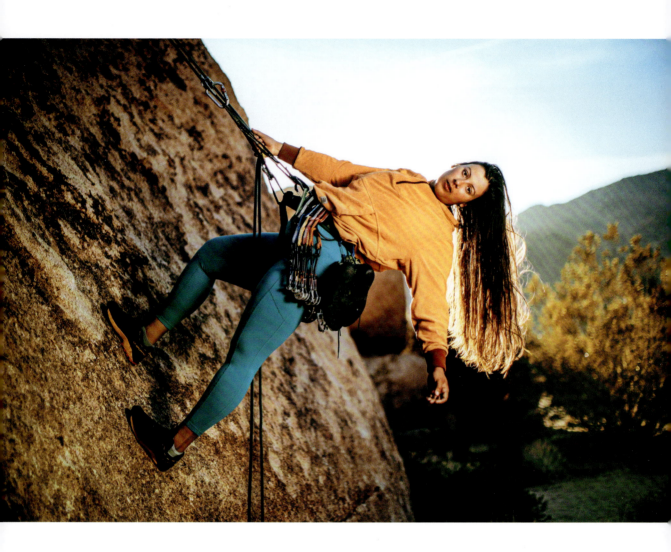

patience, adversity, and problem-solving skills to advance. These issues are essential to address to implement change for people like me so we can exist in the same spaces as everyone else. The industry needs to cognitively transform infrastructure to be more diverse so that companies and organizations make decisions with diverse identities and ideas involved. Ultimately, that will create a more inclusive outdoors—one built for me, you, and all body types.

BRANDON DALE

GROWING UP IN LOUISIANA, I WAS FORTU-
nate to be surrounded by a family deeply connected
to a lifestyle in which you live in reciprocity with
the land. My roots in this tradition run deep, with
an uncle serving as a game warden, grandfathers
who were farmers, and a mother who went out of
her way to ensure my brother and I experienced
the joys of the outdoors through hunting, camping,
and fishing.

Hunting became a central part of my upbring-
ing, as did fishing, as I looked up to avid fishermen
like my uncles and dad. From the time I killed my
first deer under my uncle's mentorship at twelve
to witnessing my grandmother skillfully process
and make deer sausage to the ongoing family tra-
dition of wild game dinners, it became evident
that my family hoped I would carry forward this
legacy of living in harmony with nature. However,
as life unfolded and I navigated through college and
beyond and continued to hunt and fish primarily
alone, I realized how scarce People of Color are in
hunting and conservation, especially in places like
New England. During this phase of my life, I rec-
ognized the importance of intentionally creating
space for others like me. That realization fueled
my commitment to mentoring and connecting
with People of Color, fostering a love for sharing
the traditions of hunter-conservationists.

As an ambassador for New York Hunters of
Color, board member of New York Backcountry
Anglers, and vice president of Trout Unlimited, I'm
actively involved in activities, such as organizing
mentor hunts, building communities, coordinating
habitat restoration projects, spearheading conser-
vation projects, and promoting diversity in the out-
doors through hunting and fly-fishing. I also estab-
lish partnerships with land trusts, liaise with state
agencies, and lead initiatives for environmental

BEHIND THE SCENES

I met Brandon when I was filming a video in New
York for Hunters of Color (by Jimmy Flatt and
Lydia Parker, also featured in this book). I want
to say we especially hit it off, but after getting
to know Brandon, I learned that he's just one of
those genuinely kind people who makes *everyone*
he interacts with feel like they're hitting it off.

We camped near the Catskills the night of
our shoot. Brandon was ecstatic because he had
just harvested a turkey the day before, so that's
where the turkey feathers came from in his pho-
tos. That night, we made chicken, bacon, and
turkey mac and cheese. One of his new mentees
came out late to meet us so they could go hunt-
ing early in the morning.

This memorable experience enabled me to
commemorate this project's halfway point in all
the ways I love to enjoy nature—with a friend, in
a beautiful setting, making a delicious meal.

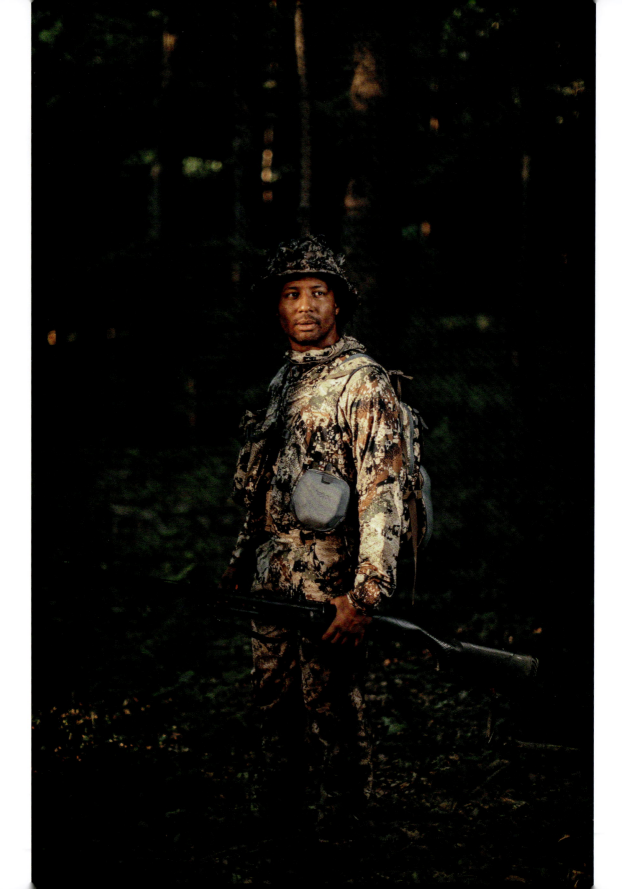

goals. My focus in all programming is to emphasize the vital connection between humanity and nature and hopefully instill pride in being a part of nature through hunting. Fostering an ethical and respectful framework that allows folks to understand hunting as reciprocal is also important to our programming. Additionally, through hands-on activities on the lands that we hunt on, I integrate conservation efforts through habitat restoration projects that promote biodiversity and holistic forest health, reinforcing our symbiosis with the land as hunters.

As a hunter, it is my job to build an in-depth understanding of animal biology, habitat and forest ecology, land use practices, and ethical behaviors when hunting wildlife. But beyond all of that, my role in the environment shifts dramatically when I hunt. I transition from an observer of nature to an active participant. In the realest sense, I *become* nature. Many people have the misconception that hunting is solely about killing and not about food consumption. This notion neglects the multifaceted elements of hunting, where the emphasis for many is not the kill itself but rather ethical engagement with the ecosystem. Hunting serves as a tool for active attention to conservation efforts that directly impact the health of local ecosystems, such as addressing issues like deer overpopulation and ecological damage, all while contributing to food security and sustainable living practices.

After each hunt, a true highlight and source of profound joy is witnessing my mentees' commitment to integrating these activities into their livelihoods and family legacies, eventually passing down these traditions for future generations.

Looking at the statistics of hunters and anglers in the United States, it's evident that their numbers are declining significantly, dropping from around 7.6 percent in 1978 to 4.8 percent in 2022. This annual decline of over 0.07 percent is concerning, projecting a future with no hunters by 2081 if the current rate persists. The decline can be linked to the aging demographic of hunters, who are mainly older white men, as there has been limited industry outreach to new BIPOC hunters. This trend is alarming as much as it is disheartening, as hunters and anglers play a vital role in funding federal and state conservation efforts, contributing nearly $800 million annually to conservation funds through hunting tag, ammunition, firearm, and equipment purchases.

Additionally, the existing efforts to address this decline, often called R3 (retain, reactivate, and reengage) programs, have not adequately focused on inclusivity, particularly in BIPOC communities. As the demographics of the United States evolve, the lack of targeted initiatives to involve People of Color in hunting becomes apparent. There is a clear need for more inclusive programming to reverse this exclusion and ensure that the rich

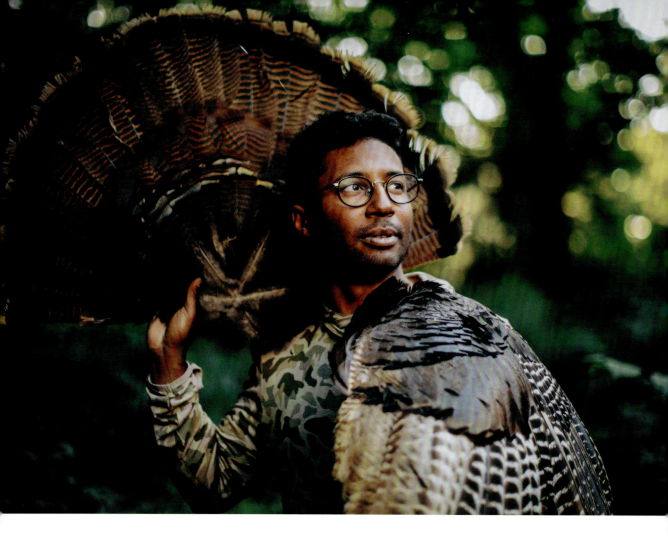

> **I transition from an observer of nature to an active participant.**

hunting heritage and traditions remain vibrant and accessible to a diverse range of participants.

I have felt this lack of access in the outdoors as a Black man. When I applied to colleges, I strategically chose institutions near bodies of water so that I could fish. However, the journey to these natural spots wasn't always straightforward. I often encountered barriers like navigating inaccessible public lands and facing discomfort in unwelcoming rural areas from people who thought I didn't belong there.

As I navigate the cultural and social dynamics of hunting, I see the potential for change and the need to bring more folks in. It's not the land that creates inaccessibility but rather the surrounding lack of resources, community, and education to create spaces that welcome folks who aren't traditionally represented in the hunting (and angling) outdoor space. Building a supportive community that welcomes and guides individuals

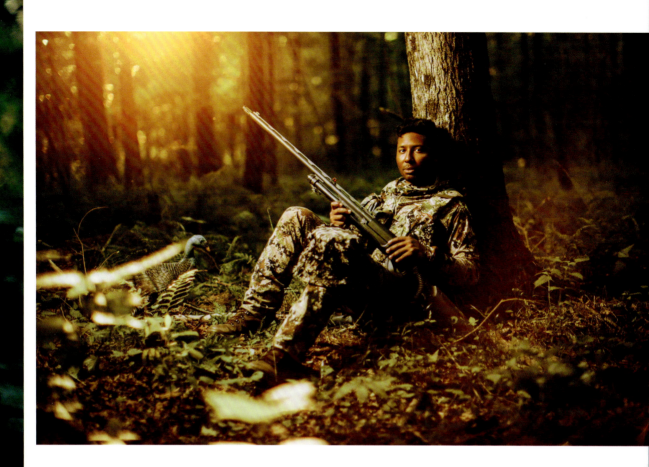

through these barriers is crucial to reduce challenges and make hunting easier to access. Honoring Black and Brown people's reclamation of their connections to hunting, angling, and conservation is profoundly historical, emphasizing the innate connection to these practices that our ancestors have passed on.

After each hunt, a true highlight and source of profound joy is witnessing my mentees' commitment to integrating these activities into their livelihoods and family legacies, eventually passing down these traditions for future generations. This was how I learned (from my grandparents, aunts and uncles, and parents) to be a hunter-conservationist and live in reciprocity with the land. I have been highly impacted by seeing people who resemble me and hail from similar communities and families acknowledge their place in hunting and the outdoors. It's a gift to watch them find belonging, build empathy for nature, and reclaim their history.

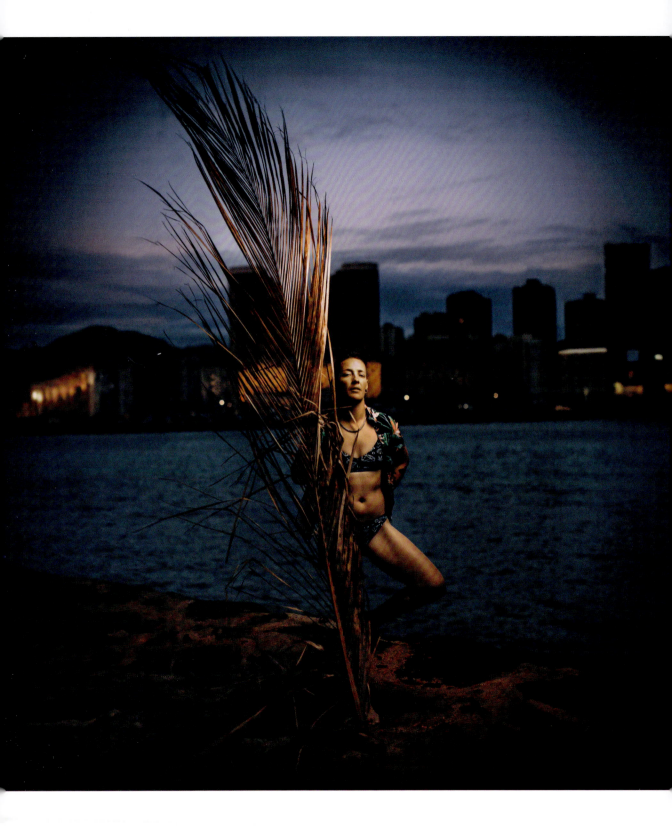

RICKI SANCHEZ

I WAS ASKED LAST MINUTE TO BARTEND A fundraiser at the Aquarium of the Bay in San Francisco. I'll never know if coincidence led me to the aquarium that night; it felt oddly random yet simultaneously meant to be. Little did I know that I would witness something underwater there unlike anything I had ever seen before—something that would change my life forever.

The fundraiser was for Diveheart, a nonprofit organization that provides scuba-diving opportunities to people with disabilities. While I was serving drinks, they began a demonstration of an adaptive dive team assisting a quadriplegic diver. As I walked closer to the glass, I witnessed the immense trust among the team members and the specific adaptations made to support the diver's needs—all of which captivated me. Later that evening, I was presented with a unique opportunity to join the Diveheart team on an adaptive scuba-diving training, which would be held in Cozumel, Mexico, in two weeks, coinciding with my upcoming birthday. Something inside me told me I was meant to do this—it pulled at my heartstrings. With a spontaneous "Fuck it—why not?" I welcomed the chance to be part of something remarkable.

During my childhood and middle school years, surgeries on my legs led to a year-long period in a wheelchair, offering me an insight into the challenges of being treated differently and dealing with accessibility issues. I remember having to hobble up stairways to get to my classrooms due to the school's lack of an elevator. I was even left behind in a classroom during a fire drill. This challenging time involved corrective surgeries from nine until fifteen, addressing rare breaks and growth plate issues. The lasting impact includes permanent back problems, requiring a shoe lift to prevent a limp and alleviate back pain. This experience shifted my perspective, granting me a more profound sense of compassion and humanity.

BEHIND THE SCENES

I met Ricki when I was living in San Francisco. We were part of a big group of gays that frequented the Castro District nightly. We went on to be close friends after six annual camping trips in the Trinity Alps throughout our twenties.

Over the years we have been in touch off and on, but not like when we were young. When I thought of this project, I saw that Ricki was working with an adaptive scuba organization. I knew it would make a great story for this book, but I also saw a beautiful opportunity to reunite with an old friend.

Seeing her in Hawai'i was such a wonderful reminder that those friends you really love and feel close to will always be able to pick up with you right where you left off.

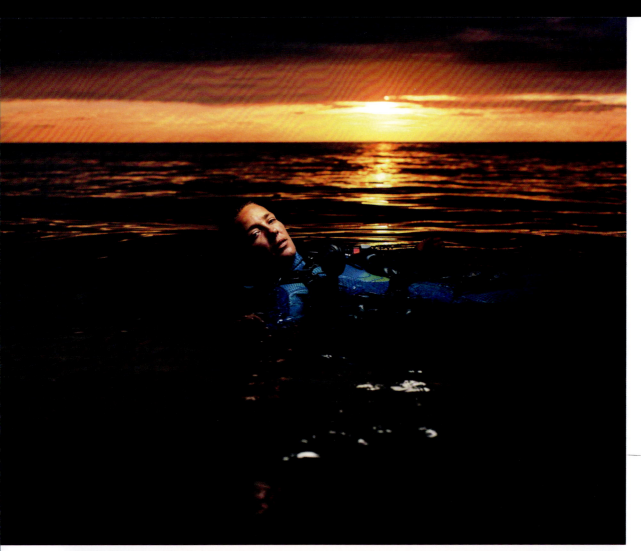
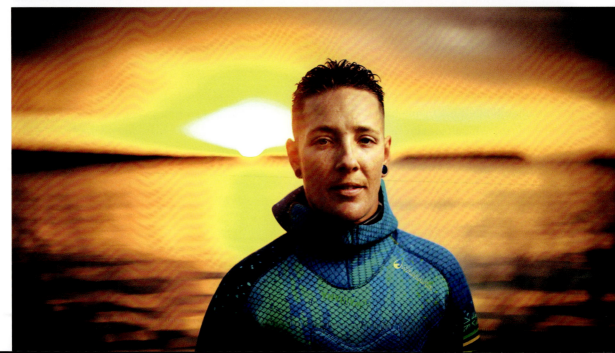

This awareness has turned my work into more than just a job; it feels like a calling. As soon as I completed my training in Cozumel, I knew I had to participate on a larger scale. With determination and passion, I moved through the required training to run programs independently. As an adaptive scuba instructor, I have the chance to make a positive impact by supporting individuals with disabilities and educating my local dive community. Unfortunately, leisure activities such as scuba diving are a privilege rather than a right for those who face accessibility challenges every day. My training paired with my love of the underwater world allows me to break down these barriers.

Our training includes crucial empathy exercises, where we simulate disabilities to gain insight into the challenges individuals face underwater. Experiencing activities like swimming with only my hands deepened my understanding of divers with disabilities, providing valuable insights on how to assist them effectively. One key lesson was the importance of never assuming needs but rather asking if assistance is needed and recognizing varying levels of independence. Proposing these empathy trainings in schools and workplaces could be transformative and foster understanding and compassion from an early age. This investment has the potential to create a more inclusive and compassionate society, extending empathy beyond wheelchair users to people with all kinds of diverse life experiences, nurturing a shared sense of humanity.

> **Being in the water is a powerful experience, a painless escape—the only time when every ache and emotional noise fades away.**

The joy of showing the disabled community an underwater world they can't typically access makes these human interactions meaningful and fills me with gratitude, far beyond the ordinary scope of a job. The belief that everyone should have the opportunity to enjoy the outdoors motivates me to continue this work. Whether surrounded by mountains, the beach, or the desert, nature's beauty should be accessible to all, and I'm so grateful I get to bring others along with me in experiencing it.

Being in the water is a powerful experience, a painless escape—the only time when every ache and emotional noise fades away. Underwater, I find unparalleled focus and presence, free from distractions and mental clutter. It's that profound silence, that peace when all the chatter is suddenly replaced by calm as divers hit the water. It's the moment where limitations vanish. For me and those I dive with, it's a current of shared human connectedness that flows beyond the confines of explanation. In the water, we're all just humans, equal and pain free, transcending the barriers that exist on land. It's a powerful experience—a reminder that beneath the surface, we are all the same.

KAM REDLAWSK

I WAS ABANDONED AT BIRTH IN DAEGU, South Korea, and adopted by a white family in Michigan. I had a regular working-class Midwest upbringing. I played more "tomboy" types of sports with my big brothers and soccer for about thirteen years. In high school, I began to notice things were different about me physically.

While playing soccer my junior year of high school, nothing happened when I went to kick the ball. Even though I thought "kick," I physically couldn't—there was a disconnect between my body and mind. I suspected something was wrong as this lack of control persisted, and thus began the journey of learning that I had an extremely rare muscle-wasting disorder: GNE myopathy.

I worked to be my own best advocate to find out what was going on while I was traversing the diagnosis process. It took me about five years and five different diagnoses to find some semblance of what was happening to me. As my disease progressed, I started using a cane first, then braces as my legs weakened. It was frustrating because my body was wasting away, but I still had no answers. Every time I would find an explanation, I would eventually learn my diagnosis was incorrect and then I would have to start all over again. The hardest part was doing it all alone because no one believed me.

Disability is incredibly diverse. Society tends to lump all disabled people under one umbrella when, really, everyone has different conditions, diseases, and parameters around their situation. My disease is progressive, so I am constantly forced to adapt to a moving target—and adapt to loss. Every week, every month, every year something changes, and I lose something. I'm not just losing parts of my physicality; I'm losing things that I loved and used to do, things that I equated with my identity. That's been one of the most difficult aspects of having a progressive condition.

My condition has also forced me to look at aspects of my life beyond my physicality. For that, I'm really grateful, because it's pushed me to live my

BEHIND THE SCENES

I met Kam when we made a film together about her disability and how it deepens her connection to nature. It was our first time meeting in person, and we spent an entire week down in Joshua Tree filming together.

I am embarrassed to admit this, but I never had a friend with her level of disability before, so I was nervous. Would I offend her? Would I act weird? Would I be able to tell her story in a way that she would be proud of?

I am so grateful that we became friends after that film. She's taught me a lot and opened up a world of possibilities when it comes to who I can connect with. If I had never met Kam, I don't know if you'd be holding this book.

life knowing that it's progressive and I do have time, but one day, I won't have any mobility left. That really gave me a focus and purpose. My life isn't over, but I know these things I can do will be over one day—so I'm going to live.

I have been living with this disease for more than twenty years, and it still hurts me to talk about it. Even though I've lived with it half of my life, saying it out loud makes it feel real. I'm not remembering something that has happened; I'm experiencing something that is happening *now*.

The more people see us, the more they will think of us and realize we are more alike than not.

My disability has never stopped my relationship with nature. I never had any role models or ever saw any disabled people represented out in nature. I just knew that I loved road trips and being outside. It would be nice to do so much more when I'm out in nature. I wish that national parks or recreation areas would think of disabled people when they create trails—making them flatter or paved so we can traverse the space with ease. At the end of a road trip, when I'm looking in the rearview mirror, there's inherent sorrow because I wish I could've seen more.

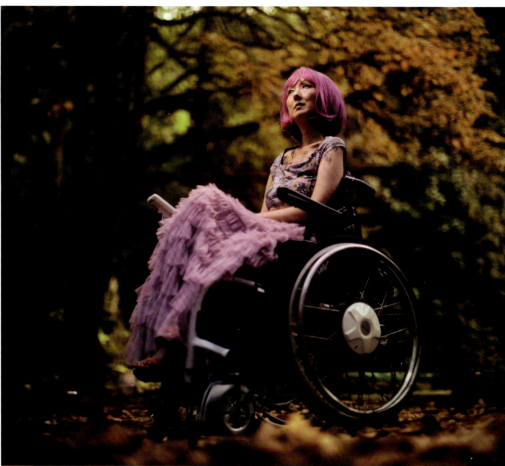

I think most nondisabled people think disabled folks don't want to come out of our houses or do things outdoors. But the reason you don't see us is because places are inaccessible. What people don't see is that we are human and normal just like everyone else—we have the same passions, the same curiosities, the same heartaches and struggles. The more people see us, the more they will think of us and realize we are more alike than not. That's why stories like mine are so important.

Disability is such a harrowing experience for people to imagine because imagination is just empathy in creative motion. To imagine what life is really like for a disabled person requires empathy, which provokes change—changing minds, laws, accessibility, and structures so that they include all people. For access to nature to be truly inclusive, it's essential to represent the spectrum of the human condition that exists.

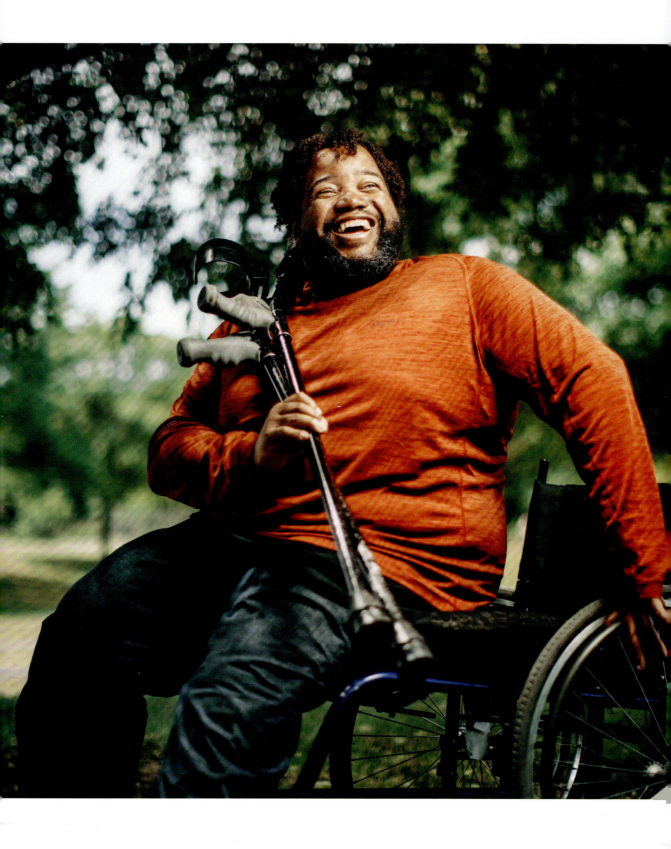

ARTHUR ASTON

I LIVE WITH SPINA BIFIDA, A CONGENITAL condition where the spinal cord doesn't form properly in utero. I was not diagnosed until I was born. Today, you can see that a child will be born with spina bifida through 3D ultrasound machines. This technology was not available in 1981, so my diagnosis came as a surprise to my parents. It affects the lower part of my spine, so I have feeling only above my knees. I can't wiggle my toes or feel hot or cold sensations below my knee. I wear leg braces that come up to my thighs. I use crutches to walk and a wheelchair for long distances or sitting for extended periods. Spina bifida also affected my bowels and bladder for the first part of my life to the point where I wore diapers until I was thirteen. It took three surgeries to fix my bladder.

I grew up in New Jersey in the eighties. At the time, playgrounds were not accessible for kids like me. Where my grandmother lived, there were two playgrounds where my group of cousins would always go. I got around primarily on my crutches at the time, so I sometimes fell and stumbled on the mulch and gravel under the play equipment.

Being disabled, I know that if I want to do something, I can find a way to do it. My father always taught me that I may have to approach things differently. My parents were very aware of my limitations, but at the same time, they pushed me. We had an in-ground pool with a nine-foot deep end and four-foot shallow end in our backyard in which my dad taught me to swim. My mother was

concerned and terrified, knowing my legs didn't work. But my dad's thought process was that if we had this big pool in our backyard, where we would be entertaining and having barbecues, "Arthur shouldn't be the only one not using the pool, especially when he lives here." He wanted to make sure

BEHIND THE SCENES

I found Art through Nicole Rivera Hartery, also featured in this book. When I interviewed her, she mentioned that her friend Art from high school now builds inclusive playgrounds, and I knew I had to meet him.

We got to take photos on one of the playgrounds in New Jersey that Art helped build. What's so cool about these inclusive playgrounds is that they very intentionally ensure kids (and adults) of all sorts of abilities can play together. There's even a spot underneath the structure for children who are neurodivergent or easily overwhelmed to sit and hang out so they still feel like they're part of the fun.

The photo of him looking up and laughing is one of my favorites. This Black man and his wife were walking by while we were taking the photo and he yelled out some words of encouragement to Art—something like, "Okayyy, brotha!" It was really sweet and made us laugh, and that's when I snapped the photo.

I wouldn't be sitting on the side while everyone else enjoyed the pool that was in my own backyard.

My dad was an interior decorator and very intuitive and innovative. When I was a toddler, maybe two or three, he made a walkway out of a wooden board for me to walk back and forth on and strengthen my legs.

I was very close to my dad. He always saw my disability and helped me navigate not around it, but with it. His name was also Arthur, making me Arthur Jr. He passed from prostate cancer when I was just seventeen.

In my early thirties, I started working for Jake's Place, a non-profit organization that builds inclusive playgrounds—not just for disabled kids but for everyone. These inclusive playgrounds are built for everyone, whether you have a disability or not. Their unique features, including barrier-free surfacing, allows children and adults with disabilities as well as others without disabilities to use them.

My parents are a big reason I do the work that I do. I studied to be a psychologist, hoping to offer mental health services to families impacted

> **Being disabled, I know that if I want to do something, I can find a way to do it.**

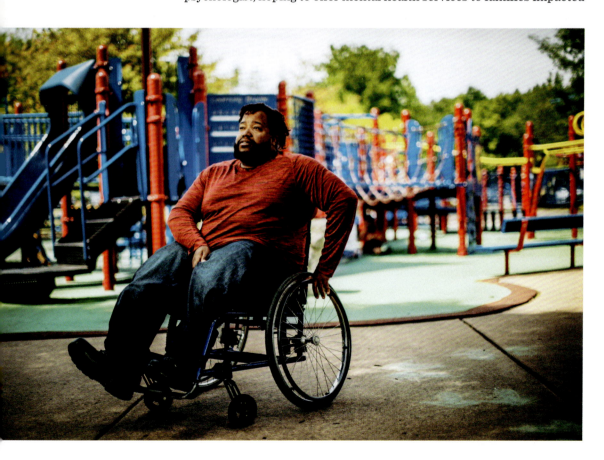

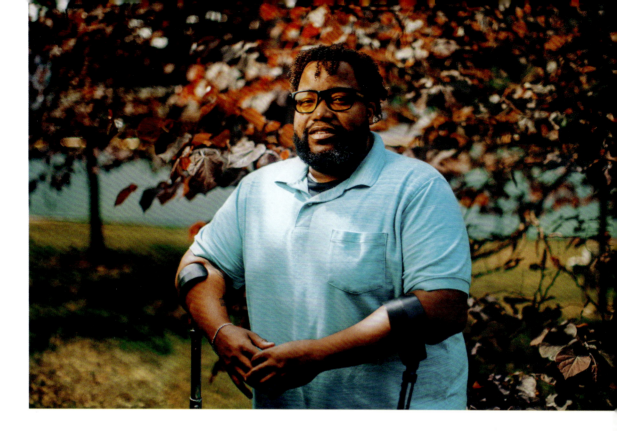

by disabilities. My career pivot goes back to my parents, who taught me, "Sometimes things aren't going to go your way, so you're going to have to change some shit."

That's why I go to schools and talk to young people about my disability. It's why I helped businesses find inclusive ways of making shopping easier for their disabled customers. It's why I started a podcast interviewing other disabled people about how they navigate this sometimes exclusive world. It's why I help build inclusive playgrounds, so kids like me can grow up feeling like they belong in any space they choose. In a way, I feel like I am passing on my parents' message of inclusivity through my work.

If I could talk to my dad now, I would thank him. I would thank him for teaching me at a young age that life wouldn't be easy and that there would be obstacles to being disabled, let alone Black and disabled. He kept it real with me throughout my childhood. That prepared me for the discrimination I would face as an adult and the skewed views and stereotypes that the world holds toward those within the disabled community.

Above all else, I would thank my dad for always including me and teaching me to support others like me. That helped me be in harmony with my identity as a disabled person and inspired me to educate and advocate.

If I could talk to him today, I would say proudly, "Look at us, Dad. We're doing it."

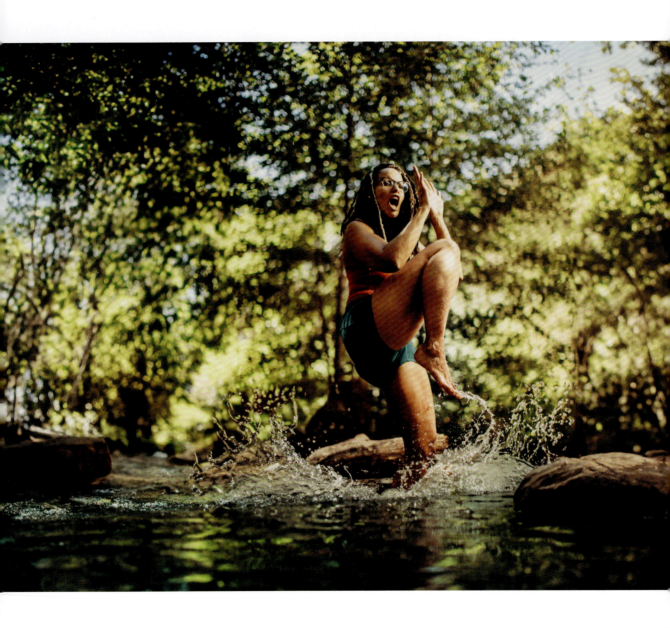

NICOLE SNELL

I HAVE A PASSION FOR HELPING others find their power and live limitlessly through self-defense education. A therapist might say that my childhood has had some effect on my passion for self-defense, even if it hasn't been a conscious one. But I can see how all the choices I've made have stemmed from my childhood—it's probably why I wanted to get out of the house as much as possible and why I was in every extracurricular you could imagine. I overachieved in school, graduating as valedictorian of my high school and then summa cum laude from college. I was not just trying to be the best; I was trying to make sure I could take care of myself, because the people who were supposed to do that did not.

When I was a kid, I didn't want to be in the house, so being outside was the only way I could escape that environment. I wasn't allowed to venture very far, so I would sit in my backyard, play in the dirt, catch ants, try to catch lizards, look at the sky, and watch the sunset. Being outside gave me a feeling of safety. It was the most freedom I was able to have, so I cherished those moments.

Through my involvement with a college group focused on domestic violence prevention training for the US Department of the Navy, I discovered Girls Fight Back, a personal safety and self-defense company. I had just been laid off from my job as a television production executive, so I contacted the owner of Girls Fight Back, expressing my desire to be a part of their impactful work. Although there wasn't an immediate opening, I was offered a position three months later and began my training.

Girls Fight Back was founded in honor of a beloved college student named Shannon McNamara. In June 2001, Shannon was murdered in her off-campus apartment near Eastern Illinois University. Her killer dropped his credit card at the scene and left behind DNA evidence linking him to the murder. Because of how hard Shannon had fought for her life, authorities were able to collect enough evidence to convict the killer. Inspired by how Shannon fought back and refusing to allow her to be forgotten, her friend and sorority sister, Erin Weed, started Girls Fight Back. Its purpose was not to avenge Shannon but to keep her fighting spirit alive and give women a sense of peace. Now, under my leadership as CEO, Girls Fight Back liberates people of all gender identities by bringing them back into their power. Beyond teaching physical skills, I use empowerment-based self-defense, which incorporates verbal and nonphysical skills because those are things we use every day. So many confrontations can be de-escalated and deflected by using nonphysical or verbal means. For example, when you're hiking on a trail and getting a weird

feeling from someone, that sparks your intuition and heightens your situational awareness. This awareness acts as a precursor to anything physical, and it's what studies have found that people most often rely on to avoid violence. Opening up the definition of self-defense to include all the ways we can be effective in defending ourselves can reduce violence and save lives.

Being in nature is a powerful healing tool that everyone has the right to experience comfortably.

In *The Gift of Fear*, author Gavin de Becker talks about how our goal is not to be fearless, because fear is a survival tactic; it helps us know there's a problem. Once you are aware there's a dangerous situation at hand, you can figure out what you need to do to get to safety. A lot of times when people experience fear in the moment, they begin to act, whether that's running away or defending themselves. That fear then dissipates and is replaced with action.

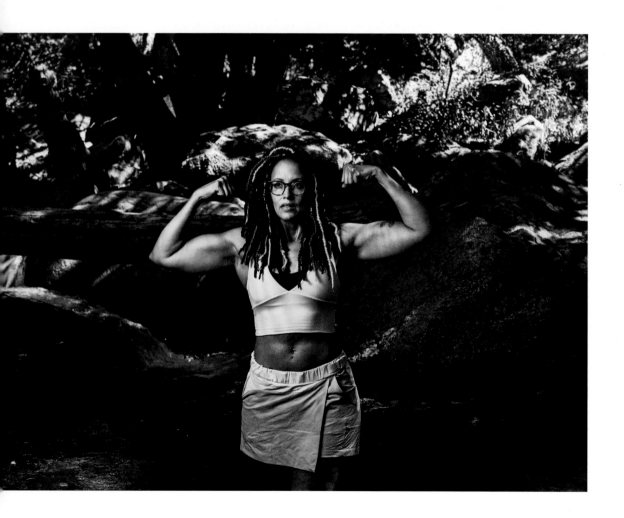

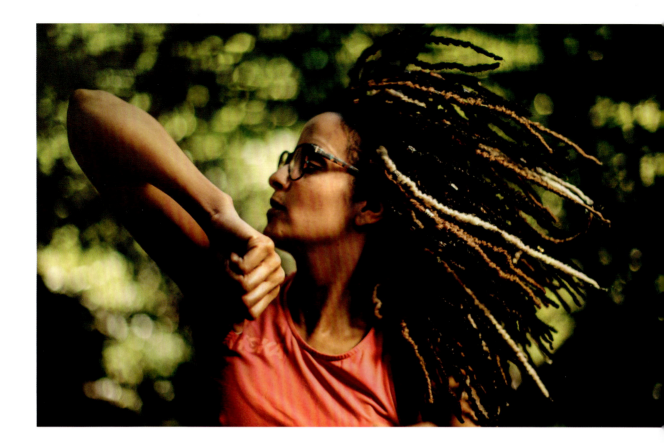

From insects to amphibians to mammals, all creatures have some sort of defense mechanism. To survive is an instinct that all living beings share. Humans, especially women, are not the exception! Having the skills to help us protect ourselves is a human right, giving us the confidence to walk around the world freely and allowing us access to nature without skepticism or fear.

Replacing fear with power is critical to a person's health and well-being, especially when it comes to feeling comfortable in solo outdoor adventures. Self-defense isn't about what you *should* do; it's about what you *can* do. Being in nature is a powerful healing tool that everyone has the right to experience comfortably. My mission with Girls Fight Back is to reconnect people to the power they have inside themselves and acknowledge the skills they already use daily to protect themselves. I am a reminder that nature gifted us with survival mechanisms not for us to walk around in fear but to experience peace, joy, freedom, and safety.

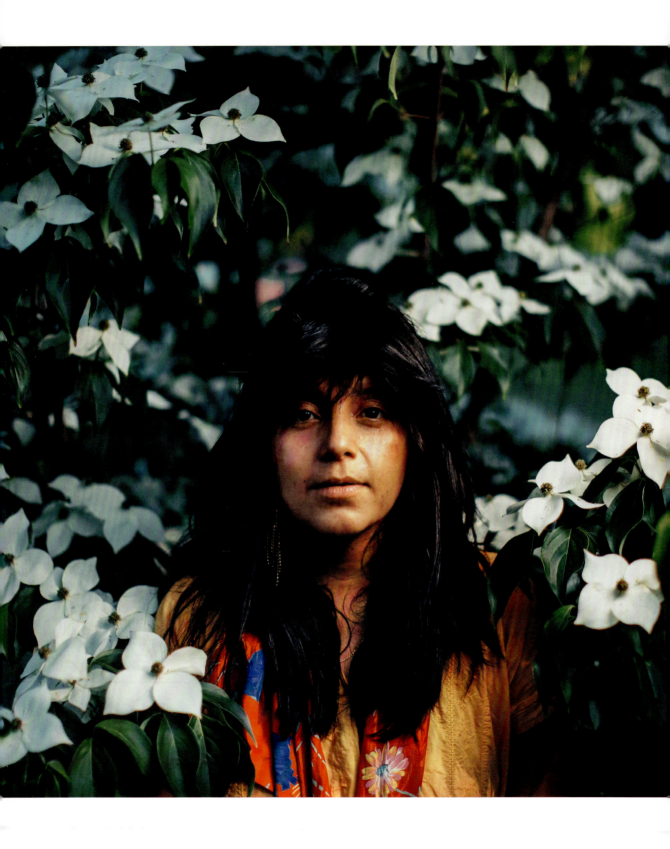

MARCELA MALDONADO

KINDNESS PRESENTS ITSELF IN STRANGE ways in New York City: A stranger wordlessly helping an elderly person down the subway steps with their walker. My neighbors sitting on their stoops and looking out for me when I came home from work at midnight. The bodega guy around the corner from my house refusing to sell me cigarettes before I turned eighteen and giving me small treats when I got straight As on my report cards. Kindness is ubiquitous here; it just manifests differently. If you look closely, most people are looking out for each other.

Before I moved to New York, I spent weekends the first ten years of my life on my grandparents' cacao farm or my aunts' gardens or homesteads in Ecuador, where I was born. I spent time in nature as a part of my daily life, climbing trees to grab fresh fruit or going to the river to escape the midday heat. I chased frogs, created weed gardens, and picked flowers that had no names.

> Everyone deserves to be outside if they want to be.

In the city, there are fewer opportunities for those types of adventure. Life at home was rough. Wandering the city streets and accessing nature was my form of escapism, even if it meant I sometimes went places I shouldn't have. I loved exploring train tunnels and hiding in the divots when a train would pass only feet from my face. I also loved finding little nooks in the parks that felt private and comforting, like those special places back in Ecuador. They were hard to find, but much like kindness, they were there if you looked.

As a high school sophomore, I got accepted into a program called Summer Search, which provided summer enrichment experiences for at-risk youth. In addition to the program, they also offered mentorship to students for the entire year. The first summer activity was a wilderness trip in Colorado, where I got to experience backpacking, rock climbing, kayaking, mountaineering—the whole outdoors shebang. For the first time I was experiencing nature in an entirely different way. I can't emphasize how important this experience was as I started to navigate my early career.

In pre-med I discovered that I couldn't handle gore, but I enjoyed my biology courses. In my last semester I took an ecology course on invasive species and something clicked, so I pivoted. Since graduation, I've become a land manager, helping restore coastal scrub and grassland in California, managing forests in Massachusetts, and preserving land in New York.

Once I returned to New York from years of managing land in other states, I felt a responsibility to provide equitable access to the places I managed. I was so close to home and my own lived experience of finding bits rather than the whole. It was hard to ignore the lack of diversity I was seeing.

Throughout my years in land management, I was almost always the only Person of Color, let alone Woman of Color.

In the first year of fostering the access I didn't have, I invited five hundred people to the preserves I managed. An endowment created for the Eugene and Agnes Meyer Preserve, intended to ensure access to the preserve for everyone who loved nature, allowed me to temporarily remove the most significant barrier: transportation. I wanted people like me to experience those quiet spots in nature, to know that they even existed. Everyone deserves to be outside if they want to be. Everyone has a right to that peace you experience when you connect to the land.

This work also became part of my academic journey. I discovered that how land is managed and where it is protected is a more significant predictor to access—or lack thereof. Where preserves are located is even guided by racial inequity—the people with the funds needed to protect land are usually white people living in white-centric spaces. I lived that so intimately. It's ironic: the job I was working to build access to nature was the same job that built barriers for people like me to work in land management.

Kindness in New York presents itself in strange ways; maybe bringing others outside was my unique way of showing it.

Family & Ancestors

FAREN RAJKUMAR & MOHIT KAURA

WHEN I WAS VERY YOUNG, MY BIOLOGICAL father died from a police misfire in New York. A few years later in Florida, my West Indian immigrant mom remarried a sensitive law enforcement officer (and hobbyist photographer) whom I have always called Dad. He gave me my first DSLR camera when I was fourteen. For fun, we would take photos outdoors or have impromptu photo shoots. I admired the art he would create with his camera, taking pictures of birds, leaves, alligators, or whatever other strange creatures you can find in Florida.

I also wanted to be outside, run wild, pick flowers, climb trees, take photos, and make art. But I was a sheltered older daughter growing up in white suburbia, raised by a protective mother who had lost her first husband and wanted her daughter to play it safe. Even though creativity was encouraged, education came first. I planned to become a doctor, a common goal in Indian households, but that changed quickly when I couldn't cut it in the sciences and all I loved to do was read and write.

I struggled to make friends in my unsurprisingly homogenous creative writing graduate program. Hoping to find connection through shared culture, I joined the Bhakti yoga club on campus. Mohit was the club president and a charming guy. At the beginning of our relationship, Mohit would send me messages about the poems I shared on my blog and take me to epic sunset spots. We weren't looking for anything serious. Then we learned together about mind-expanding psychedelics, meditation, and mindfulness, which brought us closer to each other and to the earth. My inner child thrived as we ran barefoot in nature talking to the trees, getting dirty, and not caring.

On our first camping trip, we took all our gear on a ferry to an island off the Gulf Coast called Cayo Costa and spent three nights on an isolated beach.

> **Every sunset, every night by the fire, and every community we've been lucky to tap into are gifts we would never have discovered from stationary living.**

We spent the nights stargazing and did yoga and painted during the day. Mohit would build the fire, and I cooked the meals. These carefree weekends in nature's lap became our new normal. Mohit grew wilder and less tame all the time.

I shouldn't have been shocked when he bought an old van and declared he was going to drive out West so he could climb and hike every day. While I stayed in Florida to wrap up my last two semesters, I flew out to visit a couple of times, and we lived in his Ford Econoline named Shanti, which means "peace" in Hindi, on the Pacific Coast Highway. I was surprised at how well we got along living in a box on wheels without air-conditioning or running water. I rock climbed outdoors for the first time and got hooked.

Toward the end of my program, my mental health was suffering because of how stressed and unfulfilled I was. So I dropped out, sold all my belongings, and moved into the van full time. I told Mohit, "I don't know what I'm doing, but let's do this together." He always understands my wild heart.

Many People of Color come from parents who struggled a lot, and the last thing they want for their child is to be a dirtbag. My family disapproved of my choice in the beginning. When I left Florida, I was so scared of their opinion that I wrote a goodbye email instead of talking to them. I was supposed to finish grad school and pursue a career in academia. Mohit was supposed to get a full-time job in engineering and help support his family back home in India. Our nontraditional route came at the cost of recurring guilt, a sense of obligation, and identity crises we often feel.

My identity crisis also comes from the lack of diverse representation in outdoor media—especially for Black and Brown nomads. Vanlife is often depicted as a trendy choice for a white hipster who works in tech and buys a hundred-thousand-dollar apartment on wheels so they can chase views while working remotely. Their vans are tricked out with every creature comfort and appliance, and their gear is brand name. If you aren't sharing videos of everything you do, it doesn't count.

Our story is different. Mohit chose vanlife because he was drawn to minimalism. His environmental engineering studies opened his eyes to humanity's impact on the earth, and he was disgusted every time he compared privileged American life to the more modest culture of India. I chose to coexist with him and learn to covet less, buy less, and waste less. I cannot stomach the idea of living in a big house full of material objects that I barely use while children around the world do not have shoes or books or food. We work seasonal gigs and hustle. Vanlife keeps us humble and sane. Taking up less physical space gives my soul permission to roam.

When we meet other nomads, we swap stories about why we chose to leave it all behind, where we've been, and how we get by. Gathering around the communal fire with other nomads can be beautiful, but my skin color often gives me an unwanted sense of being othered or exoticized, feeding an antisocial tendency that is very different from Mohit's hypersocial ways. We keep each other balanced. I encourage Mohit to implement boundaries once in a while, and he helps me lower my guard when it's safe.

Living out of a vehicle is not always easy and often feels unsafe, especially in remote towns. We don't stop, for instance, if we see Confederate flags. In some neighborhoods, I feel like a freak stepping out of our vehicle. I wonder what they must be assuming about our race or religion or financial status. Racial bias runs deep in this country. I worry that we look suspicious

to everyone, and it's a constant effort to not let that play with my self-worth. I'm grateful to have a companion through this journey.

Every sunset, every night by the fire, and every community we've been lucky to tap into are gifts we would never have discovered from stationary living. When I was a kid, I took photos outside with my dad in my backyard and local parks. Mountains, oceans, deserts, and rainforests felt like faraway worlds that only existed in documentaries and books. Now, we have lived in those landscapes, explored and made friends, hurt ourselves mid-adventure, and healed physically and spiritually. Anything we desire to experience feels within our reach because of the van.

I used to think that a nomad was someone who hadn't taken root and was just floating lost. But Mohit and I have stayed in some towns for a few months at a time. Whenever we plant those temporary roots, we build community. We are constantly searching for like-minded souls to eventually build something lasting with, perhaps some land in the desert where we can safely gather, share culture, and live authentically. Maybe that will be our home base one day. But while we keep searching for "home," we have the van and each other.

CHRISHA FAVORS

MY FATHER WAS IN THE MILITARY, GIVING ME a unique upbringing that included living internationally. When we settled back in southern Georgia, it felt like a homecoming and an expansion of the familial relationships I hadn't yet nurtured. I met my maternal grandfather for the first time when I was nine years old. His name was Charlie John, but everyone lovingly called him "CJ." I was an indoor kid before meeting my grandfather, but seeing how he connected with his land gave me my first glimpse into my individual guardianship of the earth.

Cultivating that relationship with my grandfather at such a young age was a pivotal part of my life. Through his mentorship, I realized I loved being outdoors and had a prowess for sustainable living practices. It wasn't until I was a teenager that I realized he was Indigenous, from the Cherokee people, and that's why he held this sense of deep-rooted agrarian stewardship.

My grandpa passed while I was still in college, the same year my cousin died suddenly at age twenty-two. While I struggled with the grief of their passing, my grandfather's death came with a sense of pride, knowing he dedicated his long and fruitful life to tending to his land. He grew up with little means, and it was an irreplaceable gift to pass his land on to his family.

> There's a deep sense of familiarity and nostalgia when I am outside, in my garden, in nature.

In 2020, I uprooted my life and bought a beautiful thirteen-acre piece of land in Lane County, Oregon, on Kalapuya land. More than being a homeowner, I knew I was ready to be in connection with and have a claim to something that's so much bigger than me. Through my grandfather's teachings, I knew this ownership came with an immense responsibility. I will be here for a short while, and this land has been here for millennia—my job is to keep it inhabitable not just for myself but for the plants, trees, animals, and generations to follow.

I don't take land ownership lightly, especially with all the identities I hold: being Black, being Afro-Indigenous, being queer, being a woman. Throughout history and the present, a multitude of barriers have impeded individuals like me from purchasing land, especially in Oregon. Oregon has a dark history of banning Black people from being landowners, which is a disgraceful fact I have learned since living here. I am one of the few Black homeowners in this area, and with that comes a sense of pride and reclamation.

As an Afro-Indigenous woman, my land is a pertinent part of the generational wealth I'm building. It's paramount to honor every tiny grain of my ancestors' existence and all the energy they put into making the world a better place for their people. I feel deeply connected to my ancestors and

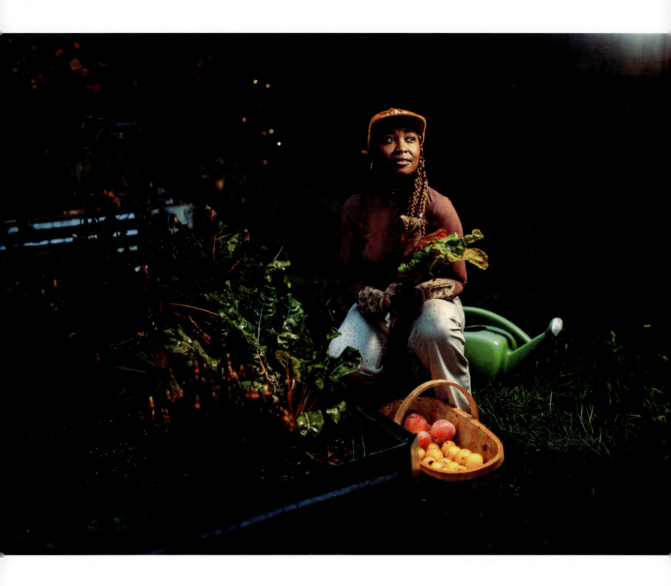

want to make sure I continue to recognize them for everything they sacrificed for me to get here.

 My grandfather taught me so much about homesteading, land ownership, and being a good steward of the land, but the biggest lesson is that representation is vital to relatability. Lacking that glimpse of individuals who share your qualities, cultural background, or pursuits can create an absence of connection and belonging. Without having that representation within him and watching him care for his land, forage, fish, and carry on his ancestral traditions, I am not sure if I would have this appreciation for nature that extends beyond my existence.

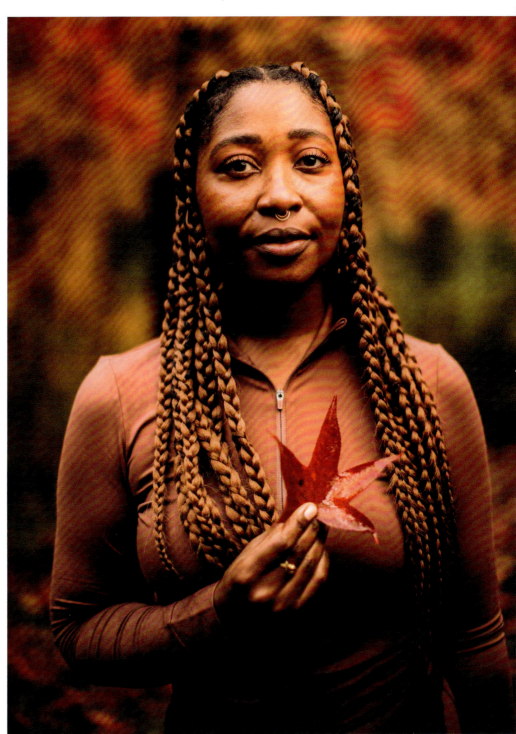

CHRISHA FAVORS | 57

My grandfather taught me that if you're going to take, you have to give back in some way, which has transformed how I care for nature. Even as a landowner, I think holistically about my footprint. I remain intentional about how I add to the property, preserving the rawness that it held before me.

I always wonder what the trees on my property have seen throughout their existence. My hope is that they've always felt honored and respected. I hope that through my stewardship, the animals are well fed and can use my land as their habitat. I hope the original stewards of this land know how much I honor them for their knowledge, efforts, and resilience. Most of all, I hope I can do my part to allow this land to grow and flourish, keeping it sustainable and beautiful for future generations.

My grandfather taught me that if you're going to take, you have to give back in some way, which has transformed how I care for nature.

There's a deep sense of familiarity and nostalgia when I am outside, in my garden, in nature. I can feel my grandfather's presence as I move through my land, holding a sense of pride from the cultural wisdom he has passed on to me. Inhabiting this land rekindles the childlike wonder I experienced by being his little apprentice of nature. Through his mentorship, leadership, and representation, I hope to honor him by carrying on his legacy through ethical land ownership and reciprocity with Mother Earth that echoes through my relations, both past and future.

MELODY FORSYTH & RUBY FORSYTH

WHEN I WAS PREGNANT, MY DOCTOR informed me that my daughter had Down syndrome. At first, Ruby's diagnosis was hard to accept. Having a child with Down syndrome comes with a lot of medical complications, and as a nurse, I was fully aware of—and terrified by—the challenges our family faced. I did not know anyone with Down syndrome, so I envisioned my family's future as being stuck at home or not being able to travel like we loved to do. We lived in Utah for many years and had never been to Zion National Park, so before I got too pregnant and it got too hot and as a "last hurrah" before Ruby was born, I said, "Let's go on a family trip."

One morning in our hotel, we noticed a family eating breakfast and preparing for a day in the national park. What caught my eye, however, was that their child was in a wheelchair. It gave me the thought: If they can be outdoors with a child with a disability, why can't we?

There is a common misunderstanding that Ruby's nonverbal nature implies a lack of awareness about her surroundings. At times, other people speculate that she has no quality of life because of her disability. But when I watch Ruby in nature—exploring, playing, touching, feeling, and climbing on her own—I know this isn't true. The outdoors has impacted so much of her development. How is that not quality of life?

Being a parent of a child with a disability has its challenges, but it's never a burden. Instead, I get

to witness the beauty of her connection to nature. Observing Ruby's enthusiasm for exploration, it's clear that she moves through life without an awareness of her disability. She has zero sense of danger. Anything she wants to do, she goes for it—that's an interesting lesson, one I have learned personally. The narrative I would tell myself, being plus-size, was that certain activities were not for

BEHIND THE SCENES

A lot of moments in my life have felt monumental: finishing the Pacific Crest Trail, becoming an uncle, and sitting in my car waiting to photograph the very first people for this project, Melody and Ruby Forsyth. I knew that I was about to start the biggest journey of my life. It felt akin to the moment I stood at the Southern Terminus of the PCT at the US–Mexico border, feeling a mix of nerves, excitement, and anxiety about how this huge endeavor would change my life.

In our initial interview, Melody told me how much Ruby loved being outdoors. As rain poured down on us during our shoot, Ruby was unfazed. It was serendipitous to photograph a family first. When I think of the outdoors, I think of my own family—that's how we spent time together. It made me happy to see parallels of my love of nature and family in these two special people.

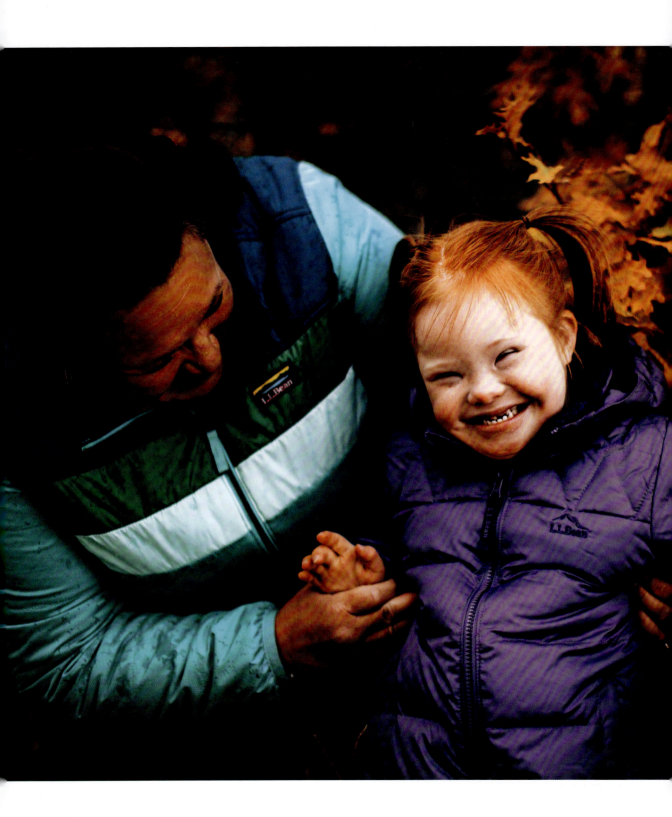

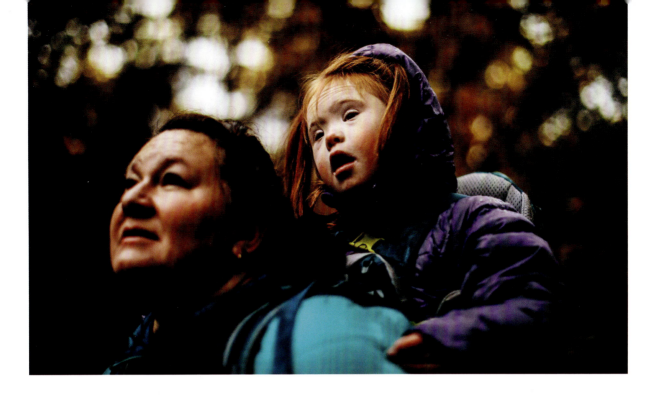

me. Ruby has made me realize the limits I put on myself in that regard. What I do outdoors might look different or ungraceful to some, but I'm doing it because it looks fun and I want to try it. Ruby has broken many barriers for me, giving me the confidence to be in nature without caring what others think.

The more we share our journey as a family, the more we can pass on the message that disabilities don't have to keep you from getting outside together. Even if we inspire one family to get outdoors, it's worth it. Exploring together with your kids provides amazing opportunities to create a special bond with them. Even my oldest daughter, who used to hate hiking, now wants to share nature with her firstborn. Nature also provides us with so many mental health benefits. Invest your time in the outdoors; it will bring your family together the way it did mine.

Ruby has taught our family how to slow down and notice everything: the rocks, the leaves, the sand. She doesn't let her diagnosis limit her. She just gets outside and has fun. She wants to do all the same things we do; she wants to be included.

If I could see that family from the national park now, I would thank them for helping our family realize that we can do it too. Not letting society's barriers stop their family from being together in nature gave me the courage to get outside with mine. Their simple act of getting outside with their child completely transformed my family and my life.

> **Ruby has broken many barriers for me, giving me the confidence to be in nature without caring what others think.**

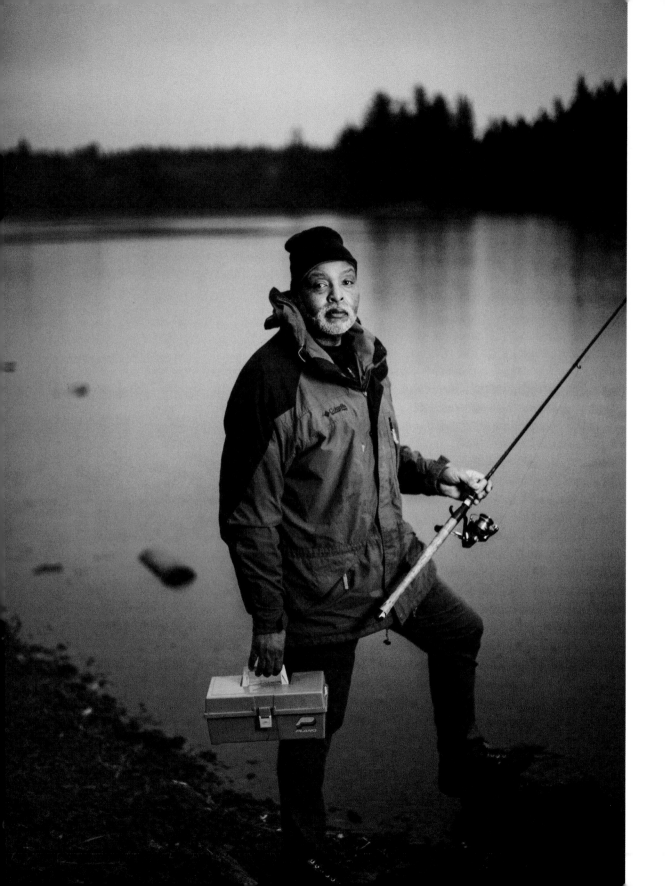

GABRIEL CHILLOUS

I RAN AWAY FROM HOME AT AGE THIRTEEN. My mom was raped at a young age and had me at age twelve, and so my grandma, the meanest woman in the world, cared for me. Tired of being abused, I left to live briefly at a friend's house down the street. A few days later, I went to the police department in downtown Los Angeles, where they fingerprinted me and took photos of my body to document the bruises my grandma had inflicted on me.

Eventually, after entering the foster system, I found a foster family, the Bowers. Originally from Knoxville, Tennessee, they dedicated their entire life to fishing. The first trip I ever went on with them was to the Salton Sea in the Southern California desert. We camped out the night before and got up early to get to the lake to fish. To our surprise, the entire bank was dried up and full of dead fish. Although it was less of a fishing trip due to all the dead fish, it began my love of being outdoors.

When I met my wife, her son Jason was three. Eventually, Tasheon came along, and then Jonathan. We left our home in Southern California and traded it for the lush, green landscape of Washington State. That's when life started to get fun. We didn't live far from Puget Sound, so we would drive the kids out there to camp, fish for flounder, and catch crabs. It was always a good time, and we always came home with something.

> Nature makes me feel like my younger self because I act like the biggest kid when it comes to fishing. It's simply about being outside.

As a dad, it made me happy to get the kids outside, even if they didn't enjoy it. It's hard to tell when they are teenagers if they are having fun since it seems like most are bored with their parents by then. When my daughter, Tasheon, became an adult, however, she started to connect with nature in her own way.

Our first hike together was summiting Loowit (Mount St. Helens) in Washington. Tasheon has a lot of drive and can hustle up a mountain; it made me delighted to see that she had a little bit of me in her. It was a monster hike, but I enjoyed every minute because I was with my daughter. I felt the same delight when Tasheon was featured in an advertisement for Eddie Bauer. My wife and I were so proud to see her in those photos among several other young women. I remember saying to my wife, "Does she not stand out? Isn't she the most beautiful thing you've ever seen?" Seeing my daughter, a Woman of Color in a space I never was represented in growing up, meant everything to me.

I had the same awestruck moment when I walked into an REI and saw a Black man on a huge poster upon entering. Growing up, I didn't see many brothas out camping or fishing, so to see a brotha in a camping ad was a great feeling. This brotha was dressed so sharply and just out enjoying

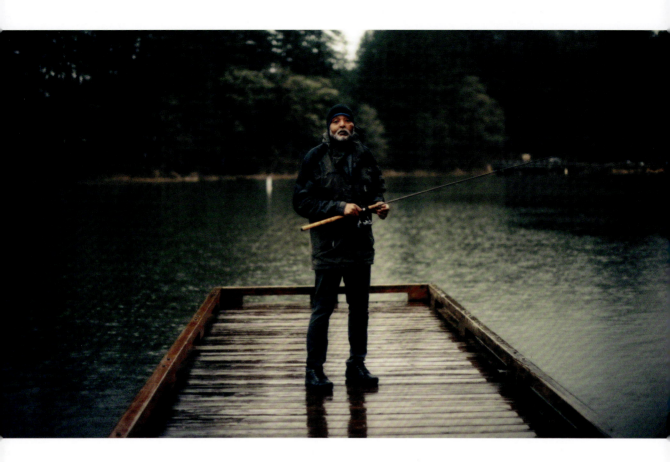

nature. It was a special moment because I finally saw myself represented in nature, the place I have loved for so long.

For me, being outside was never about finishing a hike or catching a fish. I've caught plenty of fish, so I don't worry about that anymore. When I am out fishing and get to witness families with their kids, it brings me back to my own childhood, to those moments with the Bowers. Nature makes me feel like my younger self because I act like the biggest kid when it comes to fishing. It's simply about being outside. I have so much more to focus on when I am on a camping or fishing trip now—like watching my own children and their children enjoy the wonders of nature. At the end of the day, when I'm with family, fishing is just the excuse—being together is the real catch.

JAYNE HENSON

MY CONNECTION TO THE LAND RUNS DEEP. My grandparents, their parents, and my parents all contributed to the agricultural legacy that courses through my veins—generations of roots. It's like our family has a farming gene, passing down traditions from one generation to the next. This notion of transgenerational farming inspired the name of my farm: Transgenerational Farms, a tribute to the land shaped by my ancestors and a commitment to guiding its future.

Beyond familial ties, I strive to extend this connection to others in the trans and queer community who may not share the same direct familial link to farming. The name honors the past while envisioning a more inclusive future. Growing up, I didn't see myself reflected in the farming community around me, nor did I encounter many trans or queer individuals in rural spaces.

In my small hometown in southwest Kansas, I was a 4-H kid, spending my days with my sisters,

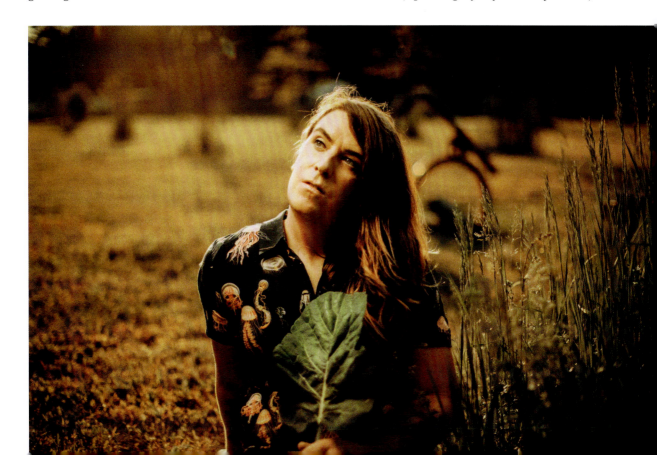

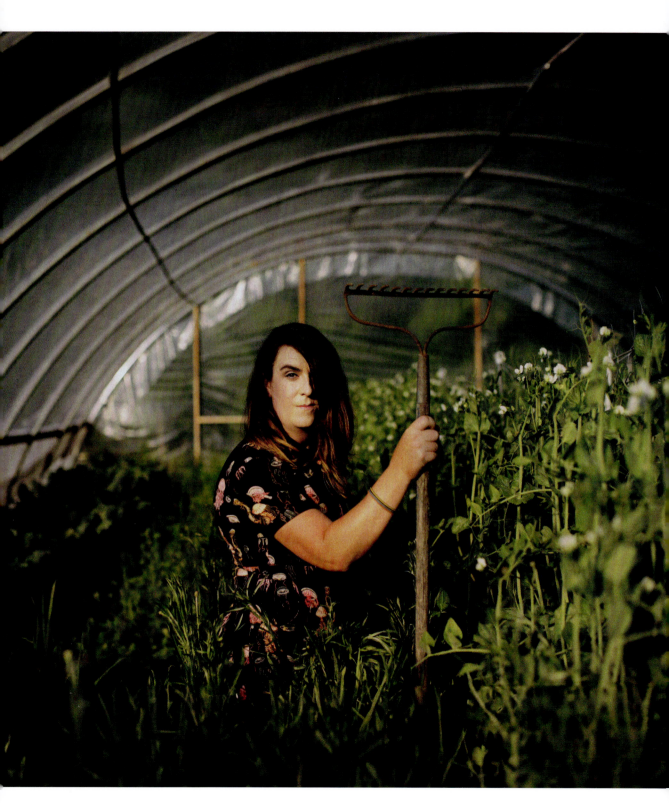

showing horses, and raising animals. Bonding moments with my dad involved frequent pheasant and quail hunting trips, and deer hunting became a tradition with my uncle.

During my sophomore year of college, my uncle died at forty-two due to non-Hodgkin lymphoma, likely linked to the use of Roundup and herbicides, a common practice in conventional farming. After his passing, my parents stepped up to manage his part of the farm alongside my grandparents. Despite his absence from my life now, my uncle will always remain my most significant mentor in hunting and fishing.

Farming is physically and mentally demanding; it's not a profession you can endure unless it resonates deep within your soul. Like my uncle exemplified, it's more than just a job—it's a connection that's hard to put into words. Farming isn't glamorous, and it often wears you down. But for me, the struggle becomes worthwhile when I consider the profound impact on people's lives, especially those who share my queer identity. Feeding people, in its purest form, is a powerful and deeply meaningful act. It's an unparalleled way to have a genuine, cellular-level impact on others, giving them the energy they need to navigate their daily lives.

> **Being trans is inherent to who I am, just as being a hunter and a farmer are deeply ingrained aspects of my identity.**

When I transitioned, my connection to nature noticeably shifted. A sort of distancing occurred, as if I needed to create a stark separation between the perceived "masculine" aspects of my past and the "feminine" aspects of my future. It felt almost imperative to disassociate from elements like getting dirty, hunting, and fishing, as acknowledging them seemed to challenge my legitimacy as a woman.

But I found that my identity as a trans person and a farmer and hunter intricately weave together—they're simply inseparable. Being trans is inherent to who I am, just as being a hunter and a farmer are deeply ingrained aspects of my identity. These roles hold immense significance for me, and I've reached a point where I can fully embrace various facets of myself without succumbing to societal pressures to conform to specific expectations. The validation of my womanhood no longer hinges on conforming to external norms, allowing me to authentically embody all the parts of who I am.

A trip to Colorado with my uncle marked a foundational moment for me: one of the first genuine adventures I had ever experienced. Driving through the Colorado forest searching for a campsite during a crowded summer, we explored, found hidden campsites, discovered serene streams, and he taught me how to fly-fish. A memorable excursion to see my aunt in Estes Park led us to an encounter with a herd of bighorn sheep high up in the mountains. Their presence, so close we could touch them, was a serendipitous moment

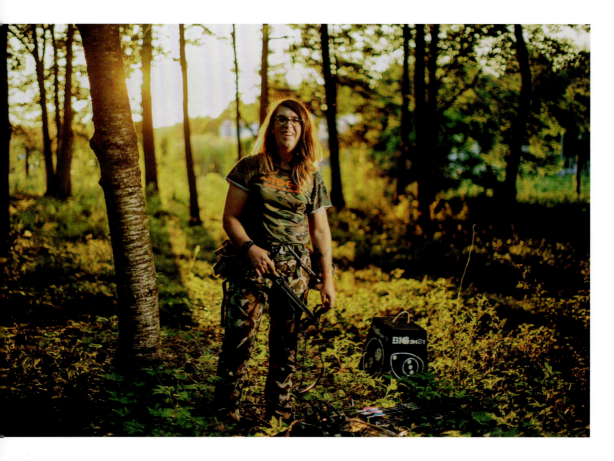

that solidified my appreciation for nature and a love for my uncle's adventurous spirit.

I often reflect on how my uncle might have responded to my transition, wondering whether he would've embraced me. It's a bittersweet reflection that plays in my mind. Despite the sorrow of the unknown, he was still a positive outdoor mentor and someone I truly admired. He never knew me as me, yet I find immense beauty in him not knowing. Our shared memories remain untarnished and joyful, a testament to the unique transgenerational bonds forged in the depths of nature.

SCOTT ROBINSON

AIRPLANES HAVE CAPTIVATED ME SINCE I was a kid—a love rooted in my family's military history and fueled by a celebration of technological evolution. My fascination transcends admiration, encompassing the incredibly diminutive timeline from the origins of flight to landing on the moon within a single lifetime and emphasizing a profound connectivity on the world.

Growing up, I aspired to be both a pilot and a firefighter; my mom, Katherine, who recognized my lifelong obsession with airplanes, found it fitting. My six-year stint as a volunteer reserve firefighter coincided with what I call the "dark ages" of firefighting job opportunities. Even though there weren't positions during my training, I discovered aerial firefighting, initiating my future in wildland preservation. Unable to get a job, I moved closer to home in the Bay Area, which coincided with my mom falling ill and starting a five-year battle with cancer.

For me, the connection to nature takes on a nontraditional venture through my experiences as a pilot, aerial firefighter, and skydiver. Being outdoors for me consists of existing in the middle ground, soaring between the familiar scenes people traverse on foot and the soaring altitudes where airliners cruise. At two thousand feet or upward of thirteen thousand, my perspective shifts, and I get

> **In nature, there's a timeless quality that allows us to stay connected with loved ones departed—here before us, here after us.**

to witness the intricacies of nature from above—communities of trees, the patterns of the land, or even elk running through a meadow. This connection deepens as I see firsthand the impact of fire on landscapes and the ever-changing balance between human presence and nature. Witnessing this destruction triggers a profound sense of empathy, integral to my roles as an EMT and a volunteer firefighter.

During my mom's rigorous chemotherapy process, I witnessed health care professionals who treated her not as a statistic but as a person. Her dedicated doctor went beyond treating the disease; he advocated for her, catching the cancer when it reappeared. This personal approach profoundly impacted me, shaping how I approach and care for the natural landscapes I'm dedicated to preserving. It reminded me of the crucial difference between health care providers who view patients as numbers and those who genuinely care—an insightful lesson in empathy in or out of nature.

I will always love all things aviation, but skydiving played the most significant role in my life as I grieved my mother's death. In the skydiving community, there's a time-honored tradition for those who've passed away: a final jump known as an "ash dive." My mom, having heard about this ritual,

70 | ALL HUMANS OUTSIDE

made a heartfelt request. She never had the chance to skydive herself, only expressing an interest after she was too sick to jump—so she asked me to take her ashes on a freefall.

After her passing, with a ceremony to follow, I flew my mother's ashes to my home in the sky, where I could fulfill her wish. Amid the vast, dimming sky, I took my mom on her first and final jump. The setting sun painted the sky in hues of pink, my mom's favorite color, and as I released the ashes, they caught the light, taking on a cotton-candy glow against the sky's vibrant farewell.

Every element of that evening was so exquisitely beautiful and profoundly ethereal that I couldn't help but think that Mother Nature herself painted that moment solely for us. I don't subscribe to any spiritual way of thinking,

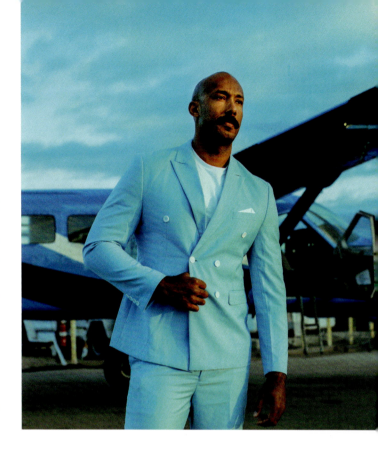

but I will admit that I don't know what I don't know. What I do know is that if there is something up there, somewhere, placing these tender moments for people around the world, then I am incredibly thankful for that one.

In nature, there's a timeless quality that allows us to stay connected with loved ones departed—here before us, here after us. Like the wings of a plane guiding me to the endless expanse of the sky, my love for aviation crafts an axiomatic unity with both my creators, both mother and Mother Nature. It has enabled me to witness the circle of life and the inevitable passage of time. Nature offers us reflections of birth, aging, and loss, spinning a web that connects our human experiences. Whether it's the resilience of a wise oak tree or the renewal of spring after the quiet of winter, nature provides archetypes that resonate deeply within us. In these patterns, we find a universal language that guides humans through various stages of life, offering a powerful connection to something greater than ourselves.

As I move through the aerodynamics of life, nature remains an inevitable constant, a place of solace and peace, and a mirror reflecting the soaring heights of my mom's everlasting spirit.

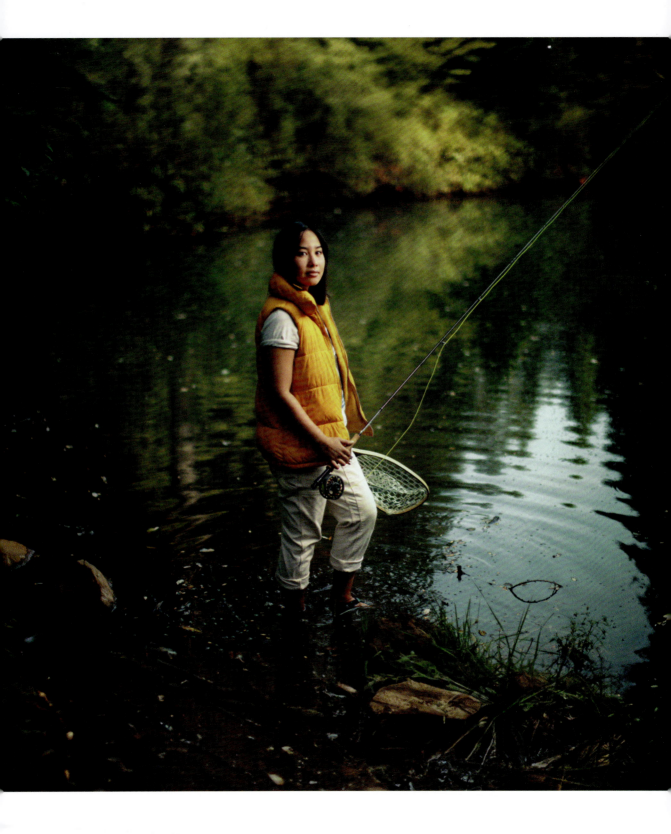

ANNA LE

NEAR THE END OF THEIR LIFE, SALMON SWIM hundreds of miles upstream from the ocean to the river where they were born to procreate. During their monthlong migration, their bodies deteriorate and mold. They do not eat but instead use all their energy to preserve and protect their eggs or sperm. Only about 30 to 40 percent of salmon survive the journey, their sole purpose being to have sex and die, creating the next generation.

I grew up in San Bernardino, California. My parents—immigrants and refugees from Vietnam—came to America in the early eighties following the Vietnam War. While they aren't what I would describe as "outdoorsy," our time spent outside was shared through fishing, a passion embedded in their cultural background.

My household, consisting of my mom, my sister, me, and my maternal and paternal grandmothers, was very matriarchal. I was deeply connected to my Vietnamese ancestry, to the point where my parents barred me from speaking English at home. My grandma would say passively in Vietnamese, "If you don't speak Vietnamese, you're going to starve."

In my family, food meant connection. My grandmothers introduced me to traditional Vietnamese foods and the traditional methods of how to cook. We would harvest fruits and vegetables from our backyard, giving me a rich cultural experience many first-generation people might lose due to assimilation. Fishing was never just for play or "catch and release." There was always an intention behind it. We would catch the fish and then go home, where my grandmother would cook it. Fish equaled sustenance.

My career as a fish biologist specializes in fisheries and aquatic science. Food insecurity became the driving force that landed me here. About 12 percent of the globe relies on coastal communities and fisheries for sustenance and fish as a food product. Growing up, I wanted to be the one who could educate others about the importance of the preservation of fish communities, a gateway for conversations that extend into broader issues.

If there are no fish in a body of water, I always ask why. Is there something wrong with the water? Should I be drinking it? Should I be showering in it? And if there's no water whatsoever, is that equitable? Can we survive as a community? Am I going to be able to survive as an individual? These insights from studying the biology of fish equipped me to communicate scientific information in a way that is accessible and understandable for people, which inspired my career shift to environmental education. My focus has been predominantly K–12

> Something about my work makes me feel like I've lived this life before or I was meant to be doing it. My work feels like home.

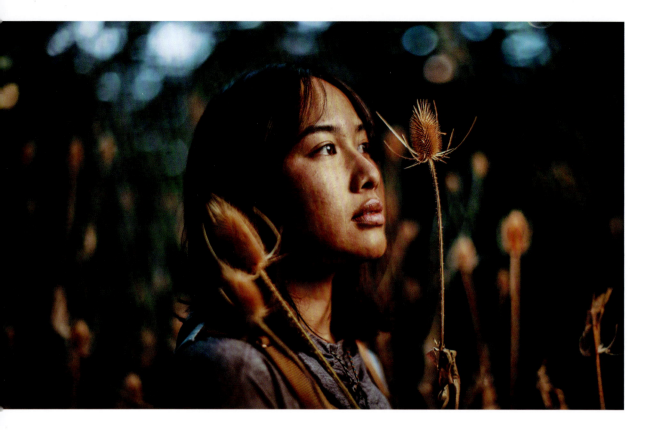

students because making an impact starts with young people, the demographic being primarily rural and BIPOC communities.

Breaking into my career as a conservationist was an uphill (or upstream) battle, especially pursuing a biology career in a field dominated by older white men. It demanded grit as I sought job security and fought systemic issues. I wanted to create a new approach to learning about environmental education, integrating the knowledge acquired from my identity as a multicultural Woman of Color.

I continue this endeavor to educate communities because, like the salmon, I care holistically about the next generation. Something about my work makes me feel like I've lived this life before or I was meant to be doing it. My work feels like home.

As an adult, I learned more about my family history and how part of my parents' upbringing in Vietnam was in coastal fishing communities and villages. I was fascinated to learn that a deep cultural and identity connection is rooted in my love of conservation, nature, and fish. I am connected to the fish by the sea and bound to them, with their spirit gracefully swimming through the currents of my bloodstream, forever connecting me to my family's legacy.

EMMELINE WANG & JOANNE YEUNG

IN TRADITIONAL CLIMBING, NAVIGATING diverse cracks and embedding gear into the constrictions and cracks on a rock wall is a mentally stimulating and all-consuming process. Emmeline Wang faced the test of scaling forty-five feet up a delicate sandstone wall in Red Rock Canyon National Conservation Area near Las Vegas while her fiancée, Joanne Yeung, witnessed from her peripheral vision while belaying a friend on a route next door.

The fragile rock, crumbling even with gentle contact, posed a considerable challenge for secure placements. As she got to a brittle sandstone area on the wall, Emmeline encountered a section of flared rock where the bulging terrain had limited her options for placing gear. Despite making a calculated decision to climb toward a more secure central crack system, a rock as big as her torso beneath her broke. Emmeline suddenly fell twenty feet and landed on a ledge, slamming her back into the rock face and breaking her ankle. As her adrenaline subsided, her willpower waned and pain escalated, and she realized that she needed to be lowered to seek medical attention.

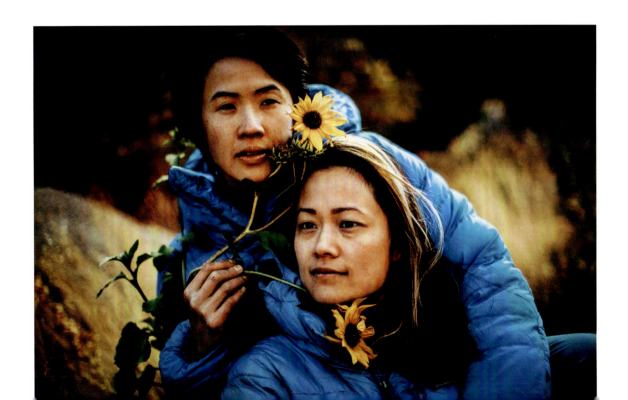

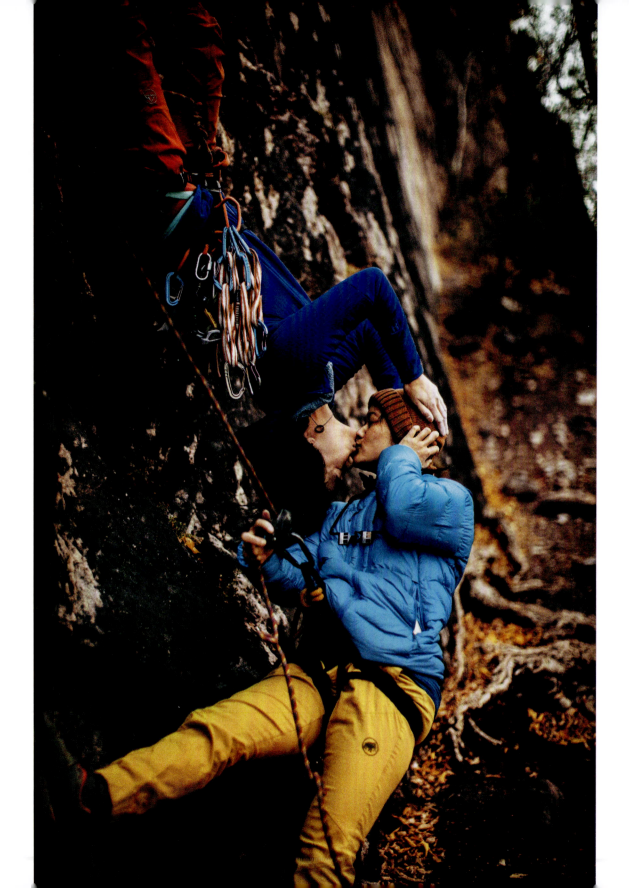

JOANNE YEUNG

The aftermath of that accident changed our relationship. It forced us to reconfigure our lives in a different way and figure out how to support each other through an experience like that. The entire recovery process, what we're capable of doing, how we spend time together—those were changes that were temporary but taught us how to work together afterward.

WHILE COMING FROM seemingly different childhood experiences outdoors, Joanne and Emmeline both grew up in California. Growing up in Orange, Joanne didn't have many outdoor outings with her family. Emmeline, from Fremont, spent her time outside via sports and family vacations to Yosemite National Park.

Their romantic journey, however, began at a crag cleanup hosted by the Bay Area Climbers Coalition, where Joanne discovered they had both dated the same person a few months prior. Initially hesitant about interacting, Joanne was surprised to find Emmeline intriguing. Emmeline, on the board of the coalition, had yet to learn of Joanne. Their first interaction occurred during a group activity to remove graffiti at the crag, an unusual but bonding chore that brought them together. Despite their shared history of dating the same girl, they connected over the task. Over the next two months, they became friends, discovering shared interests and moments of awkwardly cute interactions.

> Climbing is very similar to dance; you're figuring something out, working toward something—but really, it's about the expression of movement and the intimacy you have when you're outside.

Their friendship evolved when Joanne realized her growing feelings for Emmeline, marked by a memorable gym incident where Emmeline complimented Joanne's "cool" ears, correcting herself instead of saying "cute."

As their connection deepened, Joanne invited Emmeline to brunch, where Emmeline, being a highly trained barista, offered to make coffee. This seemingly simple gesture marked the shift from friendship to something more, with the shared activity of potting plants becoming a whimsical symbol of their growing bond.

EMMELINE WANG

The climbing aspect, feeling secure with my partner, especially when she's on the other side belaying me, translates so much into trust and how we handle conflict or problem-solving together. There's an undisputed trust that we have for one another, not just in the sport itself, but also in life.

We find so much peace in the outdoors. As humans, no matter who you are, it's really hard to exist in society. Going out into nature is where we find a lot of our connections. With climbing, I can distill it down to the expression of movement. All of us have ways in which we love to express ourselves, whether it's through art, singing, music, or dance. Climbing is very similar to dance; you're figuring something out, working toward something—but really, it's about the expression of movement and the intimacy you have when you're outside.

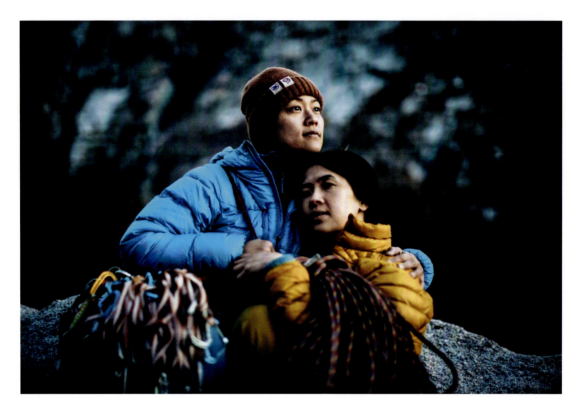

ON TOP OF a trad climb in mid-September on South Six Shooter in Indian Creek, Utah, Emmeline got down on one knee and proposed. With the golden sun painting the red sandstone desert landscape, Joanne said yes.

FRANCES REYES-ACOSTA

I WAS BORN AND "GRAISED" IN FRESNO, CAL-
ifornia. My siblings and I played outside all the time. When my parents took us out to the lake to camp, one person would sleep in the car, and the rest of us would sleep on the ground next to it—that was how my family camped. It was the same when we would ski. Instead of spending all the money on expensive products, we would rent gear and wear jeans we waterproofed ourselves. The outdoors worked for me that way.

When I started raising my children, they began connecting to nature in their own ways. Danielle, my oldest, learned to ski when she was only four. She was just a tiny little thing. When Kika came along, she also learned to ski. Then my youngest chose to sit and play and see if she could eat all the candy. Regardless of what we did, the outdoors was normal; it was our day-to-day.

I love to swim. It's so therapeutic that I swam through all of my pregnancies. Living with multiple sclerosis, there were periods of my life that were difficult to work out and swim. However, when I moved to Fresno, I moved into a home with a swimming pool. That got me back to a place where I could swim and still connect with the outdoors anyway I could.

I don't swim much anymore, unfortunately. I was diagnosed with cancer during the pandemic, which made me rethink how I was living, what I was eating, and all other facets of life. When

I finally had to stop working and retire, I spent maybe six months being very depressed.

Eager to get moving again and focus on my mental health, I volunteered with a few local

BEHIND THE SCENES

The biggest lesson I've learned in my almost twenty-five years of taking portraits is that you have to work for your subject. Never make your subject feel like they are working for you. In other words, as a photographer, you have to adapt to the person you are photographing in the way you pose them, the way you engage them, and the way you let them react to being photographed.

Frances was particularly fun to photograph because she has stories. A *lot* of stories. And throughout the photo process, she was telling those stories—of her family, nature, and hilarious quips and general observations. I had to maneuver around her storytelling; there was no way I was going to tell her not to speak while trying to photograph her.

The black-and-white photo with the jewels on her head is one of my favorite photos from this series. She had started chemotherapy just days before this was shot. When I look at her photos, I see resilience, beauty, power, and a life fully lived.

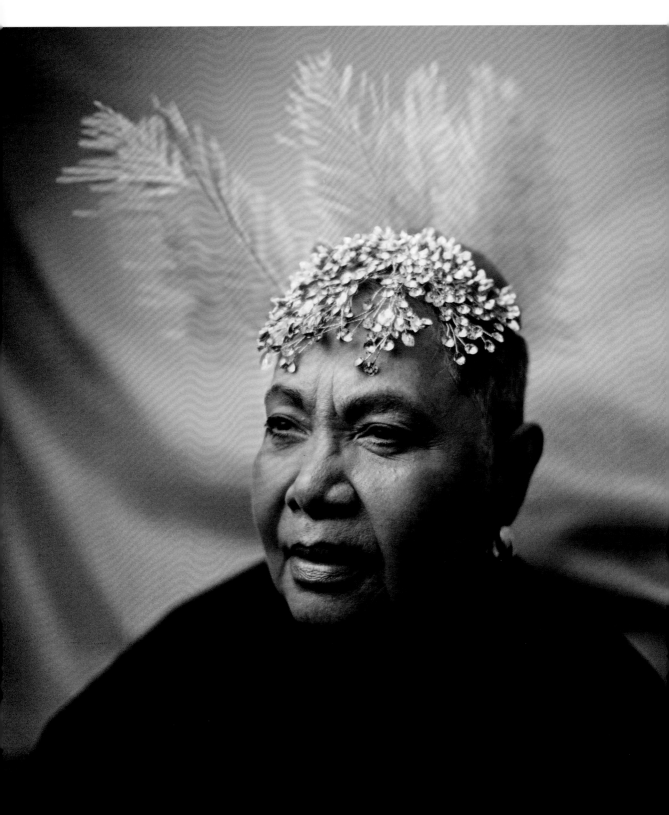

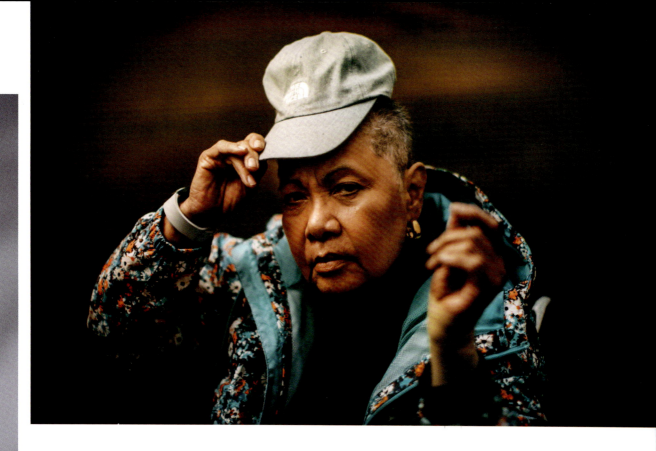

nonprofits. It felt good to help people, even though I was going through my challenges with cancer. However, if you turn around and look at someone else, we can never honestly complain about where we're at in life because they probably have the same problems or worse. I believe the world was created that way—help yourself because it helps others. I find this same symbiosis in nature.

I don't have grandchildren yet, but when I think of their time in nature as they grow up, I think of what will be or will not be. Everything has changed so much in the last few seasons. It takes a lot to scare those of us involved in the outdoors—but what is happening to our earth is scary. We are losing out on opportunities available to us to continue to have lives that we can share with nature, and therefore enjoy lives shared with each other.

> **I believe the world was created that way—help yourself because it helps others.**

Nature is so important to our being because it connects us all. By embracing the outdoors in our special ways, we connect with each other through our shared affection for the natural world. Whether skiing downhill, swimming in pools, or simply basking in the serenity of nature—we find unity in our diverse expressions of love for the environment. Nature affects us all in different ways; we affect nature uniquely, but the one thing that will remain constant is nature's power to unite and uplift us all.

KAMAL BELL

I'M A FIRST-GENERATION FARMER. MY FARM is called Sankofa Farms. *Sankofa* comes from the African language Akan Twi. I chose it because I wanted to build something that had value and connection to our undiscovered heritage as African people here in America. Sankofa, in a broad sense, is an idea that comes from us who hail from the Akan people of Ghana. Its meaning generally translates to "as you move forward in life, it's not taboo to go back and fetch what you forgot."

Since I was young, I loved being in nature because it was always my best teacher. What got me involved in farming were the myriad issues I saw in the Black community, one of those barriers being access to healthy and nutritious food. My work as a farmer was never about just owning a farm; it was about building infrastructure and sustaining our lives.

On my farm, the tunnels are fourteen feet wide and one hundred feet long. Each bed is thirty inches wide and one hundred feet long. From transplant to harvest is about twenty-eight to thirty-one days, based on the season. I grow collard greens, kale, chard, celery, parsley, cilantro, zucchini squash, watermelon, beets, okra, and carrots, among many other things. I have bees in the field that have become a tool for meditation, rather than honey production. In addition, I do community outreach for schools, adult education programs, and youth programs to teach people about the different farming systems that exist.

When I was a teacher at a public school, they had an agricultural and biotechnology instructor position with a subcategory in agricultural biotechnology. In this position, I would teach Black students, ranging in age from twelve to fourteen, that through farming and agriculture, there were ways to change their realities and community. We would do activities like incubate chickens and extract DNA from strawberries.

Through this education, I could see that their thinking was disrupted, which was good. They started looking at the world differently, but more importantly, they started looking at *themselves* differently. The stigma of being Black and outdoors changed because it was not about playing sports or any other societal expectations they had cultivated in their heads. There's a natural connection that people have with the earth, and I saw my students reconnecting back with the source—the place we all come from.

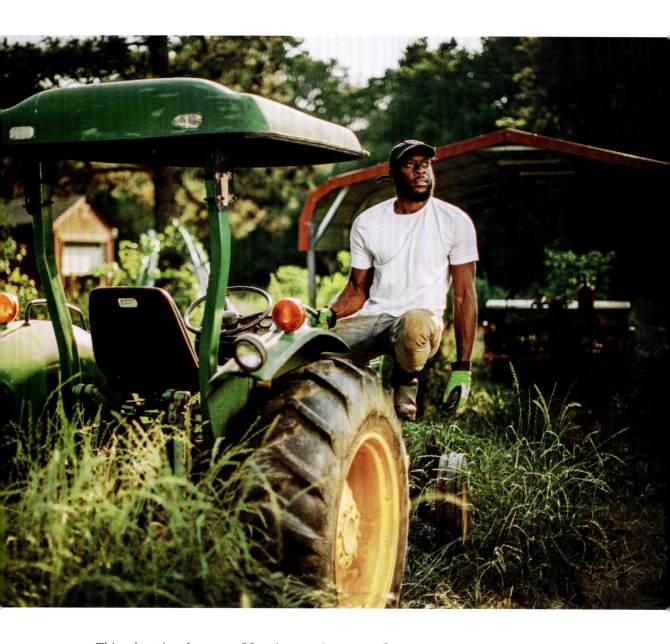

 This educational aspect of farming was important for me to pass on because I wanted students to be in a better position to acquire land of their own and then build systems on it, because they face huge barriers to land ownership. We talk about land loss, but rarely do we talk about the land and the process of how to develop it. I wanted them to be in a position to not only overcome those barriers but also possess the knowledge of interacting with the land. Beyond education, I want young Black kids to see that this type of profession is possible for them.

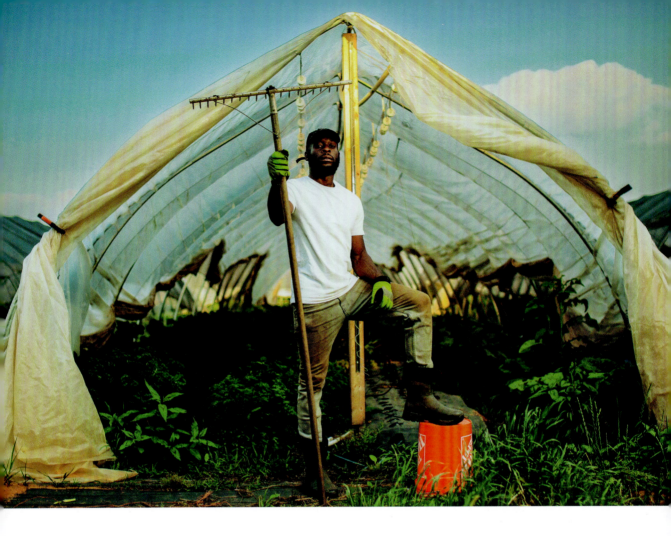

While I don't feel an ancestral reclamation from farming specifically, my approach to farming does. Centering Black people's needs through food is a gateway for us to heal from the traumas embedded in us. Farming is a way to keep my ancestors' legacies alive. Speaking their names creates spirit, stories, feelings, and energies that we can connect to. Just like the concept of sankofa teaches, it keeps us linked to our past while still allowing us to move forward.

Being a farmer has given me balance and allowed me to talk about issues that might be difficult to address. Being in the sun, feeling the wind, and smelling the crops and soil empower us as humans. I hope that through my own ancestry, I will leave behind the stories of our past, the seeds of our present, and a future cultivated by us.

> **Farming is a way to keep my ancestors' legacies alive. Speaking their names creates spirit, stories, feelings, and energies that we can connect to.**

NOËL RUSSELL

I GREW UP WITH PEOPLE WHO PRAYED, AND when we would pray, we would all hold hands. When I held my mom's hands, I would get emotional. She has these shiny, glossy hands, and her skin is paper thin. I would observe the marks on her fingers, her palms, and the brown-speckled backs of her hands. I would get overwhelmed running my fingers over those scars. I was obsessed with how her hands looked and the reasons why they'd been torn and injured.

My mom is an immigrant from Juárez, Mexico, raised in East San Jose. Saying she worked in agriculture can sound dignified, but the truth is that my mom was a field worker. She worked before and after school throughout her entire childhood. Her hands were scarred from years and years of working in the fields. She used to tell me that her fingers and skin were worn—that's why they're so shiny—and it amazed me. I can't remember ever being unaware of everything that came before me, how lucky I was, and the sacrifices she made.

My mom snuck over the border in a family of ten, one by one, to be together in the United States. She worked in the fields all day, cutting her knees on the earth. And then, after breaking her back working all day throughout her childhood, she decided to move off the grid to the forest, where there was no pavement, into a tiny cabin, just to raise my sisters and me someplace quiet and beautiful and safe. I had a unique experience assimilating to outdoor culture as a little Mexican kid living in the mountains. My mom had a dream for my life to look different and incrementally better than hers, and that's the reason why I am who I am.

I was an outdoorsy kid, but I didn't know I was. I would flip through my mom's L.L.Bean and Lands' End catalogs and wonder why my hair didn't look like the people in the photos. My mom would tell me: "Those are just some people. There are so many other versions. Like you, when you go stand in a creek and try to catch fish at the campground with Grandpa. You are so outdoorsy." Her words emphasized the nexus of what it means to be a part of nature.

> We were as rich as can be because we were together outside.

Outside my own doing, there hasn't been a moment in my life where my body has been forced outdoors. My mom's experience of being outdoors was forced. She didn't get to have the kind of fun I've had outside because that was the space where she had to work. When I think about my mom's hands, it's a staggering reflection of the immense weight I carry but also the cherished blessings I've generously received.

When I was little, we got a travel trailer, and I got in trouble with my mom for going to school the next day and telling people that we were rich. I remember the first camping trip with the new trailer, my family seated together and eating in the forest. We had a lot of food in that tiny galley

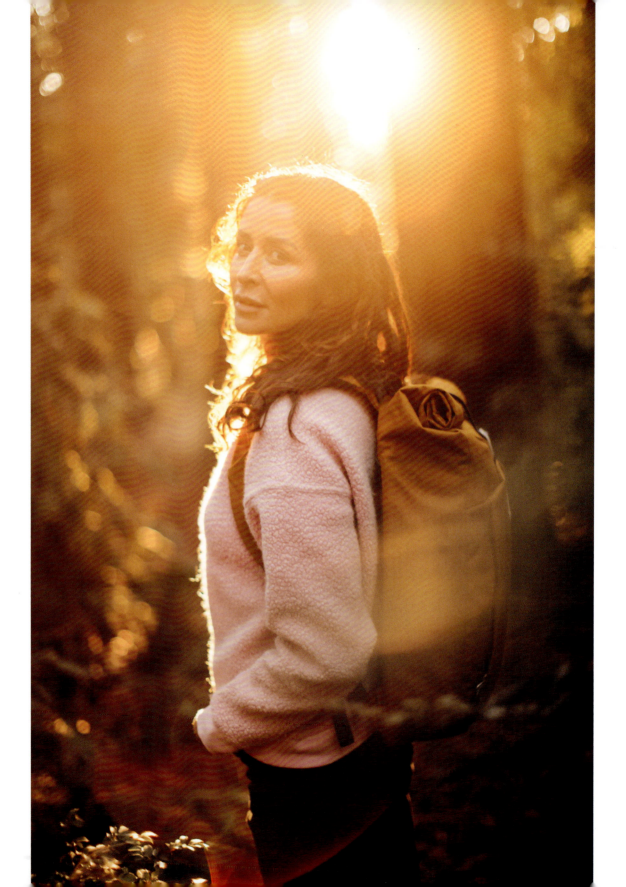

kitchen. And we were all together. We had food, and we were warm, and we were all going to sleep together in a beautiful place—just for the fun of it. I remember thinking that was what being rich meant—not like my friend who had a giant pool or the other friend whose parents took their boat on Lake Tahoe. We were as rich as can be because we were together outside.

To this day, I still get so sad and so happy when I hold my mom's hands and pray. I do so many things outdoors that I willingly put my body through, and they leave scars and marks too, but it's always different. My mom shed blood in the fields so I could scrape my knees against rocks on a sunny day and crack a beer after. She busted her back in between rows of strawberries so I could bust mine carrying extra snacks in my backpack. One generation later, my hands are torn up because I basically put a cheese grater to them by deciding I love trad climbing. This stark contrast is a weight as much as it is a gift; because of that, there is not a moment in my day that I do not remember how filthy rich I am because of my mother's hands.

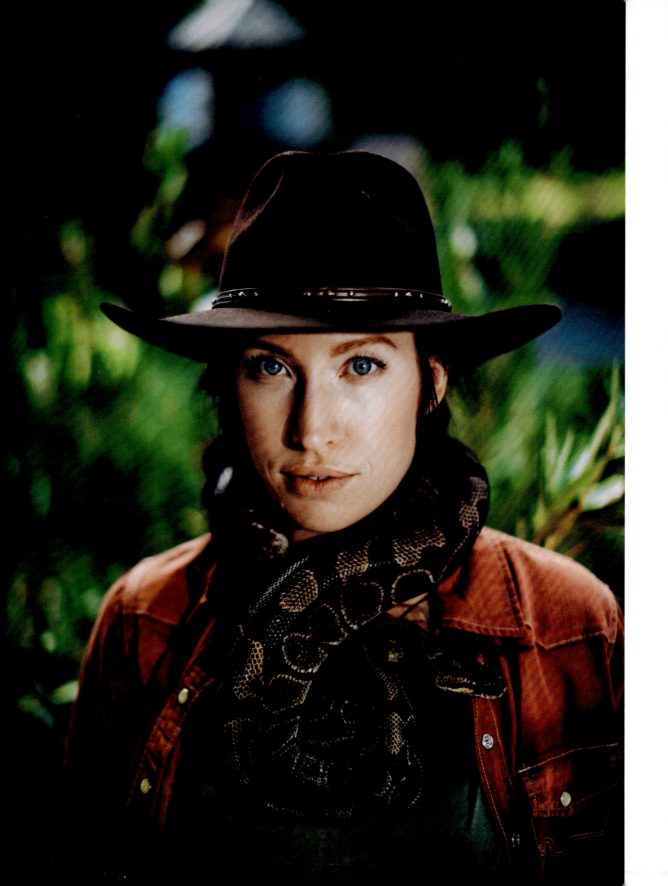

GILLIAN LARSON

I ENTERED THE EQUESTRIAN WORLD through my mom, who competed in dressage. Even though I held that same love for horses, I knew my path as an equestrian was different. I was always more interested in the outdoors and exploring trails with my horses. Shorter rides turned into longer ones, and eventually I went on to complete my first thru-ride on the Pacific Crest Trail. Thru-riding was co-opted from the term "thru-hiking," which means to complete a long-distance backcountry route in a single season—except I am completing these trails with my horses.

Traveling with horses is a unique way to recreate outdoors because it becomes more about the partnership and the obstacles you can overcome together. You must embolden them to be confident and secure in sometimes dangerous situations. There must be a lot of trust between the human and the horse, especially since they are a large prey animal. It can take a long time to get horses to trust you with their life and safety, and in turn, you must trust them to make good decisions.

The most significant catalyst to start thru-riding was my first horse, Shyla. She was a remarkable

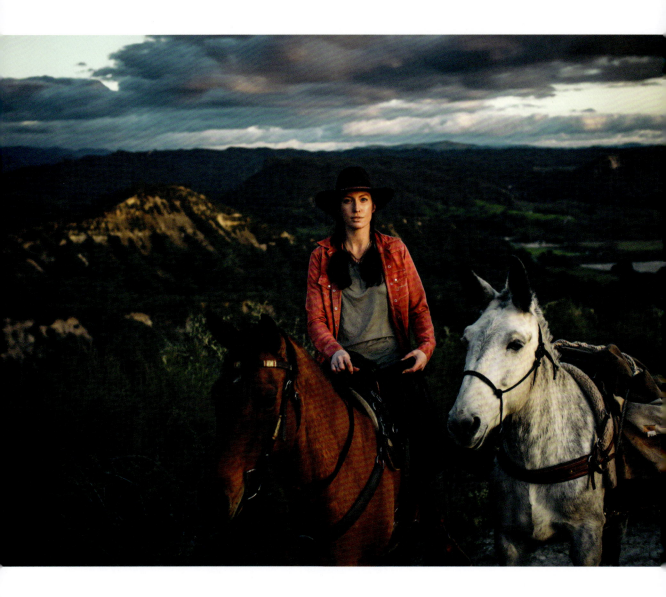

athlete. During college, we would do fifteen-mile rides in between classes. I wouldn't have gotten into long-distance riding if it wasn't for her because I knew she loved to do it. She loved movement. Shyla was fearless and trusting. Having such a strong relationship with her allowed me to dive into something I had no experience with growing up.

 I grew up in Los Angeles and had never spent the night outdoors. I had never even boiled water in the backcountry before deciding to try riding from Mexico to Canada with Shyla. There was so much security and trust in that partnership, allowing me to take on things outside my comfort zone.

We always relied on each other—even when sometimes I was a novice at what we were undertaking.

I lost Shyla in the backcountry several years after my first thru-ride to what I assume was an aneurysm. We were walking down the trail together, me in front of her, and suddenly I felt her lead rope go tight. She had collapsed and started seizing. She was gone in a matter of seconds.

I had Shyla for fourteen years. We had ridden from Mexico to Canada together three times. The most challenging part of this was not just losing that partnership but losing my friend. I relied on her a lot to take care of me, since I was still young and naive. I could never have been successful with the horses I have now or have been competent enough in the backcountry for them if it wasn't for Shyla having been such an equal partner. She really allowed me to grow to my fullest potential.

My love of the outdoors, my love for packing, and the leadership I have taken on with my less-experienced horses are all because of Shyla. I'll forever be indebted to her and the life she gave me.

It can take a long time to get horses to trust you with their life and safety, and in turn, you must trust them to make good decisions.

GILLIAN LARSON | 91

MATT BLOOM

ON THIS OLD VHS HOME VIDEO THAT MY DAD recorded, he and I are sitting on the couch late at night, and he's interviewing me. I have no memory of this conversation, but we're on the couch, and I keep talking about his camera. Even at a young age, I recognized that my dad had an affinity for photography and cameras, and clearly, I was interested too. By fifth grade, I was burning through disposable cameras, taking pictures of my friends on the playground at school. Finally, in high school, I took my first photography class, and my dad was instrumental in teaching me how to use a camera, and how to compose and light a photo. I was officially in love with the medium.

By the time college came around, I was deep into photography and decided to major in photojournalism. I was obsessively taking photos early in college, spending a lot of time in the darkroom, taking photojournalism and art photography classes. My dad bought me a Pentax ZX 30 for my nineteenth birthday, and I carried that thing with me everywhere I went. Something unclicked for me, though, and I fell out of love with photography, changed my major, and stashed my camera in a box somewhere.

When I was 31, my dad noticed that his peripheral vision was slightly obscured. After a medical evaluation, the doctor found a growth behind his eye. He assured us it was a good thing he had found this growth early, because these things migrate and become malignant if left unaddressed. My dad had the growth removed and continued getting tested every few months. The following summer, he learned that cancerous cells had spread to his liver and, subsequently, his bones.

Six months after his diagnosis, my dad was in hospice in our house, in a lot of pain and on a serious cocktail of drugs. Every few hours, my mom, my brother, and I would take turns giving him a slurry of anxiety, pain, and antipsychotic medications. Every dose made him scream in pain and, I thought, terror. I gave him his last dose around nine o'clock. Christmas night. That was the last time I saw him alive.

Two years later, still reeling from my dad's death, I quit my job and used the $12,000 he left me when he died to thru-hike the Pacific Crest Trail. A friend from college had hiked it a decade and a half earlier, and since then I had told myself I would do it one day. In January, when PCT permits became available, I applied for a May 15 start date. My dad's death, and the realization that he didn't get to do any of the things he

After nearly two decades away from photography, the power of these images got me back into it.

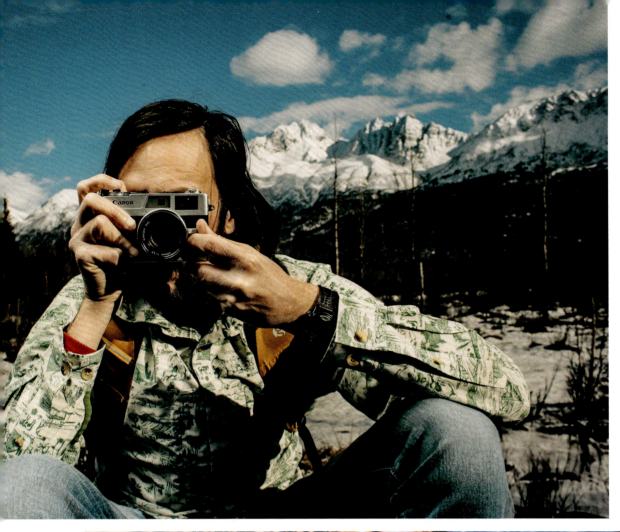

wanted to in retirement, was ultimately the catalyst for that first step.

On my thru-hike, walking around Castle Crags in Northern California, I had a moment when the thought of my dad became so overwhelming that I cried for a half hour, tears streaming behind my sunglasses as I lumbered through a scree field. I realized that I had an opportunity to do some of the things he never got to do. While hiking the PCT wasn't something he had wanted to do, I knew it would be meaningful to him, too, because it meant so much to me.

Nearly a decade after my dad passed, my mom moved from Half Moon Bay, California, to Asheville, North Carolina. As I helped her go through boxes that I hadn't seen in a very long time, I discovered the Pentax camera my dad had given me when I was nineteen, in addition to years of memories from his life in the form of negatives, prints, and old slides he had taken.

Going through his things was an overwhelming experience. Photography has this immense power to put you in a place you've never been and make you feel connected to things you know nothing about. Looking at photos from my dad's life—college, a summer in Europe, Santa Monica in the seventies—it was as if he were speaking to me from the past through his photographs.

After nearly two decades away from photography, the power of these images got me back into it. Now I don't leave home without a camera. I walk and walk, as I did on the PCT, and I try to create images that make other people feel the way I felt about seeing my dad's photos—like I was in on a secret about a time and place I'd never experienced.

BEHIND THE SCENES

I met Matt on the PCT. After enduring a long night of an unexpected snowstorm and temps below twenty degrees, my friends and I made it to Harts Pass in Washington about thirty miles south of the Canadian border. We were hitching down to Mazama to dry our things and enjoy one last night in town before the end of our thruhike. Matt was walking along the road after a twenty-four-hour hike through the night. We picked him up in our hitch and headed to trail angel Ravensong's house; Ravensong, or Carolyn Burkhart, was the first woman to hike the PCT solo. That evening I took a photo of Matt and a fellow hiker in a bathtub full of apples for *Hiker Trash Vogue*.

Even though Matt and I didn't hike together long, we have stayed friends throughout the years. We have bonded over our eternal love for both nature and photography—including him in this project felt really special.

Forging
New Paths

MIRNA VALERIO

ONE AFTERNOON MONTHS AFTER MIRNA Valerio's book, *A Beautiful Work in Progress*, was published, a student named Chris walked into her classroom and said, "Miss Valerio, I want you to know that I really love you, and I love that you're at this school. You bring so much to us. I also want to tell you that you don't belong here."

While she sat there speechless, Mirna knew that this fifteen-year-old had just spoken the truth she feared to embrace. After nearly two decades of teaching, most recently Spanish at a New Jersey boarding school, she had been contemplating leaving her profession.

Mirna grew up in the eighties in Brooklyn. In a classic Gen X city kid upbringing without social media or smartphones, she was always outside, running around local parks and swimming in public pools. A cherished memory, perhaps the beginning of her adoration for nature, was a four-week sleepaway camp in the Catskills. Mirna grew up poor in a working-class family, but funding through her stepdad's union helped pay for urban youth to attend the camp every summer.

Mirna went to a boarding school as a teenager, the same one where she eventually became a teacher, and in ninth grade, she started playing field hockey. Astounded at the unexpected opportunity to join the team and participate in an unfamiliar sport, Mirna started running to condition herself for the team. Dot Harrop, her field hockey coach, created a space for Mirna that put her on a trajectory toward excellence. "She was the first person to ever acknowledge me as somebody that could even maybe play a sport—that's why I'm a runner."

While teaching at a new school in Georgia one winter, Mirna started to see the beginnings of her life's biggest chapter. After nearly six years of telling stories through her blog, *Fat Girl Running*,

BEHIND THE SCENES

Well, Mirna is just a hoot. If you're a shy person before you meet her, you won't be afterward. I met her at her property in Vermont, which she had recently purchased and was building a trail on. It was absolutely stunning. It was also very special to capture her in a place so personal to her. People tend to light up when they're outside, but when they have a connection to the place, they *shine*.

Mirna brought two big bags of shoes because I had the idea to throw all of them for one of the shots. Her son was interning for her that summer and was nice enough to help us throw shoes in the air. It turned out to be one of my favorite shots. Although it might seem a bit ridiculous, I thought it was a great encapsulation of Mirna and how I see her: silly, yet strong and powerful.

Mirna was contacted by a journalist at the *Wall Street Journal*. Abstaining from content related to diet culture or weight loss, the article about Mirna's fitness journey was published. The discourse, although some of it was negative or critical, generally leaned toward a genuine excitement at seeing a fat Black woman running outside.

What followed were speaking engagements, sponsored trail races, and features in notable news outlets like *Runner's World*, CNN, Tough Mudder, and the CW. Mirna appeared as a contestant on *Who Wants to Be a Millionaire?* and garnered partnerships with reputable brands like Merrell, L.L.Bean, and Lululemon.

They learned at that moment that something like that is possible for us.

Mirna's affinity for running had become something much bigger than she ever thought she would experience. A few years later, Lululemon launched a five-story advertisement featuring Mirna on the side of a building in Brooklyn, right in the neighborhood where she grew up. As she stood there, admiring this profound milestone with her mom and brother, two Black men drove up and took notice.

"Is that YOU?" they said, astonished at seeing a Black woman from Brooklyn serving as a face for one of the biggest athletic brands in the world. In a powerful moment, they said, "Wow, they finally remembered us."

"That's been one of the pinnacles of my life. I've had a lot of great things happen to me and happen for me, but to bring it back to my own neighborhood where people never saw anybody like me on a wall or a billboard—that's why advertising exists. People look at those things and they learn things about themselves, about the world, about society. They learned at that moment that something like that is possible for us."

The same day that Chris told Mirna she didn't belong at the school, she went to the office of the head of the school and quit her job. Whether they were spoken in a destined event or fortuitous circumstance, Chris's words gave Mirna the soles she needed to run toward her shine. "Miss Valerio, your star is rising, and you have to follow it."

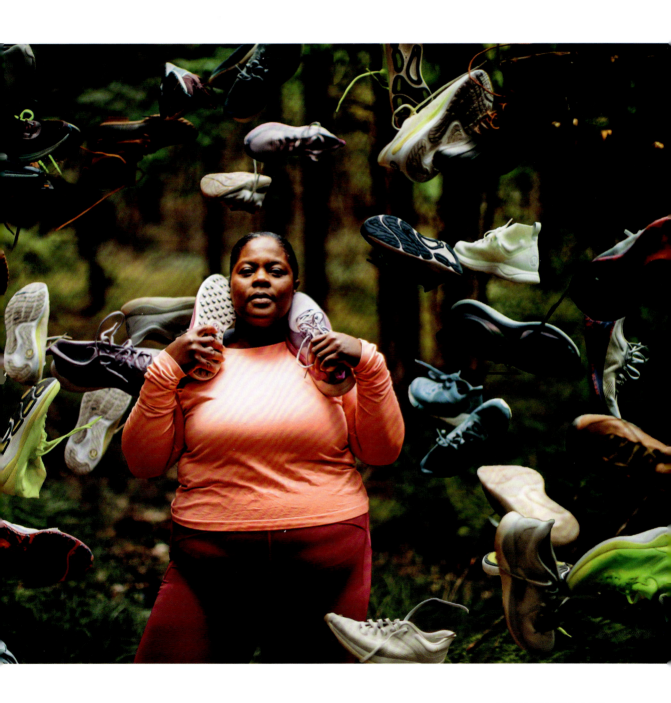

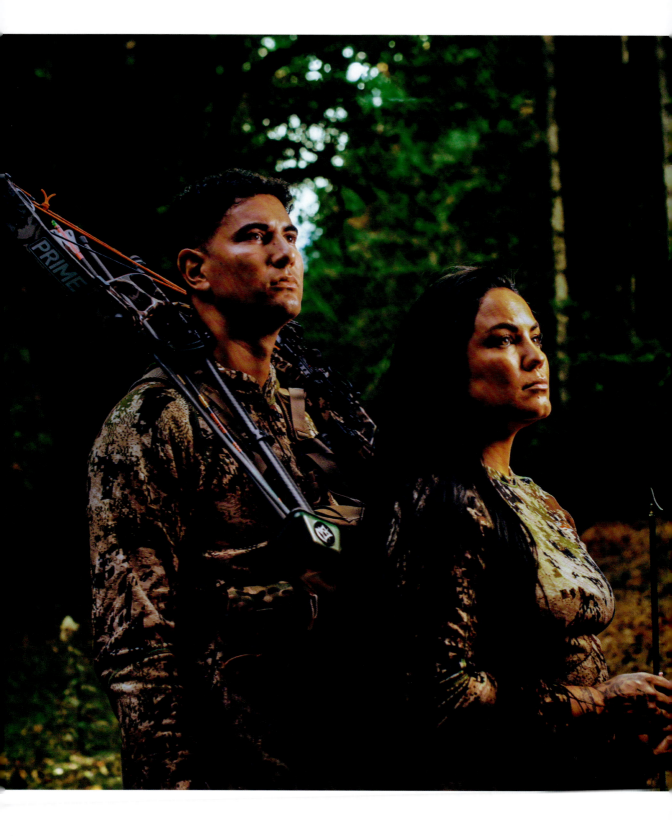

JIMMY FLATT & LYDIA PARKER

JIMMY FLATT

In many cultures, there's a prayer that honors a hunted animal after it's been killed and recognizes its sacrifice. When I approach an animal that I've killed, whose meat I will harvest and body will sustain mine, I say this blessing: "Thank you for the life that you have given me. I will see you in the next life when all that's left of us here are bones." This is my way of showing gratitude and letting the animal know it didn't die in vain. Instead, it will sustain the lives of my family and myself. One day, I too will pass that on to nature.

As a hunter, I view outdoor recreation in an entirely different way than most outdoor enthusiasts who don't hunt. I ask questions about nature like: Is this environment sustainable for life? Is this where I'd want to be if I were living out here full time? Where's the food, water, and shelter? Where are my migration corridors? Contemplating these questions gives me a deeper connection to the animals I pursue because of my intention to harvest them.

I know hunting isn't easy to understand. How can I say that I have a connection with an animal when I'm going to kill it? How is this sustainable if I am going to take an animal's life and remove it from nature? These questions feed my conservation ethos, ensuring I do my part to provide resources, do land stewardship and conservation work, and support organizations that protect those habitats and the resources they provide.

Energy isn't free. If you're going to summit a fourteener, you will be expending thousands of calories just to get to the top of that mountain. Those calories must come from somewhere; most likely, the meat, ingredients, or food for that trip comes from a farm. That food had to be shipped from the farm across the country so that you could buy it in a grocery store and then cook it up. When I go hunting, I take the entire process into my own hands, and then that animal provides me with the energy I need to summit that mountain, allowing me to tap into my ancestral roots.

> It's powerful to think of ourselves in the circle of life, the food chain, and the environment, playing a role in ecology.

LYDIA PARKER

Everything we eat requires starlight. Most forget that the sun is, in fact, a star. When I think of food in this way, it makes me so much more grateful for animals and the food they provide. As a Mohawk woman, I say an old Indigenous prayer called the Ohén:ton Karihwaté́hkwen, or the Thanksgiving Address, when I am giving gratitude. An excerpt translates to: "We give thanks to the grass. We give thanks to the food. We give thanks to Our Grandmother Moon. So be it, our minds are together."

Expressing gratitude reminds me that everything we do in this life—from the animals that

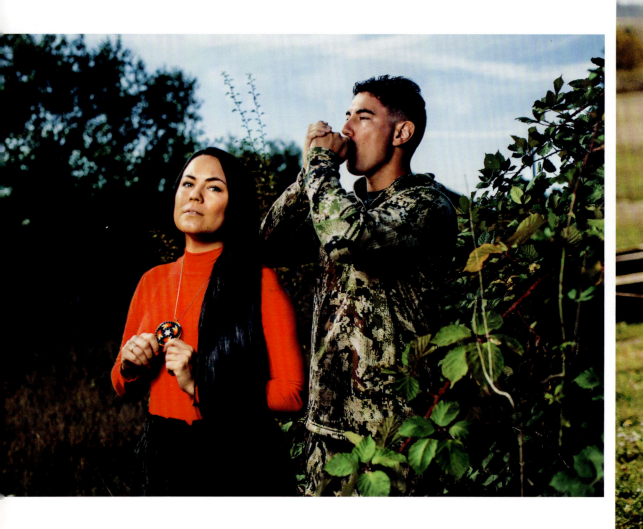

provide us food and energy to the grass that sustains the animal—everything depends on the starlight. Hunting allows me to give thanks genuinely and practically.

JIMMY FLATT

In 2019, when I started my organization, Hunters of Color, no other organized efforts in the United States were working to get People of Color into hunting and conservation. I grew up in a multicultural household, Asian/Pacific Islander/Latino-Hispanic, yet I never saw anyone who looked like me when I was out hunting. When a study came out in 2016 from the US

Fish and Wildlife Service that a staggering 97 percent of hunters identify as white, it reaffirmed those observations.

Today, Hunters of Color runs two programs: one-on-one and community-based mentorship. We hold numerous events in a variety of locations, from archery courses to shotgun skills courses to butchery classes. Our target audiences as an organization are generally people in larger cities and urban areas where that connection to nature may have been lost. It's important to us that we be a conduit for our community

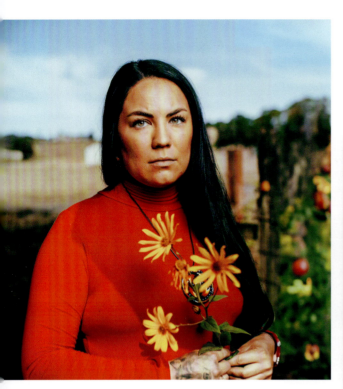
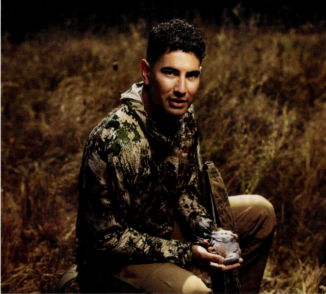

members to have the same opportunities we have had as outdoor lovers and environmentalists.

LYDIA PARKER

As humans, we forget that we are all animals, and sometimes we act like we're not. It's a beautiful thing that we are animals because, akin to other creatures of this earth, we belong in nature. We've done so much to erase and ignore that we are nature. It's powerful to think of ourselves in the circle of life, the food chain, and the environment, playing a role in ecology. Hunting allows us to connect to who we are as animals and get back to our roots. Hunting is our reminder not just of where our food comes from but also to give gratitude to the earth and nature, the place we *all* come from.

ASH MANNING

THOUGH I GUIDE CLIENTS ON RAFTS through whitewater rivers, I still cannot purchase a personal flotation device (PFD) rated for my weight. I must instead rely on my skill to ensure my safety. Not having gear that fits my body poses major risks when I swim or tip my boat on a rapid. The advantage of being plus-size is that I sink to the bottom of a rapid quicker and then get pushed out of the hydraulic faster, meaning I spend less time underwater. However, I face the risk of getting pushed too far down because my PFD can't sustain my body weight and then either getting pinned under a tree or rock or sucked into a cave.

One winter several years ago, I went on a monthlong rafting trip in the Grand Canyon. A company had contacted me the previous summer and offered to make me a size-inclusive dry suit. My hips are about twenty inches bigger than my waist. When I sent them my measurements, they told me it was impossible to make a suit for my body shape. I went on the trip with a different dry suit—a massive hazard because it was so tight. I decided not to wear it because if I fell in the water, it would restrict me from swimming.

The Grand Canyon in late November is unbelievably cold. I hit a big hole and swam, stiffening in the water from the sheer jolt of shockingly freezing water. I had to use all my willpower to unlock my legs to swim back to the boat. My friends helped me

> **Body shape and size don't matter to the trees, to the rocks, or to the whitewater.**

back in, and we made an emergency stop at the closest campsite to warm me up. I was so cold that my fingers went numb and my lips turned blue. While the sun was going down behind the canyon walls, my body got colder, and everyone could see I was not in a good condition. Eventually, I warmed up and avoided an emergency evacuation. However, the circumstances would have been profoundly less risky if I had had a properly fitting dry suit.

Less-experienced people will still seek out these extreme sports, regardless of their access to gear that works for their bodies. If they don't have the appropriate floatation devices or equipment, they can't keep themselves warm or safe.

The outdoor industry needs to accept that people like me not only participate in these sports: we enjoy them, and they bring us closer to nature. The easiest way to be more inclusive is to simply make a larger range of sizes. I think it's assumed that plus-size people aren't outdoors doing extreme sports like whitewater rafting, mountain biking, or climbing. If we are to make nature accessible to everyone, we must make gear that fits everyone.

I connect to whitewater, and I view my life in the scope of its terminology. Sometimes it's smooth sailing and easy to navigate; sometimes a new rapid forms, and it takes me down and kicks my ass. Then there are those moments where I feel superhuman, running Class V rapids and hitting

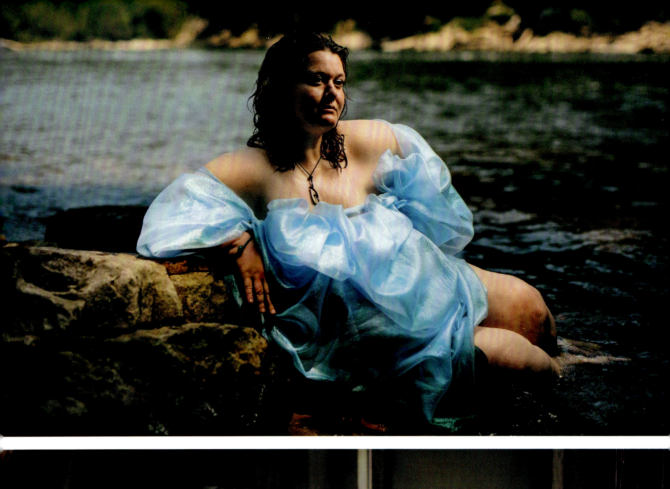
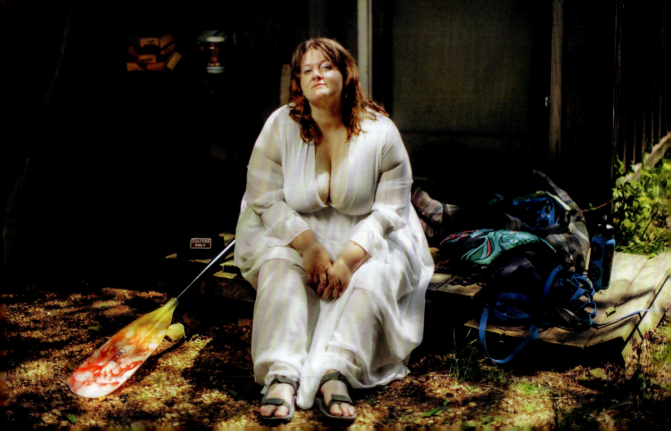

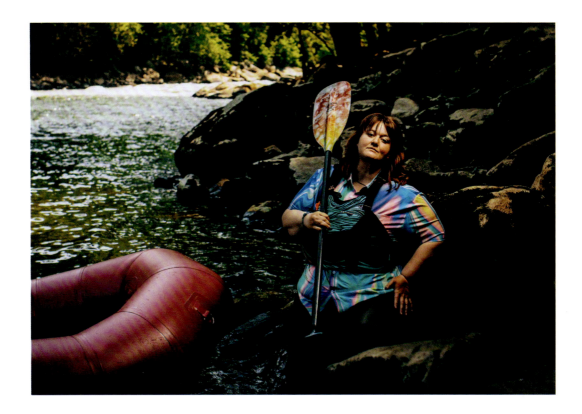

everything just right. The milliseconds of adrenaline stretch far, but in one breath it's over, and you've either succeeded or failed and have to get your shit together—but either way, you've taken care of yourself, and you still get the experience of being outside. I wish I could take this feeling and bottle it, because it would sell like hotcakes.

There are so many people who love the outdoors but don't have the access to even recognize it. Body shape and size don't matter to the trees, to the rocks, or to the whitewater. That's why we need gear for all body sizes—if not for safety, then for the experience of wonder, enchantment, and the overwhelming and ethereal sensation of being a part of nature.

DAHLIA MENELAO

ON JUNE 21, LONG-DISTANCE HIKERS CELE- brate the summer solstice, the year's longest day, known infamously in the thru-hiking community as "Hike Naked Day." True to its name, participants joyfully galivant through the woods in the buff, laying bare their chafe, scars, and farmers' tans for nature to behold. It's a day of no inhibitions, silliness, and unadulterated fun.

Fueled by a desire to cope with the grief following the death of her longtime best friend, Chelsea, Dahlia Menelao embarked on an inaugural thru-hike of the Appalachian Trail in 2022. While Hike Naked Day was the first time she participated in this annual revelry, a state of undress was terrain she had already traversed.

> The experience of a cross-country hike was more vulnerable and revealing for Dahlia than any night on stage.

Dahlia, from Baltimore, Maryland, started stripping when she was twenty-two. She was inspired by the magnetically confident women she saw dancing on stage the first time she stepped under the neon lights whose hues cast colorful shadows upon the nameless patrons and dancers' soul-baring figures. Exotic dancing, for her, transcends mere profession; it has become liberating and joyful, a form of self-expression that has allowed her to take off the layers of societal judgment.

Despite the universal and humanistic nature of sexual desire, society tends to treat stripping and sex as taboo. The history of stripping dates back over twenty thousand years to Paleolithic cave paintings and evolved through eighteenth-century European courtesans (sex workers) who entertained during banquets, laying the groundwork for modern stripping.

Stereotypes surrounding sex work and stripping uphold the prevailing assumptions that individuals in this industry lack self-respect, come from troubled upbringings, or lack motivation in other life pursuits. On the contrary, one in three exotic dancers work to put themselves through college, a statistic typically unknown to the general public.

"I think the biggest [misconception] is that we're just whores. That we didn't give it a shot in life. We are smart, we have degrees, and we have families."

Dahlia's relationship with her profession extends beyond the club, confiding in those with whom she shares the stage. She describes the women she has befriended throughout her years of dancing as "wholeheartedly kind individuals," an affirmation she associates with her thru-hiking community.

Throughout her years of dancing, Dahlia has shared holidays with her coworkers, meeting their partners, parents, children, and extended families. Dahlia speaks affectionately about her own nine-year-old son, guiding him toward independence

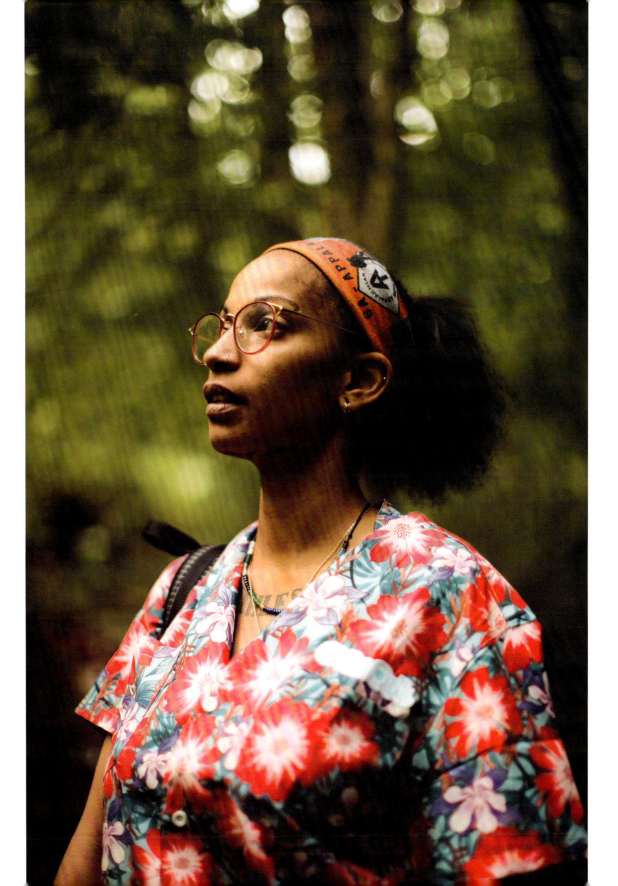

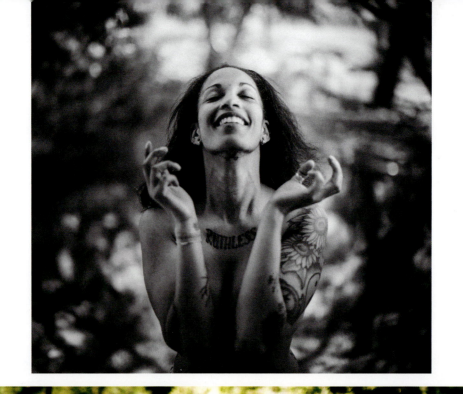
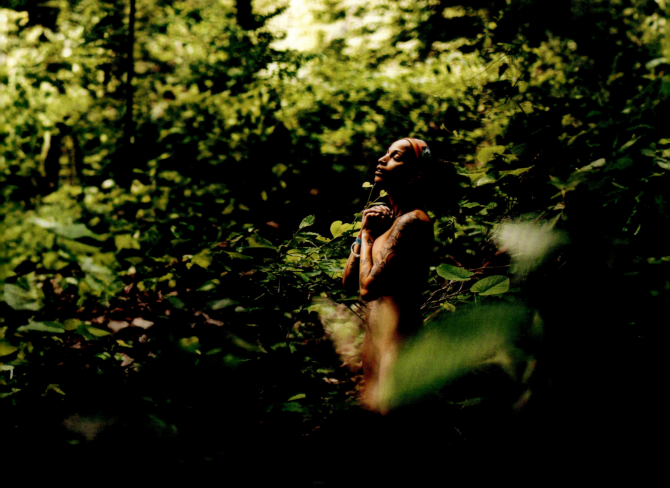

and instilling the qualities of a well-mannered young man. Her ultimate goal is to nurture in him a profound respect for women.

For Dahlia, stripping is not strictly for income; it's a foray into bodily autonomy that encourages openness and self-love. She has come to appreciate the power of being unapologetically comfortable with herself, a lesson she learned through shedding inhibitions through dancing and thru-hiking the AT and embracing the unassuming connection between nudity and nature.

Immersing yourself in nature for an extended period builds confidence and fosters love and appreciation for the body. As thru-hikers become accustomed to the trail, hygiene can take a backseat, and they become more comfortable with their natural state. The experience of a cross-country hike was more vulnerable and revealing for Dahlia than any night on stage.

"At work, I'm showing my sexuality and my body. Whereas in the woods, I'm connecting with myself, my body, and what's around me."

Dahlia has found uninhibited freedom from dancing in the nude, a liberation she embraces. Yet it is amid the wild scapes of nature, breaking free from ceilings, walls, and stages, where Dahlia has truly discovered herself and her body. Here, surrounded by the crickets' symphony and the spruces, firs, and pines, she experiences a profound sense of release that transcends the physical boundaries of her profession.

Transitioning from the confines of the strip club to the rugged trails of Appalachia, Dahlia found unparalleled liberation and healing in navigating the wild. Stripping and backpacking, seemingly disparate realms, unite in the shared essence of somatic reverence and the remarkable terrain of nature that strips away her second skin, revealing the soul-baring woman underneath.

BEHIND THE SCENES

Dahlia is unhinged in the best possible way. While she photographs so well, she is also such a goofball in front of the camera. We had such a great time hanging out in Damascus, where we happened to both be attending Appalachian Trail Days.

I lived in Portland, Oregon, for almost a decade, and a night out with friends usually entailed a strip club or two, as Portland has the most strip clubs per capita in the United States. When I heard that Dahlia was a stripper, I knew I wanted to include her. Stories like hers, ones with stigmas attached, are so important to hear—maybe the most important when it comes to changing hearts and minds.

My only regret about this shoot is that she forgot her stripper heels back home in Baltimore.

ANASTASIA ALLISON

AS A SPECIAL AGENT FOR THE RAILROAD, part of my job was to educate people about staying safe in the vicinity of trains. My job required me to endure a lot of trauma—in five years I handled seventeen fatalities. I was at a low point in my life and career and couldn't get myself out. One January, I was driving home from a snowshoeing trip with my mom and my husband, Aaron, at Stevens Pass, a rural mountain pass in the heart of the Cascade Range in Washington State.

It was a clear day, but it was barely ten degrees. I must've hit black ice because suddenly, we were spinning across the four lanes of Highway 2 in the path of an oncoming semitruck. Miraculously, our vehicle came to a stop, we didn't hit anything, and no one was hurt. To this day, I can't explain how things ended the way they did.

Although we walked away physically unscathed, my mom and Aaron did not have the same experience that I did. They said we were lucky to be alive, while I had experienced this profound out-of-body phenomenon. Many of those feelings were of guilt that my mom and Aaron were in the car, which made it difficult for me to go up to Stevens Pass afterward, due to trauma responses like nausea and a racing heartbeat.

Following this event, I went to lifespan integration therapy, which helped rewrite the memory. That helped me reflect and start looking at my life and how I lived it. I began to notice all these places where fear was holding me back from pursuing the things I was passionate about—specifically the outdoors. Soon after, I quit my railroad job and decided to take this wild idea I had dreamed up just a year earlier and dive headfirst into making it a reality.

My company, Kula Cloth, is an antimicrobial pee cloth designed for outdoor lovers who squat when they pee. The idea for Kula Cloth was conceived while I was backpacking the Wind River High Route in Wyoming. I had been a backcountry instructor for a nonprofit that taught backpacking skills to women and was wildly frustrated with how much toilet paper I saw in the backcountry. So, I started researching Leave No Trace toilet paper options and heard about using a pee cloth to reduce waste. It sounded disgusting at first, but for the love of nature, I decided to try it—and I loved it.

The Kula Cloth was intentionally designed to be a beautiful piece of art hanging on people's backpacks. I wanted others to get excited about sustainability and talk about Leave No Trace, incorporate these principles and experiences they had in the backcountry into other areas of their life, and question whether their lives at home and the outdoors are sustainable.

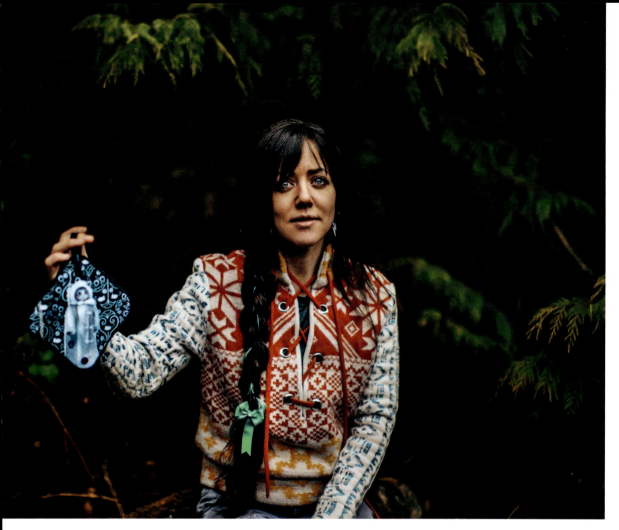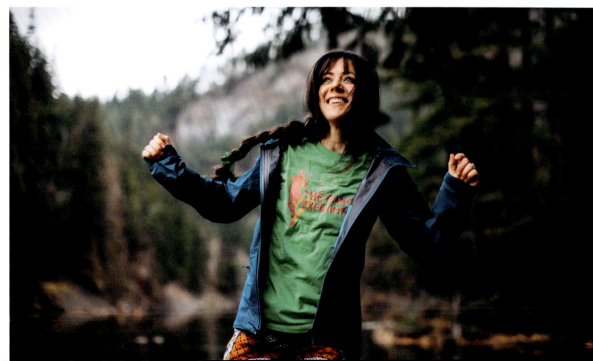

Several years after that life-altering trip over Stevens Pass, Aaron and I traveled over the pass once again, this time on our motorcycles. We planned to get a bratwurst in Leavenworth, a Bavarian-style town east of the Cascades in Washington, while I delivered custom Kula Cloths to coffee shops in the area. There was a dramatic difference between this trip and the first one, the wake-up call my life had needed.

As we went over the pass, I noticed Union Peak, the mountain we climbed that day we almost got smashed by the semi. Over the motorcycle intercom, I told Aaron, "Hey, we've climbed that!"

"When did we climb that?" he asked.

"That's the mountain we climbed the day of the incident!" I responded, smiling, realizing how much had changed since that day.

When I look back at that moment on the pass, I am thankful it happened because it was one of the most pivotal days of my life.

There was a dramatic difference between this trip and the first one, the wake-up call my life had needed.

WHITNEY WASHINGTON

ONE WINTER SEVERAL YEARS AGO, I FOUND myself in a deep state of depression and craving to be outdoors and more active, so I started walking to train for a 5K. Right before the pandemic shutdown began in March 2020, I successfully ran that 5K. During lockdown, while most people were inside, scared of the world outside, I got out my childhood bike. I hadn't been on a bike in over a decade, but that feeling of pure freedom returned to me when I started riding again. After riding around my neighborhood in Jacksonville, Florida, for a few weeks, I knew I wanted to go farther. I just needed to start.

The next year, I cycled from Washington, DC, to Seattle, Washington, which took about three months. To research long-distance bikepacking, I watched a lot of biking videos on YouTube from various creators. I wanted to know what it would take to ride more than 3,500 miles. One bikepacker in particular lit the fire in me when he asked, "What's stopping you from going on your adventures?"

In my head, I answered the question with, "Because I'm scared that I wouldn't fit in."

During the pandemic, the government provided people with stimulus checks, which benefited me greatly since I had very little money to fund a cross-country trip independently. I used that money to buy all the gear I needed and an Amtrak ticket to DC. My goal was to get there and then figure it out. I knew I could get stronger and go farther over time on the trip if I just tried.

I had a lot of fear at the beginning of the trip, even though I knew I needed to make some drastic changes in my life. Respecting my accomplishments led me to trust myself and my intuition. As I traveled along this route, I would sometimes stay off the beaten path at strangers' houses, which can be scary and requires a lot of trust. However, I knew I would protect myself by using my best judgment and not staying in places I felt unwelcome or unsafe.

> Sometimes people can't imagine something is possible until they see it first—let your story lead when people see you.

Along my journey, I passed through many conservative small towns. One day, while cycling through Indiana, I passed a biker bar with a sign that read "Breakfast Sandwiches." I was slightly intimidated to pull up on my bike with all the bikers' motorcycles parked out front, but I was hungry, so I told myself, "I'm just gonna go in there."

When I walked inside, everyone turned to look at me. I didn't look around as I approached the counter and told the clerk I wanted one of those breakfast sandwiches and an orange juice.

"Did you bike here?!" one of the bikers asked curiously.

"Yeah, I'm biking across America." The look on the biker's face quickly changed from scorn to both shock and intrigue. I realized everyone's initial

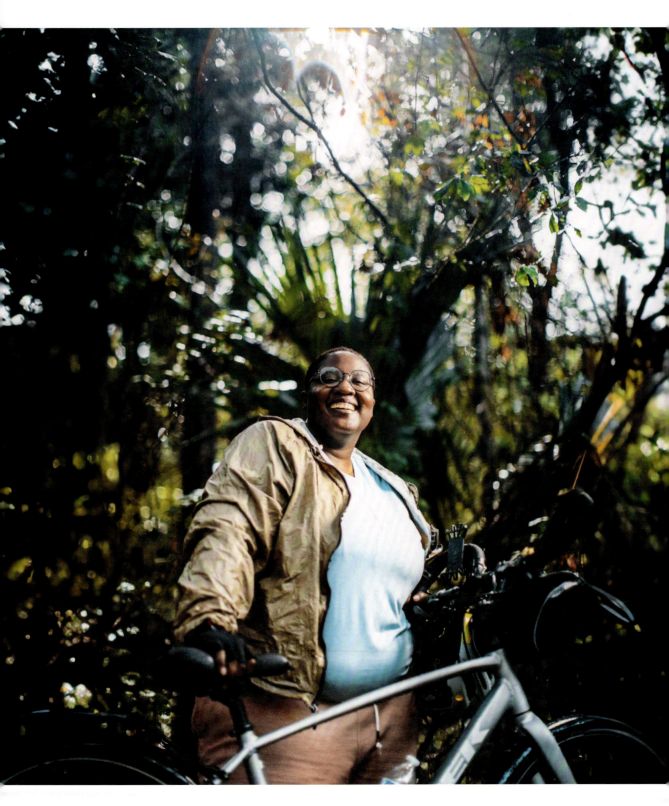

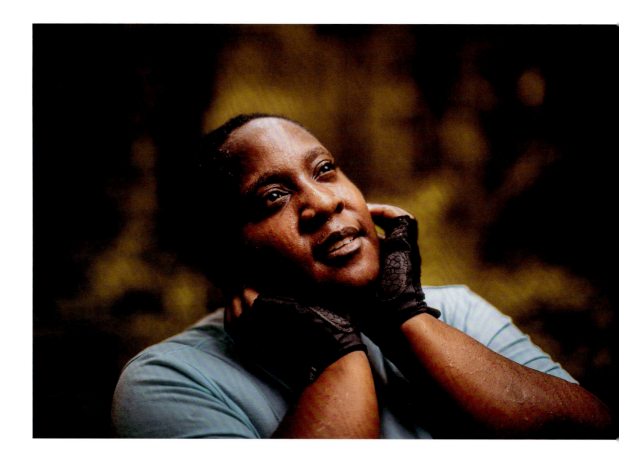

judgments of me had been rerouted because, as a plus-size Black woman, I was changing perceptions and busting untold stories like mine wide open.

Being that representation, not just for myself but for others, is essential because we have all these narratives that aren't necessarily true. Being in a bigger body, I have been fed this idea that I am only capable of so much because of my size or that I have to lose weight to do certain things. Sometimes people can't imagine something is possible until they see it first—let your story lead when people see you.

That's how I recaptured life. I hid and silenced myself for a long time just trying to get through it. I believed all the stereotypes and false narratives that I'd been told for so long, which hindered me from following my dreams. Cycling across America helped me learn new perspectives—about life and my body—and guided me to a life that wasn't in my head but rather in my heart.

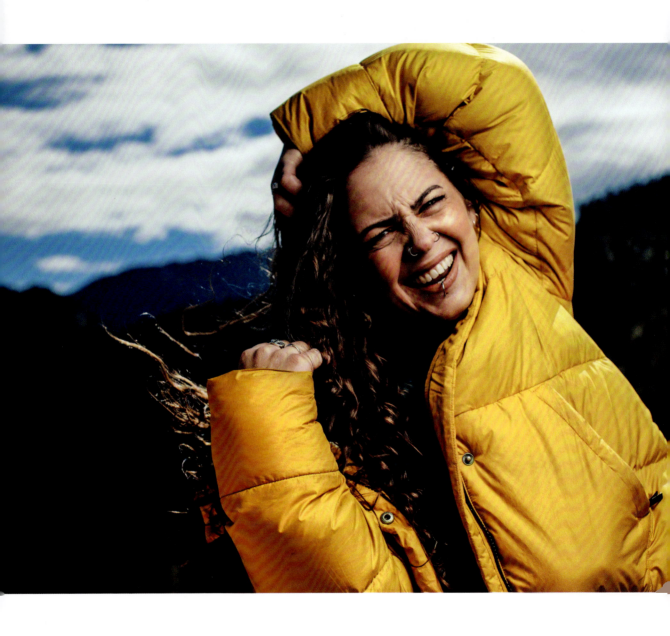

AMELIA DALL

FOR AS LONG AS I CAN REMEMber, I had always wanted to be an archaeologist. However, as a child, I wasn't even sure what the name of the profession was—I just knew I wanted to work in museums or with archaeological collections. This is largely because of my proximity to historical and archaeological sites in the area where I grew up, my mother's love for museums, and my willingness to always keep learning.

Growing up less than ten minutes from Harpers Ferry National Historical Park, I remember getting to bike with my father and brother to watch the filming of a movie at the park and being able to swim in the Potomac River nearby, as well as walking on trails. I also grew up going camping (whether in a tent or a cabin), and I vividly remember a time where we camped at Cape Hatteras National Seashore in North Carolina. We also took yearly road trips to North Carolina and Illinois in the summer. Whenever my mother and I had time, we'd venture to Washington, DC (only an hour's drive away), and go to the Smithsonian museums. Most of our family trips were to historical places and sites or museums.

I was born deaf and had some hearing, which then later became more of a loss, and I am now profoundly deaf. I also have the "deaf gene" (GJB2, or connexin 26). However, I can hear very well with my hearing aids because I've worn them since I was three. Going to a deaf school and then a deaf university (Gallaudet University), the barriers I faced weren't as much about my deafness but more my educational opportunities, as neither of my alma maters offered much in the way of ensuring the growth of my career aspirations. But after graduating with my master's degree and "venturing out in the real world" (that is, the hearing communities and workforce), it was noticeable that my barriers were related mainly to inclusivity. I was not as involved in group settings and social conversations as I'd have liked to be. I was also not hired professionally as a full-time employee until about three or four years after I acquired my master's degree in anthropology and archaeology because the majority of employers were hesitant to take on a deaf person who uses ASL (I am not an oral deaf person). It took me more than seven years as an unpaid volunteer for various organizations and a seasonal/contract worker to prove my credibility in the profession.

I love going out to archaeological and historical sites and parks because I love to continue to learn and see how incredible each human occupation in history has been. It truly is fascinating to read and

121

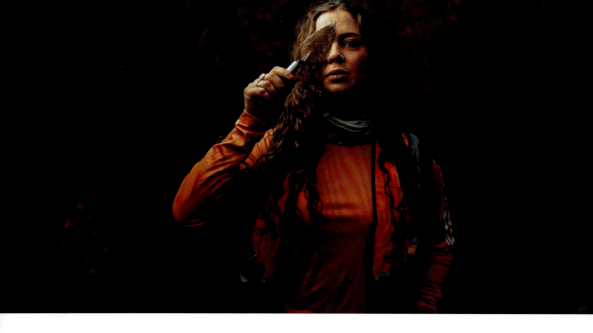

see archaeological objects from generations ago. I also hike, backpack, rock climb, raft and kayak, hunt, and fish.

All those activities connect me to nature because I enjoy all the little moments where I can learn to improve my skills and experience. Since I don't wear hearing aids when I am doing outdoor activities (except for archaeological fieldwork), I do believe my other senses have improved, which in turn helps me do fieldwork because I pay more attention to the ground surface.

Being deaf, I'm more conscious of my surroundings, and when doing fieldwork and spending time outside, I have a better peripheral vision. I can identify archaeological objects (like projectile points) and sites much more often than my coworkers. My former supervisor gave me the nickname "Eagle Eyes" because I'd record several projectile points when doing the fieldwork for nearly every project. This tells me I have a heightened visual experience. I can also feel the vibrations of the earth (like whenever a car is going to pass by) and pick up on other subtle cues (like smelling elk and knowing they're nearby).

As I trek through my life as an archaeologist, my eagle eyes navigate the layers of history and the nuances of nature. It's a journey that speaks not just of a deaf professional but also of a profound connection between my senses, the echoes of the past, and my unwavering passion for discovery.

> **It's a journey that speaks not just of a deaf professional but also of a profound connection between my senses, the echoes of the past, and my unwavering passion for discovery.**

DEZMINE WASHINGTON

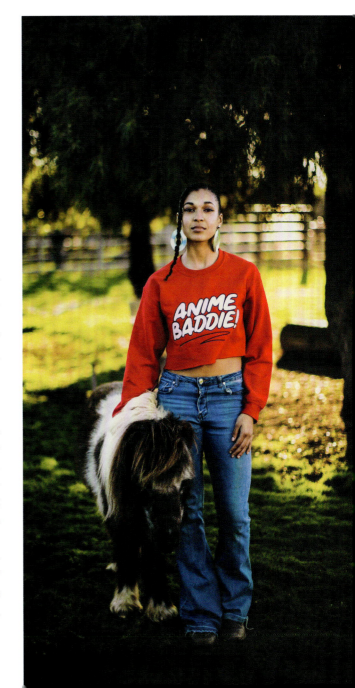

GROWING UP IN THE AGRICULTURAL PLAINS of Stanislaus County, California, Dezmine Washington nurtured a deep adoration for horses and ponies from before she could remember. Her grandfather, or "Gramps," as she lovingly calls him, was a seasoned team roper engaged in competitive rodeo events. Her childhood memories were adorned with moments sitting under the walnut tree on Gramps's farm, intently observing the horses and ponies while they played.

While Gramps embarked on roping escapades with his friends, Dezmine found solitude when she was placed securely on a reliable horse, exploring the surrounding area and immersing herself in nature, deepening her connections to her equine companions. Being the only Black girl among Gramps and his roping partners, all white and in their fifties, Dezmine quickly grasped the distinction that set her apart in this equestrian world.

In a county where the African American population barely reaches 4 percent, Dezmine, having a white mother and a Black father, grappled with the disparities between her and the kids in her town. She attributes those distinctions in her personality, interests, and vernacular to her father, a Black man from East Oakland, who was a distinguishable contrast to the white cowboys in her hometown.

"I had this Bay Area 'litness' and then this western quiet. I always felt conflicted with my identity."

Although these early differences caused her to become aware that her perspective differed from

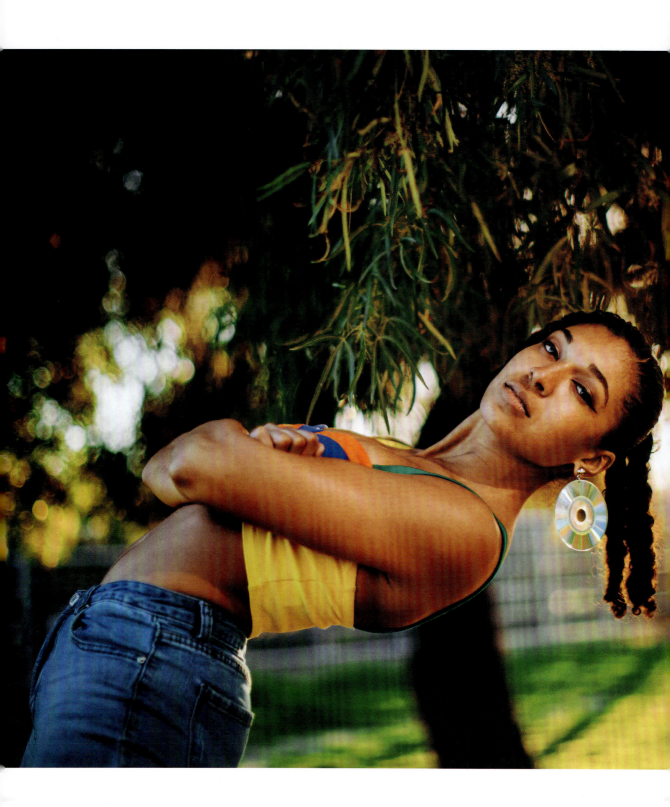

that of other children in her community, it also embedded empathy and benevolence for the friends she made on the farm—the horses and ponies. As Dezmine got older and garnered more knowledge about the majestic creatures, she began to recognize the parallels between them, especially in the ramifications horses experience as utility animals and the systemic oppression she faces as a Black woman in America.

Horses are large prey animals with a keen sense of fear and anxiety, which aids them in protecting themselves from predators. Horses have historically been used as utility animals more often than companions, contributing to their owners' misunderstandings when they express fear. Dezmine makes an interesting distinction: prey animals possess a heightened awareness of their surroundings and are constantly conscious of potential threats, while Women of Color remain acutely attuned to systemic challenges and prejudices surrounding them.

"Prey animals are very practical animals. They react to any stimuli. If you're riding a horse and something startles it, the best scenario is for them to just look at the problem and keep moving. However, if they see something and get so afraid that they react negatively, then they may be punished.

"I feel the same as a Black woman. We have been trying to tell people about the problems and issues that affect us as Black women in this society, yet somehow we get scrutinized, ignored, and sometimes punished. When we speak up, we get labeled 'the angry Black woman.'"

Beyond broader social exclusion, the equestrian world has historically held many

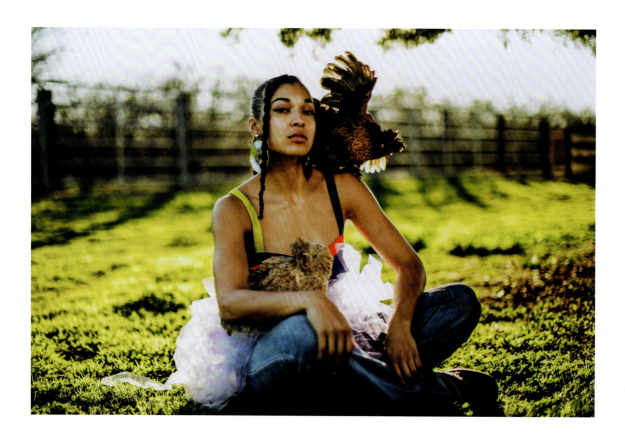

barriers that have disproportionately affected People of Color, creating challenges for their entry and inclusion.

While accessibility to training facilities, cultural disconnects, and representation are noteworthy components of the lack of diversity in the sport, socioeconomic status plays the most significant role in why only 4 percent of equestrians are Black or African American. Despite these barriers, Dezmine continues to care for horses and ponies as her companions rather than mere utilities or possessions.

As she explains, "Not only do I try to sit and listen to them, but I always try to do the best I can on their behalf."

Her connection with these animals and the natural world has formed a bond that transcends the everyday human-horse dynamic—nurturing an interspecies friendship through the time spent with them on Gramps's pasture.

> **Not only do I try to sit and listen to them, but I always try to do the best I can on their behalf.**

KIM MERRIKIN

I'VE EXPERIENCED A LACK OF ACCESS TO the outdoors, primarily due to my size but also when it comes to the social exclusion that often accompanies being autistic. Regarding outdoor gear, it's hard to find outdoor clothing and gear that fits me, limiting my ability to do many outdoor activities. When I do finally find the right gear, I then have to face the social barrier. When I find my way through both barriers, it is beautiful and life-giving.

Autism isn't a disability because the autistic person is lacking something; it's a disability because the world has a staunch neurotypical bias that excludes many people of all neurodiverse backgrounds. Outdoor communities (and the world) still have a long way to go in welcoming every type of person into these spaces.

Freedom in the outdoors also looks different for neurotypical or allistic people versus autistic people. My autistic brain still needs rhythms and

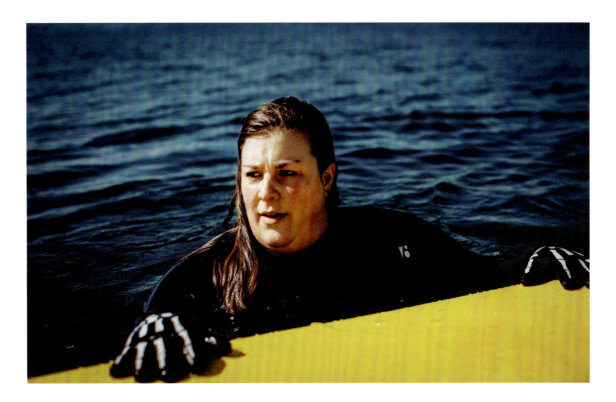

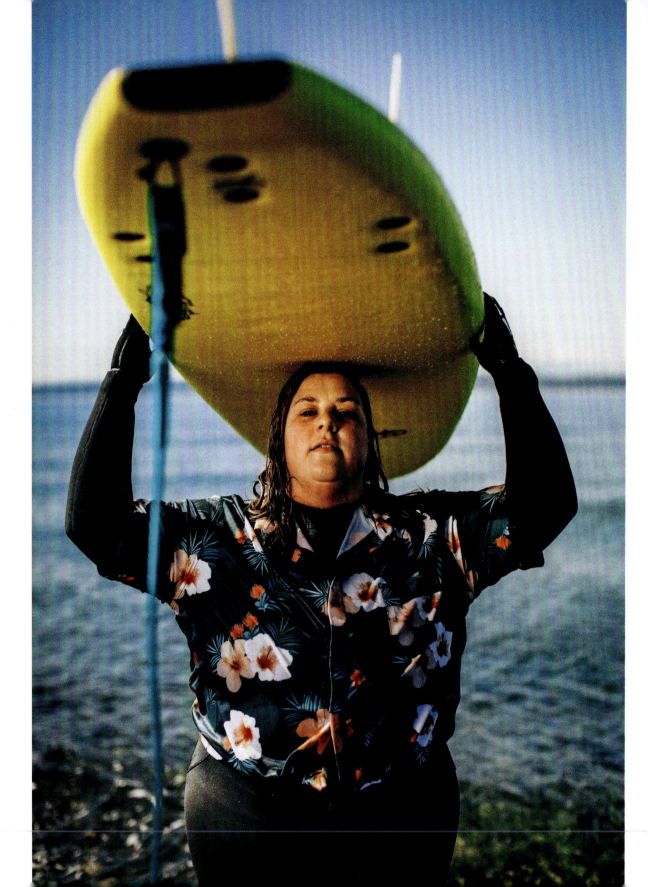

routines that sometimes leave me outside of how most people engage with the outdoors. Many outdoorsy people can do things at the drop of a hat, and I find that difficult. For example, if someone invites me on a last-minute hike, as an asthmatic, autistic, fat woman, I need to know the exact details of this hike so I can prepare. I want to become more spontaneous, but being on the spectrum can feel like existing in a different operating system than the rest of the world—an operating system that requires more data to draw conclusions.

The autism spectrum is vast. There are multitudes of expressions of autistic traits for each person who is on that spectrum. For me, I experience sensory-processing disorder, meaning I am very sensitive to touch, sounds, and light. Because of that, I can be overwhelmed with my surroundings more easily than allistic people.

The beauty of life on the spectrum is that I can sometimes see a much bigger world than allistic people. My autistic senses fire all at once. The sensory experience of being in nature can sometimes be this calming overwhelm. All at once, in slow motion, I can feel the breeze through my arm hair, hear the rustles in the trees, listen to the brook down the hill while smelling the underbrush, and be acutely fascinated by capillary action pushing water to the top of an eighty-foot tree.

My autistic senses fire all at once. The sensory experience of being in nature can sometimes be this calming overwhelm.

A world designed for neurotypicals, at times, can be onerous for a person on the autism spectrum. Crowded bars, shopping malls, and even going to work can be overstimulating to the point where I want to shut down. That same overcoming happens in nature but in the comforting form of captivating awe. Everything simultaneously comes together; delicately, nature reminds me how unbelievably and beautifully divine the world is and how holistically unifying my mind can be.

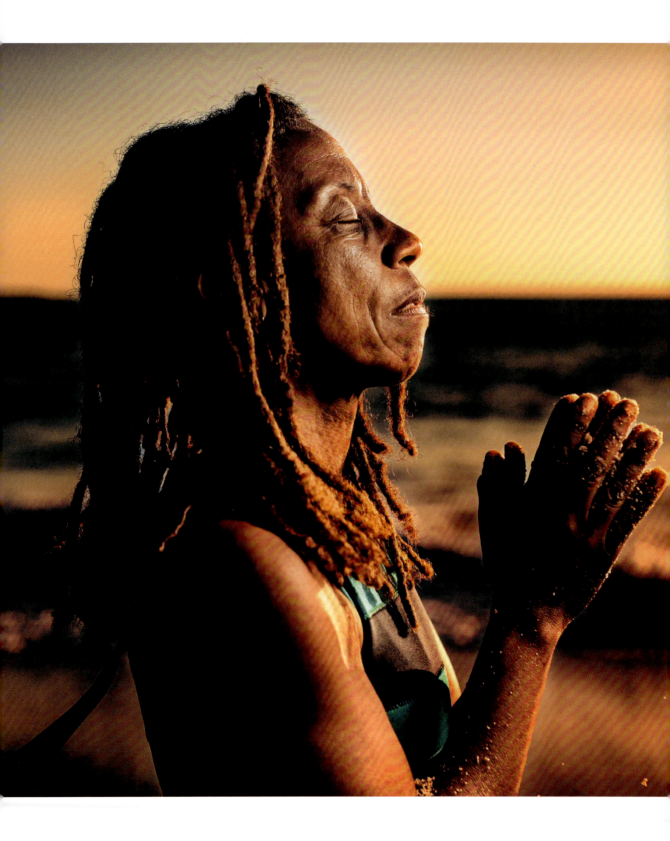

MARY MILLS

AS A KID, I WAS ATHLETIC BUT AFRAID OF THE ocean. I got recruited by a school in the Pacific Northwest for soccer, but I suffered a knee injury in my first year of college. Years later, still active and game to try my hand at different sports, I wanted to try triathlons. I learned how to swim, becoming a somewhat strong swimmer because of my fitness level, but not fast enough to win a race. At sixty years old, I'm a surfer, but I am still scared of the water in many ways. I'm always well aware of how the ocean can and will humble you, regardless of whatever skills you think you possess.

I have always been athletic. I was lifting weights during a time when people thought it was unacceptable or strange for women to go to the gym. Women were expected to be thin when I was younger, but I wasn't built that way—I'm muscular. It was weird to be an athletic woman growing up in a time when it wasn't considered normal, because I always loved my athleticism and appreciated what my body could do. But I decided that if society won't accept me, then *I* can accept me.

At thirty-nine, I had been a competitive cyclist and would frequent the local bike path at the beach. I live in Los Angeles, and one day, while riding on a section of the beach bike path, I noticed a sign for a group that offered women surf lessons. I'd wanted to surf since I was thirteen, so I stopped out of curiosity. My intuition told me I wasn't ready yet. It turns out I was pregnant. Three months after I had my son, I went back and started taking lessons.

Standing on the board in the water for the first time was a personal revelation. I asked myself, *What took you so long?*

When I learned to surf at almost forty, I assumed I would only have about ten good years left to do so. Society has an exclusive way of discounting middle-aged and older women in athletics. I love telling people how old I am. There's this old-school belief that we aren't supposed to ask a woman her age. That idea implies that after a certain age, your value decreases. That's why we see

BEHIND THE SCENES

There are some people you just don't feel worthy being around because they are so damn cool. That's Mary. If "vibes" was a person, it would be this lady: she's hilarious, she's sassy, and she's badass.

She also photographed beautifully. She was so natural in front of the camera and so genuine in her expressions. These are some of my most treasured photos from the entire project.

One of my most memorable interviews was with her. When I asked her if she wanted to be an inspiration to younger women in surfing, she told me straight up, "I don't want to be an inspiration. I just want to surf."

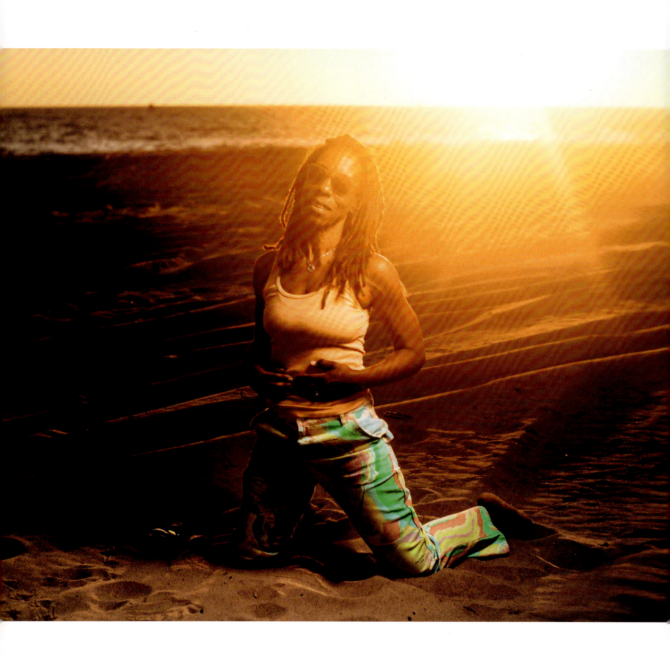

women trying to look younger or lying about their age. But the beauty of aging is you don't give a shit anymore. At twenty-five, you care what people think and how you look. I think that's bullshit—I'm sixty and still having a great time and kicking ass.

We live in a world that tries to tear everyone down. People say you're not cute enough, you're not small enough. You know what? I'm enough, and I accept this body, this face, and this age. I can acknowledge how good I've been at athletics—and still am at my age—but I have nothing to prove to people.

I'm at a place in my life where I'm sincere; not mean, but honest. With that, I do not necessarily want to be an inspiration to others, nor do I care if I am. Whenever Black people do something, there is always this expectation that you have to bring other people into the fold and inspire them. I just want to go outside, find silence, and have fun. I fight battles on land daily, so when I go in the water, I just want to surf. If I am inspiring people by just being there, that's enough. I surf for recreation. I'm not in the lineup to fight the power. Surfing is my time to power down.

Women are usually highlighted and celebrated for being young, skinny, or blonde. What we don't see represented enough are women of all different ages, sizes, and colors. Women can be athletic past forty-five, and I am here to show everyone that even after menopause, you can still be athletic, you can still have muscles, and *you can still kick ass*.

> **Standing on the board in the water for the first time was a personal revelation. I asked myself, *What took you so long?***

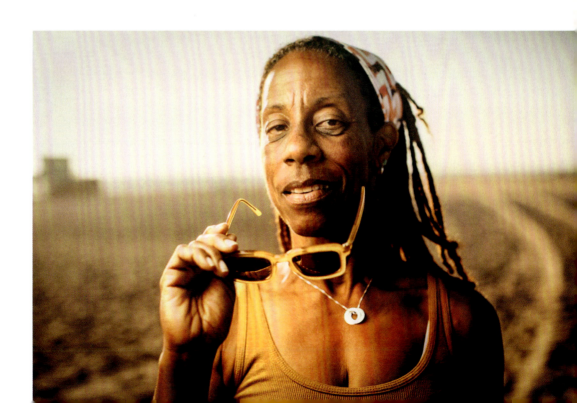

DIVYA ANANTHARAMAN

IN A 2011 MTV INTERVIEW, LADY GAGA WAS asked a rapid-fire question: "If you could do something dangerous just once with no risk, what would you do?"

She quickly answered, "Die."

As a taxidermist, I find this answer both fascinating and valid. I think, given the choice to experience something without its repercussions, most people would choose death—if only to answer all of life's eternal questions: What is it like to die? What does it mean? If we were to be able to return from death, would it be more or less scary?

My father passed away during my senior year of college. A few years later, I tragically lost my best friend to suicide. These profound absences in my life compelled me to reassess my relationship with death, prompting introspection and influencing my personal and professional passion in taxidermy.

As a child of Indian immigrants, I recognize how ancestral rituals, traditions, or funerary rights often get diluted or discarded, a survival mechanism amid a society built from colonization. The distance we maintain from our demise, especially in Western culture, can be influenced by the necessity for cultural assimilation.

Living in New York City, I have a unique way of connecting with animals, primarily birds, that isn't feasible with live creatures due to practicality and ethics. Working with these delicate creatures opens up a softness, tenderness, and vulnerability to nature, producing a less burdensome acceptance of my mortality. Taxidermy is a meticulous process. It involves many intricacies, like skinning the animal with precision to avoid imperfections, thorough cleaning, tanning, injecting preservatives, posing, and the subsequent drying phase, creating layers of complexity. It's a comprehensive

BEHIND THE SCENES

I felt like I needed a week to photograph Divya with all the beautiful outfit options she brought. It was overwhelming to help her choose what to wear because she is so stylish.

We met when I was making a film for Hunters of Color outside of Albany, New York. When I was conceptualizing this project, she was one of the first people I thought of because taxidermy is such an interesting and unique way to connect to nature. Also, you don't see a lot of Women of Color in that profession.

We met in her taxidermy studio in Brooklyn and then took photos in a nearby cemetery where a bunch of parrots live atop the entrance. She walked around in a gorgeous rainbow dress and then wore it to the bar we ate at afterward. While I love all the colors on their own, I also really love how they represent Divya's queer identity, which I believe is also reflected in her work and reciprocity with nature.

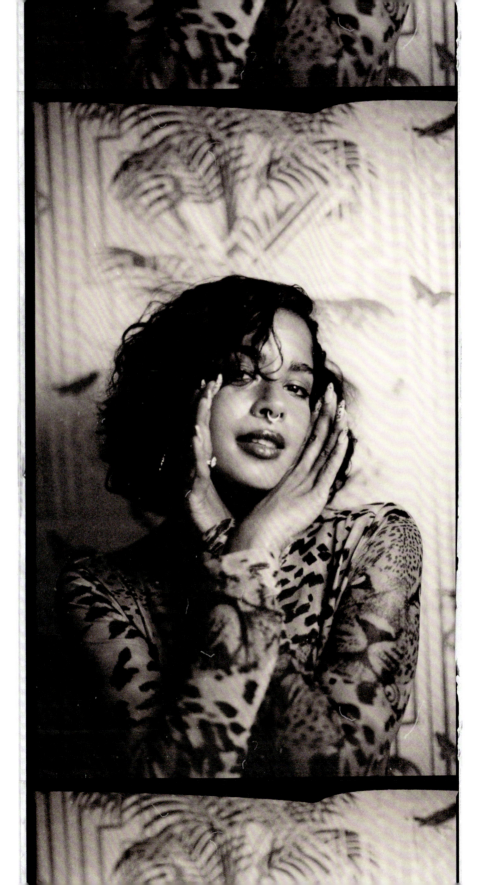

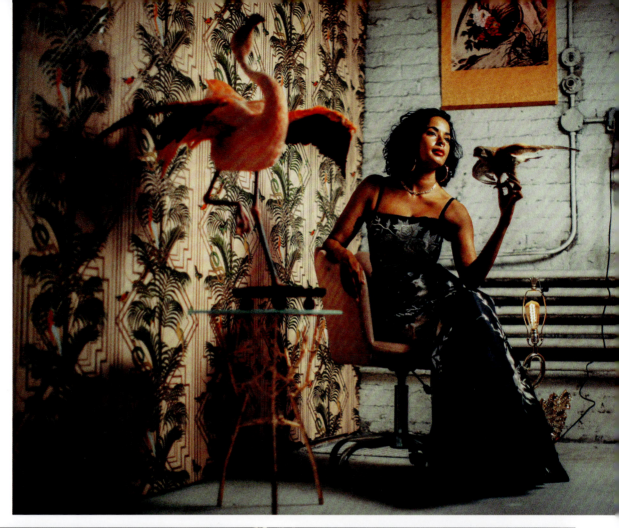
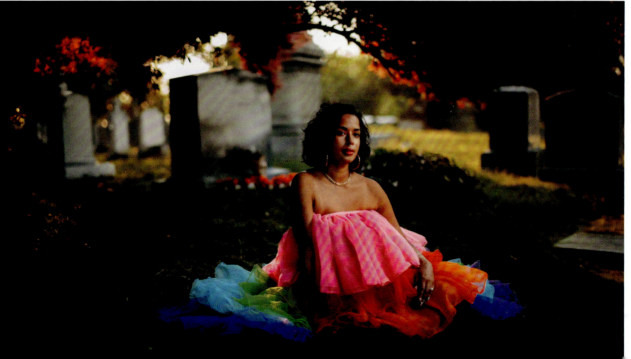

procedure that demands attention to detail and craftsmanship. Yet some nuances lie beyond the technical aspects.

The misconceptions of this profession imply that we physically remove animals from their ecosystem to be placed on a shelf in someone's home. It's quite the contrary: most of the animals I preserve are ethically sourced and deceased from old age, sickness, or other natural means. I find it crucial to establish a clear distinction in my work—I'm not asserting superiority over these animals; instead, I am creating a proximity to nature that humans can't always access by preserving the animal's essence.

While preserving the essence of every animal is impractical, there's a balance, and taxidermy is another way for me to care for and connect with nature.

However, when you think about it, many things we do in art involve extracting elements from nature. It's like questioning where the minerals in paint or the plants making up a canvas came from. All living things contribute to art, and taxidermy, in a way, retains a small part of the animals that have passed away. While preserving the essence of every animal is impractical, there's a balance, and taxidermy is another way for me to care for and connect with nature.

We are not encouraged to talk about death, or explore it, or allow ourselves to sit in our grief for too long. The reality is that death is ceaseless, grief fades slowly, and we are powerless to the manner and timing of all of its certainty. Death is indisputably part of our human existence, and embracing it can connect us deeper with our integral role on the planet and its beauty. Taxidermy, for me, isn't a way of avoiding or glorifying death but rather immortalizing creatures that once existed in a physical form and preserving them in death to commemorate their existence in an exquisite exhibition of Mother Nature.

BRITTANY KAMAI

WHEN I WAS LITTLE, I WATCHED THE MOVIE *Twister* over and over again because I was utterly fascinated by the storms. I knew the characters were chasing after tornadoes and throwing detectors into them, but I didn't quite understand the process or that they were even scientists. I also didn't understand my ancestors' intimate relationship with storms because I hadn't yet learned about how they traveled across the open ocean as voyagers. Some deep knowing kept me fixated on watching the weather.

As I grew up, my curiosity led me down a path where I would become a scientist who studies physics, a field that tries to figure out how things work. When I took an introductory astronomy class, my professor dropped a huge bomb on us by saying, "We only know what 4% of the universe is." I remember thinking, "What the hell?" My response—what is the other 96%?—became the driving force behind my interest in astrophysics.

The more I dove into it, the more I became obsessed with the unknowns. What's dark matter? What's dark energy? It was so wild to me, that these concepts are prominent in our current understanding of the universe yet no one has any solid answers or explanations. To contemplate the nature of dark matter, think about weighing a bottle of water and discovering that it's five times heavier than you expected just by looking at it. That's exactly what happens with galaxies—their mass is way greater than what we can see—that's where the name dark matter came from. And dark energy is even weirder. Imagine throwing that water bottle into the air. You expect gravity to pull it back down, but instead, it accelerates away into space. An invisible energy is acting in ways that challenge what we know about gravity. This puzzle feeds my relentless curiosity about what's happening in the universe.

Being an astrophysicist gives me what feels like a superpower, because I can understand how everything works—from lightning in the sky to the sound of a waterfall. Physics explains these natural phenomena, and studying these concepts has made me realize how deeply connected everything is. Light is a wave, sound is a wave, and when I look up at the stars, I'm seeing the result of hydrogen atoms smashing together, creating light that's traveled for billions of years across the universe into my own eyes. Some of that light started its journey before our planet even existed, which is so beautiful to reflect on. Physics is great at explaining a lot of things, but there's still so much that remains a mystery.

I remember when I first left Hawai'i for graduate school, I felt the pangs of being homesick. I grew up being immersed in nature, and suddenly

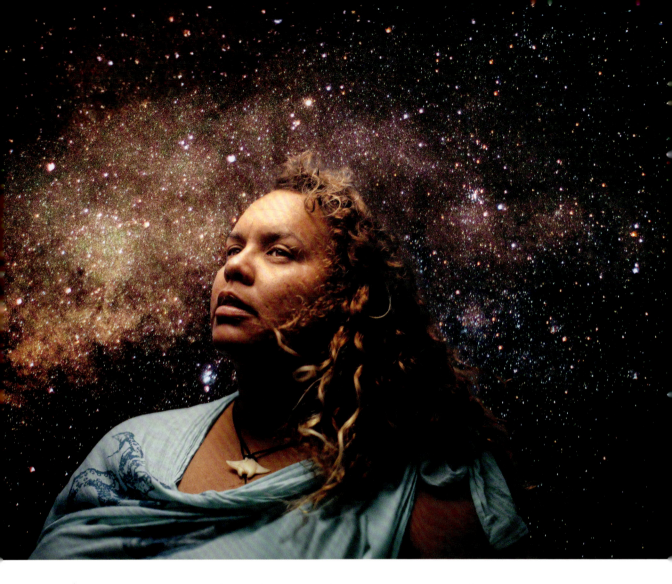

I was in this new place, feeling disconnected. One memory in particular stands out—sitting in a valley with a friend before I left, staring at the moon and crying because we were both about to go through such big transitions. The moon was giant, glowing orange that night. Years later, while living in Nashville, I found myself looking up at the moon again, missing home. That's when it hit me—the moon—I was looking at was the same one I saw back in Hawai'i. I realized that no matter where I was on the planet, I could look up at the same celestial bodies and gain a sense of comfort.

I find it incredible that every human who ever existed has looked at the same exact stars. This realization reinforces my profound connection to the lessons of my ancestors. When I look back on why I was so drawn to the darkness of the universe, it makes sense now. The sun and galaxies are bright and beautiful, sure, but I've always been more interested in what's in

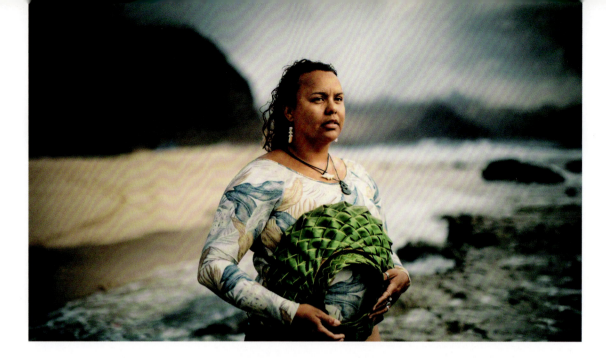

> **When I feel disconnected from my culture, I float in the ocean, flow with the waves, feel the wind on my skin, and look up at the stars . . .**

the dark. In a Hawaiian worldview, darkness is not something to fear but rather something to turn toward to deepen your understanding. It feels as if my ancestors sent me down this road for a reason, blending my cultural heritage with my love for astrophysics.

Hawaiians are people of the sea. We traveled our watery continent on deep-sea voyaging canoes guided by the stars, winds and the waves. Our kūpuna, our ancestors, have always been connected to the ocean's depths and the expanse of the heavens. In our creation stories, they talk about how we have a deep connection with coral polyps in the bottom of the ocean, and how pō—darkness—is just as important as ao—light. There's this duality between darkness and light, between being awake and being asleep. In Western thought, darkness is often framed as something to be afraid of, but in Hawaiian culture, it's seen as a natural part of the cycle of life. When we finish our lives, our spirits jump into pō, the darkness.

Our ancestors used chants to pass down knowledge of the stars and sea roads, helping their descendants navigate between our islands. Our kūpuna made their way through the storms to discover who we truly are. While most people see the earth as separated by land, my people understand that we are all connected by water. When I feel disconnected from my culture, I float in the ocean, flow with the waves, feel the wind on my skin, and look up at the stars—all to feel that connection again. My kūpuna reminds us that the ocean connects us all. Just as the universe's dark matter and dark energy weave through the cosmos, the vast, shared darkness of our experiences connect everything—and everyone.

Healing in Nature

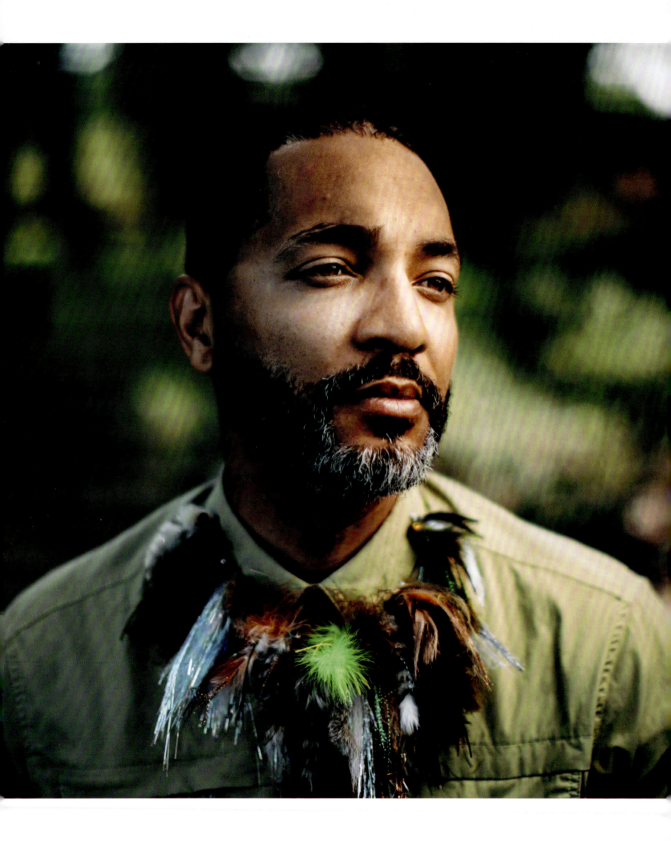

ASH WHITE

WHEN MY WIFE WAS GIVING BIRTH TO OUR third daughter, her uterus ruptured—a life-threatening situation that required an emergency operation. While she lay resting in the recovery room, stitched back up, I quickly returned to our house to grab our forgotten hospital bag. But at home, I received a sobering call from the hospital chaplain. "Get back to the hospital. Your wife is about to die," he said urgently before he hung up.

Rushing back to the hospital, I found her unconscious as she underwent multiple blood transfusions and the medical team discussed the grim possibility of organ donation. This wasn't a conversation I wanted to have—I just wanted the doctors to focus on saving her. My wife ended up unconscious for almost a week, surviving on life support before she eventually woke up.

In the following months, I navigated life on autopilot, tending to everyday tasks while my emotional and mental well-being struggled to keep up. I began experiencing physical symptoms, which I initially dismissed as panic attacks. However, these episodes evolved into hallucinations and a mental breakdown, prompting me to seek medical help.

As my emotions caught up with my conscious mind, I found myself unable to function, wracked by constant fears of losing my wife and feeling the need to protect her at all costs. Seeking therapy became my next step in disentangling the emotional turmoil that haunted me, which led me to a therapist who suggested outdoor sessions in a local park, gradually progressing to nature walks and, eventually, fly-fishing.

It took me about six months after the incident before I stumbled upon fly-fishing, but that was the turning point for me. Back then, there wasn't much understanding or documentation about why fly-fishing could be so beneficial for trauma survivors, especially considering the general attitude toward PTSD. It was a time when people, including

BEHIND THE SCENES

I'm a talkative person, but I didn't say much when I spent time with Ash. I wondered if he thought I was too quiet. The thing was, some people make you feel safe, welcome, or like family, and I got that feeling with Ash.

I met him at his house right outside of Minneapolis, and his wife kindly took us to float the river with his oldest daughter, who was about to start college. She came up with the fishing flies necklace idea—the shot turned out so beautiful because of her creative eye. For the photo, she told Ash, "Do your kind eyes."

Ash *is* kind. The way he spoke and talked about nature comforted me, and I think that's why I was quiet. I wanted to take it all in, the new friends and the nature surrounding us.

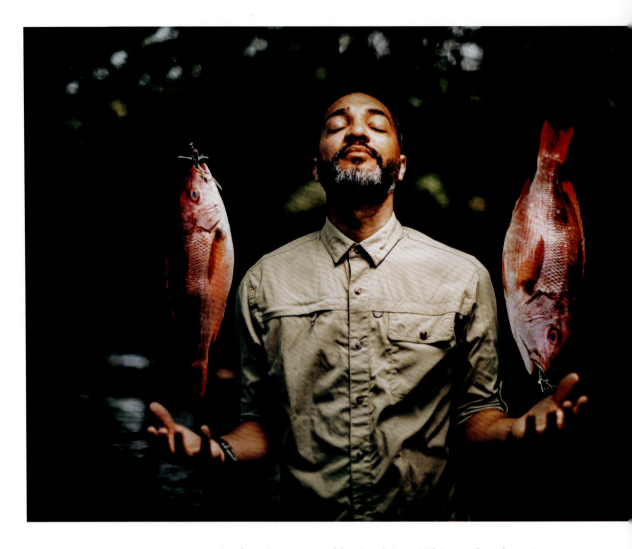

troops returning from Iraq, were told to "suck it up." This newfound passion not only became a therapeutic outlet for me but also a way to help others, particularly survivors of trauma, discover the healing power of nature that is often underestimated or inaccessible.

The search for a good therapist took a while, but I finally had a breakthrough with the one who suggested we have our sessions in nature, which was an act that marked a significant shift in my healing journey. These sessions prompted me to integrate the therapeutic benefits of nature into other areas of my life, even as a corporate leader encouraging outdoor meetings and mentoring junior associates in the calming embrace of green spaces.

As a vice president at a Fortune 500 company immersed in the emotionally taxing realm of D&I (diversity and inclusion), finding solace in nature has become an integral part of my self care. When I started in this posi-

tion, I recognized the need for a self-care plan, a practice I now advocate for everyone navigating arduous roles. Spending time outdoors, a lesson learned through therapy, has become a nonnegotiable part of my routine. Therapy doesn't just rejuvenate my spirit; it's also a practice I insist my associates adopt.

Nature, with its ability to facilitate genuine connections, became a guiding force in my leadership philosophy. The outdoors provided a unique setting where trust naturally flourished during long hours spent in a boat as a fly-fishing guide, discussing not just fishing but also the delicacies of our personal lives. Clients sought more than just catching fish; they craved an escape, a moment to breathe and slow down, reinforcing the profound impact that nature can have on our well-being. These lessons, learned through adversity and discovered on the waters, continue to shape my life and leadership style, emphasizing the importance of embracing tranquility.

The river, surrounded by trees, became my sanctuary for healing and restoration—my personal space where I commune with something greater.

The river, surrounded by trees, became my sanctuary for healing and restoration—my personal space where I commune with something greater. It's my haven, my church, and the space where I can spend time with my maker. Nature is where I found solace and healing.

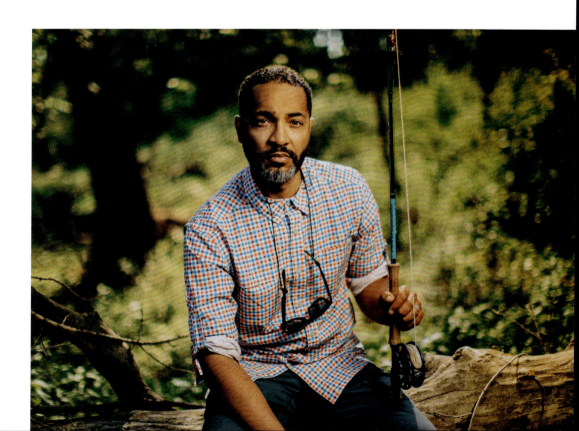

TASHEON CHILLOUS

"YOU BREATHE LIKE A DRAGON." AS A FAT person, I have heard a lot of disparaging comments throughout my life, but this particular one has always stayed with me. It made me want to hold my breath. When I reflect on all the gifts the outdoors has given me, providing solace during times of trauma and the space to grieve, breath is an essential component of my relationship with nature.

If something is on my mind—anger, frustration, sadness, grief—I release it. I consciously exhale to let go of those feelings. Being outside and breathing has always helped me work through those emotions that hold on to me so tightly. Nature is the place I could expel my grief, an understanding solidified through the loss of my brother, Jason.

Jason died in early 2018 from various health complications originating from kidney problems he had from a young age. In May, just a few months later, my grandmother passed away, and by June, I found myself at the bottom of my lows. My pain only grew when my grandpa passed at the end of 2018 on New Year's Eve. However, though grief persisted, so did my love of nature.

Following that tumultuous year of profound loss, I started dedicating more time to getting outdoors. I worked myself up to more challenging hikes because, for me, doing the hard thing always seemed to alter my life's course. Finally completing the Loowit Trail, which circumnavigates Mount St. Helens in Washington, became a turning point. During that hike, I decided I wanted to become a personal trainer to share this gift of movement and freedom. A few months later, I successfully passed my CPT test and started working.

Movement and fitness have always been a big part of my life. Standing amid all the history and beauty the landscape around Mount St. Helens bears helped rebuild my relationship with the outdoors and with movement. Being a fat person in fitness spaces like gyms or trails can be triggering. Whether in person or online, I provide a space for my clients to learn how to work on their relationship with movement in a liberating and comfortable environment.

Being surrounded by others who share similar experiences and identities in the fitness space, whether they be fat, queer, or BIPOC, fosters a sense of safety rarely found in other communities. Many of us share deep-seated fears of being outdoors, apprehensive of people complaining that we take too long, take up too much space, take too many breaks, eat the wrong kind of food—or breathe too loud.

Nature has fundamentally liberated me, allowing me to embrace my body and all its capabilities. Amid the trees, the water, the myriad of tiny and giant creatures—the curves of nature—I find liberation in being a part of it all. I see myself as nature in all its beautifully diverse forms.

> Nature has fundamentally liberated me, allowing me to embrace my body and all its capabilities.

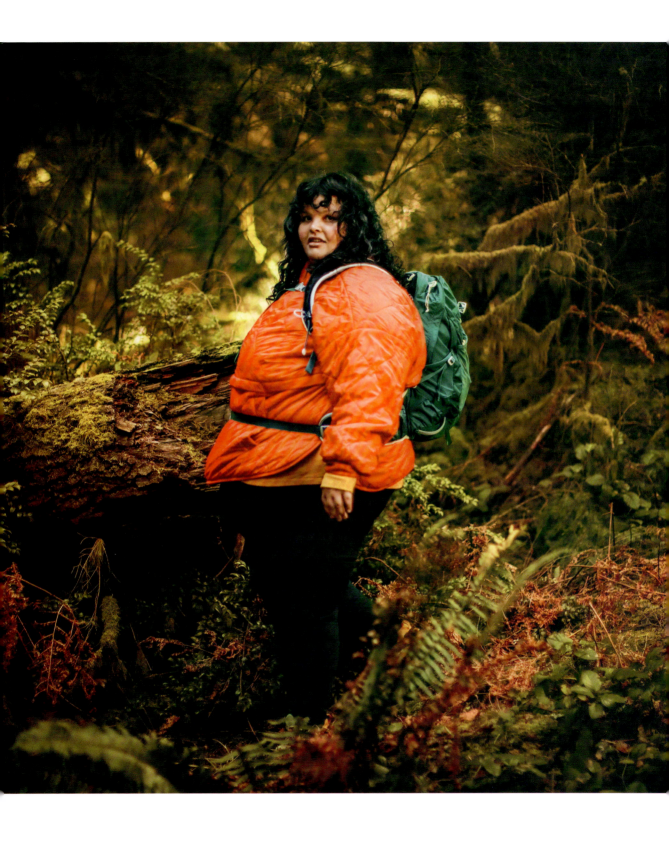

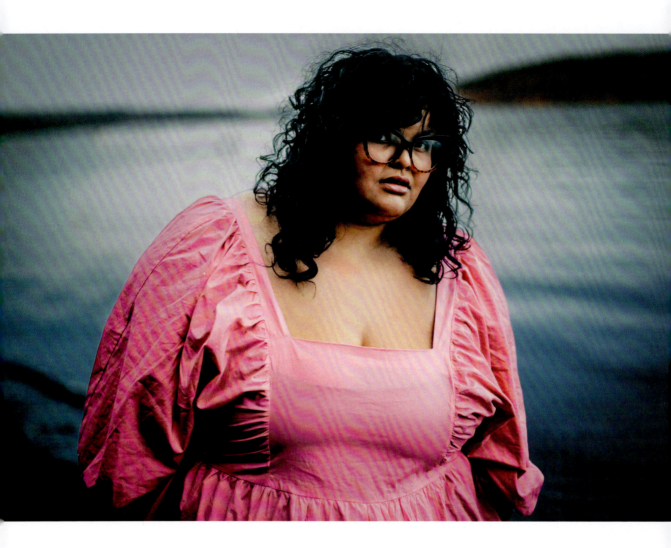

 When I think about my trauma around movement, its focal point has always been breathing, which I think is ironic, because I love moving my body to the point of breathlessness. I just let others stifle my breath for so long. Taking in a deep breath while I think of those lost, like my grandpa, my grandma, or Jason, and then releasing that breath is beautiful and cathartic. Nature has always allowed me to inhale and exhale, providing space to process all my grief. But most significantly, out of all the gifts it has bestowed, it has given me the freedom to *breathe*.

DAY SCOTT

SEVERAL YEARS AGO, I WAS MAKING MY WAY toward Idaho along a desolate Wyoming highway when I blacked out. After a huge bang, I opened my eyes and realized I was stopped. I didn't immediately know what had happened. I saw smoke and lights and heard the alarms in my car going off. I got out of the car to find parts of a pronghorn antelope smashed into my radiator and its antlers sticking out of my fog lights.

After I tried for many hours to contact someone for help, highway patrol and a towing service finally came to pick me up and take me to Lander, Wyoming, about three hours away. As we got closer and my phone regained service, it started blowing up with calls and texts. The only response I could muster was "I think I'm fine, but my head hurts so bad." I became progressively more disoriented, so I had the service guy drop me off at the nearest hospital. When I got to the emergency room, I knew only my name and nothing else.

For the next eight months, I saw a mix of neurologists, neuropsychologists, and other medical professionals who all evaluated me. What I kept hearing from all of them was a resounding, "Oh, shit. This is complicated." I had suffered a traumatic brain injury (TBI) and received a total of ten diagnoses. I began speech, occupational, trauma, and physical therapy to address all the conditions related to the TBI. I eventually had to move into

> **Birds reminded me of my own resilience and adaptability.**

a ground-level home after I blacked out going up the stairs to my apartment. I couldn't do anything social or even go to the grocery store; I had to avoid places where people were moving or bright colors were visible. I had cognitive impairments—my speech, gait, and vision were compromised. However, every morning in my new home, I would make tea and stare out the big picture window, watching the birds play outside.

These birds would swat each other as they fought over food—and it made me laugh. I had been a naturalist and environmental educator at a bird sanctuary and had taken photographs of birds for years, but I had never paid attention to their mannerisms. In fact, birds were far from my thoughts—my main wildlife interests were botany and herpetology. In a short time, I became obsessed with these birds because seeing them brought me so much joy.

When I was in speech therapy, I had to relearn how to read, write, and even talk at my original capacity. As an exercise, my therapist had me read short paragraphs and then tested my memory on what I remembered. I usually choose a book on birds. A few months later, I was writing funny little excerpts about birds and their personalities. My reading and writing started to improve significantly because I was researching birds. They were all I could focus on every day, whether through

149

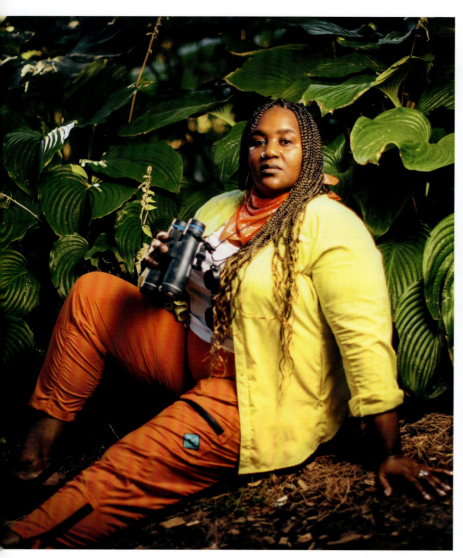

reading, writing, or listening to audiobooks. I was so captivated by birds that I began seeing them every night in my dreams. Today, I am a student, wildlife biologist, and conservation photographer. My research has been focused on owl populations and the evolution of snails.

Before my accident, I didn't realize how different identities shaped my experience of the world. I've come to understand the power of intersectionality—its strengths and challenges. My experiences as a Black woman, scientist, and disabled person intersect uniquely, much like how different bird

150 | ALL HUMANS OUTSIDE

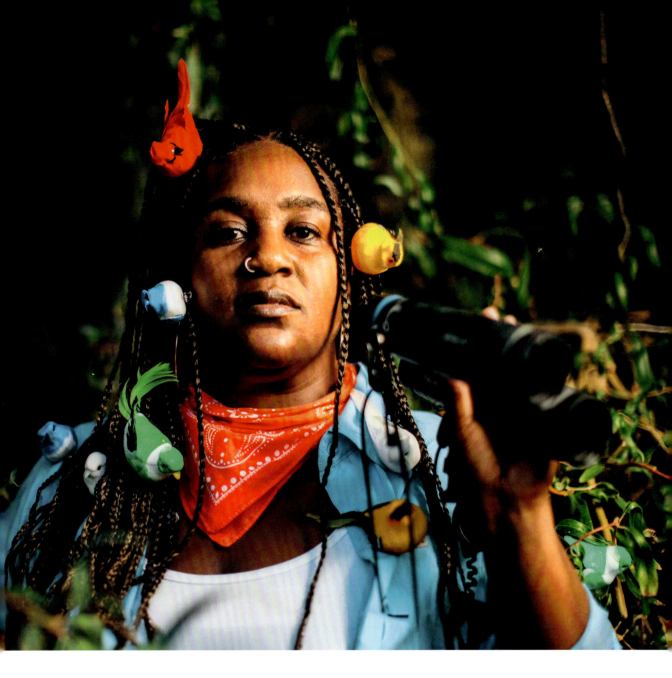

species converge in nature. Birds have different needs in different seasons, whether that be food resources, migration patterns, or finding a mate. All of these things accumulate to dictate how they survive as a species.

 Birds remind me of my own resilience and adaptability. My life has gone through indelible changes, especially after the accident and its effects, which disconcerted my certainty of survival. But between my bold coloration, silly quirks, and ability to go the distance, I believe I've transformed into a bird, acquiring the skills to adjust, endure, and take flight.

TARA MYERS

ONE NIGHT, AN ALARMING SOUND WOKE ME from a nearly impenetrable sleep. An intruder was trespassing in my house. With my husband gone, my teenage daughter and I were the only ones home, and a threatening voice in my head whispered, "He's going to hurt us. He's going to *rape* us."

Fear, an old companion of mine, took a different shape this time as I confronted the intruder. I unleashed a surprising surge of aggression, resorting to actions I'd never believed I could muster. Thumbing his eyes, kicking him in the groin, and violently slamming his head against my hardwood floor, I found a strength within me that defied those years of perpetual fear. During the struggle, I urgently instructed my daughter, "Get my climbing rope from the closet, Amalie!"

As I tightly secured the intruder, awaiting the arrival of the police, I abruptly jolted awake. The reality of the break-in dissolved into the lingering shadows of a dream, leaving me to grapple with the revelation that, even in my subconscious, I had become a defender against the fear that had I had found repulsive for most of my life.

During my childhood near the Delaware Water Gap in New Jersey, I formed a connection with nature, but my adolescence was marked by profound mental illness, severing those ties for decades. Traumas, including being gang-raped at fifteen and trafficked for crack and having multiple abortions, left me feeling disgusting and like I was a terrible human being. In the following years, I found myself unable to be deployed in the army due to the debilitating impact of PTSD. However, I realized these issues weren't just singular but inherited. Our mother's homelessness and our time in foster care created a disparate childhood upbringing for my younger sibling and me.

In my healing journey, I became a therapist, and I found solace in helping others with backgrounds that reflected mine. Despite my progress, the trauma of rejection lingered. Yet I realized this was a shared struggle, primarily rooted in the impacts of my childhood experience. Along the way, I encountered a rockstar therapist who was pivotal in my ascension from fear. This therapeutic alliance not only mended the frayed knots of my past but also enlightened me to the disparities in the mental health care system that often fail those who need it most.

Fear and depression lingered despite seemingly having it all at forty—marriage, three kids, a beautiful home, and a master's degree earned against the odds of being a high school dropout. A turning point arrived at forty-seven when I climbed Cucamonga Peak in Southern California, standing above the clouds and discovering that nature was

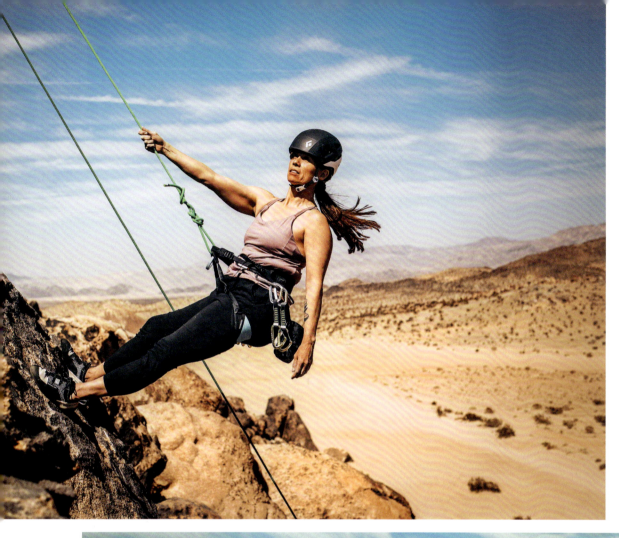
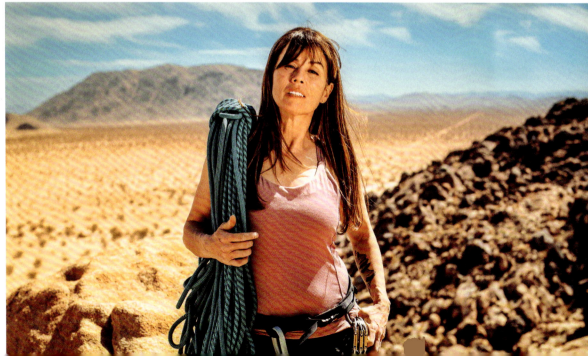

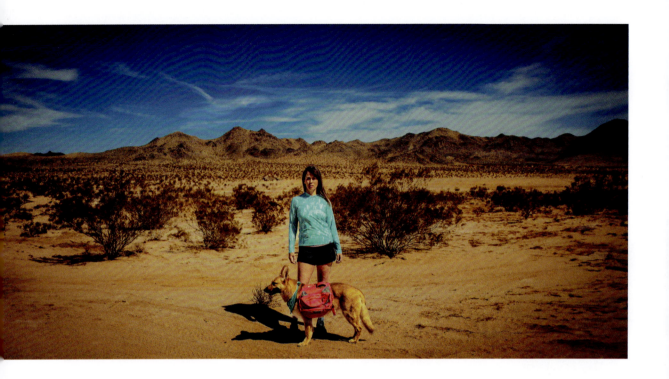

the missing piece in my life's puzzle. The more I hiked, the more I yearned for more challenging pursuits, which led me to get a preemptive tattoo of Mount Whitney, wearing the ink as a commitment to climbing it one day.

My integration back into nature continued at fifty with climbing Mount Whitney and eventually rock climbing, a willful rejection of my deep-seated fear of heights. Climbing became a regular physical pursuit that helped me overcome the nightmares that once plagued my dreams and my realities.

I woke up from the nightmare feeling empowered, surprised by my instinct not to defeat but rather immobilize the intruder. Fear is an integral part of my story and something I can't erase, but guided by the lessons of nature, I've learned to embrace my trauma, letting it belay me to the top of life's sometimes scary but redefining routes.

Fear is an integral part of my story and something I can't erase, but guided by the lessons of nature, I've learned to embrace my trauma, letting it belay me to the top of life's sometimes scary but redefining routes.

DANI ARAIZ

I WAS NINETEEN AND ONLY FREE FROM MY traumatic childhood and constrictive religious household for a little over a year when I got hurt. While working for a parcel company, a faulty set of loading stairs slipped from underneath me, and I landed on my head. Immediately following the injury, I was placed on bedrest and prescribed a cocktail of fentanyl, norco, and soma. I wasn't granted rehabilitation nor given proper medical imaging and was left to rot for eight months, while my only mobility assistance was from a walker or my then boyfriend who was strugglingh with his own addictions. Soon I became homeless.

Eventually, receiving imaging, a neurosurgeon informed me I had suffered a traumatic spinal cord injury. My doctors told me surgery may not fix the pain or improve my mobility and strength and advised me to not have children or lift more than seven pounds, and then offered a procedure with a 50% chance of failure and paralysis. I was terrified and declined with hopes the future held options that weren't so uncertain.

It wasn't long before my kidneys started to fail from all the medications I was prescribed. I knew if I stayed on this path that I wouldn't live to see my thirties—the life I was living had become unbearable. I needed to cut ties with the things that were hindering my healing and seek a healthier lifestyle.

> The river has never rejected me, and it has held me afloat when I needed it most.

Growing up, whether by going fishing, hiking, clamming, or camping, my mother was the parent who got us outside—it was because of her that I first fell in love with the outdoors. I was twelve when my parents divorced. Spending time in nature took a backseat as my mother anchored herself to her religious convictions and the duties of being a single parent of three children. It was those childhood memories that inspired me to start my journey to wellness in nature. Eventually I ended my toxic relationship and bought my first kayak. I floated several miles of the Sacramento River with my little fishing pole like I was Tom Sawyer.

Kayaking has allowed me to reclaim my life, especially meaningful after being told my opportunities would be so limited. Being on the water became a conduit for healing the trauma that led me to the river. It has given me confidence and helped me tremendously with inner peace and mobility, rebuilding my strength and control. Kayaking has also encouraged me to seek other healthy activities that have allowed me to challenge myself more both on and off the water. Through all of this, I have found sobriety and accountability. The river has taught me to not become overwhelmed by everything all at once. It has helped me to learn to break down moments in life, not worrying about the rapids that lie ahead but gifting me time for

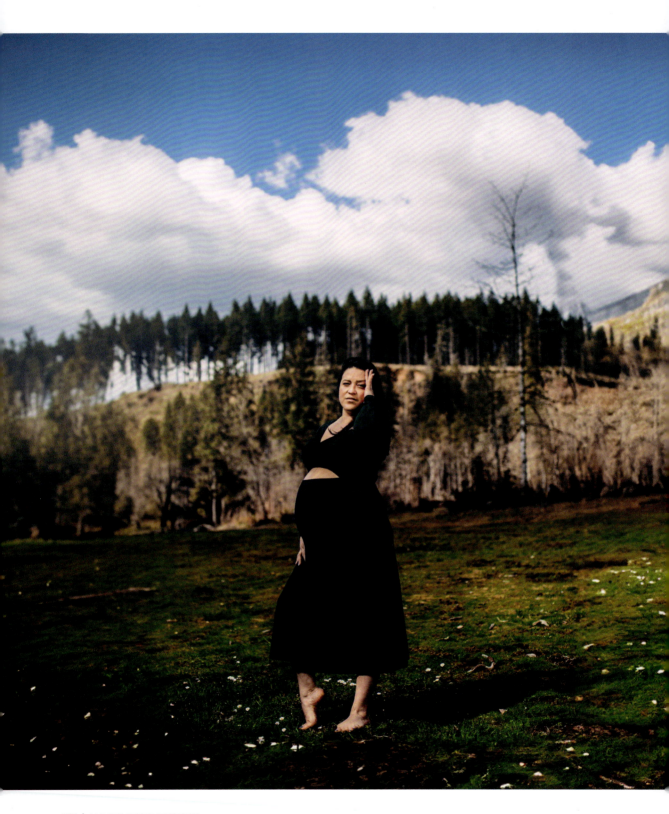

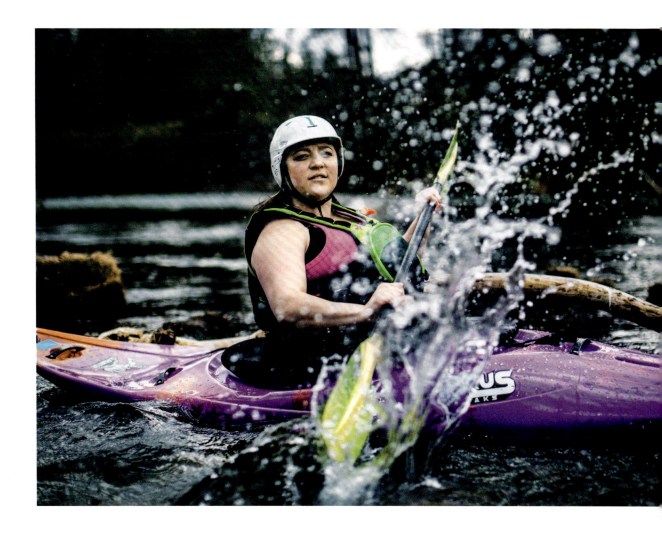

reflection while focusing on what is in front of me. I do things I used to think were impossible, and I get to appreciate nature in ways that only a lucky few or the intrepid do. While my early life was difficult and wildly painful at times, the currents of life have brought me back to nature, back to myself, and helped me discover a sense of belonging on the river. For that I am grateful.

 The river has helped keep me present and flowing with intention. I know not where my destination is in life, but I am not panicking about how I will get there. I look forward to sharing the joys of nature with my new son and I hope he finds a way to connect with nature in his own way. The river has never rejected me, and it has held me afloat when I needed it most. Now, as I hold my son River close, he is a reminder that even in the darkest of waters, the flow of life can lead to unexpected shores.

SUMMER CRIDER

WHEN I WAS GROWING UP IN THE SWAMPS of northern Florida, my dad, a wildlife biologist, loved to take me hiking through the forests and wading through the swamps. He always taught others about awareness and how to share the land with other creatures, specifically gators and snakes.

When I was about ten, I was hiking with my dad and a childhood friend. My dad is about six foot seven, and as his long legs reached over a big log, I noticed a venomous cottonmouth snake showing the white of its mouth close by. Being deaf, I have more sensitive eyesight and peripheral vision than most hearing people because I need to use it in place of sound. When I saw the snake, I immediately signaled them to stop. It was a proud moment, realizing that being deaf didn't make me inferior; instead, I had unique advantages, like my heightened visual awareness of the unobserved.

When I'm outside, my other senses are heightened because of the absence of sound. I can feel more. I can feel vibrations through a hollow log or objects hitting a canoe from beneath the surface of the water. My dad is really good at imitating animals and their mating calls. When I was young, he would take my hand and put it on his throat so I could feel the vibrations as he made an animal's sound.

> In the conventional world, there's an expectation to conform, sound, and look a certain way. However, nature grants us the freedom to be our authentic selves.

Between my time in public school and college, I didn't come across many role models or folks like me who were deaf and working outdoors. The system pushed me toward becoming a teacher, and I found myself stuck in a cycle of screen-related work that led to fatigue and anxiety. Conventional therapy and medications did little for me. Remembering nature therapy from my art therapy studies, I decided to take a break and flew to Alaska. Being surrounded by the wild, hiking, gardening, and interacting with nature made a significant difference in my mental health. After researching online, I discovered the Association of Nature and Forest Therapy, enrolled in their certificate program, and made that my career.

I think the first barrier to entering this career as a deaf person was that I didn't see any other deaf people doing it. These barriers relate back to communication, or lack thereof. People did not try to understand me or work with me on lipreading, so I felt like I had to accommodate them. I often think of my life as a bridge because of the barriers I have had to break down for myself, constantly crossing between these two vastly different worlds, one silent, the other noisy.

In my work, I help people see things that they might typically overlook while being outside. This

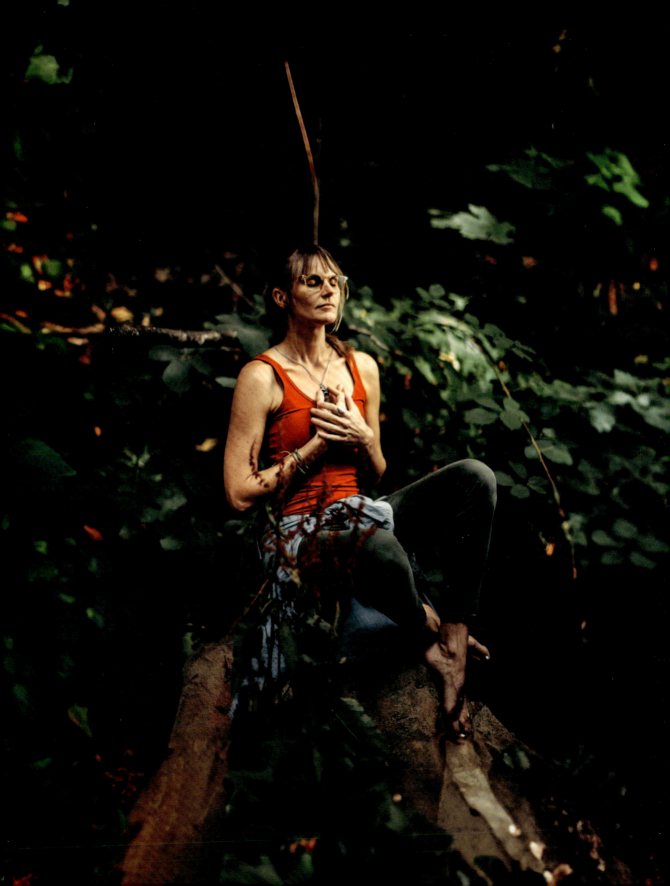

is both related to the natural world and our sense of self—I remind people how to slow down and breathe deeply. I try to use nature as a way to get people off their phones and out of the city, instead sitting under a tree watching the clouds roll by. That's when people can start connecting with memories. That's when healing happens.

Nature has helped me discover many parts of my identity, both as a deaf and queer person. And while my identity is constantly changing, in nature, I feel like I don't need those identities, much like I don't need sound.

In the conventional world, there's an expectation to conform, sound, and look a certain way. However, nature grants us the freedom to be our authentic selves. Through guiding individuals with various disabilities, including those who use wheelchairs or are blind, I've learned that the accessibility system is human-made, not nature-based. Nature doesn't impose restrictions based on abilities; it welcomes everyone. I challenge the notion that interaction with nature should follow specific able-bodied norms. Instead, I encourage diverse ways of experiencing the outdoors through mindful, heartfelt, and quiet exploration—you don't need to hear nature to feel it.

FRANCISCO SILVA

THERE ARE TWO TYPES OF CHILDHOOD MEM-ories: the happy ones, and then the bad ones. The happy memories are of my parents, still married and still living together. The bad ones were when they got divorced and my mom abandoned us. Our lives completely changed as we were uprooted from a stable household to my grandma's house, where we didn't have running water or electricity and we slept on the ground.

My dad moved to the United States to work and send money to us in Mexico for the next few years after the divorce. Childhood memories of laughing and playing with other kids were nonexistent as my dad was gone and worked just to buy our basic necessities. It was a harsh five years, but he eventually saved enough to bring us to the United States.

When I moved to Chicago at age nine, we lived in a mixed neighborhood where many people didn't know Spanish, making it difficult to make friends. At this time, I felt like the outdoors started to call my name, beckoning me to nearby Lake Michigan. I started spending more time going to the beach, running, and biking. Nature began to help me through a lot of those horrible memories of abandonment and sexual traumas from Mexico. I finally had a restart in life.

Fast-forward to adulthood: I was working a job that was absolutely killing me. I was constantly stressed and realized I couldn't be there anymore, so I quit with the intention of taking a three-year hiatus. Unfortunately, that break was cut short by about six months because of the pandemic. However, I truly embraced the outdoors during that time and went on my first thru-hike of the Appalachian Trail.

Before I started thru-hiking, my goal initially was to find myself. I quickly realized, however, that I didn't need to find my soul because I know who I am. It then became more about proving to myself that, despite everything I had been through, I could hike long distances. The job I was working at paid a high salary, and I was bringing in a lot of money. However, the more money I made, the less happy I was. When I started hiking, leaving behind all the comforts and material things back home, it made me feel more *human*.

Thru-hiking taught me that I had to earn everything I was garnering as I walked. I had earned a space in the shelter, my meals, that shower after days of not being clean. When I was home, everything was just there for me, and I never really appreciated it. Being able to survive with everything in your backpack was a lesson I wanted to take back home to teach my family, to teach my daughter.

I have implemented these lessons in the volunteer work I do with various outdoor nonprofits in

> I quickly realized, however, that I didn't need to find my soul because I know who I am.

the Phoenix area, where I work with a diverse mix of people from all social classes, ages, and races. Working with teenagers, some from single-parent homes, is my favorite because I never had that access to the outdoors growing up. I help lead hikes, teaching Leave No Trace principles and first aid and showing how to pack your backpack and carry it properly to optimize the best possible experience when you're out there.

 Throughout my life, nature has brought me balance. It's helped me with the depression that stemmed from those bad childhood memories. However, nature also helped me appreciate everything I had gone through and the natural rewards I earned for making it through those challenges. The perseverance to improve myself and my quality of life is all because of the outdoors. Nature is the only medicine I need to ingest. It has brought me comfort and healing, and it enriches me with good, happy memories that balance out the bad ones.

JESSE CODY

THE DAY I TURNED FORTY, I REALIZED HOW much love existed in my life. To mark being "over the hill," about fifty or sixty of my closest friends and family gathered to celebrate me at my dad's house in Cambridge, Massachusetts. All the people I love were in the backyard: my parents, stepdad, brothers, aunts and uncles, best friends, and even a few ex-girlfriends. That occasion brought me a lot of emotion, especially being in the place where I grew up. Going into this party, I knew I should enjoy my time with these people as much as possible because, in my head, this birthday would be my last.

Through my twenties and thirties, I struggled with crippling depression and suicidality. I flunked out of college and moved back home to Cambridge. Before leaving college, I excelled at acting and got leading parts in multiple plays. After that, I became a runner and won seven state championships. In my senior year of high school, I was the fastest high school miler in the United States. Through it all, I still remember constantly feeling like a failure, and those feelings spiraled and worsened over the years.

I didn't realize the impact of having all the people who love me gathered in one place. I remember thinking, *How could you even think about taking your own life and hurting all these people?* My thoughts of suicide were to eliminate *my* pain; I'd never honestly considered the suffering I could inflict on *them*. Through all of that guilt, however,

I did feel that love, and I knew I had to give myself a chance. I owed it to the people who loved me to at least try to find out if something could give my life a purpose. That's what led me to hiking.

When I thru-hiked the Appalachian Trail, those 2,200 miles helped me find not only an appreciation for those people in my life but also an appreciation and a love for myself—one that I had never experienced before. On my last day on the AT, I conversed with Mother Nature and thanked her for

BEHIND THE SCENES

I met Jesse while making three short films for a Croatian outdoor company in Big Bear, California. He was one of the people I was filming. In the few days I got to know him, I realized I wanted to include him in *All Humans Outside*. On a hike one morning, I asked if he would be one of the 101 people I included in the book, and he got emotional.

When someone cries, my knee-jerk reaction is to lightly make fun of them, but this moment was really special. It was flattering that my request meant that much to him. Jesse's response to my project helped me see my work beyond my own desires—it clearly also speaks to others, offering them their own powerful points of connection and understanding.

what she had done for me. I had this overwhelming feeling that those six months on the trail spent finding myself and finding the ability to overcome were not to be kept only for myself. I felt like nature wanted me to share this emotion with the world.

A few years ago, I started a nonprofit organization called Hike the Good Hike that supports other mental health programs helping people through outdoor therapy. Its conception comes from my nearly twenty years of struggling with mental health. The AT had given me this profound love for nature that led to a love for myself, so I combined those two elements to start a supportive community that helps people discover the benefits of nature.

The outdoors holds many parallels to how we are built as human beings. When you're out in nature, there are challenges, ups, and downs among immense beauty and perfect moments. When taking on the outdoors alone, you have nowhere to turn other than to face yourself.

When I was battling my demons before I found the outdoors, I just wanted to close in on myself in my room and turn the lights off and sit in that darkness. But nature has this way of forcing you to confront yourself and converse with your demons—no matter how hard those conversations might be. Nature has an incredible therapeutic ability, a power, an energy, and a magic, and when you have that solitude within it, you can find some light—and that light truly saved my life.

The AT had given me this profound love for nature that led to a love for myself, so I combined those two elements to start a supportive community that helps people discover the benefits of nature.

BECCA MORENO

IN ALL THE IDENTITIES I HOLD—CHILD OF AN immigrant, eldest daughter, neurodivergent human—I have throughout my life felt like there is no room for failure. Society often tells little boys when they fail, "It's okay; try again." When girls fail, we're told, "Maybe that's not for you." We have been raised with this perfectionism that encourages us to make choices only when success is certain, avoiding risks where failure is possible. Highlining has been the way I have been able to break out of my own scarcity mindset and learn that even in the context of a cruel world, there is room for gentleness and kindness, especially toward myself. Nature is brutal, but also incredibly healing.

Despite what you may think, highlining is a mostly calm and introspective sport akin to martial arts. Don't get me wrong, rigging can definitely get intense: trying to span a gap with a one-inch piece of webbing in a way that won't kill you takes courage and resilience as you make sure your anchors are strong, check your gear, incorporate redundancies, mitigate safety risks, and stay in good radio communication with your teammates. The walking part is just the tip of the iceberg. But when it's my turn and I scoot out on the line, it's as if the whole world fades away.

My identity is stripped down to just my body and my thoughts. It is profoundly vulnerable. If those thoughts are unkind or self-deprecating, the line will show me. If my body is tense, the line will reflect that tension back to me. It's like I'm star-

ing into a truth-telling mirror that is Nature with a capital N. But then I get to try, fail, fall, and climb back up again as many times as I want without anyone swooping in to tell me, "Maybe it's just not for you." How rare is that! I get to tinker with my own potential and be curious about what I find.

When I'm walking on a highline, I get to marry my movements and instincts with the flow of the

BEHIND THE SCENES

Out of all people featured in this book, Becca was the most surprised when I would show her quick previews of the photos we just took. It always makes me feel good to show people how I see them.

Becca's friend had a beautiful property outside of Boulder where he was gracious enough to let us shoot. A short, steep hike led us to the top of this beautiful gorge Becca highlined across as the sun set among the tall mountains behind us. Her friend joined us as well and was so helpful holding my studio light.

I love witnessing people in their element; I always get to be in mine when I am outside taking photos, but Becca reminded me just how lucky I am to photograph all these people in a setting where they are their most authentic selves.

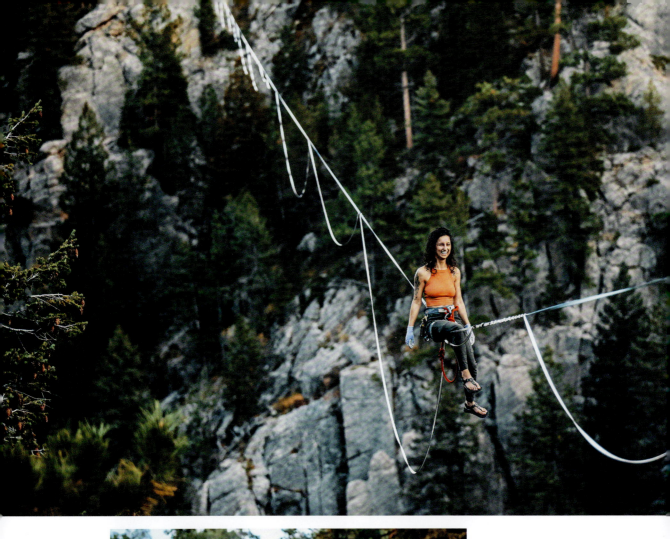

wind around me, the expanse below me, and the subtleties of the line underfoot. I face my mortality with joy and gratitude, and I look back at my friends at the anchor with feelings of abundance and love. I get to decide what success looks like for me that day; I get to be compassionate toward myself; I am in charge of my attitude.

I can make a million and one analogies for life with highlining. "Life's a balance"; "no one can walk the line for you, they can only walk alongside you—you have to do the work"; "when you fall, try, try again." But the greatest gift highlining has given me is a well-tuned relationship with my gut and with my instincts, and the benefits have permeated into every corner of my life on and off the line. When I find something as special and as life-altering as that, naturally I want to share it.

There is a lot of misogyny in highlining, often upheld unintentionally by good-natured and well-meaning people. Seven years ago when I first got into the sport, folks would say, "There are the highliners, and then there are the girlfriends." The messaging back then was that there was no room for women in the sport. Those with gear held the power; they dictated line tensions that were only ideal for men; and for better or for worse, they were gatekeeping highline knowledge. When I realized that rigging skills and owning gear was my biggest barrier to access in the sport, I set out to learn it all for myself. Along the way, I found allies in two other women interested in rigging, and we became fast friends. In an effort to improve highline and slackline access for women and People of Color, the three of us started an organization called Meraki Slack. *Meraki* in Greek means "to do something with soul, creativity, and love; to put something of yourself in your work." And that's what we do. Our aim is to expand access for women and People of Color into a very male-dominated sport. This program has been a way to make space for people to show up as they are and progress at their own pace, because nature doesn't discriminate. Our sport has come a long way, but there is still so much work to be done.

> **But then I get to try, fail, fall, and climb back up again as many times as I want without anyone swooping in to tell me, "Maybe it's just not for you."**

BECCA MORENO | 171

GABRIEL VASQUEZ

THE DAY I LEFT THE MARINE Corps, I spent the night at LAX to fly straight to Minnesota. That next day, I was purchasing gear to kayak the 2,300-mile source-to-sea route on the Mississippi River. Growing up in Austin, Texas, I would ride bikes around the neighborhood, but that was as close to the outdoors as I'd gotten up until then. Little did I know that the Mississippi trip would inspire me to become the first Mexican American Triple Crowner and lead me into a profound healing from PTSD through Mother Nature.

When soldiers leave the military, life hits the brakes on us. Everything stops, and we get stuck in our heads. A lot of us feel like we have no purpose in life anymore. Now that we have all this time alone, we can finally process and think about what we went through. And then that's when it starts.

PTSD is life-altering, regardless of what type you struggle with. As veterans, we get it from going to war. It's this trauma that you keep on reliving. So you're just existing and suffering, constantly thinking you're alone. With my PTSD, I felt alone and lost; I was scared. I didn't know whether to be sad or mad or both—I was confused and numb. I thought it was something I had to live with for the rest of my life.

When I accepted my trauma, I finally learned how to handle it, and how I managed my PTSD was with the outdoors. Nature helped me process everything I couldn't process while I was in the Marines. I knew I couldn't let it control my life anymore after letting it do so for over a decade.

The Marine Corps was good for me. It was good for a lot of people, but at the same time, it was bad for all of us. In the Marines, there's so much toxic masculinity. As men, we're supposed to be strong, brave, and courageous. A lot of us feel like we're not allowed to talk about the shit that's bothering us. In the Marines, that mindset is intensified.

PTSD is a big problem in the veteran community. We shouldn't see the things that we see in war. We shouldn't see our friends get hurt or see them die. I knew suicide was an overwhelming concern in our community, but it didn't hit me hard until one of my best friends from the Marines committed suicide.

Three days before Drew killed himself, I was thru-hiking the Appalachian Trail. He called me to tell me he wasn't doing well. I told him, "You're going to be alright, bro." I begged him to meet me on the AT and come hike with me.

"I promise you, it's going to save your fucking life," I pleaded.

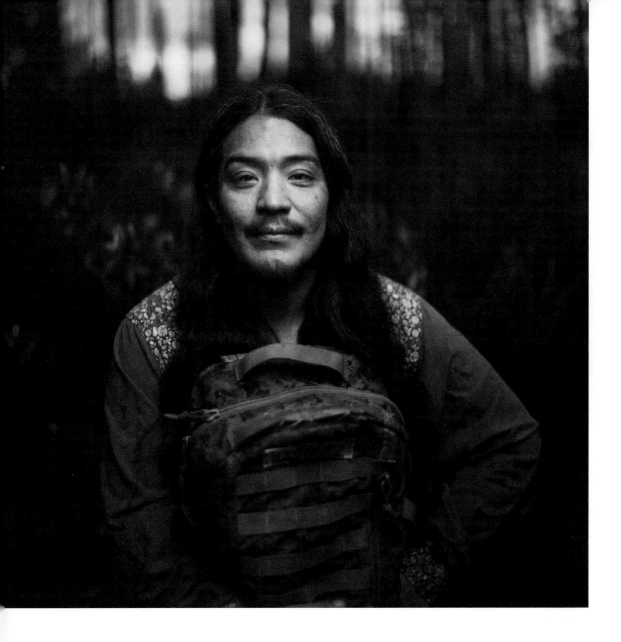

Nature helped me process everything I couldn't process while I was in the Marines.

I told him what the outdoors had done for me and what it could do for him if he gave it a chance. I thought I had talked him down.

Drew was a good man, and I miss him, and I think about him a lot whenever I hike. I think about all my friends who have killed themselves. The fact that twenty-two veterans a day die from suicide is impermissible. PTSD is a dark place nobody wants to be in, but my time spent in nature was the light that showed me the way out.

SHAYNEDONOVAN ELLIOTT

I WAS BORN DEAF, AND THROUGHOUT MY life, I have felt a lack of connection to hearing people. Because of that barrier, I funneled all my energy into being outside and connecting to nature. Being around hearing people is difficult when you can't understand or interact with what they are saying. However, when I am outside, even though the trees are not actually speaking out loud, I feel like we share a language.

I feel this unspoken language in photography too. As a deaf photographer, my entire world relies on my eyes. Photography helps me visualize emotions and use my eyes to communicate. It helps me place my own thoughts and feelings in expressive ways. I have been through so much in my life, so my art is a way of showing people that you're not alone. My eyes are my language.

After my family settled back in the United States when I was a teen and I graduated from high school, I moved around to fifteen different states, seeking a place I could connect with. When I moved to Washington State, it felt like a place that

truly fit me. I have ADHD, so having access to the outdoors allows me to keep moving. I was trying hard to work on myself, and nature gave me that sense of self-discovery.

When I planted my feet in Washington, I found it really hard to find people to hike with. I was coming out of a traumatic domestic situation and was feeling lonely, so I decided to adopt a dog to take on my adventures. When I started searching, I knew I wanted to adopt a deaf dog, because maybe we would be able to understand each other. After an internet search, I found a deaf Dalmatian. When I contacted the seller, they

informed me a family had adopted the dog. But after two weeks, they reached out to say the family backed out, and he was mine if I still wanted him.

A week before I got my dog, I was on a hike with my friend Lacey. Deaf and blind, she had become my best hiking buddy in Washington. On that hike, I told her, "I am going to name my dog after you." Sadly, she committed suicide shortly after that hike, which was really painful for me. I drove to Louisiana for her memorial service and then to Chicago to pick up my new companion. True to my oath, I named him Lace.

When I picked him up, he was jumping all over me, and I immediately felt such a connection to him. I started taking him hiking all the time, and he helped me begin to find myself. Although we had this beautiful friendship, I still found myself struggling with depression from everything that had happened in my life.

Although I can't hear, I can feel, communicate, and see—listen to a language that transcends the barriers of sound.

One night, in an act of desperation, I was getting ready to end my life. I looked at Lace, a rope in my hand, and he looked back at me. As we stared into each other's eyes, something was different, because I felt like he was speaking to me. Without words, he was saying, "I know that I need you, and I know that you need me too." From that moment on, I felt like we were closer than ever. We understood each other. *He saved me.*

The language I speak with Lace is hard to explain. All I know is that there is an undeniable connection between us. In that moment of despair, I knew that it was not just about me; it was also about Lace. After that, every time he came up to me, he would stare at me and talk to me. He could hear what was in my mind, and I could hear what was in his. We would look into each other's eyes, and what transcribed was a silent language.

The communication between me and Lace feels like my conversations with nature. It's not audible or spoken, yet there is an exchange of energy. When I am walking through nature, the trees tell me things like how many centuries they have existed or that I am going to be okay. They feed me positive energy and absorb the bad. Although I can't hear, I can feel, communicate, and see—listen to a language that transcends the barriers of sound.

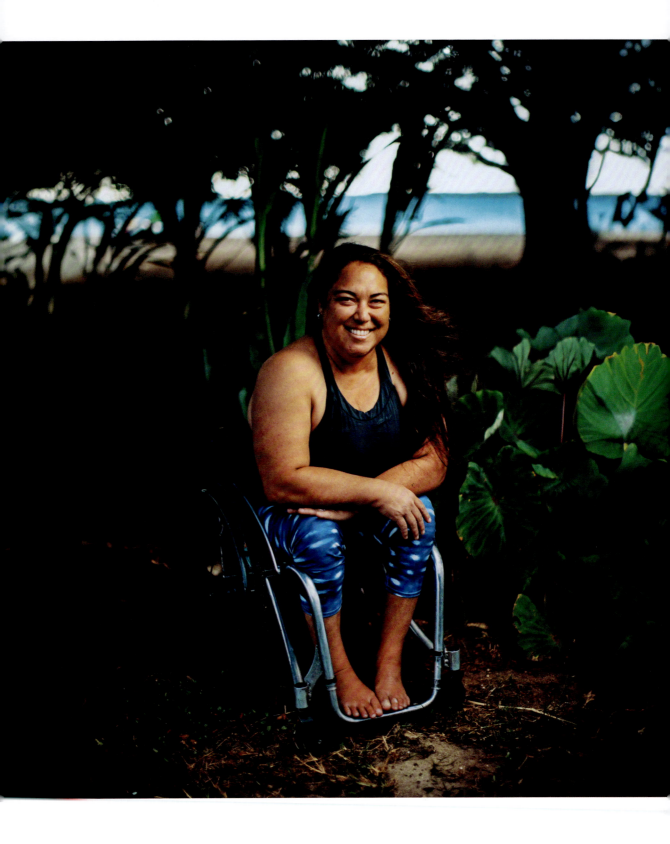

ANN YOSHIDA

THERE'S AN OLD NATIVE HAWAIIAN TALE, HE Moʻolelo no Hamanalau, the story of Hamanalau, an extraordinary woman and my namesake. Through this story, I have learned more about her and found that her blood runs in me. Humans carry the identities of the people who came before us: our ancestors. Even though we never met our ancient ancestors, we inherit their characteristics. In hindsight, it's clear to me why I have traveled the world, why I'm a paddler and surfer—because that was all within my ancestors.

When I was injured in a car accident more than two decades ago, I was a surfer with a great connection to the water. But the accident left me paralyzed from the chest down, and so I didn't think I would ever be able to get in the water again. I spent a few months in the hospital and about a year and a half doing inpatient and outpatient rehab. Soon after waking up in the hospital, I overheard someone talking about an indoor pool. I told my PT and OT that I wanted to see the pool and get in it. They didn't have a lift or even a ramp in the pool, so when we got there, they told me I couldn't go in. I told them to dump me in, and I'd figure it out. Somehow, I convinced them, so they lifted me, still in my scrubs, out of my wheelchair and into the pool. When I entered the water, although it was difficult since I could not use my legs to kick, I immediately swam.

This moment reacquainted me with my identity and reminded me of the power water gives me. The power I felt wasn't even physical—it was spiritual. It gave me a glimmer of hope that I could still be who I am and didn't have to hide what had become of me. It reminded me I could still live in my *extraordinary*.

A couple years after my accident, a group of friends and I started an organization called Access

BEHIND THE SCENES

This is the truth: my favorite moment of this entire experience was with Ann and her nephew Joshua. Ann had only been back in Oahu for less than a day and was due to leave that evening to return to Texas, so the fact we were able to get together felt serendipitous.

After we were done taking photos, she told me to join her in the ocean as we neared sunset. I'm not usually a big water guy, but how many chances do you get to swim in Hawaiʻi while the sun dips below the horizon?

Joshua joined us. He has difficulty focusing on conversations and sometimes says certain words consecutively, but when Ann got his attention and asked him to sing "Kiss the Girl" from *The Little Mermaid*, he sang it beautifully from start to finish as the sun went down behind us while we floated in the ocean. That's a moment I will keep with me forever.

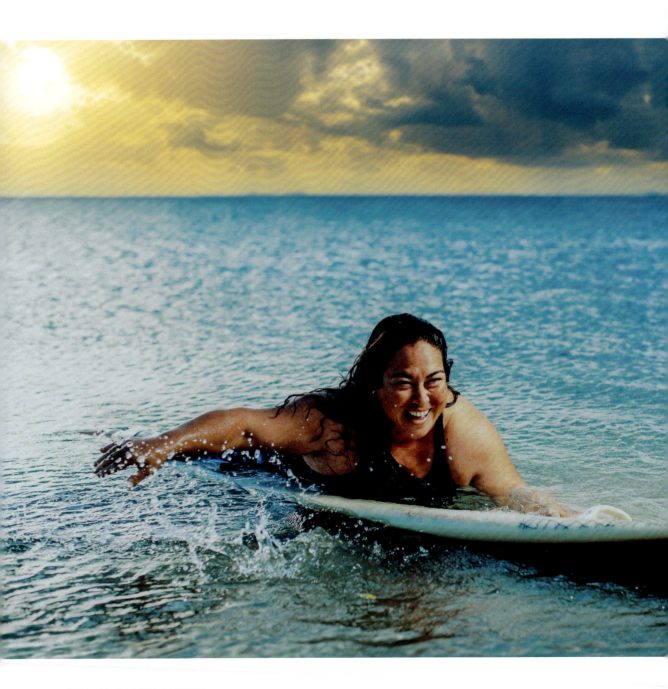

Surf, to get people with disabilities in the ocean and teach them how to surf. Our goal was to show that having a disability is not a liability. Instead, the lack of knowledge of the water is the actual liability.

I became a spokesperson for helping people access the water. When I got my doctorate in occupational therapy, I learned who and how I can serve. It gave me a holistic view of the techniques, skills, and tools I could use to get a person into the water—no matter their disability. Being disabled, I knew I wanted to connect disabled people back into their power.

For eleven years after my accident, I trained to become a paddler, ultimately qualifying for the Paralympics. On my final race, I flipped halfway through and was disqualified. But when I got out of the water and into the rescue boat, someone took a photo of me—and in it, I was smiling. Instead of feeling defeated in that moment, I was so overwhelmed with emotion and accomplishment that I couldn't feel anything but total joy. When you're at that level of competition, getting the gold isn't the point; it's about how much power I had as a human to get there. I was no longer living a normal life—I was living in my extraordinary.

> Your mana and nature's mana create balance and help people in the ways they need.

In Hawaiian culture, everything natural has a soul, a spirit, or *mana*—a spiritual power. When we connect to that power, synergistic energy is birthed. It doesn't matter if you're in the mountains, a park, the grass, or the ocean: it's two powers, nature and you. Your mana and nature's mana create balance and help people in the ways they need.

Your mana is individualistic and comes at different times. No one else can experience it for you, nor can you know when it's time to for you to experience it. For me, my mana is attributed to nature, to the ocean, to water—this is the power I had when I started Access Surf, when I was in the Paralympics, and when I am in the water. While I have faced many challenges throughout my life, my ancestors, Hamanalau, and my mana have empowered me to continue to embrace my *extraordinary*.

Overcoming

BEN MAYFORTH

I WAS BORN WITH SPINA BIFIDA ALONG WITH multiple other birth defects, including a missing kidney, misplaced liver, and severe scoliosis. I have osteoporosis in my right leg, giving me low bone density, and my liver is completely exposed because I only have four ribs. My complete diagnosis is called VATER syndrome, which stands for the various affected parts of the body: vertebrae, anus, heart, trachea, esophagus, kidney, and limbs.

I had to have severe bowel appendage reconstruction surgery up until age twenty. We didn't know what was going to happen because I'd had friends who had the same surgery and hadn't survived it. Following this surgery, I spent two months in bed in a spica cast. While this was an extremely difficult time, it was also formative for me. I knew there had to be a good reason for it. It helped me see the value in good health and taking hold of it to do the things I loved to do.

Despite all of these conditions, I was fortunate enough to avoid needing a shunt (a small tube that drains fluids from a baby's brain), which significantly lowers your life expectancy. However, I had to use wheelchairs and braces growing up and was unable to escape the notice of other kids. This led to my being chosen last for athletic activities, particularly pickleball, where my physical limitations were indisputable.

> When I am outside and climbing, I can let go of everything I have been through.

As early as the second grade, I was a lobbyist through a March of Dimes ambassadorship. Through the organization, I would go to Congress and ask them to put funding toward research to help examine why congenital disabilities happen. Some of the people in Congress would cry when they heard my story, which made me aware there was something different about me. My parents, encouragingly, always told me I can do anything I put my mind to, and I dreamed of becoming a professional athlete, like a baseball or basketball player. Today, I am a professional athlete—just not in the way I thought I would be when I was young.

My journey into rock climbing began as a personal response to realizing the importance of maintaining good health. Fueled by a passion for adventure and action sports, the lack of access to such activities in my upbringing led me to wheelchair basketball. However, after enduring four years of collegiate sport-related stress and an unhealthy environment, I decided it was time for a change. Exiting a team I never thought I would leave marked the beginning of a new chapter. Amid an identity crisis and learning I was bipolar during my senior year of college, I found solace in rock climbing.

My body was made to climb. My arm span is six feet, one inch, and I stand at five feet, one inch. My

upper body strength is through the roof, and due to the low body mass in my legs, I don't weigh as much as an able-bodied person.

In my mid-twenties, I started competing in paraclimbing competitions around the world. I received second place at paraclimbing nationals, which landed me a spot on the US team. In my third competition, I placed tenth, which pushed me to work hard and rank second in the next competition the same year. Since then, I have not yet missed a podium.

Have you ever been in a place where you didn't belong, but for some reason, you loved that feeling? Making people uncomfortable just through my presence and showing them why I deserve to be there is what climbing feels like. A lot of people don't expect me, a disabled person, to limp up to the crag and tackle their climbing project with relative ease.

When I am outside and climbing, I can let go of everything I have been through. Climbing a boulder in the middle of a canyon with mountains surrounding me is so soothing and helps calm my overactive mind. Nature inspires me to reflect on that kid lying in that hospital bed in that body cast and ensure that he's happy, defying gravity and disability alike, and proving to himself that he belongs.

CHANNING CASH

CHANNING CASH'S LIFE TOOK A DRAMATIC turn when a seemingly ordinary day in her small Laotian village turned into a harrowing encounter with a charging bull. At just three years old, she was innocently playing with other village children, immersed in a make-believe world of cooking and shared laughter. Suddenly, the tranquil scene shattered as screams erupted and a dark shadow loomed over her.

"I would play with the village kids, and I remember I was kneeling down and I heard people screaming because I had my back turned. I just saw this dark shadow and by the time I turned around, I was already tossed up in the air, and then I fell down to the ground."

The impact left her with a broken back and injuries to her left hip, rendering the lower half of her body paralyzed. In a village with limited access to medical facilities, the response was steeped in spiritual practices, as Channing's mother sought healing through unsuccessful temple visits. Slowly but steadily, Channing began regaining some mobility. Although she could not fully walk, she managed to sit up and crawl. Her resilience and progress in the face of physical challenges caught her family's attention, especially when her father returned. Recognizing the need for proper medical help, her family embarked on a dar-

> **With its vast and untamed beauty, nature became her gentle mentor, teaching her the art of resilience amid life's storms.**

ing escape from their Communist homeland, with the ultimate goal of reaching the United States.

Guided by the moonlight, carrying Channing in a sling, they navigated the darkness to evade authorities. The journey was dangerous, culminating in a near-capture at the Mekong River. However, a plea from Channing's father, explaining their dire need for medical assistance, spared them, albeit at the cost of his watch.

After an exhausting journey through refugee camps in Thailand and the Philippines, Channing finally arrived in the United States with her family at the age of six. The initial prognosis was grim—she was told she might never walk again. Faced with the additional challenges of not speaking English and being the only Asian child in her school in Illinois, she struggled with feelings of insecurity and the desire to fit in. As she navigated her early years in a new world, her family faced financial difficulties, and she served as her parents' translator while they were acclimating. Despite societal pressures and her insecurities, Channing's resilience and determination became the driving force shaping her unique path through life.

When she was eleven, her family purchased their first house, a pivotal moment that thrust her into the role of a translator during financial

discussions about mortgages and home loans. Faced with the pressure to comprehend complex terms and convey them to her parents, Channing developed an unwavering work ethic, eventually securing an internship in the banking sector as a young adult and rising through the corporate ranks. Despite achieving success in the corporate world, Channing felt a void—she had yet to explore nature.

Channing yearned for experiences beyond creating and paying bills, and she questioned the purpose of her existence. In this contemplative state, she began to break free from her self-imposed limitations, gradually stepping into the world of outdoor adventures, setting the stage for a transformative chapter in her life.

Upon uprooting her Midwestern life to California, Channing had the opportunity to engage in adaptive surfing for the first time in her life, a truly special moment of connection and freedom. Despite not having full sensation in her toes, she could still feel the sand beneath them. This sensation triggered memories of simple pleasures, like sitting on the ground and feeling the texture of the earth. Inspired by these moments, she realized the importance of taking time to connect with nature.

Despite the fear of returning to a life of financial struggle, she questioned the significance of accumulating wealth if it meant sacrificing these outdoor experiences she had been yearning for. She decided to

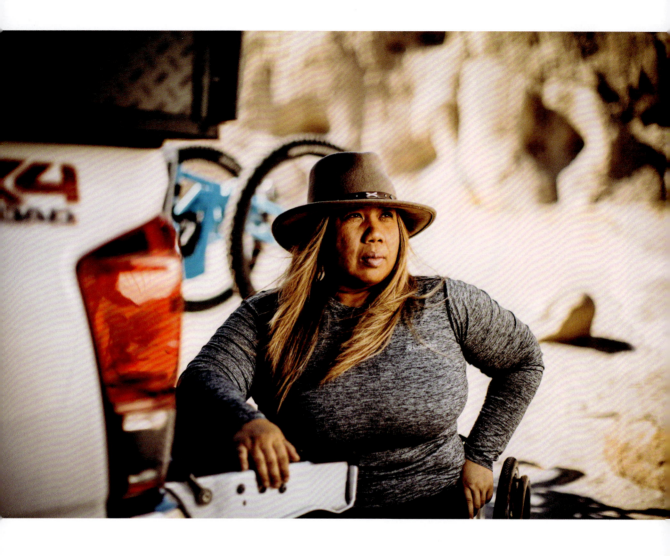

embrace new adventures, even if the path was uncertain. Determined to explore and immerse herself in the beauty of nature, she embarked on a journey to redefine her life on her terms.

Soon, Channing signed up for sprint kayaking, challenging herself with the intense balance and core strength required, and eventually auditioned for the Paralympic Adaptive US team. After relentless training, she secured a spot and spent four seasons racing across the globe. However, life took an unexpected turn when her mother was diagnosed with cancer during the lead-up to the Tokyo Paralympics.

"It was like a really hard decision because I had been training so frickin' hard, and I wanted to make it to the Paralympics. I wanted to do both. But then at the same time, I only have one mom, and I needed to be there.

So I quit the team, and I flew back home, and I spent as much time as I had with her."

Channing soon found herself at her mother's side, navigating the heart-wrenching reality of terminal illness. The unforgiving grasp of disease rendered her mother, who had once covered thousands of miles on her own two feet, immobile. In those moments, as Channing adapted to new realities, she immersed herself in every precious second, cherishing the time spent with her mother, an emblem of strength amid vulnerability.

Inspired by her mother's unfulfilled travel dreams, Channing shifted her focus to exploring the world on her terms. From makeshift setups to a purpose-built camper, she embraced a nomadic lifestyle, finding solace and beauty in nature. Now, in her upgraded camper with a fireplace, Channing continues to wander, grateful for the freedom and independence her unconventional voyage has granted her.

Amid the calming embrace of nature, Channing found her sanctuary away from the bustling urban rush. In the serene woods, societal pressures melted away, allowing her to wander freely without the weight of judgment or expectations. With its vast and untamed beauty, nature became her gentle mentor, teaching her the art of resilience amid life's storms. Graced with the unconventional freedom to drive her Tacoma and camp in remote woods, she reflected on how this empowering lifestyle had enriched her soul. Reveling in the pristine beauty of isolated moments, she realized the profound therapy found in solitude. With a heart full of gratitude, she acknowledged the uniqueness of her journey, finding solace in the uncharted path she had courageously traversed.

> In the serene woods, societal pressures melted away, allowing her to wander freely without the weight of judgment or expectations.

"The fact that I can go to remote areas deep in the woods, I feel like that's a huge independent achievement for me, because if you asked me this a long time ago, I would have been scared to death to even think of that. Now when I'm in the woods, I'm just sitting there and thinking, 'This is so freakin' beautiful.' The only thing I regret is that I didn't start this lifestyle sooner."

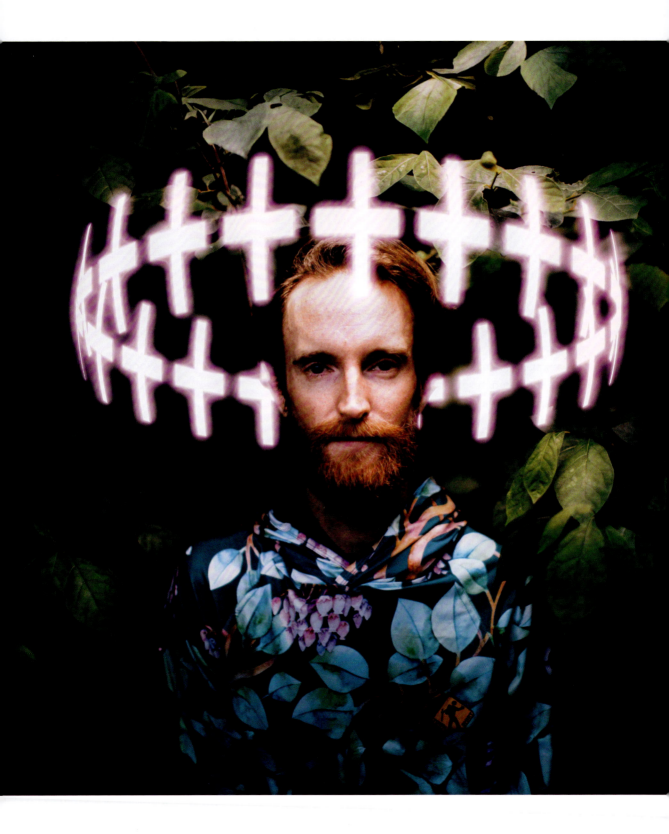

JOSH SHEETS

FINDING OUT I WAS HIV POSITIVE WAS ONE of the worst days of my life. Hearing the nurse say "positive," I started shaking with sadness, frustration, and anger. When I got home, all those emotions just melted into sorrow, which stayed with me for a long time. I just wanted to be normal. I didn't want the virus to have power over me; I wanted to have power over the virus.

I did not immediately accept my diagnosis and couldn't bear the indelible mark it would leave on my life. I felt shame for a long time because I thought I had educated myself enough to prevent contracting HIV. And I struggled with the distorted fact that if I weren't gay, I wouldn't have contracted this virus.

Coming out is a pivotal moment for any LGBTQ+ person. Telling the people in my life I was HIV positive was like coming out all over again. When I was twenty-six, two years after my diagnosis, I had to come out to my dad as HIV positive. I lived at home at the time and had been on my dad's health insurance when I was diagnosed. He had received multiple explanation of benefit letters from the insurance company. He kept asking me what they were for, and I would deflect the truth. But unbeknownst to me, my mom had already told him.

One day, he finally asked me about it. I told him, "Well, if you have to ask, you already know."

His response broke my heart. He told me, "I'm going to love you, regardless. I'm not mad you didn't tell me; I'm just mad you felt like you *couldn't* tell me."

Before my diagnosis, I thru-hiked the Appalachian Trail. After my thru-hike, my HIV status never kept me from going outside, meaning I was never sick enough that I couldn't. But it did put me in a very depressive state where I didn't even *want* to go outside.

BEHIND THE SCENES

Several years ago, I made a series of short films about twelve individuals and their stories of how they connect to nature. This book is an extension of that project. One of my films was about Josh and how he lives with HIV while thru-hiking. To be honest, as a gay man, I learned more than I thought I already knew. The AIDS epidemic wasn't long ago, and I am from the first generation that has access to medications like PrEP that help prevent HIV.

Even though I don't know what it's like to live with HIV, Josh's story felt very personal just by dint of being gay and knowing the strength it takes to come out to your parents. Josh had to do it twice. Again, I love stories that play with stereotypes, because people like Josh are able to break them down and show that at our core, we're all just humans.

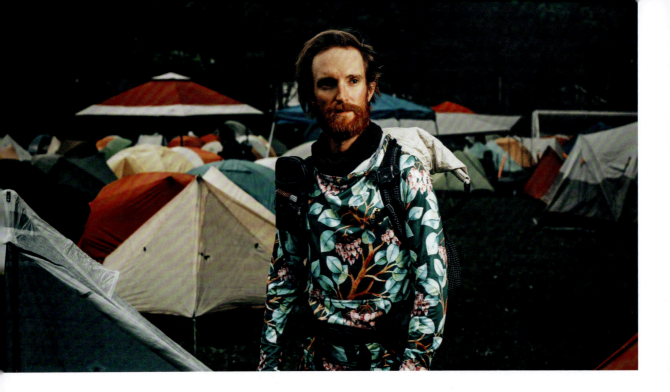

About a year after I was diagnosed, I was working in the restaurant industry and drinking heavily as a coping mechanism for my HIV diagnosis. One night, I was riding my bicycle home from work, drunk, when a car sideswiped me. It was then that I knew my path was not sustainable. In the fall of 2014, to reconnect with nature and return to my roots, I quit working at the restaurant and thru-hiked the Long Trail in Vermont. I decided to use that experience to end my self-destructive behavior. That trip set the course for moving forward and continuing my passion for the outdoors. I would not let HIV prevent me from being where I loved and knew I belonged.

Persevering through these obstacles taught me how important it is for me as a thru-hiker and a person living with HIV to keep walking through the beautifully unexpected.

Thru-hiking and living with HIV have a lot of parallels. When you're long-distance backpacking, you are vulnerable to the elements of nature. You're walking through unexpected weather; encountering wildlife; feeling hot, cold, sweaty, dirty, constantly hungry—the list goes on. In thru-hiking, you'll have perfect days, bad days, and even shittier days. You're uncomfortable a lot of the time. While HIV doesn't bear these exact hindrances, it has built my motivation to survive in the same way.

HIV has taught me to cherish being outdoors. We are not promised tomorrow nor guaranteed good health in the future. Persevering through these obstacles taught me how important it is for me as a thru-hiker and a person living with HIV to keep walking through the beautifully unexpected.

ANNIJKE WADE

NAVIGATING MY IDENTITY FEELS LIKE A CON-stant negotiation in the spaces I inhabit. As a disabled Black woman in the outdoors, each entry is layered with questions: How am I perceived? Do I feel included? *Am I welcome here?*

I was born in San Francisco but grew up in Sonoma after I was adopted at age two. My mom is also Black, so I never felt different, compared to other adoptees who might grow up in mixed families. My mom, a therapist, adopted me as a single parent, which was rare at the time because most agencies didn't approve of a woman adopting a child on her own. However, her job and finances checked out, and that's when we were united. While my upbringing was unique, I always took pride in my identity as an adoptee.

I started to explore the outdoors at a young age through Montessori education and Girl Scouts. I wasn't aware that I was different, despite not seeing many girls that looked like me in those spaces. Catalogs, teen magazines, and television never represented my identity with anyone who looked like me. In middle school, I remember being called the N-word for the first time by classmates. All of these things culminated into the realization that my identity as a Black person meant I would face discrimination and maybe have to face it alone. Having these early experiences made me realize I needed to be even more unique and step into the interests that I enjoyed. I loved computers, poetry, plays, and nature, so I used all these elements of my personality to prove that I wasn't the stereotype people thought I should or could be.

In college, I started cycling to school and my job at a political campaign in downtown Portland. I didn't have a car in college, so sometimes I would ride twenty to thirty miles daily, not thinking of distance but rather efficiency and schedules. When I moved to Santa Fe, someone at my job asked all the employees if they wanted to join a mountain biking club. So I bought a mountain bike and became hooked.

I went to Angel Fire, New Mexico, for a weekend in 2021 to go on a mountain biking trip. I had signed up for a bunch of endurance and gravel races and even landed my first bike sponsor. It was an exciting time in my bike career.

It was the morning of July 17. I started my morning run on a blue flow trail that featured jumps surpassing fifteen feet. Things were going well until I hit a feature and was launched really high in the air. My plan was to land the jump, brake, and then exit the trail to recalibrate. However, when I landed and

> Through all these parts of my identity—Black, disabled, nature lover—the most important is that my outside, no matter what I'm doing, is the right way to be outside, and in nature, I am always welcome.

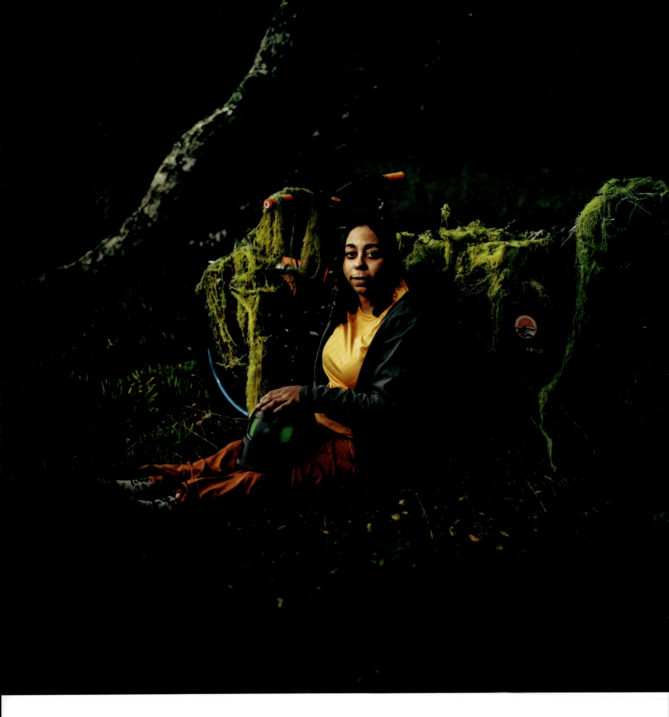

put my brakes on, I wasn't able to build up enough speed and time before hitting the next feature. The next thing I knew, I was floating through the air, and then I was face down on my belly in the middle of the trail. There was a void in my chest, and I realized very quickly that I couldn't move my legs.

Following my accident, I just wanted to get back to my life, even if it was a new one. Grief is layered and happens over time, so I knew I couldn't force its process. My doctor made it clear there were no miracles and that I should focus on living my life as a paraplegic. My accident had given me a blank slate to redefine myself yet retain the parts of my identity that make me who I am.

I ride at a different ability than I had before my accident. I have had to start from scratch in all areas of my life. In rehab, I had to learn how to transfer myself to the shower, which was a scary experience. Existence got infinitely more complex. It's tough not to compare myself to who I once was. However, these challenges have taught me to be gentler with myself and not dwell on what could've been; instead, I focus on what is and how I can utilize my abilities.

An essential identity element as a disabled person and an outdoor athlete is speaking to the validity of simply being outdoors. I used to ride black diamond trails, but now I am back to riding green. I am not at the skill level I used to be at, and I might never be—but that's okay. It doesn't make me any less valid out there. Sitting outside in my backyard listening to the birds counts as my time in nature; not every moment has to be extreme. Through all these parts of my identity—Black, disabled, nature lover—the most important is that my outside, no matter what I'm doing, is the right way to be outside, and in nature, I am always welcome.

JACK RYAN

ON A THURSDAY IN LATE NOVEMBER, I WAS getting ready for my usual weekly jiu-jitsu practice. I had been dedicating myself to the art of Brazilian jiu-jitsu for a year and a half, but this particular session marked the beginning of a series of events that would reshape my connection with the outdoors, my body, and my life.

During that fateful practice, my jiu-jitsu instructor forcibly broke my neck, leaving me a walking quadriplegic with incomplete paralysis at the C4 and C5 vertebrae. A hemorrhagic stroke struck about twelve hours later due to internal bleeding, inducing me into a two-and-a-half-week coma. Upon waking, my only means of communication was blinking through an alphabet board, a method I relied on for about a week before regaining the strength to speak.

Afterward, I was transferred to Craig Hospital in Denver, spending four months grappling with the emotional and physical impacts of my newfound disability. Post-recovery, I faced the stark reality of life without a driver's license and the limitations it imposed on my outdoor activities. However, a pivotal moment arose through a seemingly ordinary social media post seeking guidance on returning to the outdoor spaces that once defined my life.

"I surfed. I ran up mountains for fun before I got hurt, but I'm at a loss for words and a loss of direction for what I can do with this newly disabled body." This inquiry became a turning point, with many people offering advice on adaptive sports, the first of which was rock climbing. The response was transformative, introducing me to adaptive sports and providing a glimmer of hope for a return to activities I thought were forever out of reach.

Most outdoor sports now unfold in slow motion for me due to my constant struggle within my body. The misfiring of muscle groups makes rapid movements a challenge, rendering running and swimming impossible. However, I've found solace and logic in activities like rock climbing, appreciating their slow and methodical nature, which offer me a sense of control. Similarly, cycling aligns with my capabilities, allowing me to keep pace with able-bodied individuals.

My disability extends beyond the physical realm, encompassing the emotional toll of managing the judgments of strangers. The gray area of my disability, a blend of visible and invisible, presents a unique challenge as I navigate the need to articulate my disability, confronting understanding and ignorance equally.

Five years post-incident, as I reflect on my disability, I would never wish such a fate even upon

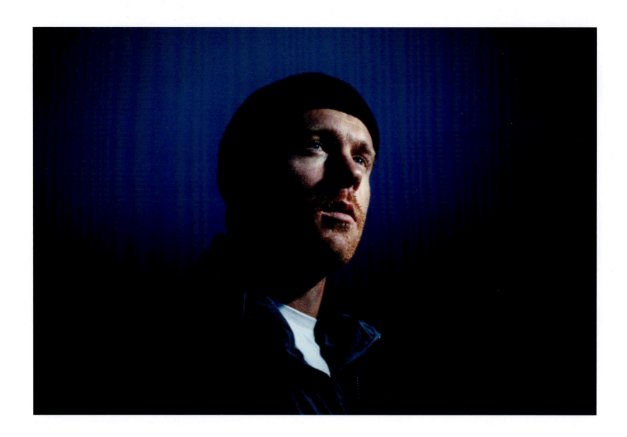

my worst enemy. But despite the challenges, the intentional approach I take to my time spent outdoors with others brings me solace. Community is crucial, providing joy and freedom because, disabled or not, we're all there for the same thing. I'm incredibly grateful for that. Through my outdoor engagements, I've developed profound empathy and gained a heightened understanding of others' struggles. This empathy becomes the cornerstone of community; it is essential for shared adventures, understanding, and collective support.

> We all recognize that we are there for the same thing, even if we may go about it differently.

True community, as I've come to realize, is impossible without empathy. The shared outdoors, marked by intentionality and compassion, becomes a conduit for creating a broader, more diverse experience within the community—a valuable realization that I cherish deeply.

My disability, as stressful as it can be, fosters a more present experience for both myself and others involved. We all recognize that we are there for the same thing, even if we may go about it differently. At the end of the day, we're sharing this outdoors experience, and that's what truly matters.

KRISTEN WICKERT

AS A PLANT PATHOLOGIST, KRISTEN WICKERT uncovers the intricate world of fungi and the complexities of tree decline. Through her work, she gathers historical information about the sites she studies to diagnose and address concerning widespread tree decline. Kristen's ultimate goal is to ascertain the reasons behind tree mortality and create strategies to protect trees from similar threats in the future. Focusing primarily on fungi, she explores the relationships between insects and fungi that pose a risk to trees, showcasing her commitment to preserving ecosystems.

Originally from Pennsylvania, Kristen grew up near the Lehigh Gap on the Appalachian Trail. Her childhood, although complex and discordant, was adorned with happy moments of running through the forest, building forts, and battling neighborhood kids with her big brother. Because of these outdoor experiences, Kristen developed a keen photographic memory for her natural surroundings. Her recollections include an intricate knowledge of every tree's location, relying on distinctive landmarks and specific tree species for navigation. This unique ability to recall precise details and navigate through dense forests became a distinctive trait that eventually served her in her career.

Her escape into the woods, spending days in her biodiverse refuge, served as a natural safeguard to distance herself from the challenges faced at her father's house.

"I was trying to escape from being in my dad's house, so I would wake up really early, leave, and then come back, eat dinner, and go to bed. That explains a lot of why I am the way I am. I just did. I just functioned. I was in survival mode. I think exposure to being on my own and managing the oddities of the wilderness in this urban area made me develop a photographic memory organically."

Leveraging her unique skills, Kristen ventures into various ecosystems to study fungi through

BEHIND THE SCENES

I had a blast with Kristen. We had never met in person before, but she was so kind to invite me to stay at her place in Morganstown the night of our shoot. We went on a cute little date afterward to a nice restaurant and sat on a patio overlooking the river. We even saw a beaver playing down by the water.

Kristen's knowledge fascinated me, but beyond that, I was impressed by what a genuinely well-rounded person she is. We had some really thoughtful conversations and just got to hang out like we had been buddies for years. When I was crafting this project and thinking about the people I would meet, these were the kinds of interactions I was hoping for.

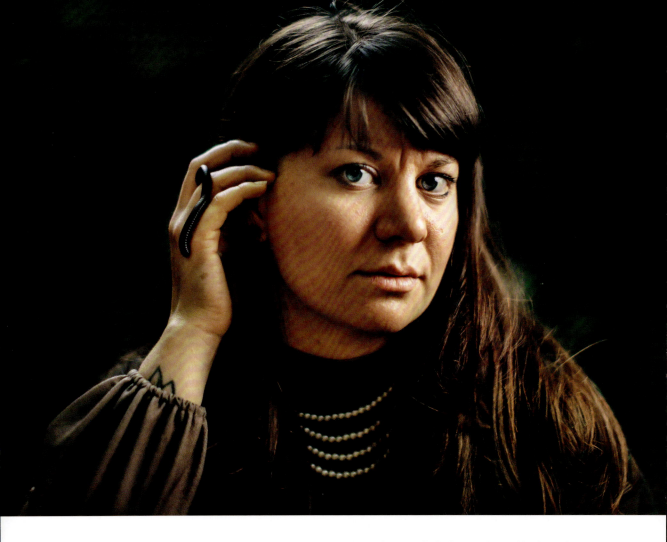

millipedes. Kristen's ability to identify specific habitats, honed by her photographic memory and knack for recognizing details, became crucial in her research. She could adeptly analyze the landscape, considering factors like slope, shade, tree types, and log sizes. In the process, she stumbled upon more than just fungal insights. A larger, unexpected discovery unfolded—one intricately tied to the fraternal behavior of millipedes.

In the damp forests of Appalachia and bountiful valleys of the Sierra Nevada resides *Brachycybe lecontii*, a millipede that exhibits parent-like traits with its offspring. As she explains, "The millipede fathers do parental care and carry around the little babies and farm fungi depending on what their colony needs: taking care of its babies, releasing chemicals to take care of them, and farming fungi for when they're sick. There's a bigger universe we don't even know about. This little thing has a brain smaller than the head of a pin, yet it possesses what we could perceive as *love*."

Nature and love, two elements inextricably woven into the fabric of human existence, propelled Kristen in a long section hike of the AT. Seeking a fresh start and healing after the end of a bad relationship and losing her stepdad, she set out from her backyard in Pennsylvania to Mount Katahdin, the official northbound end of the AT. During her hike, she encountered surprising acts of kindness, like a stranger giving her a ride and then buying her a military-grade poncho to keep her dry from the AT's notoriously wet climate. These moments of generosity stood out against enduring weeks of continuous rain and frigid weather. Kristen's resilience, shaped by her love for the outdoors, made her realize the interconnectedness of humans and her research.

Outdoors, she finds strength and peace.

"Individual plants or fungi have different traits, and you have brown hair, and I have blonde hair, and we're humans. How we are in nature and the traits or the things we do every day and take for granted in our community apply to things outside our backyard. We are nature. We are creations. We're just like the plants that I study."

In nature's embrace, Kristen finds personal connections with the smallest of creatures, like the millipede fathers caring for their young, which was something absent from her youth. However, as she works through childhood trauma, Kristen sees her past with new clarity, uncovering moments once blurred by the need for survival. Outdoors, she finds strength and peace. And akin to the millipede, Kristen serves as a parental figure to nature, helping protect the places that always protected her.

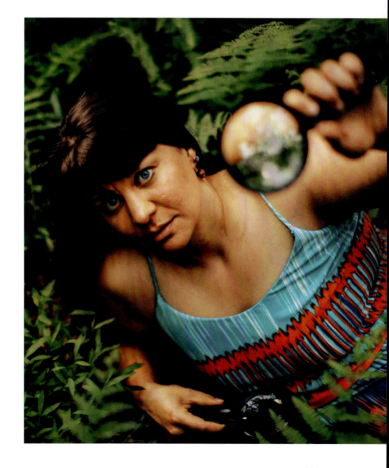

203

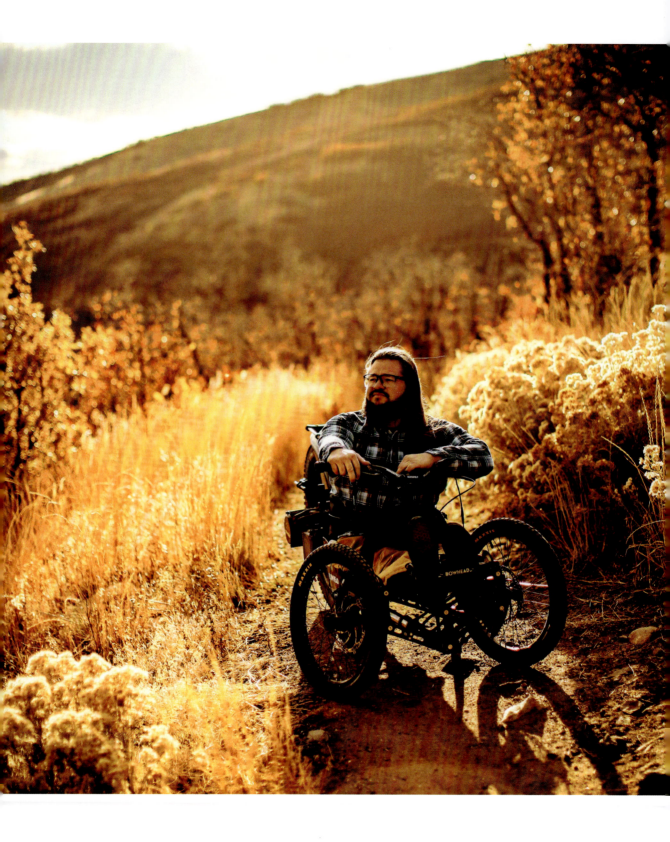

MATT TILFORD

ONE MEMORIAL DAY WEEKEND, I WAS CAMP-ing with some high school friends at Lake Don Pedro in Northern California, a place I grew up visiting with my family. Returning to camp from our friend's lake house with six of us in the car, I missed a turn at a construction site, driving us off a six-hundred-foot cliff. I wasn't wearing a seatbelt and was ejected from the truck.

I was found about 550 feet down a ravine in a dry riverbed. While some of my friends sustained minor injuries, my friend Jake managed to walk up the road and signal a passerby to call for help. As a result of the crash, I had no recollection of the month preceding the incident. I do, however, remember coming in and out of consciousness as I woke up on a steep incline, feeling around me and realizing the legs lying next to me were mine.

I sustained a T12 bust fracture to my spine, and I am now a paraplegic. In addition, I broke my ribs, had collapsed lungs and a compound femur fracture, and blew out my ankles. From the accident site, I was flown to the nearest hospital to make sure I was stable and then relocated to Stanford for surgeries. For thirty days, I was on a ventilator in an induced coma. The first memory I have from waking up from the coma was my dad at my side with my hand on his chest, repeating, "Follow my breathing."

Nature provides peace and solitude for those struggling with new disabilities and the depression that sometimes comes with that.

I was eighteen when I became disabled. While all my friends were partying and having fun that summer before venturing off to college, I was starting life over again. It took a year post-injury to get back outside again. I had to relearn how to do everything outdoors, like camping, wakeboarding, skiing, and mountain biking. Getting on an adaptive mountain bike for the first time was the most independent and free I had felt since the accident.

My disability launched me into various jobs in accessibility. While in college, I got to test pilot robotics exoskeleton suits and sell access devices to rehab hospitals and spinal cord injury units nationwide. The most rewarding endeavor was starting a chapter of the United Spinal Association in the Bay Area. My friend and I helped guide other disabled people on using local transportation or plan meetups at local art galleries. The goal was to connect people in our community and help them learn from each other while integrating back into the world from the depressing hospital environment.

The spinal cord injury is my primary disability, but it has affected so many other elements of my life. Financially, it's expensive to be disabled, especially if you want to afford adaptive equipment to be outside. A nondisabled person can go

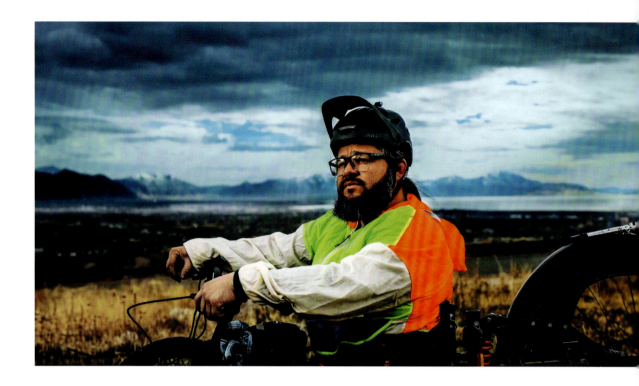

to Walmart and buy a bike for $250; mine costs around $20,000. Disabled people get left out of a lot of social gatherings or events due to inaccessibility and get treated differently when doing simple things, being singled out with backhanded encouragement.

 Access to the outdoors is so important for disabled people. Nature provides peace and solitude for those struggling with new disabilities and the depression that sometimes comes with that. It helps us naturally experience the world, rather than how society has built it to exclude us.

 The outdoors makes me a better person. I'm happier there. Using a wheelchair can feel confining, which makes me not want to limit myself to a city—I want to be in nature. My mountain bike has been my conduit to discovering the parts of nature that have been exclusionary to me and so many others. My wheels have rolled not just over trails but over the obstacles of societal constraints, making a path for me to find inclusion and connection and rediscover my body, resilience, and ability.

LOLO VELOZ

LOLO VELOZ WAS GETTING READY FOR A routine day of sixth grade when she realized something wasn't right. Her period had started, but she knew she was going to be late for school, so she stole one of her mom's panty liners and went off to school. A few hours later, she had bled through her pants and almost fainted from the blood loss, setting the grave tone for periods to come. She often felt embarrassed to speak up and didn't know that her painful, heavy cycles that lasted more than seven days weren't normal. For the next sixteen years, she endured being told it was "just a bad period."

Throughout her life, Lolo would miss school, work, and life events due to the debilitating pain and havoc her periods caused. And through it all, she would take care of her little brother while her single mom worked long hours to make ends meet; at some point, the family had to resort to a women's shelter to keep them safe from the domestic issues happening at home with Lolo's father. This upbringing made Lolo fiercely independent and incredibly resilient. But it also meant she spent most of her younger years caring for others, leaving her own health on the back burner.

It wasn't until Lolo was twenty-six that she discovered a clue about the invisible culprit she'd been battling since her first horrible period. During a work shift, a coworker asked if she had endometriosis, and after looking into it, Lolo instantly thought, *This is it! This is it!* She was on her way to a diagnosis after countless doctor visits and trips to the ER.

Endometriosis is an inflammatory disease where tissue similar to the lining of the uterus, known as endometrium, grows outside the uterus and attaches to other organs in the body. This abnormal tissue growth can cause severe pain, inflammation, infertility, painful sex, chronic pain, constant fatigue, urinary and bowel issues, heavy bleeding, irregular cycles, digestive issues, and more. There is currently no known cause or cure for endometriosis, and many people who live with

BEHIND THE SCENES

We shot Lolo's photos in Tucson the day after she and her partner, Brett, finished the Arizona Trail. I was lucky to have some time to hang out with them beyond our photo shoot, as we stayed a night in an Airbnb and I got to cook dinner for them.

Photographing Lolo took me back to when I hiked the PCT and was working on my first book *Hiker Trash Vogue*. My photos of her are very reminiscent of that project because Lolo still had her "hiker trash" aura.

By the time you read this book, Lolo will have walked thousands more miles with endometriosis. She's a true badass.

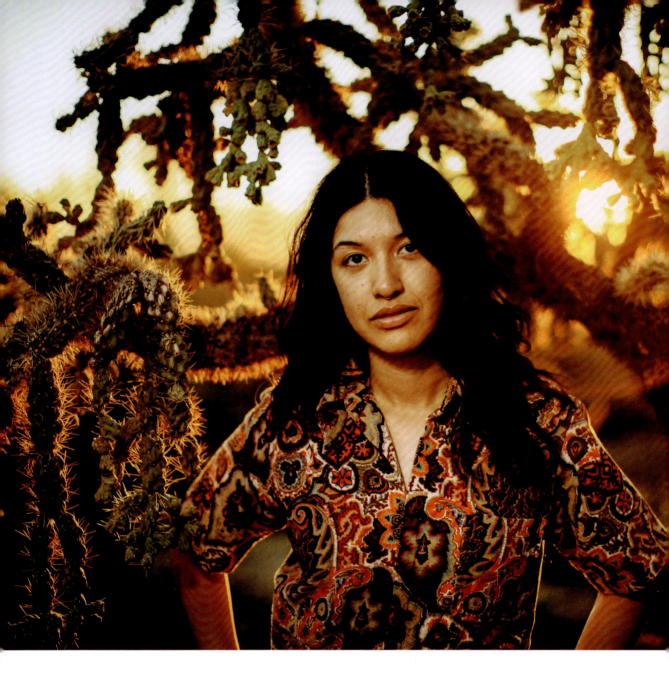

it suffer in silence because it can be very difficult to detect without invasive procedures.

The lack of research, awareness, and nonsurgical diagnostic methods also means that endo is commonly misdiagnosed for up to about ten years on average—it was no surprise Lolo's initial ultrasounds had not detected it. A month after she was misdiagnosed with pelvic congestion, she fought for a laparascope, against the advice of her OB-GYN, that would confirm the presence of endo, between stages 1 and 2, on her kidneys and bladder.

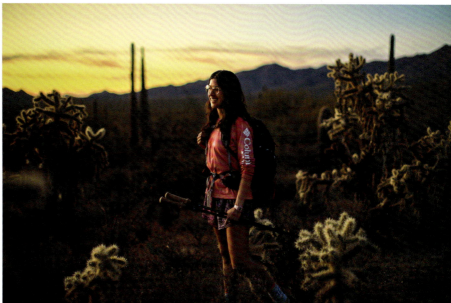

"It was bittersweet," she says. "Endo can feel a little bit like a death sentence." But knowing what she was facing was validating. She continues, "I can finally stop asking myself what's wrong with me. It was always endo."

In some ways, the diagnosis even allowed her to shift her focus. "My whole life has revolved around dealing with my pain," Lolo says. But when the Covid-19 pandemic hit, she was furloughed and found herself with an abundance of free time, so she made the spontaneous life-changing decision to thru-hike the 500-mile Colorado Trail southbound.

Lolo began daydreaming about thru-hiking the Colorado Trail. "I never in a million years thought that I'd be a thru-hiker," she said. But the combination of a childhood fraught with hardships and dealing with an invisible chronic illness has made her more than capable. "My pain cave is so deep," Veloz says, "my level four is someone else's level eight."

So she took off for a life-changing thru-hike of the Colorado Trail. She loved it so much she hiked it again, in the opposite direction, that same summer. After a thru-hike, she gushes, "I feel powerful. I feel confident in my body, and I feel physically strong, which isn't how I normally feel. I normally

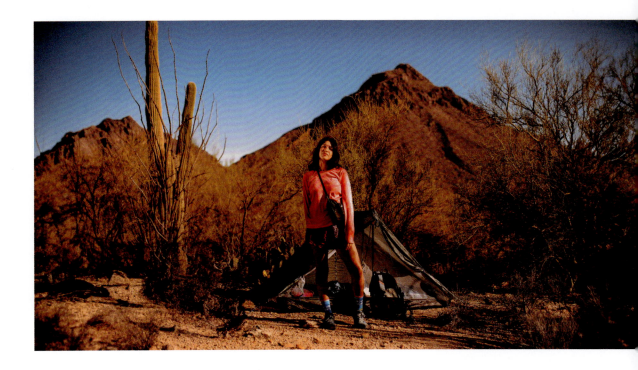

feel like I hate my body—it's the enemy, it doesn't treat me well. It's a bully to me. Thru-hiking means I get to kick it back." Hiking helps Lolo heal her relationship with both her body and her upbringing. "Hiking is the first time I've only had me to worry about, [the first time I] only have to figure out what *I* needed."

> **I feel powerful. I feel confident in my body and I feel physically strong, which isn't how I normally feel. I normally feel like I hate my body—it's the enemy, it doesn't treat me well.**

Still, Lolo sometimes feels out of place in the thru-hiking world. "I'm a weird anomaly of packages on trail. I have a chronic illness, I'm a Mexican woman, and I'm queer." She's always felt torn between multiple identities as many first-generation immigrants might and in a community that's overwhelmingly white, straight cis-men, Lolo decided to create a unique space for herself.

Ultimately, she wants to be an example for people like her—for people of color, immigrants, people with chronic illness, people who struggle with self-esteem and mental health, who come from low-income childhoods, and those who identify as part of the LGBTQIA+ community. Finally, Lolo has found true freedom in the outdoors. And for Lolo, truly living means putting one foot in front of the other, with everything she needs on her back, as far as her body will take her.

KANOA GREENE

"WHAT IF?" IS SOMETHING I HAVE ASKED FOR a long time, hindering me from connecting with nature. I'm from Hawai'i, but my mom and I moved to Florida when I was only four months old. Growing up on the mainland, I felt removed from nature because of all of my "what ifs." When friends would invite me to go tubing on the lake, those "what ifs" inevitably persisted.

What if I don't fit in the tube? What if I fall off? What if I don't have the strength to pull myself back up? I was so self-conscious about my body and being seen in a bathing suit in front of people who didn't look like me that I stayed away. The "what ifs" scared me so bad that I never said yes to any of the opportunities I was given to move my body or be in nature.

I realized that all those "what ifs" that had held me back my entire life no longer mattered.

I adopted a city girl persona when I lived in New York and went to grad school at a music conservatory in Princeton, New Jersey, telling myself that I didn't like the outdoors. It wasn't until Hawaiian Airlines recruited me to move to Hawai'i that I began noticing the nature surrounding me. They specifically sought out kama'aina like me—Native Hawaiians with mainland experience—to bring back to Hawai'i. They believed that people like us, who understand and respect the culture, can help innovate while staying true to the heart and mission of the company.

During that time, I had a procedure for a detached retina, but it was so severe that when I came out of surgery, I was permanently blind in my right eye. In my recovery, I was required to lay face down and not move for upward of two weeks at a time. It was then that I promised myself I would move my body whenever I could as soon as possible.

For me, fitness and the outdoors go hand in hand. I didn't make it very far when I took my first hike in Hawai'i. However, I knew if I poured my heart into my fitness journey, it would give me the strength to go even farther the next time. It's nature that helped shift my perspective and cultivate a very positive relationship with movement. Building that foundation through fitness gave me the confidence to ski, rock climb, paddleboard, and eventually surf.

Duke Kahanamoku, a native Hawaiian, is considered the pioneer of modern surfing, and thus Hawai'i is where modern surfing was born. My uncle Lopaka Manantan is a famous surfer. Surfing is a big part of our culture; it's in our blood. I still had all those "what ifs" when I finally took the leap to learn to surf. What if I can't find anything that fits? What if I find an instructor who tells me they can't teach me because I'm too heavy? What if I'm rejected?

When I started my company, Nakoa Adventure, I knew I wanted to empower other plus-size people to explore the outdoors without limits. *Nakoa* means "daring" and "brave" in Hawaiian, and that's what I needed to create: not just a safe space but also a *brave* space for people who look like me. A lot of adventurous spirits have "what ifs" but aren't sure how to break through them. Through my program, I give people the freedom to live out that yearning for nature that they haven't felt comfortable enough to explore.

I lost half my vision in December, and by the next May, I was on my first trail. Then I started hiking more, paddleboarding, surfing, and even becoming a certified sailor, all within a year of losing my eyesight. If life could deal me this type of unexpected circumstance, then why do I care if people think I'm too fat to be on a surfboard? I realized that all those "what ifs" that had held me back my entire life no longer mattered.

Letting go of the "what ifs" has changed my world. It would have been so easy to stay in my small world, in a small identity, and live as a city girl in my small bubble. Nature has allowed me to do so many new things with my body, impacting my life and giving it purpose. Nature made my world big.

I could have said no or "what if" to the outdoors, sports, fitness, and nature. Because I instead had the courage to say yes, it led me to endless possibilities. You may say no or "what if" out of fear, but if you dare to say yes, there's no telling how the universe will reward you. What if it's beyond your wildest dreams?

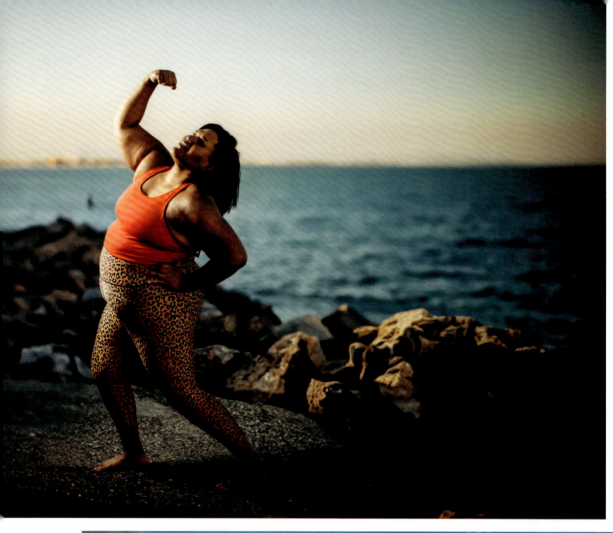
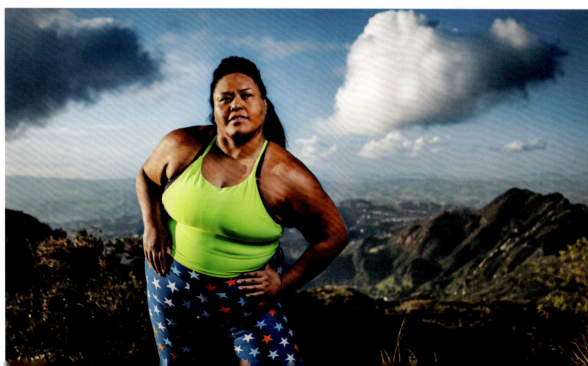

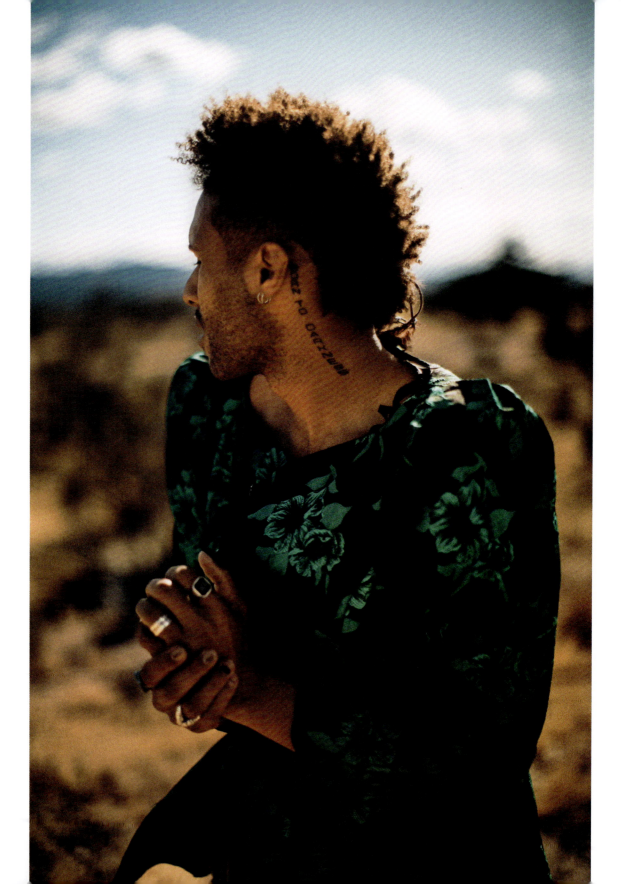

DEVANTE DESCHWANDEN

MY PARENTS, BEAUTIFUL AS THEY WERE, were on the other side of the law for a good portion of my life. I won't get into details, but their punishments and repercussions directly affected my life. We were in transit most of my life because we had to be. My mom was always looking for a new opportunity and a way to better herself and find more lucrative ways to live. My dad got caught up in criminal activities and spent my whole life in prison. I even have memories of visiting him as an inmate. I grew up in dangerous situations and had a lot of trauma, turmoil, and rage. For a long time I *became* that rage, and I *became* that danger.

Part of the way I escaped was through nature. Nature was the only place where I felt serenity. It was my safe space. I would find ways to get to the forest, desert, or rivers, depending on where we lived. Often we lived in cities, and "nature" was just a city park where I could sit in the grass and watch the clouds pass by—disassociating completely. I didn't understand at the time that I was meditating, but I was.

> The outdoors, always and forever, will be my place of refuge.

One of my grandmothers was a nomad. She had this 1984 Toyota pickup and was all over the place. She could ride horses bareback and could hit a target at a hundred meters with a bow and arrow. She made her own bullets and wore rattlesnake earrings made from snakes she caught. I have some fond memories of visiting her house that she was building with my aunt way out in the middle of the desert.

I grew up on adrenaline, pain, and nature, from running from police, to fighting, to playing with giant wolf spider nests down the street and trying to dodge javelinas. I learned about totem poles young, and I learned about energy, manifestation, and transmutation. I'm thankful for all that because I grew up in poverty for the most part, and I had a lot of ancestral poison to bleed out. It's taken me up until now to rectify that energy in my body and balance myself out to become someone who reflects my bloodline and my past.

Extreme sports are one of the ways that I interact with nature. Despite their dangerous reputation, they're more of a way to navigate different environments. I would even go as far to say that they're just sports, because nature itself is extreme. I found ways to play with the planet that seem risky to other people, but I think people often forget how complex we are as a species. Nature is really exhilarating, man, and in the moments when I start to dance with it, I am fully alive—I am fully connected.

I've had experiences with sharks while surfing and giant anacondas (freaking *massive*) deep in the Amazon; I've camped in the Sahara under a full moon and gotten stuck on a mountaintop during whiteouts with hundred-mile-per-hour

winds while trying to summit. When I'm skydiving, wearing a wingsuit, or about to BASE jump, the only thoughts going through my mind are my position in the universe, my breath, and the rush of being fully present. When I'm surfing, it's me and the sea. The waves are deafening, and I'm captivated by the way the sun reflects off the water. I'm there with all sorts of wildlife, and sometimes they come to play. If I'm rock climbing, it's me and the mountain. I'm focused on my grip and the chasm below. I enjoy climbs that put you high up because it's usually silent besides my breathing or birds singing while swooping through the sky—it's bliss.

Nature has taught me that we are not at the top of the food chain. I think we all know that, but when you interact with the world authentically, when you give in to nature and join the way that Indigenous tribes and cultures have (and continue to do), you find that we are so much more.

My childhood was nuts. I mean, absolutely insane. I've seen and experienced things that most people only hear about or see in movies or read in books. I ended up in one precarious situation after the next, and then I joined the US military and experienced even more. Overcoming fear, for me, is a matter of what's motivating you to push through. If your motivation to overcome your obstacles isn't strong, fear will beat you every time. But I was taught early not to back down from things that seem bigger than me. It's always been a catalyst for my growth.

One of the evolutionary traits of humans is that our brains developed to calculate risk. Ninety percent of my experiences—the ones that I love; my favorite experiences—have happened because I pushed through fear and took that calculated risk. My motivation has allowed me to lead an extraordinary life. The outdoors, always and forever, will be my place of refuge.

KYLE STEPP

REFLECTING ON MY LIFE MAKES ME WONDER if there is a purpose for everything that has happened to me. Why would I have survived all of these things? Why did it give me a deep love and compassion for others? There has to be a bigger purpose.

Both my parents grew up in good families, but their alcoholism and abusive relationship planted the seeds for an entire childhood of adversity. I found healing through service and passion for being outdoors during this time. I didn't want to be at home, so I would start cycling as soon as the sun rose and come back with the streetlights turned on.

One day in PE, I fell while playing kickball. When I pitched the ball, it hit me straight in the leg. When I went to try out for baseball, I got hurt again. My grandparents worried this wasn't normal, so they took me to a general practitioner who found a tumor in my leg. After a biopsy, I found out that I had a high-grade osteosarcoma, a very aggressive form of bone cancer found in teens and young adults. In addition to eighteen rounds of chemotherapy, to preserve the limb, they removed the infected bone and replaced it with stainless steel.

Being in the hospital was hard on me. My grandparents would come to check in on me, bringing me lunch and dinner, but they couldn't stay overnight because they both worked full time. For the most part, I was alone. In that time, I became close friends with the other kids in the hospital. Caesar, the first person I met, became my best friend. But throughout my treatment, nine of my friends died in the hospital, including Caesar.

One October day years later in Angel Fire, New Mexico, on the last run while mountain biking, I had this gut feeling something bad was about to happen. As I came off a jump, my back tire slipped out from underneath me and I flew into a tree, slamming into it—with the left side of my body where the metal was implanted in my leg. I knew immediately that the metal had detached from the bone and I was going to lose my leg. Yet, somehow, I felt calm. I had survived so much up until this point and knew that freedom was finally waiting on the other side.

From the first steps I took with a walker on one leg, I was already dreaming of when I could run, ski, and cycle again. While still in the hospital, I started researching adaptive sports. I came upon a nonprofit in Telluride called GoHawkeye that provides grants to adaptive athletes. It was the last day to apply, the day after my amputation. I filled out the application, and they called me a week later to

> **Caesar and my friends helped me see that we are all battling something in life; the one thing that connects us is our adversity and pain.**

invite me to Telluride to borrow a sit-ski to relearn to ski. I knew I had to use this opportunity for a purpose bigger than myself.

While finding my new purpose through movement, I had to simultaneously fight for access or simple things like a basic walking prosthetic. I also learned that insurance doesn't cover activity-specific prosthetics because they deem physical activity not medically necessary.

When I qualified for the national championships at my first triathlon the next year, I crossed the finish line with just seconds to spare. That fall, I got invited to training camps at the Paralympic and Olympic Training Center. People kept telling me, "You're an inspiration," which I struggled to hear,

because I just wanted every single person with a disability or limb loss in New Mexico to have the same opportunities I did.

Coming out of the championships, I learned about a movement called So Kids Can Move. Earlier that year, a woman named Jordan Simpson got a law passed in Maine that mandates insurance companies cover prosthetics, but only for kids. I knew immediately that I wanted to introduce this legislation in New Mexico but expand it for all ages.

Upon returning from climbing Cotopaxi in Ecuador, I had no job and I went full force into building a coalition and bringing this legislation to my home state. I recruited a bipartisan legislative team of three Republicans and three Democrats. From there, we had only sixty days to get the law passed. With a beautiful team of fellow amputees, prosthetic doctors, nurses, and volunteers determined to change the law, New Mexico became the first state in the country to mandate that insurance companies cover prosthetics, a law that passed unanimously. On April 6, 2022, the governor signed it into law, ensuring physical activity is a right, not a privilege.

During each difficult season of my life, someone has been there to show me unconditional love. When I was diagnosed with cancer and Caesar and my other eight friends didn't make it, I knew I had to live my life in their honor. I knew I had to love, lead, and serve as my life's purpose.

Going through the many things I experienced throughout my life showed me that sometimes these experiences are just a part of being human. When you face adversity, your mind, body, and heart must feel the depths of life that pain brings you. Going through so many highs and lows, I have been able to see the vastness of life. As I navigated this vastness with others—at the boys' home, safe houses, and the cancer ward—we bonded with each other through our shared pain. Caesar and my friends helped me see that we are all battling something in life; the one thing that connects us is our adversity and pain. That's why I love people so profoundly, because we all want to be loved, feel like we belong, and *find our purpose.*

Belonging
& Identity

RICHIE WINTER

THE WORD *MISFIT* MAKES ME THINK ABOUT my climber friends in Moab, wearing their retro neon gear, flipping off tourists, and running naked through the desert. Growing up on Oʻahu, many of my friends in the circus community worked as line cooks or exotic dancers, but outside of their professions, they would transform into bright and exuberant personalities, experimenting with the identity they were striving to uncover. This exploration of identity isn't limited to young people; I see outdoor misfits of all ages expressing themselves through empowering clothing choices, vibrant hair colors, and more.

Around the United States, there are small groups of AcroFlow and circus communities composed of hippies and misfits. When I was eight, I began to notice these people on the beach of Honolulu, spitting fire, swinging on a trapeze, riding unicycles, and slacklining. This group of social outcasts, ranging from eighteen to well past seventy years old, felt welcoming—they became my friends. I come from an immigrant family and had a not-so-accepting community at school, so these people made it feel safe to be different; they felt like *home*.

Watching my misfit friends was like going to the circus for free. Through all the wild and sometimes dangerous stunts they would practice, slacklining was the one I was the most drawn to. It seemed improbable, but as I watched, learned, and tried it myself, it started to feel possible—and slacklining transcended into highlining.

Highlining is walking on a strap of webbing very high off the ground between two points. In most cases, you're connected by a leash to the line. In the event that you fall, you will end up dangling below the line. In a way, I am curating this experience of walking through the air and seeing nature from a

BEHIND THE SCENES

I am terrified of heights, but Richie is not—or if he is, he doesn't allude to it. I was so nervous climbing up to the top of the rock to photograph him. Even though I was attached to a rope, I am naturally anxious when I know there is even a 1 percent risk of danger. However, it was really important for me to push through that fear. That experience allowed me to commit to what I was doing.

When we rappelled down to get the final shots, Richie was very kind and didn't judge me for being scared. I really appreciated that.

I got to meet a few of his friends who came out to help him rig the line. They reminded me of the friends I made while thru-hiking. I identified with him when he talked about being a misfit in his interview. That's how I view myself, and I believe a lot of the people in this book would echo his sentiments.

unique perspective most people don't. You're so high above the animals below you that most don't even notice you're there. It's like being in the best animal blind ever. The animals do what they usually would because you're so far away.

Beyond the physical beauty of nature lies the best part of highlining: the community. Outdoor sports attract many people who consider themselves misfits. In modern society, every year there is a new car to drive, clothes to wear, or a job to have, which can serve as a defining feature for other people to measure themselves against you. Nature evolves slowly enough that we can't count its changes; when we go outside, we get to simply exist. It forces us to be present. Misfits find refuge outdoors because they can show up authentically as themselves.

Highlining creates this rare space of vulnerability because it's an intensely mental sport. Highliners aim to stay above the line, walking as far as possible without falling. You have to be very present and focused while walking alone on the line, which evokes strong emotions. This fragility creates a community of people who see each other's humanity and form a welcoming space for individuals to let their inner weirdo out without being judged.

Nature evolves slowly enough that we can't count its changes; when we go outside, we get to simply exist.

My grandparents were immigrants and had to work hard, speak a certain way, and dress a certain way to gain respect in this country. Their assimilation polarized me; I felt the pressure of their expectations, even though I wasn't fighting for the same respect they had to seek. Meeting people in the AcroYoga or highlining communities who challenged those expectations gave me hope that I had the freedom to be whatever I wanted—and I never felt alone in doing it.

LEAH KAPLAN

HAVING A CONGENITAL DISABILITY HAS always posed its sets of challenges. I got hired at Panda Express during college, only to face termination on the first day of my training shift when the manager noticed my arm. When she asked me to type in my password and log on to the register, I rolled up my sleeve, and she looked at me and said, "You have to go."

Looking back, I realize they were aware of their wrongdoing. The manager had summoned someone from headquarters to bribe me with free coupons so I wouldn't say anything. I was twenty at the time and didn't know what to do, but I did know that I felt *awful*.

I was innocent about discrimination like that growing up, so it was shocking to be fired for something I couldn't help. I am one of four kids, all adopted: two of us from China and one each from Vietnam and Russia. Three of us have limb differences. One sibling has no arms, and the other has cleft hands. Being surrounded by my siblings made me less aware of the fact that we were different—I never felt alone.

My mom was a single parent and had a fondness for kids with disabilities because, generally, they don't get adopted and stay involuntarily in the foster system. I was six and a half when I was adopted, and growing up in Washington State meant my family was rich with outdoor experiences. My mom loved to take us all over the country, where we would hike and camp. When I was ten, she took me to my first disability convention, ensuring that I could interact with other Asian adoptees and kids with disabilities. She did an unbelievable job of ensuring we had a good life and that our world was monumental.

After high school, I stopped attending the disability conventions because I just wanted to forget that part of me and live a "normal" life. College was this opportunity to be a new me. I would hide my arm when taking group pictures with friends or cute selfies for dating profiles, which would sometimes end in rejection.

Several years ago, after volunteering at various triathlon events, I was inspired to look for a disabled community through adaptive sports. A Google search led me to the USA Triathlon Team website, where I found triathlons for adaptive athletes. I didn't even know how to ride a bike then, but I applied anyway and went to my first camp that same year.

Reconnecting with other people with disabilities was magical; it felt like being at Disneyland. It's beautiful to see how others interact with the world

and how they adapt to it. It made me realize that people with disabilities inspire me because of their mindset and how they show up. It gave me the courage to embrace my own disability.

Growing up with this arm has shaped my perspective on disability and injustice. Over time and through community, I've come to understand that it's not the individual who is limited but rather the environment surrounding them. If society could shift its perception and recognize that disabilities are often a result of an inaccessible environment, it could lead to a more accepting and inclusive way of life for everyone.

> **It made me realize that people with disabilities inspire me because of their mindset and how they show up.**

I don't see myself differently when I am in nature. The outdoors is a place of boundless adaptability, free from the worries of judgment or limitations. In this expansive world, I take each step toward the mountains, where having a disability becomes as inconspicuous as a tree in a forest. Nature, much like my upbringing with my disabled pack, is a place where limitations fade and the unique beauty of individuality flourishes.

CHRISTOPHE ZAJAC-DENEK

ON THE DAY I WAS BORN, MY PARENTS received devastating news: I had been born with dwarfism. The doctor told them that I would never run, ride a bicycle, be physically active, or live a normal life. But being strong-willed protectors of their new son, my parents did not let this shock deter them from believing in me.

Dwarfism is a medical condition where a person's limbs are markedly shorter than average. In addition, other physical deformities and differences can impact people with dwarfism, specifically spinal curvatures like scoliosis and lordosis. In the United States, less than 1 percent of the population has dwarfism. Though the most common type

is achondroplasia, the kind I have is called cartilage-hair hypoplasia. I stand four feet, four inches tall. As a result of my rare condition, I needed two reconstructive leg surgeries and a spinal fusion before I turned eighteen.

More painful than the physical strains of our condition is the societal exclusion we experience. Little people are misunderstood in the average-height world. It can be confusing to think of someone as an adult when they have a body similar in size to a child. Some people even question whether skeletal dysplasia is a disability or not.

I've worked in the entertainment industry for my entire life and then started acting in 2009. After moving to Hollywood and being cast in many

productions, I realized that individuals with dwarfism are not seen as people in the entertainment industry. We are often relegated to roles such as elves, leprechauns, trolls, and other one-dimensional caricatures. We almost never play characters resembling people. This negative representation is damaging for my community. Perpetuating false stereotypes misleads those who don't understand dwarfism.

Surfing has changed how I believe in myself.

Living with dwarfism is a very personal and intimate experience, especially when it comes to dealing with the disorder's challenges. I have felt held back in so many ways throughout my life. But I have been determined to find the means to channel my limitations and the negative energy around me into something positive. Water has always brought me joy. I grew up in Michigan and often went to the Great Lakes and the ocean as a child. I learned that one thing I love to do is surf, so I modified my life and my ability so I could do it. When I am in the ocean and I catch a wave, I have this euphoric moment of standing on water. Suddenly, my height doesn't matter. My identity as a little person and a surfer means more to me now because I have overcome so much in the water. Surfing has changed how I believe in myself.

In the world of the outdoors, little people are forgotten. I almost never see short-statured people climbing a rock wall, riding a mountain bike, or surfing. Society believes we can't do these activities because they haven't seen it. My goal is to change that narrative and bring awareness and exposure to the exceptional people living with dwarfism.

Dwarfism makes me who I am, and I think that is ineffably beautiful.

DREW HULSEY & SARAH HULSEY

DREW AND I STARTED CLIMBING IN 2019 after he convinced me to watch *Free Solo,* a documentary about rock climber Alex Honnold's free solo climb of El Capitan in Yosemite National Park, making him the first person in the world to do so. My initial disinterest in the film was because, at that time, we weren't climbers, but something about this film was calling to Drew, so I went. Watching that movie in an IMAX theater had my heart racing and my palms sweating the entire time.

When it ended, Drew said, "I think I could climb."

I responded in astonishment, *"What the hell are you talking about?!"*

To appease his curiosity, Drew started searching: "Can fat people climb?" When nothing came up, he searched for "How much can ropes hold?" Yet there was still no information about whether fat people could climb. So Drew went to the local climbing gym to seek answers but found none. As his research continued, there were still no definitive answers. It felt like researching a new appliance; all the information was ambiguous and gave no affirmative corroborations—like Alex, we had to free solo our way through this.

In the early days of our newfound love of climbing, Drew would lurk on the climbing subreddit and try to figure out the language and terminology. One day, Drew posted a photo of himself at the top of the artificial rock wall in the gym, staring intently at the last couple of feet of the pitch. The caption read: "I got my 300 lbs self up the wall."

The post became the third most popular on the climbing Reddit thread, gaining over seventeen thousand upvotes, surpassing the post celebrating Alex Honnold's free solo that garnered around five thousand. This engagement came from Drew being seen as an everyday person, serving as an entry point to people who might think they cannot climb because of their body shape or size. As he started receiving messages from strangers expressing their interest in the sport, the desire for body inclusivity in climbing became apparent—people wanted to know that fat people can do this too.

> Showing people that we are not full-time elite athletes gives others a point of entry to outdoor sports that feels accessible.

Of course, the internet wouldn't be the internet without the trolls offering backhanded sympathies about our health or giving their two cents about our weight. The first two years of climbing proved difficult for Drew. The anonymous internet comments led to a self-deprecating inner dialogue and comparing himself to elite-level athletes. Feeling overwhelmed, he even had a few panic attacks at the climbing gym.

I have minimized my time climbing at the gym because the culture or people's judgmental gazes

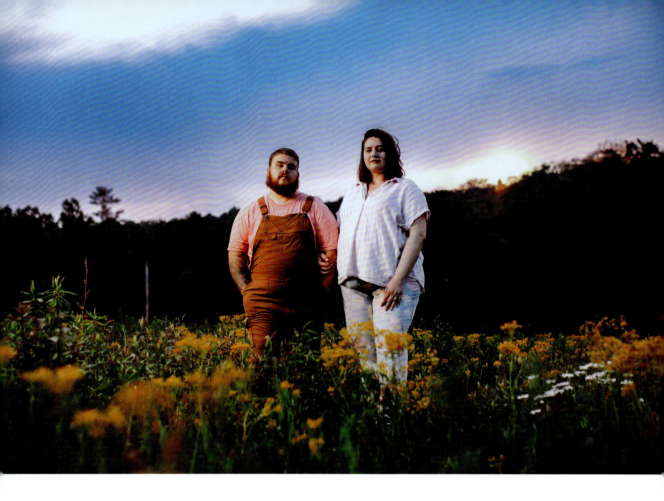

can be deterring. However, I remember those early days when we didn't see anyone else who looked like us, and that keeps me going back to climbing. Showing people that we are not full-time elite athletes gives others a point of entry to outdoor sports that feels accessible.

Now, we see more body diversity when we go to climbing events. People sometimes recognize and thank us for sharing our story. Our Climbing Is for Everybody clinics have all types of bodies, ages, genders, and sexualities participating, and they sell out every time. Some people will be in bigger bodies their entire life or don't climb for weight loss. People should be free to climb for joy and not fitness if they so choose.

With social media algorithms becoming more complex, it's easy to feel we are not impacting the climbing community via the internet like we did initially. However, we can now connect with others who look like us through in-person community engagement and events. Representation is essential to people who have felt excluded from this industry. Our endeavor is worthwhile if we inspire even one person to go outside, reach new heights, and discover a passion for the vast, vertical world.

CAZIAH FRANKLIN

IN FOURTH GRADE, I LOVED COLORING despite my lack of skill in art. One day in class, I recall choosing a crayon labeled "flesh," with a fair tone, reflective of a Caucasian skin color. The brown crayon was called "brown," and the black one was labeled "black." Eventually, Crayola discontinued the "flesh"-colored crayon, renaming it to "peach." Even at nine, I could sense that this crayon symbolized a societal assertion that white skin was "normal."

Growing up, I grappled with a narrative that seemed to define "standard" and "other." My fascination with Jeeps started at around the age when my parents began to let me use the internet. But when I watched camping and overlanding videos, I didn't see anyone who looked like me. This persisted as I attended a predominantly white private school in Fort Worth, Texas, where I continued to feel outside of the norm.

Every summer, from the time I was in second grade until my teens, I attended the same camp in east Texas. We did all the regular outdoor challenges like climbing a rock wall or team canoeing. Kids from all corners of Texas attended this camp, but again, I was usually the only Black kid. I didn't possess the language for my feelings then, but I felt the dependent relationship between performance and acceptance.

Being a good teammate made kids want to talk to me, but that made it feel almost like I had something to prove; I couldn't just relish the activities we were doing outside.

When I moved to Tennessee for college, that's where I began exploring my interest in the outdoors on my own terms. It felt like a playground for my passion to roam free with accessibility to the Smokies, Chattanooga, and Kentucky. However, my first year of college coincided with the onset of the pandemic, leading to the dismissal of all students. Back in Texas, during the seemingly endless lockdown, I decided to investigate why I wasn't seeing other Black and Brown faces in my time outdoors. Even in Tennessee, I couldn't find anyone who looked like me.

As I delved into the complexities of the civil rights movement, I uncovered how racism created profound barriers within urban society and hindered access to nature. Jim Crow laws didn't just impact segregated spaces in terms of dining or transportation services; they also exerted their influence on outdoor areas. Up until 1963, national and state parks, as well as public swimming areas, barred Black and Brown individuals from entry. Segregation and exclusion were ingrained in the nation's federal system and broadcasted that we were unwelcome in those spaces. The historical context of outdoor

> Embracing our differences can transcend racial boundaries and challenge the exclusion of people beyond those who look like me in the future.

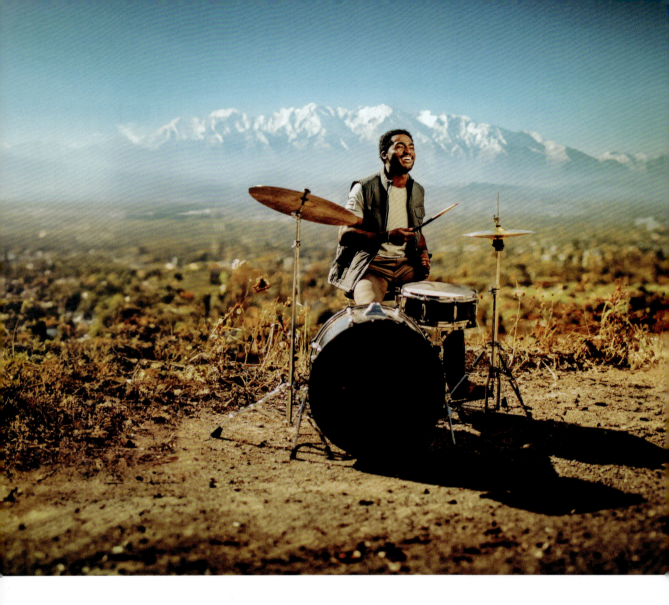

access became the driving force behind all my endeavors in nature. Upon returning to school, I explored various methods within my community to promote education without passing judgment on individuals who might need to be apprised of the dark past of outdoor recreation.

When presented in a harsh light, history can condemn rather than heal. In acknowledging the past, we can have deeper conversations to help rewrite Black and Brown ventures in nature, where I envision the diverse hues of crayons as catalysts for change and representation. Embracing our differences can transcend racial boundaries and challenge the exclusion of people beyond those who look like me in the future. Only then can humanity create an outdoors reminiscent of that Crayola box, where every color is the standard for coloring the page of inclusion.

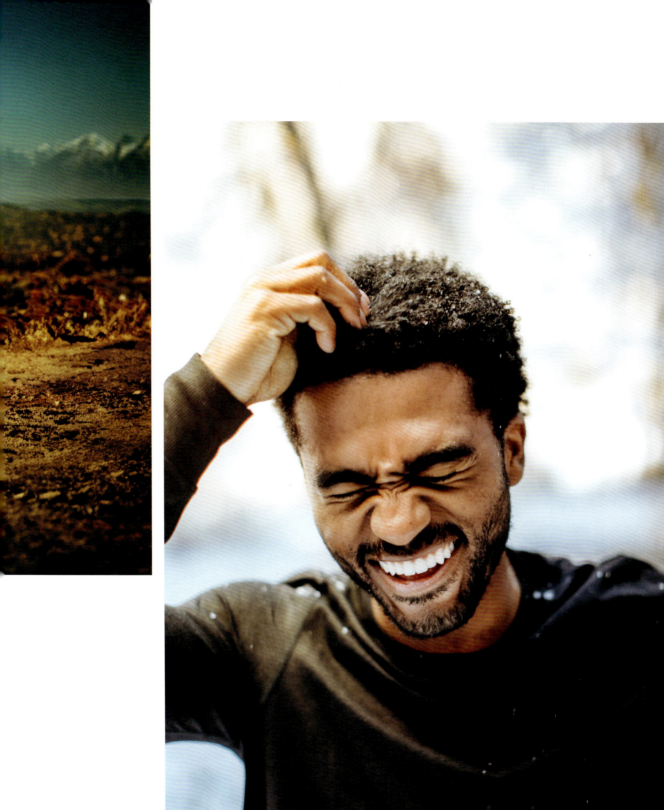

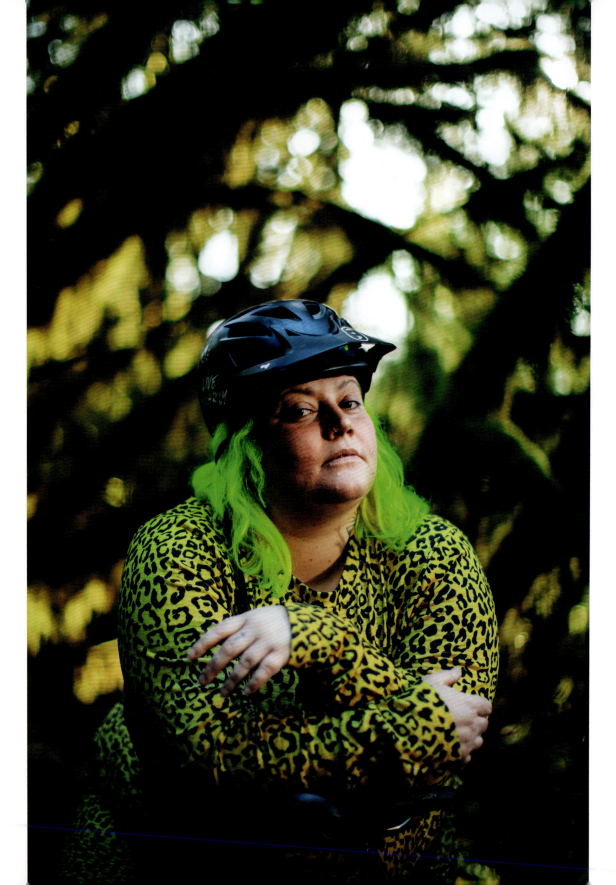

ASHLEY DUFFUS

IN MY EARLY TWENTIES, I WAS BUYING GEAR for winter when I realized that none of my ski pants fit. Searching for new pants became disheartening when I realized none of the stores had anything for my body type. I had a stereotypical Pacific Northwest upbringing, and skiing was my entire life. Not having access to gear that fit correctly felt like I was being forced out of the sport. I figured that if my body didn't fit, *I* didn't fit.

I got depressed, which led to my gaining more weight. I stopped being active and didn't participate in outdoor sports for almost five years. I remember a couple of summers after I stopped skiing. I went to the lake once over the entire season, the highlight of my year. I couldn't believe how I went from someone who was outside all the time, worked at outdoor retailers, and guided and skied a hundred days a year to doing absolutely nothing.

I was a very active kid. I backcountry skied, whitewater rafted, swam competitively for six years, and would bike commute to swim practice. But as early as the third grade, I wanted to run cross-country, and the answer I received was, "No, you don't have the body for that." Hearing adults tell me I needed to watch what I ate or that I was on the higher end of the weight range for my age group reinforced in my young mind that my body was *bad*.

After several years, finally fed up with not participating in any sports or even just being outside, I bought a mountain bike and started riding again. Even though outdoor sports had been such a big part of my identity, I was apprehensive about it. Personal and societal narratives told me I was too heavy or that I might put too much stress on the components, and the bike could break. But I had to try, regardless. On that first ride back, I made it two miles before I broke down and cried.

It wasn't until my early thirties that I began to garner some confidence. I knew I cared about sports, being active, and the outdoors, but I never saw anyone with my body type in sports or outdoor publications. Growing up without that representation convinced me I was unworthy of what I wanted to pursue. That mentality permeated beyond just sports, keeping me from jobs I wanted and relationships I desired to explore.

When I opened Cosmic Dirt, my body-inclusive outdoor apparel company, I became more vocal about how I felt about body marginalization. Beyond retail, my company acts as an umbrella for organizing community events and yelling about inclusivity. We collaborate with diverse artists to design apparel and donate some of our sales to girls' cycling programs and nonprofits like the Trevor Project. My mission

> Nature is the place where I can get my brain to shut off for a while.

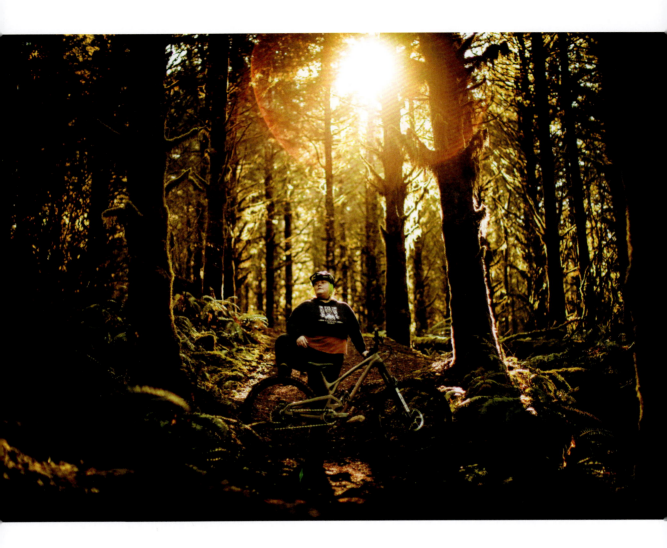

is to do everything I can to take all aspects of cycling and make them as inclusive as possible.

 I love the adrenaline of mountain biking when gravity pulls my tires back down toward the earth and I can soar through the trails. Nature is the place where I can get my brain to shut off for a while. Having access to the outdoors, whether through recreation or sport, is a human right. It gives us a better relationship with the world and the people who surround us. Bikes are an excellent tool for both exercise and exploring the natural world, and *every body* deserves that sense of adventure.

JOSE MENDEZ

I'M A DREAMER. NOT IN THE JOHN LENNON way—I'm an undocumented immigrant who was brought to the United States as a minor. I lived in the United States for most of my life without any legal status, which means I never really had a lot of access to the outdoors.

I had a very isolated and abusive childhood. I was never allowed to go outside because there was always a fear of cops or immigration officers coming to arrest us or take us away and send us back to a place we had never been before. As a result, I constantly spent my time indoors, daydreaming about being outside.

I didn't receive DACA, or Deferred Action for Childhood Arrivals, until I was twenty-six. DACA is essentially this weird limbo state where I could legally work in the United States and stay deprioritized from deportation while remaining undocumented and without legal status. After I got DACA status, I was legally able to get a job and afford everyday necessities. To deal with the trauma, fear, and depression I experienced as a child, I started going outside.

In the beginning, I would run laps around my neighborhood in Oakland. From there, I started expanding outward more and more. Eventually, I got really into trail running and ultra running. When that wasn't enough, I started spending more time backpacking and thru-hiking long-distance trails. Nature became how I processed my childhood and all the anxiety it brought up for me. I finally saw a lot of the world I couldn't explore when I was growing up.

Eventually, I became an outdoor guide because I wanted to help people with similar backgrounds have these outdoor experiences. I now teach people how to go climbing, kayaking, hiking, and backpacking. I'm grateful I get to share nature, adventure, and everything I wish I would've gotten to see growing up.

We don't see many Hispanic or Latino people outdoors because of high costs for gear, rentals, permits, and travel expenses. People say the outdoors is free, but the costs still add up if you think about all the backpacking, climbing, or camping gear you need to do outdoor activities. There's a significant wealth discrepancy between People of Color and their white counterparts, thus creating significant barriers to entry. Historically, we have never been told we can be in these spaces, or we're told it's not a part of our culture. Even within the Latino community, I have heard people say, "We don't do that" or "That's a white people thing."

Growing up as an undocumented immigrant I always felt very ashamed of who I am and where I

> **Nature became how I processed my childhood and all the anxiety it brought up for me. I finally saw a lot of the world I couldn't explore when I was growing up.**

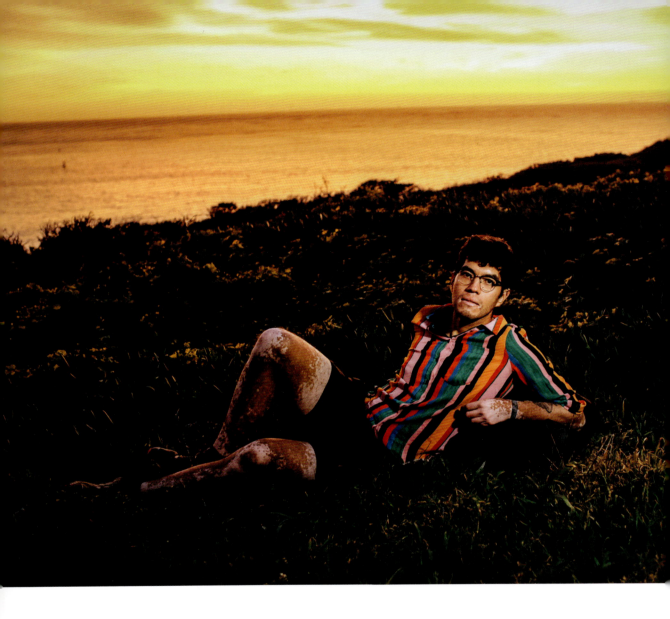

come from. That changed when I hiked the southbound Pacific Crest Trail and finished at the Southern Terminus, which sits on the border of Mexico.

It was a cathartic experience to finish this long, beautiful journey and end where I had come from: my home. I felt like I was reconnecting with my roots and this beautiful place I had never seen or experienced and was either told to be ashamed of or that I should "go back to" because I don't belong in America. Finishing the Pacific Crest Trail at the Mexican border made me realize I belong in these outdoor spaces and there is an innate love for nature in my blood that I should continue to run toward.

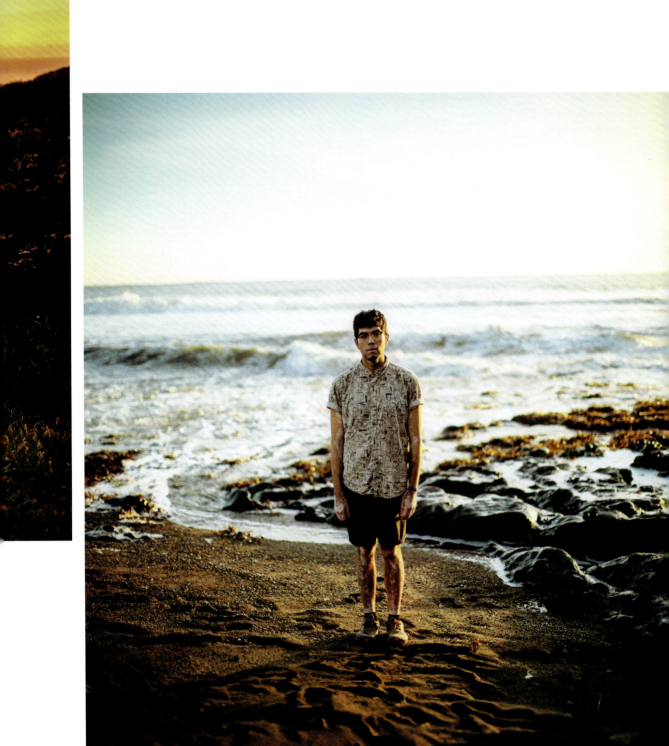

ERIN PARISI

MORE THAN A DECADE AGO, when I was climbing Mount Kilimanjaro, I was preparing to propose to my partner. She was a great athlete and had just done a marathon before our endeavor. However, she fell sick from the altitude at around fifteen thousand feet, very close to base camp, so she stayed back while I summited. After I descended, we evacuated her first thing the next morning, and I never popped the question.

We dated for a long time, but I had been having doubts about our relationship in terms of longevity. This was one of those moments where I was given a chance to stop, think, and reevaluate my decision before going down a detrimental road and further hiding my identity.

I grew up in a religious household where expressing gender nonconformity was unacceptable. When I would go to the library to research for homework (before the internet), I would also seek out affirming narratives, trying to find stories of people like me who had transitioned. While there is starting to be more language now about being trans, if you look back thousands of years, you'll find gender was divergent across time, societies, and cultures regardless of whether there were words for it.

Being trans has been like hiding in two closets. Before coming out, I hid in one closet to conceal my true identity, but once exposed, I wanted to run as fast as possible across the rooms to get into the next closet of passability so that no one could see me again. Being visible as trans for too long is dangerous. The dichotomy is that I wanted to be safe, but I also needed to be myself. I wasn't content hiding inside anymore; I wanted to be *outside*.

Nature and mountaineering are meditative places where I can discover myself holistically. I look at it from the perspective of Maslow's hierarchy. Nature is where you find your basic needs: fresh air, water, shelter, a fresh patch of berries. As you climb the pyramid, you can feel more secure and gain confidence in nature. Eventually, that leads to reflection, friendships, and a better mental state. Through nature, I was looking for even more than those basic needs. I was seeking transcendence.

Transcendence has meant different things at various stages of my life. The summits I have stood atop were there to scratch a different itch, whether that be self-fulfillment, personal growth, or giving the middle finger to those who have held me down. Nature became a place to transcend the narratives forced upon me.

Nature doesn't discriminate, but what does are the people and systems I must face to get from the

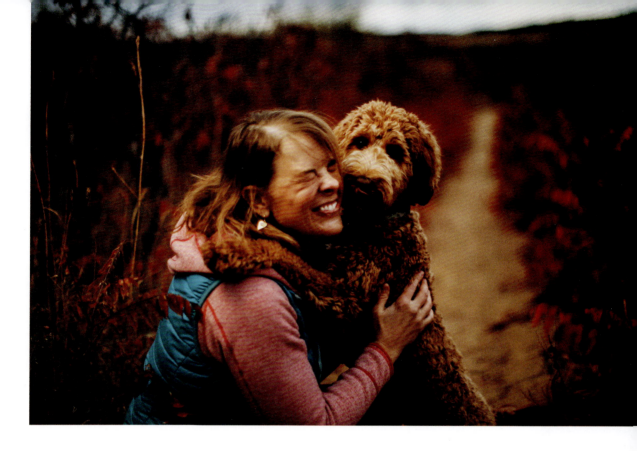

trailhead to the summit. Coming out to my family was more perilous than any risky climb I've ever endured. Finding health care to transition is inaccessible and dangerous. The time I got beat up outside of a restaurant in my hometown was life-threatening. Reaching the top of any mountain, even with the risk of hypothermia, heatstroke, dehydration, avalanches, rockslides, tripping, falling, or breaking a limb will never pose more danger than the real world.

Coming out to my family was more perilous than any risky climb I've ever endured.

There are five tiers to Maslow's hierarchy, the top being self-actualization: the desire to become the most that you can be. You need fresh air to breathe to take the next step to personal security. You need personal security to find love and relationships. That love you find will bring you self-esteem, leading you to the top of the pyramid. The higher I have climbed, the more driving those elements were to my identity.

Transitioning for me was in the lower tier of needs, along with food and water. Nature fulfilled those basic needs so that I could find confidence, so that I could have pride. Being on top of the mountain is the safest place I could ever be, and being up there means I can reach the sixth tier: *transcendence*.

JACK JONES

I WAS ADOPTED FROM LANZHOU, CHINA. MY father had gotten in trouble with the Communist government, so my parents wanted to get me out of China. My parents were university professors and through their contacts at the university had met a woman in Bolivar, Missouri, looking to adopt. At eight years old I was adopted and left behind every single person I knew in the world—my parents, my family, and my friends.

When I came to the United States, I thought the adults in my new life were the same people from my life in China. I thought my principal was the same principal, and my teacher was the same teacher, despite the fact that none of them looked remotely Chinese. It was a strange coping mechanism brought on by the drastic transition.

My traumatic adoption resulted in lifelong issues. The parts of me that made deep connections with people shut off completely. After I was adopted, I didn't cry. I didn't miss anyone. When I think back on it now, I know it's odd, but to survive, I had to harden my heart.

When I joined the army, my life felt chaotic. I didn't have a path. Thru-hiking was a way of finding a laid-out path that would hopefully build discipline, develop my mind, and help overcome that

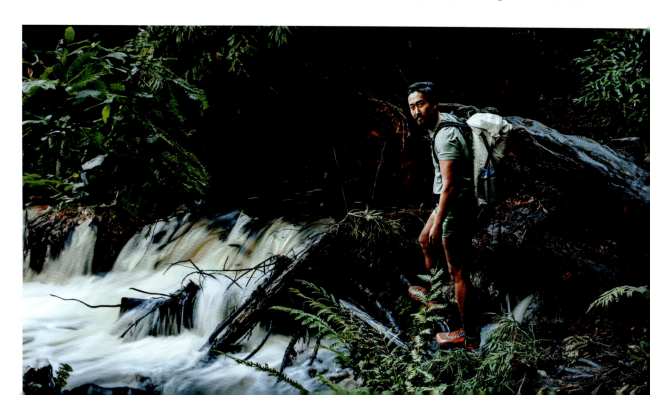

fear of connection to others. In 2020, I went on to be a firefighter. For a lot of my life before that, I had never felt a sense of being okay. Yet somehow I felt okay in the midst of fighting raging wildfires—because I wasn't alone.

It wasn't until my mid-twenties that I realized how much the adoption affected me. I always felt this need to be different or set myself apart from others. The need to do crazy things like thru-hiking—those are ways to put my isolation into an acceptable context. It's not weird to be alone when you're thru-hiking. Everyone else is in the same situation.

In 2022, I completed the Calendar Year Triple Crown, hiking the Appalachian, Continental Divide, and Pacific Crest Trails, all in one calendar

year. While it was nine and a half months of hiking every single day, I felt at peace for most of it. Spending that much time in nature changes you. Where does the water I take from the stream stop becoming the stream and start becoming me? You realize there is no actual boundary between yourself and nature. Nature breaks down those boundaries. The woods feel as comfortable as my living room.

When you're alone, you have to face all the dangers yourself. When you're with your community, there's a deep instinctual connection so tangible that it makes you feel safe. It reminds you that you're not alone in the wilderness.

The army, firefighting, and thru-hiking have interesting similarities in that they force you to spend time with people you might otherwise never connect with. My natural instinct is to be alone, but I've found this forced community to be extremely beneficial in overcoming my isolating tendencies and helping me to create real human connection.

I sometimes wonder why I couldn't have grown up with a "normal" family and not have problems connecting to people. At other points, I'm reminded that my story has given me the energy and motivation to do big things like the Calendar Year Triple Crown and has turned me into the person I am today. And my years of being in various communities, in nature, and around people who could express love and connection broke down the walls around my heart.

> **Nature breaks down those boundaries. The woods feel as comfortable as my living room.**

ZACHARY DARDEN

INDIANA HOLDS A SPECIAL PLACE IN MY heart, encompassing my love for my home state and the adventurous spirit of Indiana Jones. While the outdoors in Indiana was a constant in my life, my family would take a lot of trips to Tennessee, where my familial roots trace back to generations of ranching. When I was ten, one unforgettable vacation took us to Clingmans Dome, the highest point in the Smoky Mountains. While engaging with the park rangers conducting tours, I was captivated by their stories of exploring the mountains, roaming around in their work trucks, and discovering the depths of the lush forests of Appalachia. The idea of working in such an outdoor-centric profession lingered in my mind, sparking a childhood dream that eventually led me to become a park ranger and conservationist.

Returning home from that trip, my passion for nature found an unassuming yet meaningful symbol—a cowboy hat-like fedora inspired by the release of *Indiana Jones and the Kingdom of the Crystal Skull*. Putting on that hat made me feel invincible, like I could climb any tree, sail any ocean, or weather any storm. It instilled a sense of adventure, bravery, and deep appreciation for the places I would explore—much like Indiana Jones. Over time, it would become more than a fashion statement; instead, it was a staunch rebellion against racial stereotypes I eagerly wanted to disassociate with.

Throughout my teen years, I began to hide the nature-loving, adventure-seeking part of myself. The state of Indiana is primarily white, leaving me with this overwhelming sense of pressure to conform to racial expectations. I tried to fit in by

BEHIND THE SCENES

I found Zach through an Instagram account called @theblackparkrangerexperience a few years ago. I read his story about being a Black park ranger himself and thought it was really cool. I remember thinking, "I would love to photograph that guy someday."

Zach was so easy to work with and natural that I was surprised he'd never been photographed professionally before. I was fortunate enough to photograph him on his beautiful property forty-five minutes outside of Albuquerque, where I also met his partner, Brenda. Their land looks out at the Sandia Mountains, and it was adorned with beautiful desert cactuses, flowers, and wild horses (who made an appearance in the photos).

I found the purple blazer Zach wore at a thrift store in Albuquerque. When I said that I didn't have a dollar in cash to pay for it, the lady at the register said to me under her breath, "Fuck it, just take it."

Zach pulled it off effortlessly.

wearing the newest Jordans or listening to rap music, even though those things never truly resonated with me. My passion for the outdoors stayed concealed as my young mind created this erroneous idea that the only individuals worthy of wearing cowboy hats in the woods were white men. I knew deep down that my true self was that kid playing in the creek behind my parents' house in Indiana, fishing, building structures out of sticks with my brother, and exploring with that cowboy hat proudly atop my head.

It wasn't until I moved to New Mexico and embraced its diversity that I realized I didn't have to succumb to societal expectations, discovering the

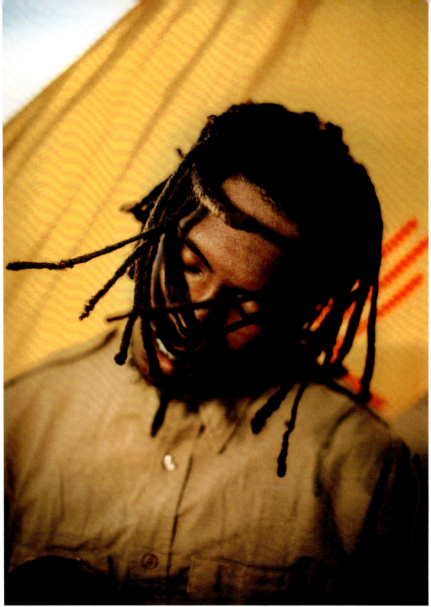

rich history of Black explorers of the region, like Esteban de Dorantes, reignited my curiosity of nature and my pride in being a Black outdoorsman. As my career segued from environmental education to conservation, my cowboy hat accompanied me into a new role as a natural resource specialist in New Mexico. My distinctive attire—with dreads and earrings as I coordinated events and trail work—set me apart from my white counterparts, who were usually twice my age. Stereotypes fueled conversations about basketball games or the newest Drake album with people who never inquired about my deep-seated passion for making change or leaving my mark.

ZACHARY DARDEN | 255

My dad always told me to leave things better than I found them, and those words have become my career ethos, hoping to change the narrative that conservation roles belong exclusively to white folks.

My dad always told me to leave things better than I found them, and those words have become my career ethos, hoping to change the narrative that conservation roles belong exclusively to white folks. A wealth of knowledge exists in human diversity. By giving everyone a seat at the table, we can inspire innovative methods, traditional practices, and a deep connection to the land—lessons that are so culturally profound that no four-year university can teach them.

My position in conservation has become more than a career—rather, it is a mission to challenge stereotypes and encourage more diversity in outdoor professions. Once a symbol of rebellion, over the years my cowboy hat has transformed into a beacon of representation both professionally and personally, showing that there is no one race or color more deserving of the wide-brimmed beauty of nature.

Changemakers

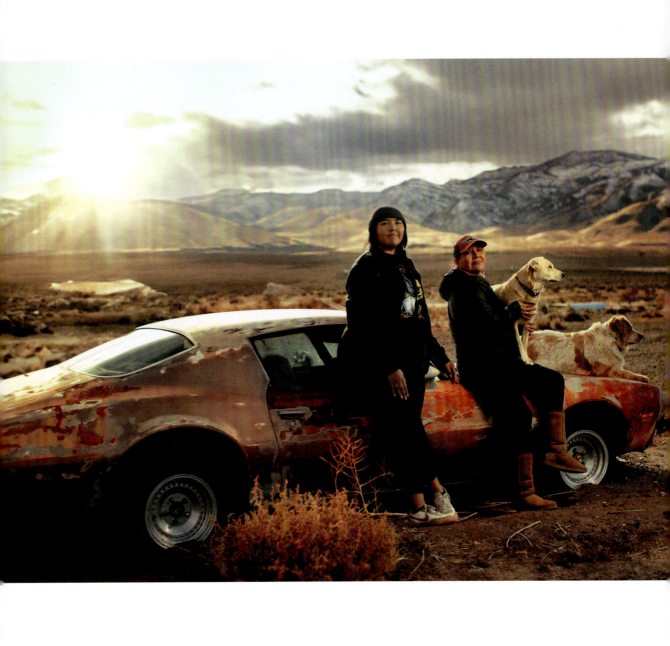

BEVERLY HARRY & AUTUMN HARRY

THE ACRONYM "BIPOC" means "Black, Indigenous, and People of Color." It is a common misconception that BIPOC categorizes everyone who isn't white under one unified community. However, Black people have their own unique cultures and concerns, and "People of Color" encompasses diverse groups, including Asians, Latinos, and Pacific Islanders. It is also crucial to recognize that Indigenous people face distinct battles, like settler violence against them and their lands. By calling them out specifically in this term, we honor their resilience, their intrinsic connections to the earth, and the environmental protections they have continued to provide throughout history.

Beverly and Autumn Harry, hailing from Cui-ui Panunadu (Pyramid Lake, Nevada), share a deep connection to their community and its environmental challenges. Growing up on the lake reservation at the terminus of the Cherokee River watershed, they witness the impact of upstream pollution and the consequences of climate change, including a current drought. The mother-daughter duo, driven by a commitment to river justice, addresses the accumulation of pollutants affecting fish species vital to their people's heritage. With an emphasis on protecting the fish and, by extension, their community, they lead cleanup efforts, tackling issues stemming from colonization and governmental inaction.

Beverly Harry, who is Navajo, reflects on the transformative discussions during the pandemic that brought her closer to her late husband, Norm, and her daughter, Autumn. The pandemic provided an opportunity for introspection, leading to the realization that the sensitive lake was vulnerable to upstream impacts. Inspired by Norm's leadership and guided by their combined expertise in water rights and analysis, Beverly and Autumn initiated cleanup efforts along the river, addressing environmental concerns and broader social issues. They aim to sustain Norm's legacy through their actions, fostering inspiration within their community and beyond and advocating for a collective responsibility toward environmental stewardship.

AUTUMN HARRY

Indigenous people shouldn't have to pick up other people's trash. That's not a long-term solution, but it's something that's needed at the moment because we're not seeing anything else being done about it.

My mom, once she met my dad, moved here to Pyramid Lake, and she's been a part of this community for more than three decades. She's done a lot

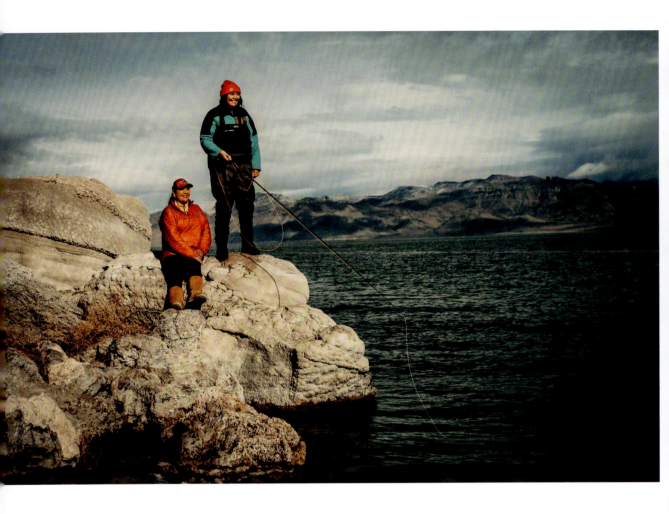

working for the Tribe, and all of the time she's been working at the fisheries while also helping develop the water quality standards that we currently have. My dad in his different leadership roles was able to help regain our water rights for Pyramid Lake. We've been doing this for a long, long time. Ever since I was young, I have been dedicated to the fish and doing what I can to protect them.

With the three of us, education is such a huge focus of our work. Indigenous peoples have been removed. There has been a lot of erasure of Indigenous peoples that continues to happen. And because of that, we're experiencing many of these issues. Our role is to remind folks that our people are still connected to these lands and that our communities continue to survive within our original homelands. We're still very much a part of these lands.

THE HISTORY OF violence against Indigenous communities dates back to the arrival of settlers on Turtle Island. Unfortunately, violence persists today against Indigenous women, who lack adequate protections, even long after colonization.

Tragically, Amanda Davis, Beverly's niece and Autumn's cousin, fell victim to murder on December 15, 2020. As an integral part of the Pyramid Lake community, Amanda, who was eight months pregnant with her unborn son, Ezra, became a heartbreaking example of the ongoing atrocities faced by Indigenous communities.

BEVERLY HARRY

People are not sensitized to the cultural traditions of Indigenous people. They don't even know about Indigenous people. They've been taught the wrong things within their history. All they know is their own color and narrative, and the narrative they follow is false. It romanticizes the killing and the violence toward the people and the land.

Our society has ignored some of these problems in the past. There's been violence within our

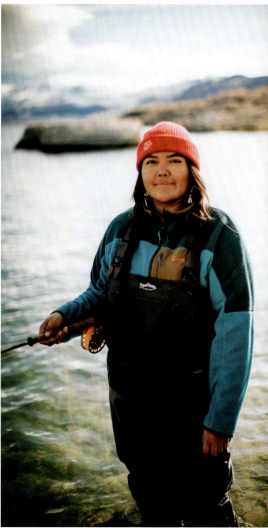

communities for a long time. Some of this violence we learn to accept, like when a Native person goes missing, and the growing problem of the impacts on the land and water.

It's ignored because we have been treated as less human. But what I know and believe is that Native people are directly connected to these lands, and they have an amazing compassion and a great sensitivity toward the land. And that's how the environmental movement came about. And I think that's how the missing and murdered Indigenous women issue came about. It was fighting against these injustices that have happened throughout settler history.

———

BEVERLY AND AUTUMN share a deep connection with the earth, rooted in their Indigenous heritage. For them, this bond goes beyond a spiritual connection; it's a daily, natural rhythm of life. They observe the land, tracking changes and preserving memories of its evolution over time. The rejuvenation of each season becomes a profound experience, influencing everything from snowfall in the Sierra Nevada to the quality of water and the spawning of fish.

Our role is to remind folks that our people are still connected to these lands and that our communities continue to survive within our original homelands. We're still very much a part of these lands.

Autumn, in particular, finds solace and a sense of self when she's at the lake, surrounded by her homelands. Fishing for trout, a practice handed down through generations, instills in her a deep appreciation for the love and care her ancestors invested in the environment. The desert, often overlooked for its perceived lack of greenery, holds a unique beauty for Autumn. It's her home, and she feels responsible for ensuring its water sustains future generations.

Both Beverly and Autumn emphasize their roles as caretakers of the land. They consider it an inherent responsibility, not just a spiritual connection. The idea of being stewards for the earth and ensuring its health for future generations is a duty they hold dear. In their reflections, there's a powerful recognition that their Indigenous identities are intertwined with the land, shaping their perspectives and fueling their commitment to preserving its vitality.

As Indigenous people, they are part of the land, for it is their relative. The water is their family. The air is their kin. Nature is their ancestor—and they are its protectors. And this is why it's important to distinguish why the "I" in BIPOC stands alone.

262 | ALL HUMANS OUTSIDE

JOE STONE

MANY YEARS AGO, WHILE I WAS LIVING IN Montana, I discovered speed flying, an advanced discipline close to paragliding that uses a small, high-performance flexible wing to quickly descend from heights. Just thirty days after wrapping up my training, a solo session on Mount Jumbo in Missoula took a tragic turn. I decided to try barrel rolls, teaching myself without any mentors, but that led to critical errors, resulting in a wing collapse and a rapid descent. I was severely injured from the impact: I had broken ribs, a lacerated liver, eight broken vertebrae, and spinal cord damage that ultimately made me an incomplete C7 quadriplegic.

I dedicated myself to regaining independence and strength. My initial goal was to achieve basic self-care within a year—getting up, dressing, showering, and cooking. Despite being told it usually takes two to four years to reach that point, I was determined to prove everyone wrong. Breaking down each goal into smaller, manageable steps, I reached independence within seven months. However, even with these accomplishments, I still felt unhappy.

Searching for a new purpose, I explored adaptive sports and stumbled upon hand cycling. Inspired by the lack of big mountain passes conquered by people at my level of injury, I set a goal to hand cycle the Going-to-the-Sun Road in Glacier National Park within a year of my accident. After three months of intense training and determination, I achieved the feat of cycling fifty miles and climbing Logan Pass. This experience opened my mind to endless possibilities and fueled my curiosity for more adventurous pursuits. Over the next few years, I continued to push my limits, embracing outdoor challenges and constantly striving for independence and wonder again.

Eventually, I returned to Missoula, Montana, to train for an Ironman triathlon. During that time, a paragliding instructor Chris Santacroce from Project Airtime contacted me and offered to get me back in the air. The experience was nerve-wracking as I prepared for an activity inextricably linked to my injury. Despite taking a tandem flight initially, my ultimate goal was to fly solo. At Point of the Mountain in Draper, Utah, I was greeted by the sight of paragliders in the air. The moment arrived unexpectedly, and as the wing lifted above me, fear gave way to presence. In the air, I realized how inclusive paragliding is—a stark contrast to other adaptive activities. Flying became a powerful symbol of equality, erasing the difference between me and others, a feeling I hadn't experienced in four years of using a wheelchair.

> The allure lies not just in adrenaline but also in the profound sense of community, shared goals, and personal growth that these pursuits bring.

In pursuing inclusion, I encountered a major roadblock when I decided to participate in the Missoula Marathon. Shockingly, they outright denied wheelchair athletes from competing, citing safety concerns and dismissing the possibility of accommodating people with disabilities. I took matters into my own hands, reaching out to race organizers with the optimism that we could collaboratively find solutions. They met my efforts with resistance, maintaining their stance that it was too risky. Undeterred, I sought guidance from other races and suggested solutions, yet every offer was rejected.

After a year of unproductive meetings, I decided to bring public attention to the issue. An article in the *Missoulian* stirred the pot, prompting inquiries about the exclusionary policy. Faced with impending public scrutiny, they hastily announced, just two weeks before the 2014 race, that they would allow wheelchair athletes. However, their begrudging decision came with restrictive conditions and discriminatory language. Refusing to register under such terms, I ran the race without officially registering to prove my point, which led to a legal battle over discrimination against people with disabilities.

A human rights investigation eventually vindicated our claim, declaring their actions discriminatory. As the issue headed toward litigation, they played dirty with an offer of judgment, seeking to shift the burden of potential legal fees onto me. Recognizing the financial risks, we reached a settlement that covered attorney fees and brought attention to the discriminatory practices of race organizers. The experience ignited a national conversation on the rights of people with disabilities in races and offered a blueprint for others facing similar battles. Today, I'm proud that the fight against discrimination in races continues, with individuals using the tools and documentation from my journey to challenge exclusion in their respective communities.

Facing discrimination of this magnitude was a transformative experience for me. Until then, I had never felt the blunt force of someone saying, "You're not allowed here." The visceral impact of being told I didn't belong was a revelation; I had never truly understood the emotional weight of being excluded. Determined to challenge this, I immersed myself in disability rights advocacy, meeting inspiring activists who mentored me. The journey

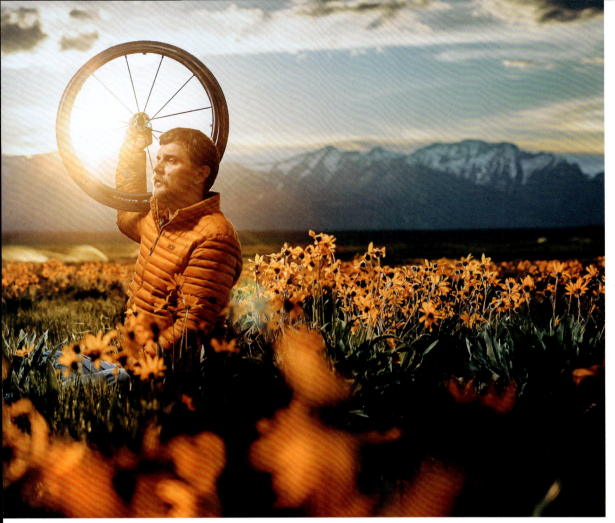
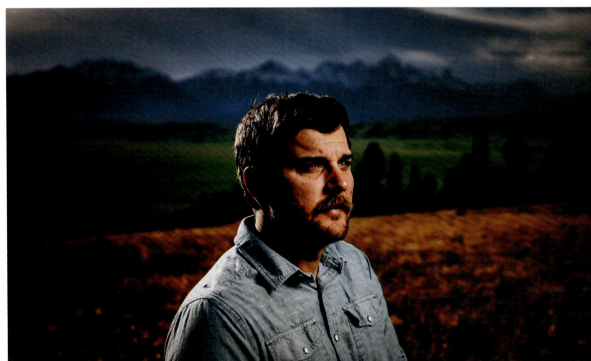

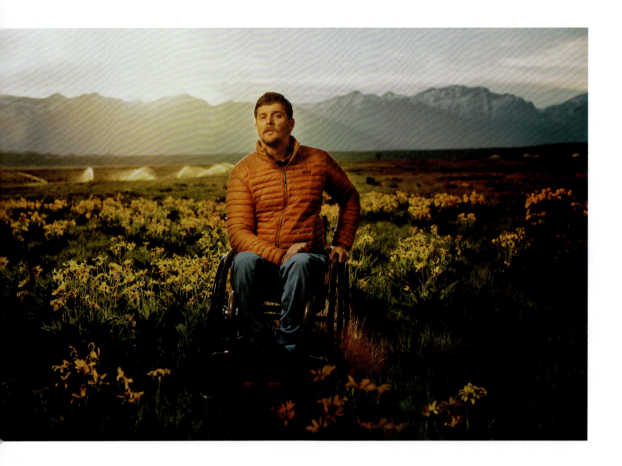

expanded my perspective on the broader challenges within the disability community. It connected me with movements like ADAPT, which was the driving force to get the Americans with Disabilities Act passed in 1990. This experience fueled my commitment to creating access to the outdoors for all people with disabilities.

 Nature holds immense meaning for me—it's a realm where I find unparalleled calm, unremitting endurance, and heightened presence. Engaging in higher-risk activities provides a unique depth of experience and teaches me about my physical and mental capabilities. The allure lies not just in adrenaline but also in the profound sense of community, shared goals, and personal growth that these pursuits bring. The risks, I've realized, are a small price to pay for the invaluable rewards of being immersed in the beauty and challenges of the outdoors. Moreover, it has fueled my passion for advocacy, stressing the need to ensure that everyone, disabled or not, has unfettered access to the wonders of the outdoors.

ZELZIN AKETZALLI

OUTDOOR RECREATION IN MEXICO IS QUITE different than in the United States because your access to nature depends on social stratification. People in Mexico who go outside for fun, recreation, or sports have the money to do so. We have huge mountains back home, but buying the gear to go mountaineering could take years to accumulate in pesos. Here in the United States, saving up for a new pair of boots or a backpack might only take me a week because one American dollar is nineteen times the money I'd make in pesos.

We have a saying in Mexico, *¡Chíngale!* which means "work hard." Work, work, work hard until you have it. When I was eleven, I started working in the stands (market stalls and street vendors) in Mexico City because my family couldn't afford my education. The Mexican people are very hardworking, and most of us hike through the mountains to get to work or get home; we do it out of necessity, out of survival—not recreation.

I grew up in a bad neighborhood riddled with drugs and alcohol. It was challenging to stay on the correct path while surrounded by constant crime and substance abuse. However, my parents taught me good values yet still gave me the independence to choose which path to take. A big lesson I learned from growing up in the slums is that you don't need

> I knew I had to share these mountains with more Mexicans and Latinos like me. I needed to bring my people to the mountains.

to care about what other people say about you; you just need to *¡Chíngale!*

My father taught me various sports and how to be a strong, independent woman. However, he never told me about mountaineering—I think because he was trying to protect me. I learned after I decided to hike the Pacific Crest Trail that my dad had the opportunity to climb Mount Everest when he was young. I am not sure why, but he ended up not going, and the two friends who did go never made it back. Regardless, I'm grateful my dad allowed me to be my own person and not conform to the expectations of women in Mexico—that motivated me to explore.

Until I came to America to thru-hike the Pacific Crest Trail, I had never hiked or backpacked. Thru-hiking inspired me to bring back what I had discovered about myself in the mountains. It became my life's purpose to bring open access and trails to Mexico. Having unrestricted access to nature requires little to no money. You don't need to pay for a tour guide to explore or a gym to exercise, which allows everyone to have a more affordable and better life.

The outdoors in Mexico can be very dangerous, less because of terrain and wildlife and more because of crime. For how hard the Mexican people work, they deserve more open space, more

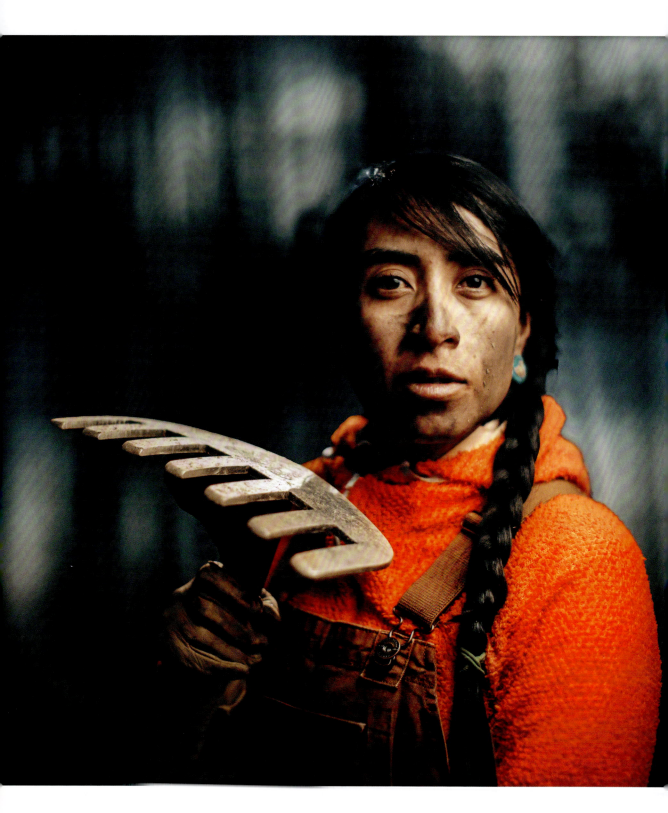

recreation, and safe spaces to roam freely. They deserve healthy minds and hearts. That's why when I go back home I build trails. I am not afraid of the dangers—I am more fearful of my silence. I want to share the love and knowledge of nature that has enriched my life with my people, so I work hard to ensure everyone has access, despite the risks.

When we are children, many of us dream of what we want to be when we grow up. In my case, I never found or dreamed of I wanted to be, because I didn't know about long-distance hiking. I'm sure many people have not yet found what they are passionate about in life. Maybe it's because they have not dared to find it.

When I finished the Triple Crown in 2019, I became the first known Mexican person to hike all three long-distance trails in the United States. It gave me a feeling of pride and great satisfaction. I had done something no Mexican had ever achieved. However, I had an experience and passion that didn't deserve to be only in my memories. When I see the mountains, something calls to me, telling me I need to go to there. I knew I had to share these mountains with more Mexicans and Latinos like me. I needed to bring my people to the mountains. At that moment, at the end of the Continental Divide Trail, my greatest challenge began. It was time to *¡Chíngale!*

HECTOR RAFAEL

AS A KID, I HAD THIS INSATIABLE CURIOSITY not just to get out and explore nature but also to leave it better than I found it. I grew up in Springfield, Massachusetts, with my sister in a single-parent household. My mother instilled in us the importance of zero-waste living, meaning on the rare occasion that there was excess food, it was either put into the garden or someone's mouth. Wasting food wasn't a luxury we could afford.

Nothing went to waste in our family. Our fruit and vegetable scraps found purpose nourishing the garden or forming compost. Wasting meat was especially frowned upon in our house, because we acknowledged the life that was sacrificed for our sustenance. *Pegao* is a Spanish word meaning "stuck" and can refer to the burnt rice that sticks to the bottom of the pot. To many cultures, especially my Puerto Rican family, this is considered a delicacy. My zero-waste upbringing instilled a mindful approach to food waste and a profound respect for its use beyond consumption, inspiring further sustainable practices.

My grandfather, originally from Puerto Rico, owned a grocery store in Holyoke, Massachusetts. As a kid, I spent a lot of time running around the nearby park and alleyway behind his store. The familiarity of these spaces created a sense of home and responsibility to preserve their cleanliness, landing me the nickname "Hector, Inspector, the Garbage Collector." It felt like second nature, a trait influenced by my grandfather's knack for salvaging and breathing new life into unwanted items. This ethos continued into my adult life, where even during hikes, I couldn't resist the urge to clean up the trails I was on. My commitment to responsible waste disposal became a mission encapsulated in my reusable bags, transforming every outing into a garbage-collecting adventure.

While living in Wyoming, I grappled with my presence in my small new community, wanting to abstain from being a resource consumer. Eager to contribute, I managed a compost pile on my land, with my neighbor soon joining and turning my efforts into a community activity.

With my passion for the outdoors and sustainability growing, I left Wyoming in 2020 and started a food collecting and compost service in the greater Salt Lake area. Inspired by various terms associated with people from Vermont, like "granola" or "earthy," I brainstormed synonyms, eventually settling on my own sassier phrase, "Earthie Crunchie." This initiative defined my purpose and

commitment to fostering sustainable practices and community engagement in my new home.

Composting is an easy and essential way to repurpose food scraps by taking something that may no longer be serving you and repurposing it into vitamins and nutrients for the future growth of the soil. When we introduce food waste into landfills, it's anaerobic (deprived of oxygen). That turns

Growing up in the hood, I endured the challenge of living in a place where waste blended with the surroundings; because of that, I am compelled to advocate for change.

into methane gas, one of the leading greenhouse gases warming our planet.

Various composting methods involve digesters to capture methane gas and convert it into energy. True composting occurs in an oxygen-rich environment where nutrients break down and turn into soil. It's a natural fertilizer. The significant advantage of these methods is we stop relying on the oil and gas industry for commercial-grade fertilizers to grow our crops. Instead, we're using ingredients that once had life to introduce new energy into the soil. It's a way to reuse, repurpose, and reduce our environmental impact by reducing waste sent to landfills.

Growing up in the hood, I endured the challenge of living in a place where waste blended with the surroundings; because of that, I am compelled to advocate for change. If we want to protect Mother Nature and keep it the beautifully sustainable haven it always has been, the first step begins in our own backyard.

In the face of our planet's fate, composting is a crucial practice for a sustainable future. Whether it's through home composting, a composting concierge service, or the alleyway behind Grandpa's grocery store, every tiny effort contributes to protecting our planet and leaving it better for generations to come.

CHEV DIXON

I'VE NEVER REGRETTED WALKING AWAY from a bad situation. For me, the real challenge isn't physical—it's more about navigating the emotional and spiritual side of things. It's about learning to respond to hate with love, finding my way through systems that sometimes feel indifferent or harsh, and trying to show compassion even when it doesn't come back to me. Those are the battles I focus on, and they've taught me more than any other kind of fight ever could.

Kids always fight over basketball, especially in the hood in Yonkers, where my family immigrated to from Jamaica when I was thirteen. In one particular game, I beat another kid on the court, and my laughter provoked him to pull a knife on me. This young kid, about my age, followed gang members and wanted to be like them. When he pulled out the knife, some men in their late twenties stood there and laughed. I realized then that I couldn't be in that environment because no one would protect me; there were no leaders to stand up to those who wanted to start trouble or cause harm.

Following the incident, my core friend group and I decided we wouldn't play basketball any-

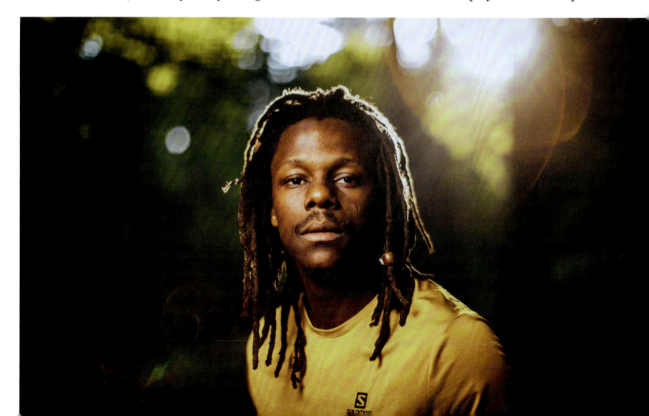

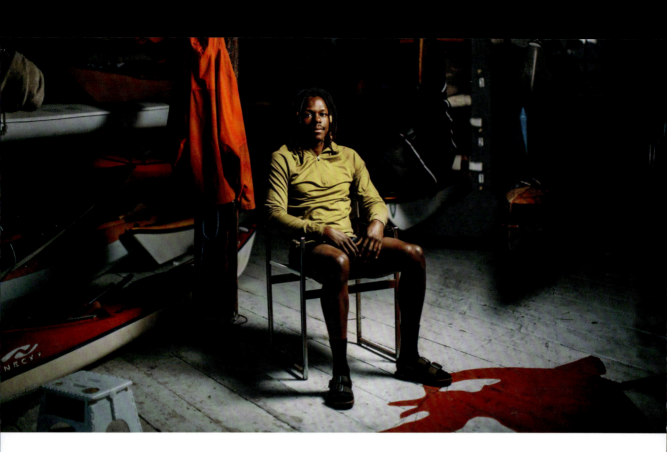

more. Instead, we would hang out by the Hudson River and stare at the Palisades. Inadvertently, we noticed we were next to a kayaking club when we saw a bunch of kayaks on the shore. Out of nowhere, a man asked us if we wanted free kayaking lessons, to which we said yes. His name was Jerry Blackstone, founder of Hudson River Riders, and he became a good friend and mentor to me (God rest his soul). That's how I started kayaking.

The ethos behind Hudson River Riders is to educate local youth on the water and teach them essential paddling and safety skills. Our program offers free kayak tours and race training, emphasizing environmental education.

Nature is diverse. Every tree looks and feels different, yet they all contribute to the ecosystem and make the oxygen we breathe. That's the beauty of community.

An essential part of this kayaking community is the mix of socioeconomic backgrounds these kids come from. We have kids from the hood and the suburbs who enjoy our program. It's powerful seeing young people interacting with others who have different ideas, lifestyles, spiritualities, and cultures. To excel as a society, we need to first develop understanding and compassion for each other, and that's what I teach these kids through kayaking.

Nature is diverse. Every tree looks and feels different, yet they all contribute to the ecosystem and make the oxygen we breathe. That's the beauty

of community. When you bring people from different backgrounds together and allow them to interact with one another, they all grow.

Beyond access, I want to show kids that there are different ways to go about life. I want them to discover who they are through nature. I want to make sure that when they get into the real world that they don't discriminate, that they can listen to others and show love. I hope they will know how to find peaceful solitude through their early exposure to the outdoors. My program is meant to serve by nurturing these kids into their future.

When I was a kid and got into an argument at school in Jamaica, my teacher took both of us outside and dealt with us accordingly. Although I was in trouble, I felt safe in that environment because someone looked out for us, even during a challenging moment. When your back is against the wall and no one is supportive or promoting peace, it breaks your heart.

That's why I try to be a leader and help as many kids as I can to help them feel safe and supported—the same way I was.

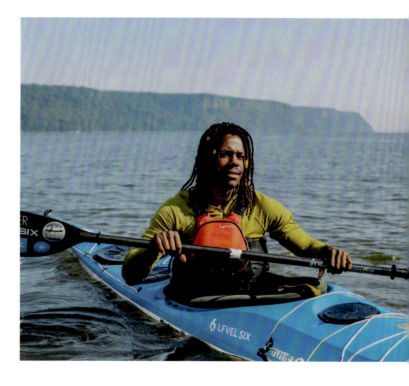

It's okay to walk away from things that aren't serving you. Suppose you search through every crevice and every corner of where a situation might lead you, and it doesn't lead to you becoming a better person with a more significant impact on society and community. Why are you there then? That is the question I raise with my students. I want to provide a space for these kids to show them that it's OK to walk away from negative environments. However, we need to be there for them when they do decide to walk away.

Our world needs new ideas and strong leadership. That will not come from a homogeneous group of complicit people. Big ideas come from all of us creatively putting our minds together for the greater good. We need to share nature because we all bring a unique perspective. The more diverse voices we have, the bigger the philosophy, the bigger the opportunities, and the greater we can be as humans, for the earth and each other.

LEO CHAN GASKINS

MY PASSION FOR CONSERVATION WORK comes from a lifelong love and appreciation for nature. As a transgender Person of Color, field ecologist, and avid birder, I have developed a special relationship with the outdoors.

When I first transitioned during my PhD program, I was living in rural North Carolina. Navigating everyday tasks like grocery shopping, working out at the gym, or going to the urgent care doctor were challenging and emotionally draining. I was often misgendered, felt uncomfortable in my own body, and was not always sure what spaces were safe to be out in. However, when I was in nature conducting fieldwork or bird-watching, that pressure washed away. The outdoors was a respite and a mental health lifeline; observing birds gave me a deep sense of peace and joy. As a result, I'm deeply passionate about not only researching and conserving the animals and outdoor spaces that have acted as a sanctuary for me but also working to make science and the outdoors safe for other marginalized people.

As a community ecologist, I study ecosystem engineers, animals that influence and shape their environments significantly, often through consumption or indirectly through changing the structure of their habitats. I now conduct research in Chicago, where I focus on muskrats and their impact on marsh ecosystems, specifically within the context of bird conservation and restoration.

Muskrats create large igloo-shaped homes out of a mixture of vegetation and mud, and these huge dens generate important gaps within the dense vegetation of marshes. Chicago is on a major migratory bird flyway where millions of birds pass through during their spring and fall journeys. Muskrat dens, by creating gaps within marshes, may potentially serve as vital space for a diverse array of species, and my research investigates this directly by using cameras pointed at areas with and without muskrat dens. This observational data shows that there is a twenty-one-fold increase in the number of animals spotted on muskrat dens versus control areas, a stunning and exciting finding! My future work will examine this experimentally and look at how we could incorporate muskrat den structures into large-scale restoration efforts. My work suggests that the muskrats, through their mere existence and den-building habits, contribute to a structural shift that benefits not only birds but also a myriad of other species, illustrating the interconnectedness of their ecosystem.

In academia, this and other published works have become inseparable from my name. A significant challenge I faced in my field was that I had published a number of papers under my deadname,

> I believe in the importance of representation and strive to be an example for others with similar identities.

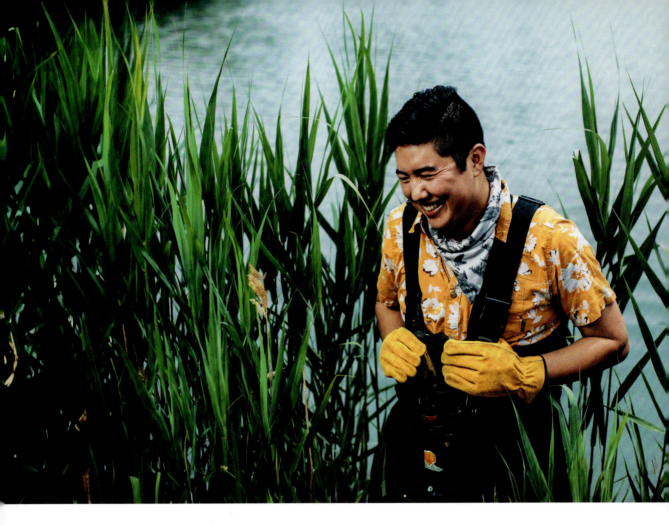

and there was no good mechanism to unify my publication record. I had three options. The first was to erase the work from my record, undervaluing my contributions to the field. Second, I could keep them without changing them, outing me. Third, I could go through the formal process to change my name on every publication, but this involved a correction attached to each paper that said, "This person changed their name from [deadname] to Leo," which would also permanently out me across my work. So instead I chose a fourth option—I published a paper advocating that all individuals have the ability to change their names without a correction.

My paper outlined a guide to implement a policy of invisible name changes, which benefits not only the transgender community but also people who change their names after marriage, as well as domestic violence survivors. I recognized the gravity of this decision—publishing this policy recommendation publicly and permanently outs me within my publication record for the rest of my career. But in order to create change, I was willing to take this risk, and I'm glad I did, as the impact was well worth it.

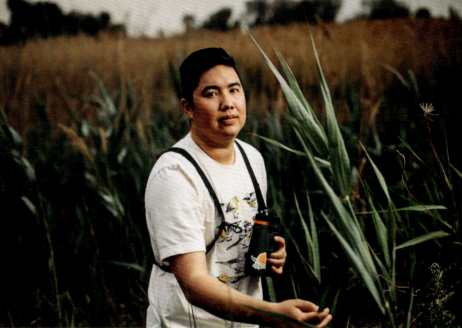

The policy recommendation was immensely successful: seventy-one publishers that oversee thousands of journals have updated their policies, including several major publishers. This shift represents the efforts of myself and many other trans scholars advocating for a long-overdue change in academic publishing, and it is one of the proudest accomplishments of my career.

Being my true, authentic self has empowered me to make my most significant contributions to my field, despite the risks. I believe in the importance of representation and strive to be an example for others with similar identities. Research highlights the effectiveness of teams with diverse backgrounds and origins in generating the most innovative solutions, emphasizing the vital need to empower those with marginalized perspectives. My goal is to pave the way for those voices in both nature and my career, fostering a more diverse and inclusive landscape in the ecosystem of science.

CHRISTOPHER RIVERA

I STUMBLED INTO WINEMAKING. AS A FIRST-generation Mexican, I never saw wine growing up in a Latino household. I went to school to be a physical therapist, and during that time, I took an entry-level job at a big winery in my hometown of Modesto, California. The job required me to drag hoses and attend to the intricate, laborious parts of making wine. I eventually moved up to doing lab work and then making wine, which led to me becoming a brand owner and making my own wine.

My winery's name is Seis Soles Wine Co., based on the Aztec creation myth. The Aztecs thought they were the chosen people of the fifth sun god, the world having been destroyed four times before them. My interpretation is that, as descendants, we are the new generation living under the sixth sun. The name celebrates Latino purchasing power and political power. We are part of the fabric in California and a big part of why America generally works.

Wine has thrived from being exclusive. There's been this idea that it's for a specific demographic; the more limited it is, the higher its value is. Traditional winemaking, in the European sense, strictly limits what regions can grow what grapes and in what manner—it can be very, very specific, and if you don't live within those geographical bounds, then you don't get the benefits of wine and you don't get to enjoy as much. These barriers can make becoming part of the culture and industry complex and discouraging. I understand that the wine-tasting experience itself is still intimidating to some people. I believe it's intentionally intimidating, meant to make it so that if you can't understand what this commodity is offering, then you probably don't deserve to drink it.

> **This representation has been growing very slowly, and I am helping break down these barriers.**

As Latinos, we work hard and like to celebrate often, typically with tequila and beer. There's this huge opportunity for Latinos to enjoy wine in their homes, with their conversations and at their celebrations, but most of us don't have the funds to take a day trip up to wine country and spend all the money that's required to enjoy wine. So that's why I decided to bring wine to them.

I travel up and down California to bring wine to areas where it's less accessible. I'm taking wine to places like Compton, Boyle Heights, parts of Los Angeles, Orange County, and up through the Central Valley to places like Bakersfield and Fresno. I want to make it so that Latino folks who work hard in those areas, and who may be a little wine curious, can now enjoy it themselves.

The wine industry, especially in California, has been built off of the backs off of minorities, primarily Mexicans—at first Mexicans who came from Mexico and now Mexican Americans. The industry has been pleased to have us as wine stewards,

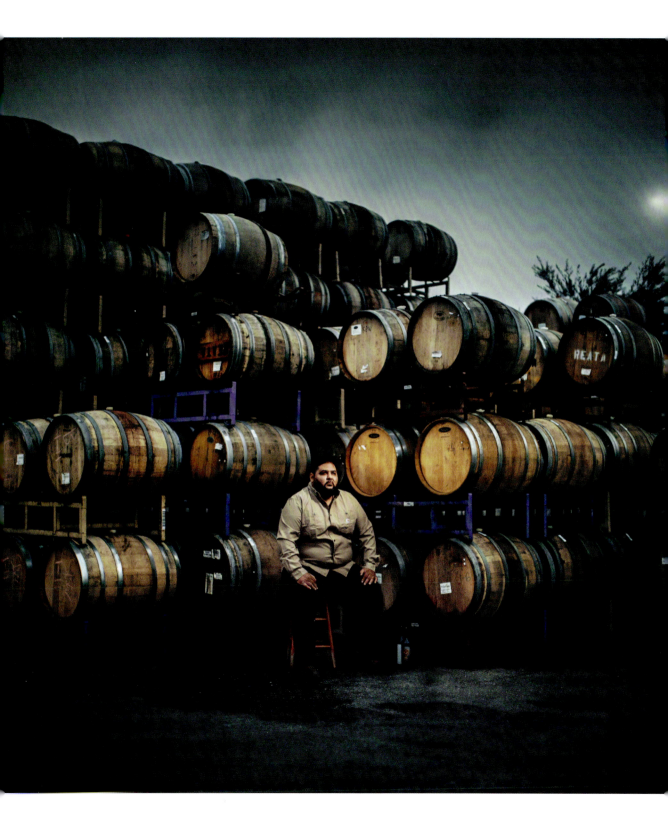

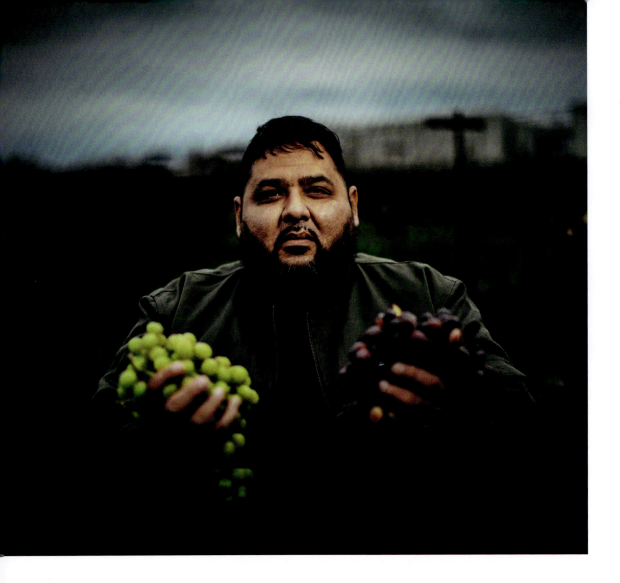

grape growers, and grape pickers, but it hasn't been comfortable with us as brand owners.

This representation has been growing very slowly, and I am helping break down these barriers. Representation is simple; other Latinos might see me, take an interest, and then seek out what kind of wine jobs are out there. As that happens, the industry is going to diversify naturally. It just takes a couple of us to get out there first and be seen.

Seis Soles, "Six Suns," celebrates what it means to be Latino. Even though you can see a clear cultural difference if you compare Mexicans from Mexico and Mexicans from California, the idea behind my winery is if you're a person who can enjoy a glass under the sun, then we shouldn't be worried about arbitrary borders. We can all share a glass, share a laugh, and hopefully have a little fun

GEOFF BABB

NOVEMBER 10 HOLDS A HEART-RENDING significance for Geoff Babb, creator of the inclusive all-terrain wheelchair, AdvenChair. At forty-eight, Geoff endured a stroke, which impacted his ability to walk and minimized the use of his arms. Twelve years later to the day, he suffered an indelible second stroke that exacerbated his disability, further affecting his mobility and speech.

Geoff grew up in White Salmon, Washington, a small town that sits above the Columbia River with majestic views of Wy'east (Mount Hood). Nature, to Geoff, was not just a way of life—it *was* his life. At seventeen, he became a firefighter, eventually becoming a fire ecologist and working with the Nature Conservancy in the organization's early days using prescribed burns as a fire management tool.

"Being in a wheelchair had a huge impact on me," Geoff says. "It took a toll on my life and being outside. I think it made my need to be outside even greater. It's been my happy place, my place of refuge, where I need to be for strength—and so [my need to be outside] only increased."

AdvenChair is a unique all-terrain wheelchair meant for unrestricted outdoor adventures, giving disabled individuals access to rugged backcountry trails that ordinary wheelchairs could never traverse. While the orange chair, intentionally and robustly engineered, is built to navigate challenging terrains, the design also allows a quick conversion to a standard-use wheelchair for everyday

BEHIND THE SCENES

I think Geoff and I have the coolest "how we met" story for this project. I was on a flight to New York from Denver one summer, before I even started shooting the project. On the way to the airport from the parking lot, a sweet, older lesbian couple behind me made a comment about my distinctive sock tan. I had just gotten off the Continental Divide Trail, so my legs were really tan, and where I wore socks was very white. A woman next to me named Mary made a little joke about it, and that led to us talking about my work and this project.

As we were nearing the airport, Mary told me she had worked with an amazing man, her friend Geoff Babb at the Nature Conservancy. She told me all about AdvenChair and what he had built to help other disabled people get outdoors. I was immediately fascinated by this, but when she told me he lived in Bend, Oregon, I knew he was meant to be a part of this project—because I just happened to be living there too!

She gave me his information, and I emailed him as I was walking into the airport. When I landed in New York, Geoff had responded and said he'd love to meet. Two weeks later, I was at his house having a beer with him and learning about his life. I even got to see the infamous AdvenChair.

It's funny to think about, but if I'd been wearing pants that day, I might never have met Geoff—what a shame that would be.

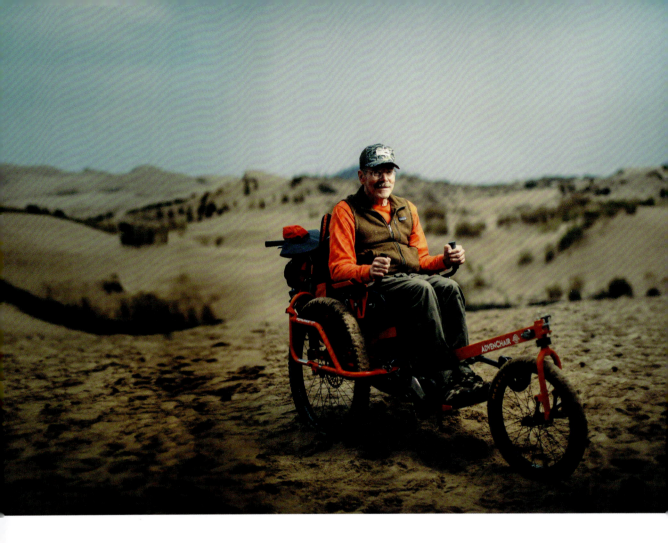

situations. With two handles on the back, two on the sides, and a point of access in front to pull with a rope, the chair requires a team of individuals to navigate off the beaten path. The vision behind AdvenChair was conceived from Geoff's desire to be in nature and the everyday challenges most wheelchair users face when navigating inaccessible spaces—indoors and out.

> "When they're overcoming difficulties together, they're not doing it for the person in the chair; they're doing it to be together outside."

Geoff and the AdvenChair, along with his wife Yvonne, twin boys Cory and Emory, and a team of twelve, took their inaugural trip in 2016 on the Bright Angel Trail, which led them two miles down to the bottom of the Grand Canyon before an axle on the chair broke. That flawed original design, which he refers to as "Frankenchair," meant that they needed some assistance out of the canyon from the US Forest Service. "This was the best thing that could have happened because it allowed us to design the chair from the ground up," Geoff says. Six years later, Geoff and his team

returned to the Grand Canyon with a new, significantly improved design and completed the rugged twenty-mile round-trip escapade in four days.

The original chair designer, a helicopter mechanic, told Geoff, "If you want to keep doing this, you'll have to find an engineer with more skills than I have." That's when Geoff met Jack Arnold, who designed the AdvenChair that other disabled individuals now successfully use. The impact of AdvenChair transcends personal accessibility—it provides users an opportunity to reconnect and share nature with their communities too. Initially seeking to find a way outside himself, Geoff realized the importance of creating accessibility for those with mobility challenges to reconnect with nature.

"It's important for people to be out and connect with what has been important to them previously, he says." The chair has a way of engaging people, and they all rally around the same project."

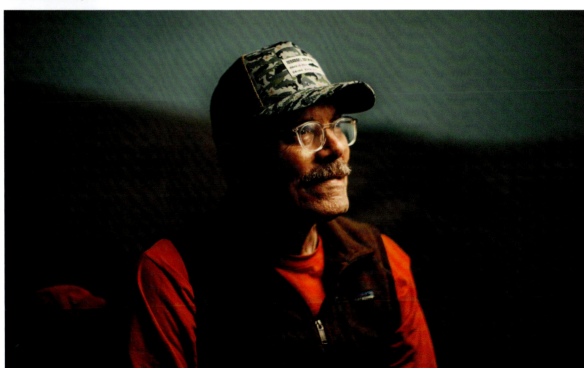

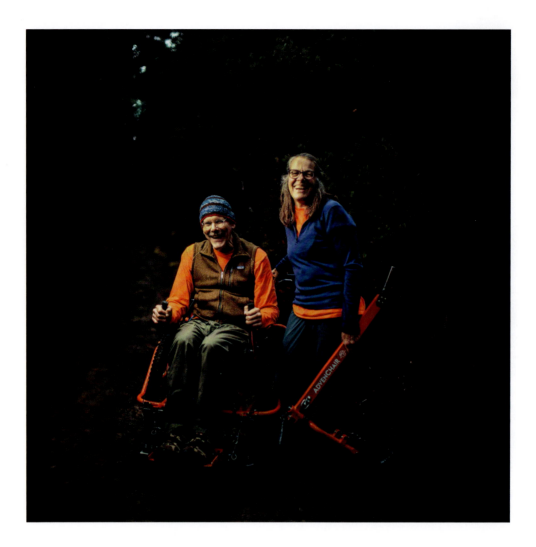

The AdvenChair has galvanized people of all ages and abilities to get outside—the youngest being a six-year-old girl born with a brain injury and the oldest a ninety-four-year-old woman who revisited a lake she hadn't been to in over twenty years. Bittersweetly, two individuals under hospice care had the opportunity to visit long-cherished natural sanctums using the AdvenChair, marking it as their last outdoor adventure.

"AdvenChairing is a team sport. It not only allows people to access nature, it brings people together," says Geoff. "Being in nature and working with other people—it's an elemental need that we satisfy when we're outside. Working together outside, under the elements, whether hot or cold, makes people feel so much more connected to the ground and to each other. When they're overcoming difficulties together, they're not doing it for the person in the chair; they're doing it to be together outside."

VIRGINIA DELGADO-MARTINEZ

MY PARENTS WERE THE ORIGINAL "OUTDOOR influencers" for my brother and me. Despite not being outdoor enthusiasts or social media stars, they introduced us to the wonders of nature at a very young age. I grew up in the Bay Area, surrounded by a diverse community of Puerto Rican, Filipino, Black, and white families. My parents, lacking expensive outdoor gear, sparked a love for the outdoors that spread beyond our immediate family and into the entire neighborhood by bringing them along on our camping trips.

My mother was one of five kids with a single mom and lacked access to nature growing up in Los Angeles. She sought to provide us what she didn't have as a child. My father's inspiration goes back to his Mexican immigrant father, whose unfulfilled dream of being a park ranger manifested through me, his granddaughter.

My grandfather worked for Parks and Rec as a janitor because he didn't speak English. This language barrier kept him from volunteering with the local Boy Scout programs. However, when any rangers or naturalists were sick, he would get to lead nature hikes in the park, a job he dreamed of doing full time. My grandfather died before I became an adult, but the seed he planted in my dad, seemingly forgotten, flourished when I became a naturalist for the East Bay Regional Park District.

I've always had an intentional approach as an educator and naturalist (someone who educates others about nature). When I brought interns into spaces, taking them to a park to explore botany or learn about endangered species, I always made sure to leave space for them to find joy—that seemed more crucial than the work or knowledge they would gain.

There's a deep-seated history of People of Color working in these environments without genuinely enjoying them. It's a narrative I've been committed to undoing because the historical perspective often paints us as laborers, whether as Black enslaved individuals or field workers. My family has a history as both. With my work, I want to unwrite the script that historically inscribes us as merely working outdoors, instead telling the story of People of Color experiencing bliss and connection in nature, because joy is another form of liberation.

Nearly a decade ago, I initiated the Black Interpretive Internship program, named after Black Diamond Park where I worked, focusing on interpretive education for young adults aged thirteen to nineteen, some of whom were parents. My motivation stemmed from a transformative internship

> As I live out my grandfather's unrealized dream of becoming a ranger and naturalist, I envision a future where every voice, regardless of background or language, can be welcomed equally.

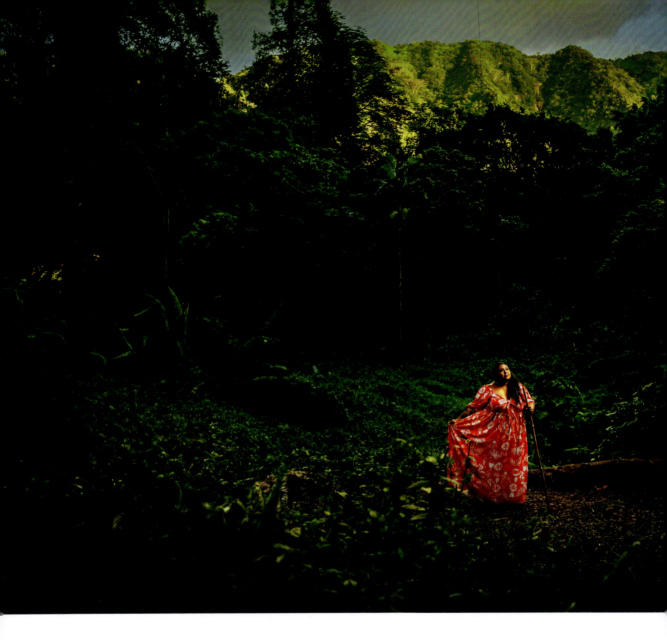

through the Black Diamond Interpretive Program as a young adult that was guided by two mentors, both People of Color, who really saw my potential. My manager at the time, Kate Collins, and I recognized the need for more diversity in our park spaces and entry-level positions and collaborated to address this by partnering with Antioch High School, one of the most diverse learning institutions in the Bay Area. We then had to work with the parks and the county. We wanted to do something different and new, getting away from the same old programs that taught kids how to cut hair or be bus drivers; we wanted to introduce these kids to conservation.

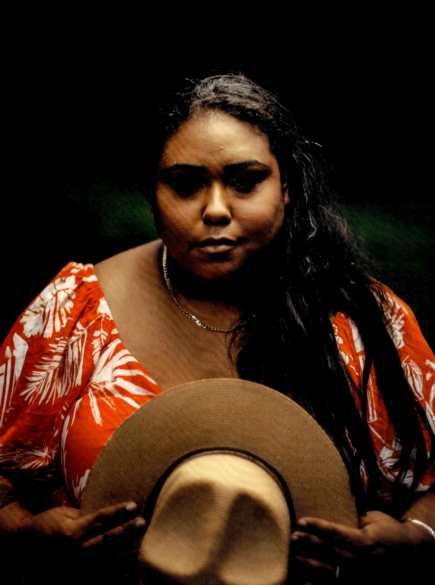

The program started with me picking up the kids from school like a van mom. We talked about our plan for the day, and then I would give a lesson on interpreting. There were also lessons in building presentation skills, exposure to various people in conservation roles, and then delivering educational programs at parks on the weekends.

The success was immediate, with 50 percent of the original cohort of students securing green jobs. The National Association for Interpretation in Washington recognized the program's success the year it was founded, honoring me with a prestigious award. I was so proud that my dreams had

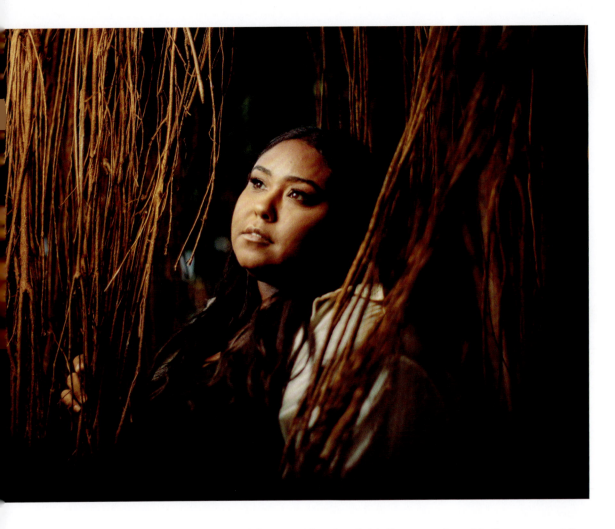

manifested from an idea that initially seemed too big for a young Afro-Latina, but it affirmed that partnership and allyship are vital to the success of such programs. To this day, I am still in contact with former students, some now in college or teaching, emphasizing this endeavor's lasting impact.

As I live out my grandfather's unrealized dream of becoming a ranger and naturalist, I envision a future where every voice, regardless of background or language, can be welcomed equally. In this journey, I also honor my parents—the first outdoor influencers in my life—who instilled in me the passion to invite everyone to experience the joy and liberation of the great outdoors.

MARY KATE CALLAHAN

WHEN I WAS FIVE MONTHS OLD, A VIRUS called transverse myelitis attacked my spinal cord, leaving me a quadriplegic. However, after a year of intense physical therapy, I regained the function of my upper body, making me a paraplegic.

My parents let me be who I wanted to be from a young age. When I wanted to join the swim team in third grade, my parents were very supportive. For me, it wasn't about winning races; it was a way to be with my friends and feel like I was a part of something bigger. That's where my love of sports began.

When I started swimming in middle school, I was able to show people what a child with a disability could do. Swimming showed me what I am capable of as a human and that if I push myself and work hard, I can achieve amazing things. These lessons followed me to other athletic pursuits throughout adulthood.

I was fortunate enough never to feel like I was an outcast because of my disability. Unfortunately, we live in a world that isn't built with disabled people in mind, so my parents taught me that I would have to be my own best advocate. High school was the first time I had to speak up for myself after my first experience of being pushed to the sidelines.

I went to an incredible school, Fenwick High School in Chicago. However, the Illinois High School Association denied my ability to continue to swim on the swim team or qualify for sectionals and state championships because of my disability. Being told I couldn't swim anymore lit a fire in me, not just for my own benefit but any disabled kid who would come after me.

I never in a million years expected that at sixteen years old, I would be a plaintiff in a lawsuit. For two and half years, I was in depositions, discovery calls, and settlement conferences. My senior year, we ended up settling, a term I hesitate to use because there was no money at stake—we were asking for nothing more than basic inclusion. In our victory, we received the criteria to allow athletes with physical disabilities in Illinois to participate fully in their high school swim teams.

From competitive swimming, recreational biking, to track and field, I embraced the challenge of combining three sports in paratriathlons. In my senior year of high school, I made my first world championship team and went to New Zealand as the youngest member of Team USA. Despite a mechanical issue with my bike at the World Triathlon Championships, the camaraderie of the paratriathlon community fueled my determination. I would compete at the world level for the next ten years.

> That's why I advocate for disabled kids to have more inclusive experiences, the same way I spoke up for myself all those years ago—because it will set them up to have more fulfilling lives.

While training for an Ironman race, I started seeing the beauty of the outdoors and the interconnectedness that comes from being an athlete within it. I spent so many hours riding my bike through beautiful places and experiencing that peace in nature. As an athlete, I have gotten to travel the world and see what nature looks like in each of those countries.

There are still many opportunities for the outdoors to be inclusive of all kinds of people. Having access to more paved trails would be incredible for a wheelchair user, but even a mom with a stroller or a person using a walker would benefit. While disabled people might have to be patient regarding accessibility, we don't need to be quiet. I remember how integral those moments of inclusivity were for me as a kid. Since the lawsuit, the number

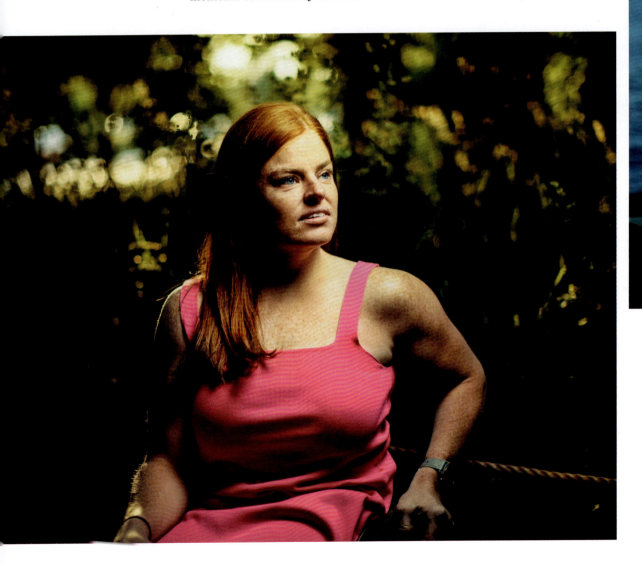

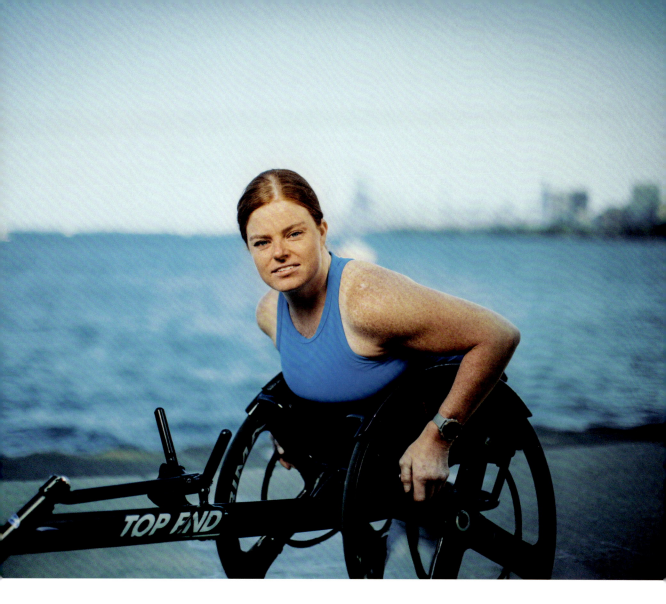

of athletes with physical disabilities at the high school level has doubled. That's why I advocate for disabled kids to have more inclusive experiences, the same way I spoke up for myself all those years ago—because it will set them up to have more fulfilling lives.

 My senior year, a few weeks before our sectional meet, I received the green light to swim again. When I swam at sectionals, I qualified for state championships. I remember sitting at the pool deck on the starting blocks, looking to my left and to my right at the seven other females with physical disabilities who were able to qualify for state championships because of the lawsuit. The crowd was on their feet, not because of our disabilities but because, in that moment, we were simply great athletes.

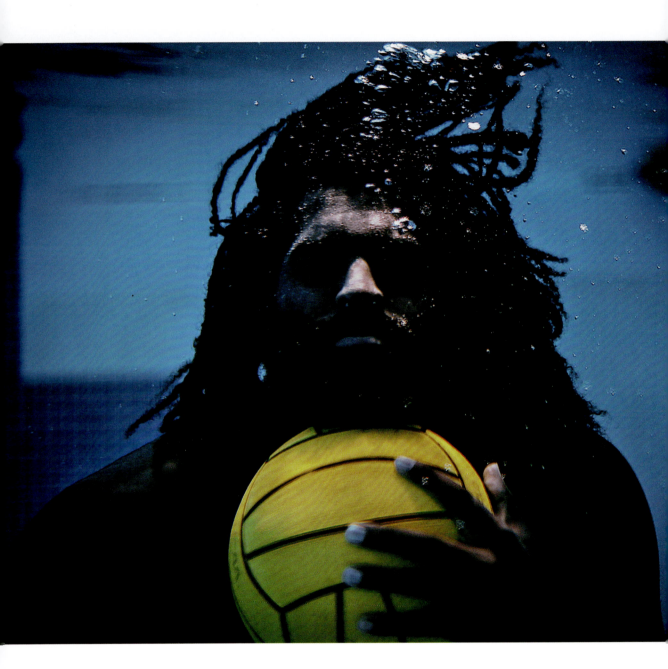

PRINCE ASANTE SEFA-BOAKYE

MY FATHER GREW UP IN Ghana, the cultural capital of West Africa, in the city of Kumasi with a ruling king. This traditional king in Kumasi is famously referred to as the "Asantehene," and my grandfather served as the chief of the Asante (or "Ashanti") Tribe. After his passing, a hospital was erected in his name to honor his altruism to his people. When I return to Kumasi, the landscape bears reminders of his legacy as a doctor, activist, philanthropist, and politician with a famous street sign carrying our family name and hospital made in his name. My last name, Sefa-Boakye, is widely recognized throughout the city, and my name, Prince Asante, is in honor of his efforts and contributions to the community.

I grew up on Coronado Island in San Diego, which lacked racial diversity, with the exception of my immediate family and a few others. When I graduated from high school, my dad gifted me with my first trip to Ghana, where I was reintroduced to family and saw relatives I had never met before. This experience of seeing myself nearly everywhere I went was a sharp contrast to my childhood upbringing of always standing out. Despite this culture shock, it still felt like the beginning of a soulful reawakening and the genesis of a mindful reconnection to my ancestral roots.

I have always been drawn to the water. By thirteen, I began to train to be an aquatic athlete through swimming and water polo. As a child I was overweight and unathletic, but I strongly disliked finishing last in workouts or performing poorly in swim exercises. Frustrated with falling behind, I put my head down and worked hard, eventually becoming a leader throughout my high school and

BEHIND THE SCENES

When I was looking for people to photograph for this book, my friends Zak and Katie suggested Asante. They were close friends growing up with him in San Diego.

Asante was at water polo practice at the University of California, San Diego, the day I came to photograph him. Shooting underwater was way harder than I thought it would be. While I was able to only be under for five to eight seconds, Asante would swim around for nearly a minute at some points. It was quite a challenge, but I'm so happy we did it because the shot of him underwater is one of my favorites.

What Asante is building back in Ghana is a really big deal. I am so honored he was willing to share his story in this book.

collegiate careers, earning the title as senior team captain at California Lutheran University. After graduating as team captain, I set off to travel throughout Europe in search of high-level training and competition opportunities, eventually settling in Brazil to join a team. It was there in Rio de Janeiro where I began to see more than one Person of Color on the water polo teams in our division. This was a stark difference from the lack of diversity I saw by the pool over the many years prior, where I could count on one hand the People of Color I saw on other teams.

Aquatics and water polo are traditionally seen as upper-class sports. Unfortunately, a major contributing factor to this is that communities with access to pools are typically more affluent. More marginalized or impoverished communities may lack the infrastructure, required maintenance, and even the ability to afford aquatic opportunities for themselves and their families. The racial disparity we see in water polo and aquatics stems from the historical trauma of the transatlantic slave trade, the racial segregation of public pools in America, and the high rates of drowning within African and African American communities.

> It was a moment of pure joy, and I couldn't help but think: *This is what it means to be outside.*

When I go back to Ghana, I feel like I am home—similar to how I feel when I am in the water. I wanted to find a way to bridge my two identities and passions together, so several years ago, I started to build the first Ghanaian water polo team in history.

My first step in this process was to assemble a team and donate equipment. I connected with a local school that had a pool where I could recruit eager students in the Central Region of Ghana. As my plan expanded, I began reaching out to the youth on the street who were selling items or washing windows in traffic to join us at the community and university pools. This then grew to trips to the local beaches with a ball in hand to engage with youth from many vastly underserved coastal communities. The ones that saw the opportunity and became serious were the ones who became our team members.

Though rewarding, this process has encountered and endured many hurdles and pains. The most heartbreaking of those was losing one of our spirited young team members, Gideon, at just twenty years old to a devastating work accident. Through poor hospital treatment and systemic health care issues in the country, Gideon was discharged back to his home where he passed away after nearly six months of neglect and lack of access to surgery. Beyond the game, we've also dealt with visa rejections and bureaucratic barriers to pursuing opportunities to compete abroad. The same week we

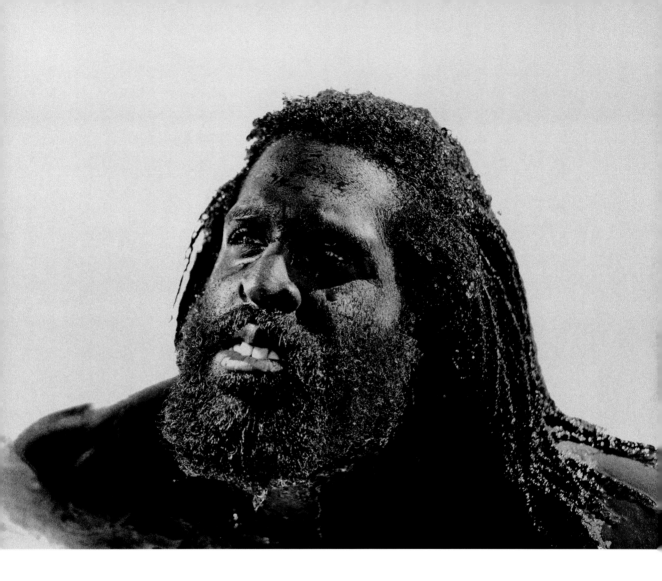

attended the funeral of Gideon, our team received news of our visa rejection to travel to Italy for one of the largest youth festivals and tournaments in the world. It's disheartening yet crucial to shed light on these issues for the sake of awareness.

 These stories are tragic, yet unfortunately not isolated, and they only highlight some of the challenges we face. We work to ensure that the kids we mentor do not face similar struggles on their paths. It's tough; however, we must confront and address these harsh realities if we are committed to improving them.

 Despite their upbringing in poverty, these kids are uniquely positioned in life. Even though I'm teaching them the same game I played, their story will be different—they're learning from a coach who looks like them and who they can identify with. They won't have the feeling of being ostracized;

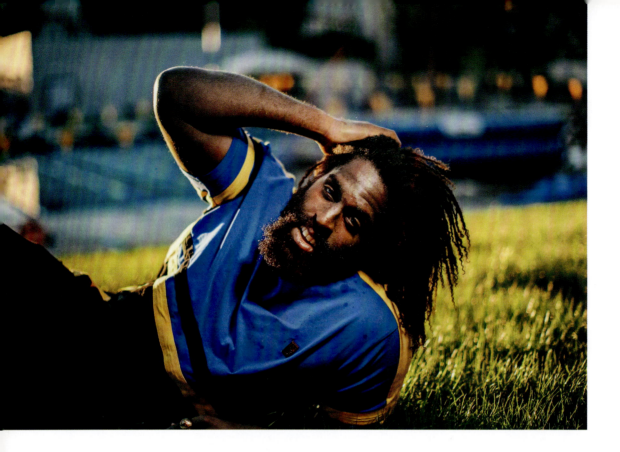

they won't ever feel like they don't fit in the sport. It makes me proud to hear a lot them express interest in continuing in the game and even getting a higher education from it. Often they express interest in wanting to be like me, and in response I encourage them to strive to be even better and also to be like the amazing, successful humans who support our mission.

In one of my most treasured moments, the team and I swam far out into the sea and formed a circle, passing the ball around. Some of the kids dove down to touch the bottom and would bring up handfuls of sand as a challenge. Excited by this feat, I joined in myself. Each time I descended, the darkness intensified, and the immense pressure would build up in my head and my ears. Despite the difficulty, I kept going. I dove deeper and deeper through darkness, holding my breath until I finally touched the ground and grabbed the biggest handful of sand that I could. The kids erupted in a cheer when I came back up with my fistful of sand and began shouting and splashing in delight.

It was a moment of pure joy, and I couldn't help but think: *This is what it means to be outside*. In that moment, we were united. We shared the feeling of peace that the water provides and the connection to the earth that binds us not just as a team, but as a people.

Community

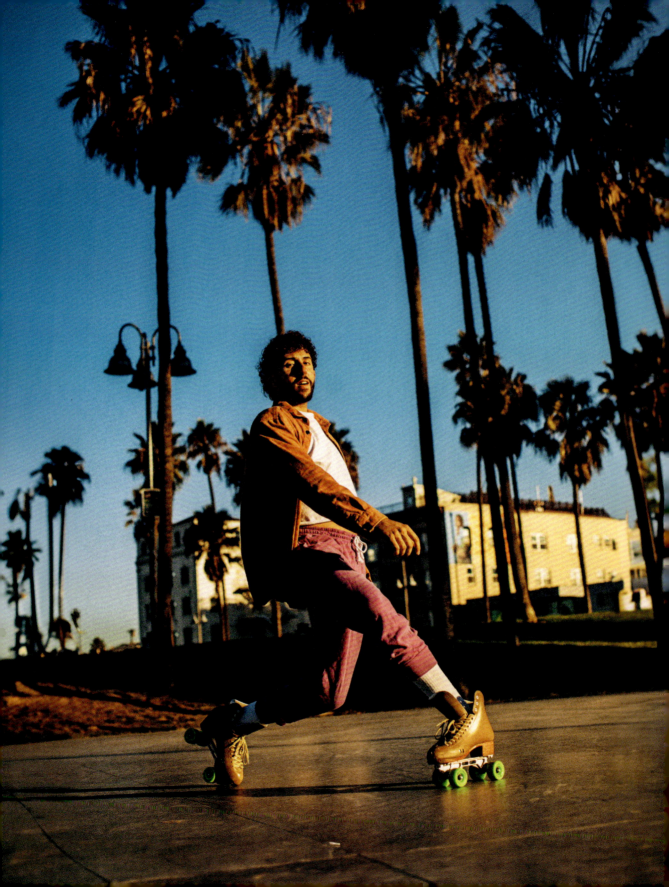

CHRIS GREENWELL

WHEN THE PANDEMIC HIT THE UNITED States, I was living in Los Angeles and working as a photographer. While significant events like Coachella were canceled, so were my jobs as emails and texts flooded in from all of my clients within twenty-four hours. Knowing I wasn't alone offered a small sense of solace in the midst of this global crisis. I was grateful to have my health and unemployment income.

For about a year, my roommate invited me to join her at the skating rink every Monday. I'd always put it off, saying, "Next week." Then, in February 2020 while at Venice Beach with a friend from my hometown, my roommate and her crew were skating like pros. It hit me—I wanted to feel that. The following week, I finally joined the rink, and my new hobby sent me on the next wave of my life.

LA is a competitive place, and the various communities I came into contact with at the beginning of my time here left me feeling disappointed. The focal point of roller skating for me is the community. I harbored a lot of judgment toward myself when I was getting into the sport. Learning different movements had to come with humility because, eventually, I would fall on my ass. I had to be willing to be taught and eager to learn. This community exudes kindness and tenderness from those who pass on their knowledge to newcomers. LA can be a place of transactional relationships, but because this sport is basically free, I met compassionate

people who just wanted to help me learn with no expectation beyond seeing me succeed.

While money doesn't significantly hinder anyone from roller skating, it can be challenging to secure accessible spaces to skate. The Venice Beach Skatepark, funded by dedicated roller skaters and personal donations, stands as a testament to community commitment. In contrast, the City of Los Angeles invested a staggering $3.5 million, earning the Venice Beach Skatepark the title of

BEHIND THE SCENES

I discovered Chris through my Explore page on Instagram one day. It was a video of him doing all these cool roller-skating tricks, and it made me realize that I really needed to include people who connect to the outdoors in an urban environment. I honestly hadn't thought of that until I found Chris, and for that I am so thankful, because urban access to nature spaces is vital to a good life in a big city.

Chris was so fun to photograph. We went at dawn to shoot at the roller-skating park in Venice Beach. He brought his boom box and some hip outfits, and we shot photos as the sun rose through the palm trees. I have always loved movement in portraiture, and Chris was the perfect person to help me capture that.

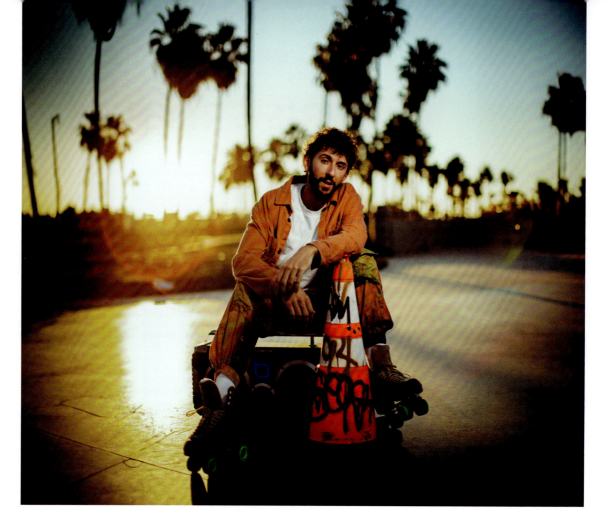

the world's priciest. Venice's charm lies in its diverse, inclusive community, offering a free skate haven for all, regardless of age or socioeconomic background. This contrasts with traditional rinks that charge entrance fees. Breaking down this monetary barrier is crucial; there is a desperate need for open spaces like Venice without financial constraints. A roller-skating organization's efforts to secure fair funding highlights the necessity for inclusive recreational spaces in a city as affluent as LA.

In reflecting on what I've observed in the LA roller-skating scene, it's disheartening to see how the city falls short in prioritizing our community. Unlike skateboarding, tennis, or basketball, roller skaters lack dedicated spaces. Venice Beach remains the only public area specifically for roller skaters in all of Los Angeles, and it took decades of persistent advocacy by the Venice skate elders to secure that space. Even now, the city often uses it for profit through permits for

Nature makes people feel unapologetically themselves, and roller skating outside in Venice makes me feel free to be myself.

filming or large-scale events. With the surge of new skaters during the pandemic, the demand for skating spaces has grown, and the newer generation of skaters is beginning to organize and advocate for more designated areas.

 The first time I visited Venice Beach, captivated by a sunset on its lively boardwalk, it struck me that this vibrant community could be my home too. It motivated my decision to make LA the setting of the next chapter in my life, where, amid its panoramas of mountains and palm trees, my passion for roller skating was ignited. The sport's movement and intricacy is a unique way to connect to the outdoors. There's something about the warmth of the sun on my skin as I move to the music that indoor rinks just can't match. Nature makes people feel unapologetically themselves, and roller skating outside in Venice makes me feel free to be myself.

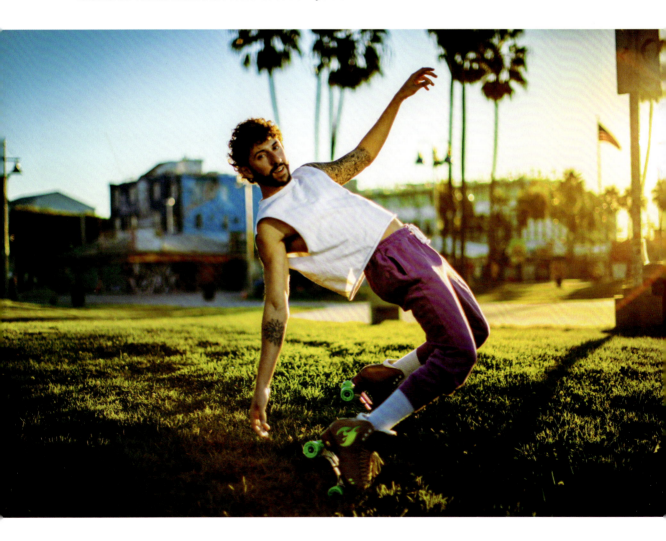

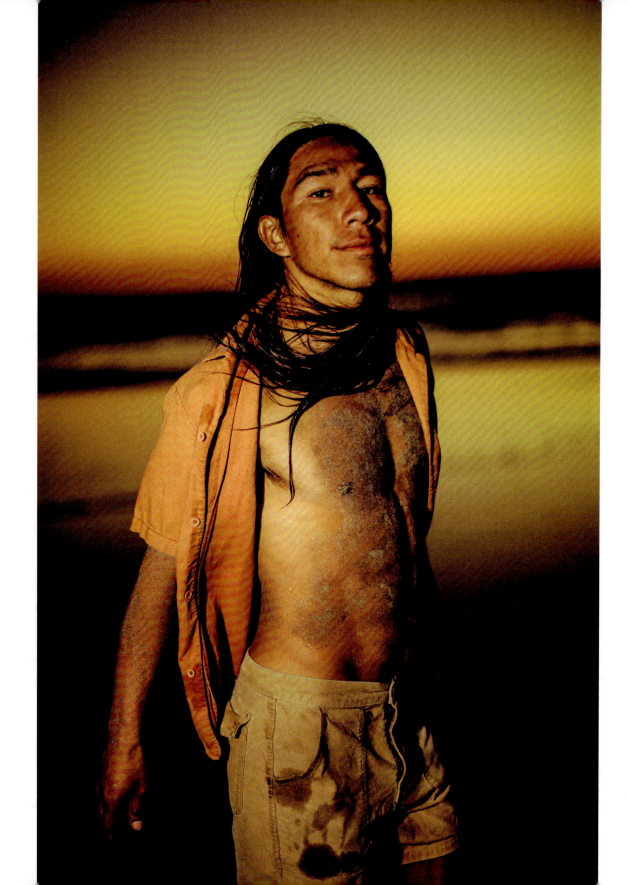

MARIO ORDOÑEZ-CALDERÓN

MUNÁ, WHERE MY PARENTS ARE FROM IN the Yucatán state of Mexico, means "an area of soft and tender water." Through ancestral connections to the water, my people held ceremonies in cenotes (natural water-filled sinkholes) and canoeing up and down the coast of the Yucatán. My story is deeply rooted in the Maya peoples' reverence for Muná. Becoming a surfer feels predestined, a full-circle moment that's a hybridization of connection and yearning to be near water.

I grew up in Thousand Oaks, California, in a multigenerational household with three nuclear families under one roof. All the men in the family worked at Boccaccio's, a European restaurant in Westlake Village. Between their jobs as waitstaff and cooks, they would be gone long hours, so it was up to the women in my family to raise us kids. Being raised by such formidable women helped me understand softness and gave me space to embrace both feminine and masculine energies.

I attribute my reciprocal relationship with nature to the women in my family, for they helped me understand how to walk the path of least harm, quite literally on the trail as well as metaphorically in life. Through their teachings, I learned how to leave things better than I found them by moving through the world with only the best intentions. These practices translated to nature through "Leave No Trace" principles and tending to the land.

Several years ago, in my early twenties, inspired by the Guatemalan kids in my neighborhood who would watch me load up my surfboard, I started my nonprofit, Un Mar de Colores (An Ocean of Colors). I always wondered why I never saw that family at the beach and what the disconnect was. Did they not feel welcome there?

Reflecting on this privilege I had as a surfer, through community, connection, and calmness, I see how much it enriched my life. I recognized that there were kids in my neighborhood in Encinitas who looked like me, yet I never saw them at the beach. I knew I didn't want this disparity to

BEHIND THE SCENES

Mario is an old soul. His kindness, empathy, and wisdom shine through his photos. It's no wonder he's a model in real life—not just because he's a beautiful human but also because he engages softly but genuinely with others, making him very captivating.

After our shoot on the beach in Encinitas, we went to a little Italian restaurant down the street and had thoughtful conversations about relationships. I can't remember what we ate, but it was delicious. Some of my favorite interactions with these humans have been simple moments sharing art, food, and life.

hinder these kids from waiting until adulthood to surf like I did. Because of my community of those who believed in me, I could expand from my original idea of an annual event to what is now a two-year educational school with a full-ride scholarship program.

I aspire to surf with kids from diverse cultures and backgrounds, imagining the beauty of us standing together, creating an ocean of colors reflected in our own Muná.

Through our programming, we educate kids on the importance of protecting land and how that preserves the ocean. We take them on tours of local estuaries and teach them about the duality of freshwater and saltwater and how their merging creates an entire ecosystem. Through nature walks, they learn about the benefits of protecting coastal bluffs and identifying native Californian plants. Our overlying educational theme is reciprocity with nature and water.

Being raised by such strong women has allowed me to step into the work I do with youth and be the best leader that I can be. My leadership demonstrates masculine and feminine dualities: I'm a rough, shaggy surfer who can speak loudly when necessary while also listening intently to the kids and allowing my softness not to hold expectations of them. That softness garnered from my family has allowed me to be more than just a surf coach, which can be a role that's a bit linear, technical, and cocky. Rather, the softness has translated to affection, care, and investment in the students themselves, not just the program.

The idea behind my organization's name came from envisioning the sunset and how, on any given day, it can include an array of colors—orange, pink, dark blue, metallic blue once the sun sets, and sometimes gray when the sun is gone. The ever-changing reflections of light on the water, a diverse spectrum of colors, paint the waves that hit the shore. I wanted the name to celebrate these colors and how they're a part of this beautiful collage of life. I aspire to surf with kids from diverse cultures and backgrounds, imagining the beauty of us standing together, creating an ocean of colors reflected in our own Muná.

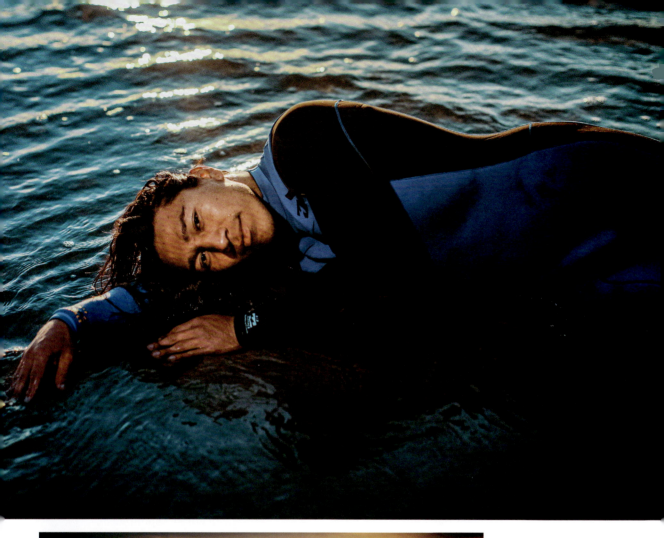
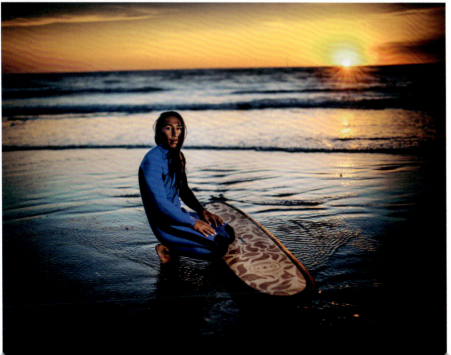

KAREN DESOUSA

I'VE BEEN A NURSE FOR EIGHTEEN YEARS. Prior to that, I worked as a ski patroller and rafting guide. While I love the outdoors and enjoyed those jobs, they don't pay well or come with insurance. Through ski patrolling I learned I really enjoyed helping people, so I sought a higher-paying job as an ER tech. Working alongside nurses in the ER, I was impressed how they cared for their patients, sometimes at the worst or final moments of their lives. I knew I wanted to be able to do that too. So, in my early forties, I went to nursing school.

While working in the ER in Ashland, Oregon, I had been hiking for years and had started backpacking sections of the Pacific Crest Trail. Sometimes my partner would come along, but more often than not he would decide not to go. As I walked farther, I began to get more clarity on our relationship and realized it was slowly disintegrating. We eventually divorced, I sold the house we lived in, and I got rid of most of my belongings, intending to live out of a van and cut back on working. Before I could finish the van build, however, the Covid-19 pandemic hit. Suddenly, it didn't feel right to leave my work to go off traveling in a van, so I continued working.

It was a scary time to work in health care. There were a lot of questions and much uncertainty, especially during the early days of the pandemic. I stayed because I wanted to be there with my coworkers and for my community. The worry was always there, though. What would happen if a friend or family member got sick? What if my peers or I were exposed at work? And what about my eighty-year-old mother?

Covid eventually affected my family in a major way. A sister and one of my nieces both live with long Covid, and their lives have been completely altered by the ongoing effects of the disease. Then, after spending three weeks alone in the hospital, my brother died of Covid. After that, it was hard for me to go to work, especially if I had patients who were there with Covid or Covid-like symptoms. Being around people who didn't believe Covid was real or who refused to vaccinate became extremely stressful. Working in the ER while trying to come to terms with my brother's death was deeply challenging, and I turned to nature, just like I have for as long as I can remember.

Fear and uncertainty gripped people profoundly in 2020. As most people were becoming more and more isolated, working from home and social distancing, health care workers continued to go to work, where we were in close proximity to each other and our patients. While most people were indoors, avoiding each other, even in parks and recreational areas,

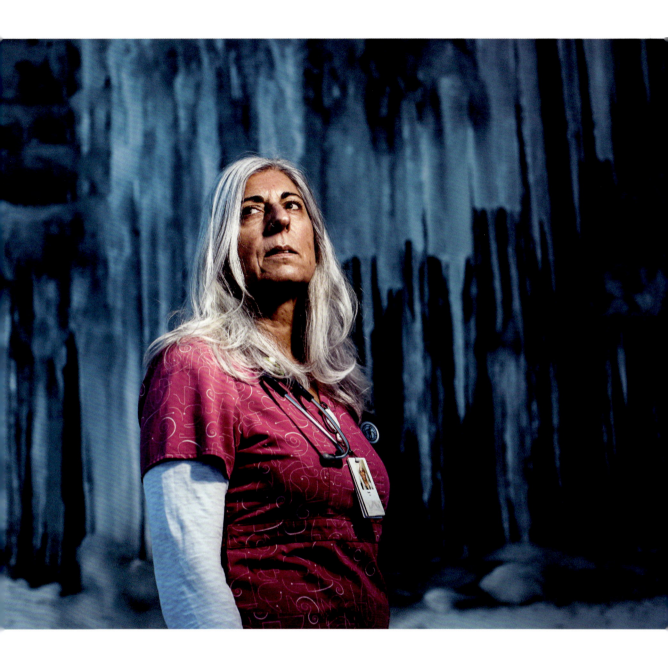

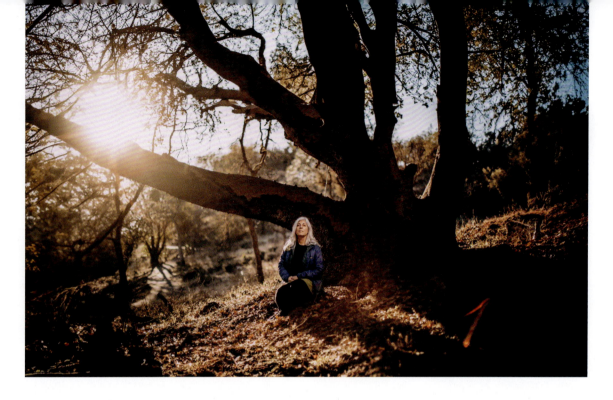

we as nurses were drawn to the outdoors. Mother Nature became a place of comfort as we sought solace outside with each other.

My health care community sought refuge in nature, becoming a tight-knit group of kindred spirits. We would take our separate cars and meet up in the nearby mountains to go hiking or skiing. While the ski area was technically closed due to the pandemic, we still hiked up the mountain and skied down the runs. These times spent with my peers reminded me of the community I found thru-hiking the Pacific Crest Trail and the Arizona and Colorado Trails. Nature has this way of making people feel more like family than just friends. It's a place where we can be free with our thoughts and beliefs while still being supportive of each other.

Nature has this way of making people feel more like family than just friends. It's a place where we can be free with our thoughts and beliefs while still being supportive of each other.

The contrast between the natural environment and the abrasive, fast-paced world of hospitals is huge. Being outside is a simple source of physical, mental, and emotional release, giving us a break from our often chaotic work. It's where we can refill our souls and get back to baseline. Nature heals.

Everybody can benefit from time spent outdoors, especially when going through hard times or feeling out of balance. Ironically, as a health care worker working in a hospital, I think the most healing place to be is outside.

PATRICK RAMSAY

IN LITERATURE, SNAKES COMMONLY SYM-bolize death, poison, or evil. However, in nature, these creatures are vital parts of the ecosystem, serving as ecological engineers and existing as both predators and prey. They function as regulators of their environment, consuming invasive rodents, minimizing tick populations, and providing plants with opportunities to find new places to grow. More importantly, they serve as a crucial food source to certain mammals and birds of prey.

As a young writer finding his voice in poetry, Patrick Ramsay discovered that his lack of knowledge about snakes contributed significantly to the fear associated with them. This fear expressed itself in one particular poem he wrote as a teenager, a clandestine reflection on the fear of disappointing his family if and when they learned of his queer identity. Surreptitiously, he used a snake as a metaphor, seeing it as a fitting image to suggest that he, as a gay man, might be perceived as poisonous or toxic. As Patrick explains, "There's an inherent queerness in some animals. The perception that humans have of animals overlap there with the queer community and society broadly."

Coming of age in Syracuse, Utah, Patrick found himself trapped by the relentless gender expectations imposed by the Mormon church. The rigid gender norms for both men and women left little room for deviation within the tight constraints set by the church. However, the moment he shifted from those two tiny boxes of conformity, it felt like breaking free from the chains of pink and blue. This newfound liberation provided a remarkable opportunity for his writing to intertwine with his queerness and connect with others like himself.

According to biblical folklore, magpies are the only birds that didn't board Noah's Ark. Instead, they sat atop it, spitting swears as the world drowned beneath. In many cultures' ancient mythologies, magpies are much like snakes, slick and sinister in their demeanor; some even say they are the birds of the underworld.

Motivated by the closing of his favorite bookshop in Ogden, Utah, and inspired by the mischievous reputation of magpies, Patrick embarked on creating a new and unorthodox pay-what-you-want literary haven. This uncommon model promotes accessibility and encourages a cycle of generosity as the community donates books to support the goals of making literary art available to everyone. His goal was to establish a space representing the diverse community in Ogden and facilitate community events, which he called "mischiefs" (the collective noun for a group of magpies). His bookstore, Happy Magpie, sounds inviting and carries the joyful connotation of "gay"—proclaiming it a safe and brave space.

> Patrick's venture has taught him a valuable lesson: the more space you make for others, the more space opens up for yourself.

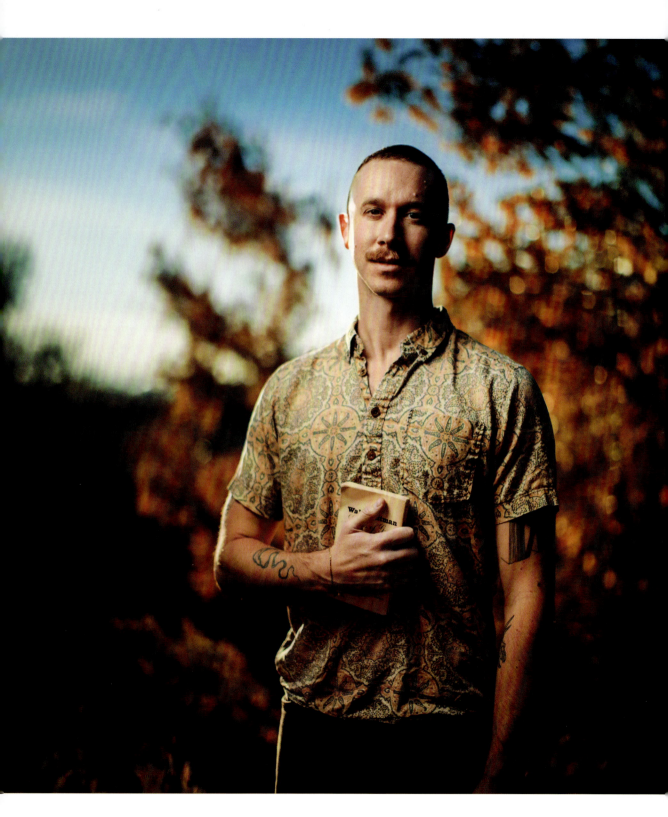

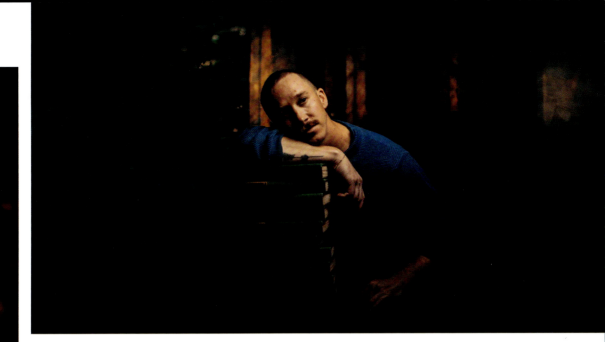

In writing groups at Happy Magpie, many individuals explore the theme of nature, finding a common thread that links their experiences within the mountains and canyons of Utah. Patrick's venture has taught him a valuable lesson: the more space you make for others, the more space opens up for yourself.

Snakes and magpies are creatures that have historically been dismissed. However, they are essential and contribute to nature's evolutionary prosperity. There's a profound connection between their misconstrued lack of value and the shared experience of outsiders in the queer community. "I'm interested in the underdogs of the animal kingdom," Patrick says. "I'm interested in the animals that may have been thrown away in some folks' minds and whose value is harder to see on the surface level."

He explains that he would "revisit my teenage poem as a queer person who sees snakes as an important part of its community and something that belongs, is vital to the environment and, if it weren't there, would be missed."

Much like the snake and the magpie, his journey as a queer person is not defined by literary toxicity but by the important role he holds in enhancing accessibility to nature through poetry and the spoken word. Embracing his identity, both creative and queer, isn't a personal victory; it's a contribution to the thriving ecosystem of misrepresented creatures, where every unique individual, like the slithering snake or the chattering magpie, is an ethereal protagonist in the manuscript of nature.

LIVIO MELO & JENNIFER JACOBSSON-MELO

I GREW UP IN THE SWEDISH COUNTRYSIDE and spent a lot of my childhood in the forests behind my house. I loved playing hide-and-seek or with my Barbies in the pine trees, imagining the branches were different floors of a city building. North of Stockholm, the land becomes very remote and sparsely populated. That's where nature feels untouched, the wilderness dotted with various national parks and beautiful trails. Almost 70 percent of Sweden is forested—it's organic not to think about where you're going when recreating outdoors because you can explore anywhere you can walk. *Allmansrätt* is a Swedish term meaning "every man's right to access" or "freedom to roam," a big part of our outdoor culture. It's very different from the US, where a simple hike takes a bit more planning because of permits or private land. Moving to the United States in my early twenties, I realized what I had and what I miss about the outdoors in Sweden: the freedom to roam.

Livio grew up in the Dominican Republic until his family immigrated to New York City when he was just shy of six. That's when he started to find a connection to the outdoors, getting dirty while climbing rocks and trees. In search of a spot to hang out, Liv and his friends would cut fences to find natural spaces that had no claim. In these places usually littered with broken bottles from kids drinking, he would discover nature in the big city.

Our access to the outdoors highlights the difference in our upbringings and connection to nature. In Sweden, I was free to explore, a federally protected right that even allowed me to roam on someone's property. Livio had a heavy patrol on most things he did outside, hindering him from seeing more rural scapes or the boundlessness of nature.

Several years ago, Livio had fallen out of love with his profession as a designer and had gotten into making outdoor gear. As he spent more money on fabric and accumulated more, I told him, "You better not buy any more fabric unless you can sell some of that stuff." On a two-week solo hike of the Collegiate Loop in Colorado, he went through the trials and tribulations of carrying his handmade gear, which inspired us to found our company, AllMansRight.

Livio always wanted to share his love of nature with his community as it was shared with him. Founding AllMansRight has allowed us to connect with people in the industry, donate money to organizations, and bring kids outdoors while supplying them with gear. Beyond simply bringing people outside, we want to inspire them to take up space in the industry. Our brand has let us share what we have benefited from by getting outside.

> **Beyond simply bringing people outside, we want to inspire them to take up space in the industry.**

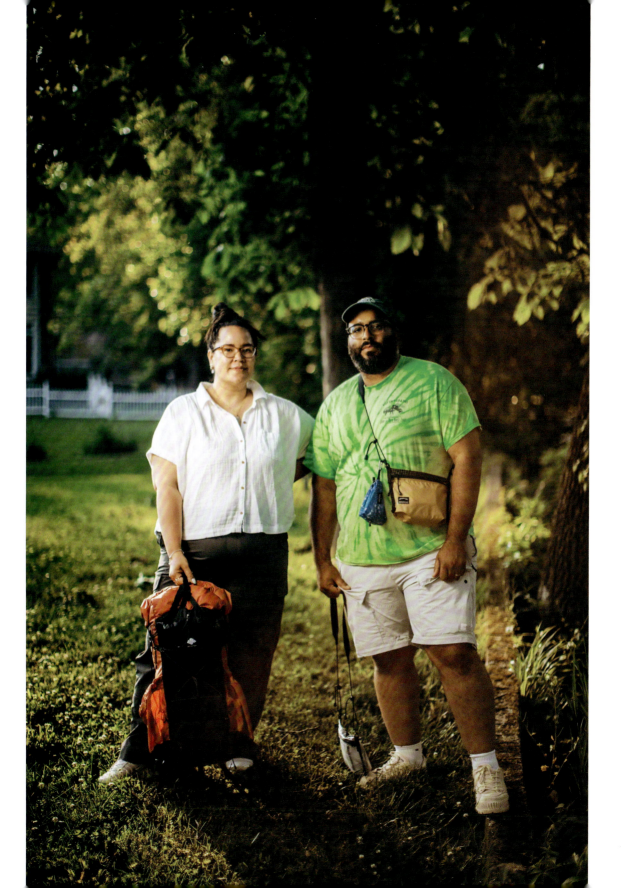

Coming from the Dominican Republic, where trash washes up on the shores, has given Livio a different relationship with waste and a holistic outlook on the outdoor industry. He sometimes feels like an outsider among other outdoor business owners, as his upbringing and artistic prowess for design make him stand apart in comparison. Although his job as a designer is a first-world profession, his outlook on waste and the cycle of apparel gives him a third-world perspective—that's why our designs are so human-centric.

Our goal is to give people a product that they love. However, we've spent many, many, many hours trying to figure out what that means. How do people come to love an object? In everything we create, we are trying to connect people on a deeper level with an object so that they love it enough to want to keep and take care of it. Whether it's a backpack or a stuff sack, we don't want to put anything out into the world that isn't better than what already exists. We don't want to add more stuff. We believe the value of our gear is only applied by the person who owns it.

AllMansRight was intentionally built from the most personal parts of our lives, especially our love of nature. We hope when someone takes hold of our handmade gear that they know where it came from and why it was created and, above all else, that it inspires them to roam freely.

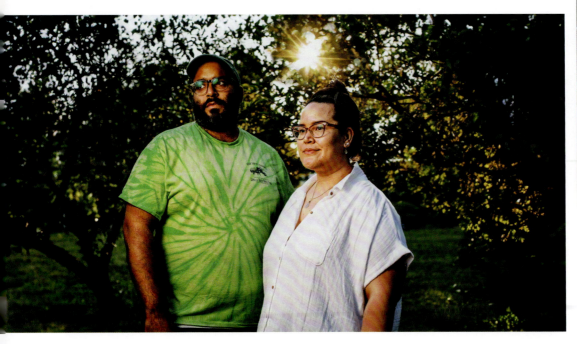

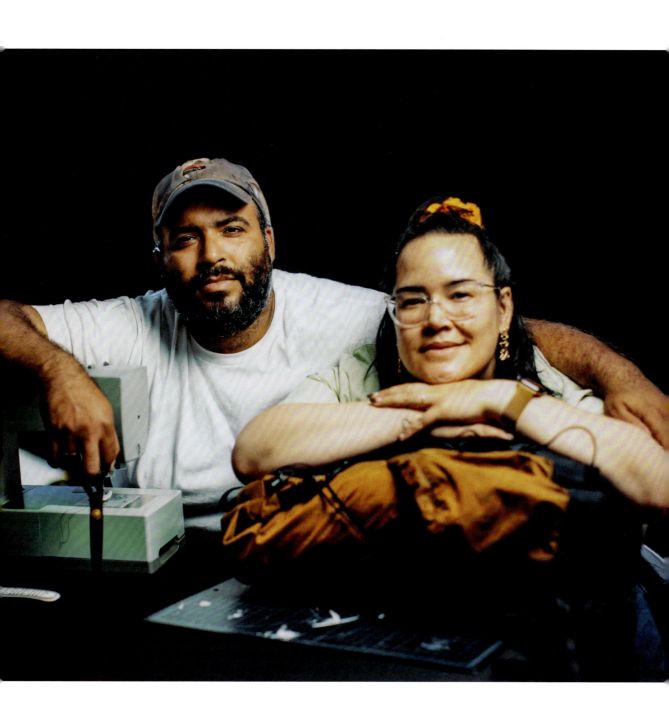

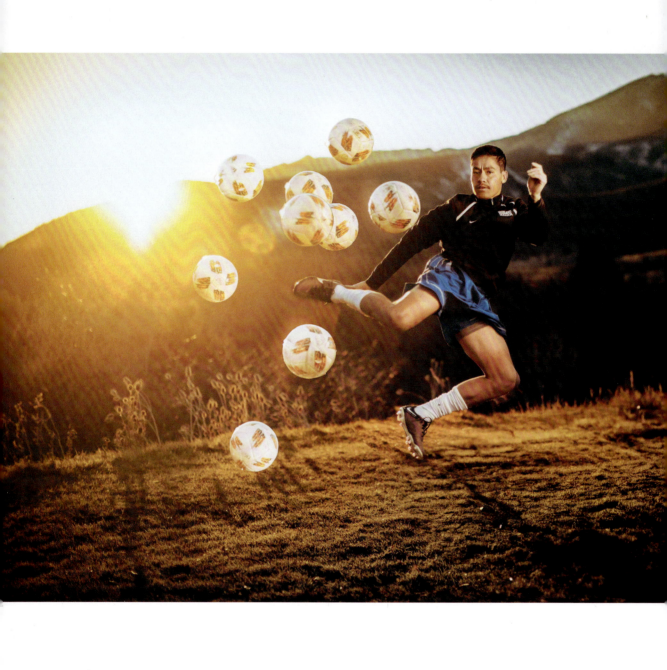

ALVIN GARCIA

MY MOM WOKE MY SIBLINGS AND me up in the middle of the night and said, "Let's pack up. We're going to the beach."

As we packed, I remember my mom being very uneasy, encouraging a sense of urgency as we packed our backpacks. Her friend eventually came to pick us up, my great-grandma included, in an old, single-cabin Tacoma—my brother and I sat in the pickup bed as we drove away from our home in Guatemala.

When we arrived at the Greyhound station, my mom told us to say goodbye to Grandma. We had lived with her as she raised us while my mom, a single parent, worked long hours to support us. I look back on my life, and that moment remains one of my saddest memories: my great-grandma standing there at the bus station, bawling and saying goodbye.

It took us four weeks to travel through Mexico to the United States by bus. There has always been a long-standing tension between Guatemalans and Mexicans because of the immigration pass, so my mom would tell us to hush up, cover up with blankets, and fall asleep on the bus as we traveled through Mexico.

As we approached Nogales in the middle of the night, the last immigration stop before entering America, my mom told us to fall asleep. When the bus stopped, an officer walked on the bus to do his routine check for visas. When he got to my mom, he checked her expired visa and asked her to step off the bus. The officers asked her questions for the next hour or so.

Our lives back home were violent and explosive, mainly because of my biological father. My dad was an alcoholic who would constantly threaten to kill us and our mom. One final altercation was disturbing enough for her to know it was time to leave Guatemala.

When we arrived in the United States, we moved around twice a year for about four years. We eventually landed in Park City, Utah, where my brother and I could finally participate in sports. We played a lot of soccer growing up in Guatemala, so being a part of teams in the US allowed us to become part of the community. The beautiful thing about Utah is that everyone is so connected to the outdoors. I was able to start experiencing nature with my friends through soccer and when they invited me to hike, camp, ski, or climb.

Outdoors culture had never been a part of my family life because of our situation. Many immigrant families are terrified of the outdoors because of their experiences crossing a desert or swimming through a river. For people like me, there's a lot of

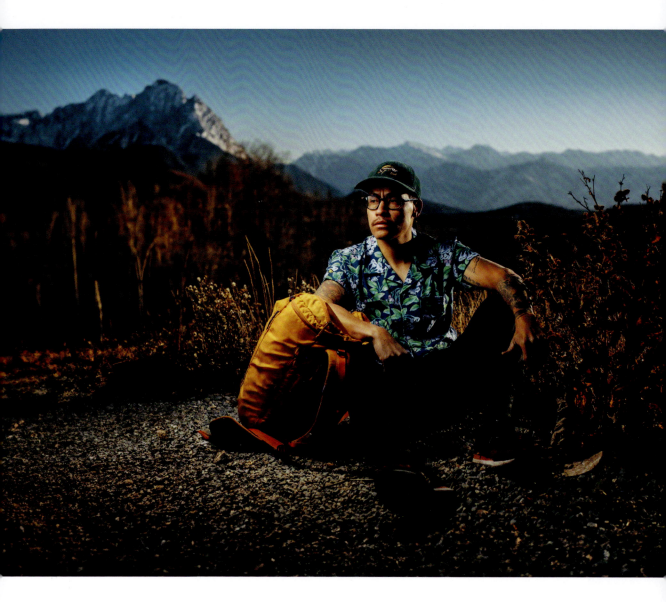

trauma associated with being outside. However, my access to nature was provided through a welcoming community, a profound privilege I am grateful for.

I've learned over the years how important it is to normalize my story and other immigrants who share it. Our stories humanize us. Nature has a way of stripping us of our separations, whether it's color, height, size, gender, or immigrant status. Nature leaves us pure, the most exposed we can ever be.

That night at the checkpoint, my mom took her chance and pleaded with the immigration officers. She told them if they were going to deport us, then they were going to have to pay for our bus ticket back. The bus driver then made it known he was on a time limit and needed the officers to make a decision. My mom opened her little fanny pack, pulled out her traveler's

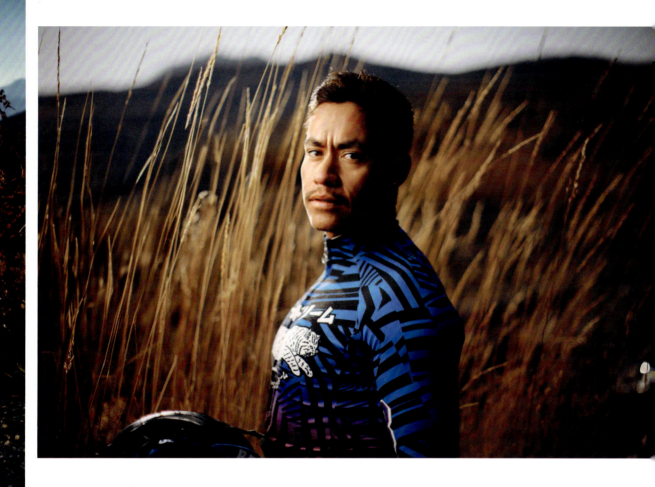

checks, and pleaded by offering the officer all the money she had to her name. She insisted that she needed to figure something out for our family, that we couldn't return to Guatemala. The officer eventually gave in and said, "Keep the money. You're going to need it for the journey up north."

We have the ability to choose how we respond to adversity, a lesson I learned from my mom. When we were stopped by immigration, she chose to fight, not fold. Sometimes, you have to take chances and make the best of what you have. I have been blessed to have that example lead my life to where it is now. When I'm outdoors biking or climbing, I carry those lessons with me and rely on them whenever I face discomfort or uncertainty.

Our stories humanize us.

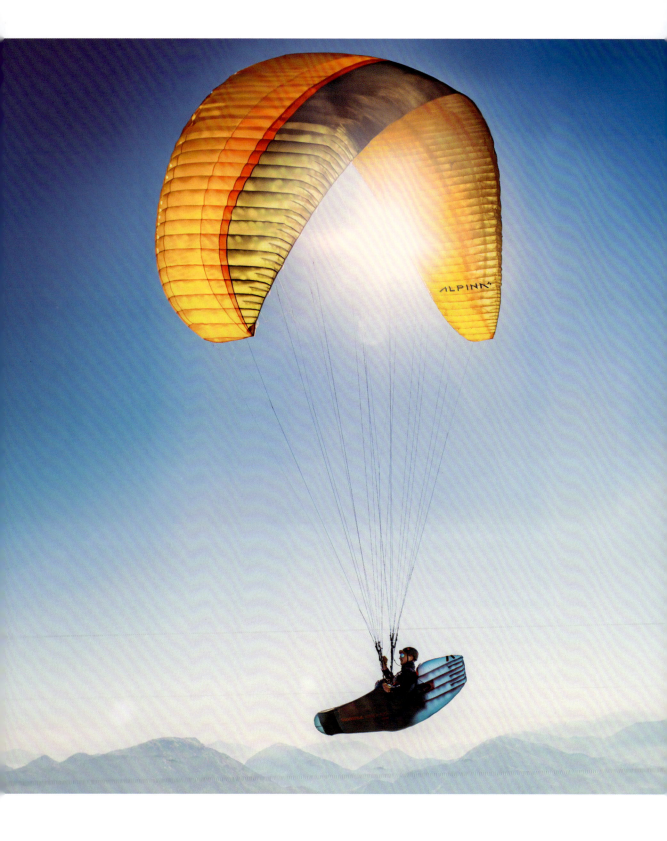

JORDAN NEWTON

IN THE MIDST OF A GRUELING CROSS-country flight, Jordan Newton was confronting the limits of his paragliding prowess. As rain cascaded over the mountain he needed to traverse, a sudden shift in weather rendered his planned course perilous. Jordan was at the mercy of unpredictable winds, compelling him to summon every ounce of skill to navigate the unseen turbulence.

Describing the harrowing experience as akin to navigating "Class V river rapids, but invisible," he averted disaster through sheer determination. Recognizing his only viable option, Jordan made a series of rapid decisions, opting to land on the summit of the very mountain he had intended to soar over. The miniscule landing zone left little margin for error and presented the prospect of a high-stakes descent if he missed. After executing a precise landing on the summit, Jordan hastily packed up his paraglider, descending the mountain on foot to safety. Although the near-death encounter rattled him, the experience imparted invaluable wisdom and a deeper love and respect for the mountains he called home.

At age seventeen, Jordan found himself at a crossroads in Sandy, Utah. He'd left his family in Texas to return to his childhood home in the Wasatch Mountains, embarking on a journey of self-discovery that would reshape his entire existence.

A devout Mormon, Jordan stood on the verge of his two-year mission, a rite of passage for young members of the church. Yet, in a surprising turn of events, he chose a different path. Abandoning the church, Jordan embraced a period of exploration, delving into life's profound questions. His quest for truth led him away from the faith he'd known since childhood, guiding him toward the spectrum of atheism and marking the end of his faith-based community.

In the wake of leaving the church, Jordan not only discovered fundamental truths about his spiritual beliefs but also about his own identity. Growing up in an environment tainted by homophobic

BEHIND THE SCENES

Jordan made our time together exceptionally special. The morning of our shoot, Jordan took me paragliding for the first time.

I am terrified of heights, and extreme sports scare me even more. Jordan made me feel so comfortable and safe, despite our abrasive take-off due to unpredictable wind force. Once we were up hundreds of feet in the air, everything got quiet, and I felt like nothing in the world could ever make me sad again.

Back at my rental that night, I felt so overwhelmingly proud of myself for doing something that scared me. Early on in this project, I learned to overcome my fears and trust my heart.

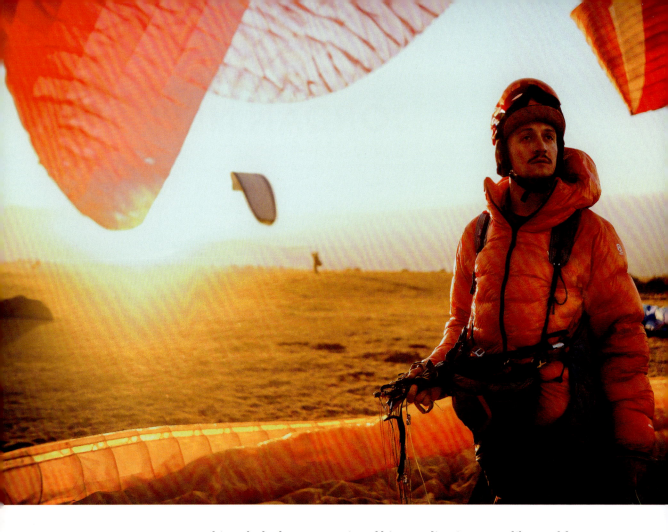

teachings, he had never questioned his sexuality. At twenty, liberated from the constraints of the church, Jordan embraced his true self and came to the realization that he was gay.

Resilient in the face of adversity, Jordan decided to pursue his GED and leave Texas behind, setting off a chain of events that would redefine his life. The death of his connections to the Mormon community paved the way for the birth of a new, stronger community—one grounded in authenticity, acceptance, and an appreciation for nature.

> **Through these challenges, Jordan became a mentor, embodying the spirit of camaraderie that defines the paragliding community.**

To understand Jordan's journey, you must rewind to his early years in the Wasatch Mountains. At eleven years old, Jordan's love for the outdoors flourished when he befriended Sam, whose family had a deep connection with the mountains. Together, they explored the rugged landscapes, embarking on hikes and adventures that laid the foundation for a lasting friendship. A pivotal moment occurred when, at age twelve, Jordan and Sam summited Lone Peak, a challenging climb that ignited Jordan's passion for adventure.

His desire to soar like the hang glider he saw on the summit became a driving force, planting the seed for his future in paragliding.

Jordan returned to Lone Peak for a solo ascent at fourteen, fueled by a profound intuition that he was destined to fly. Despite the delayed realization of his dream, Jordan eventually took flight after completing a flip-flop hike of the Appalachian Trail. The trail became a crucible for Jordan, earning him the trail name "Samaritan." This newfound identity, along with the kindness he displayed on the trail, became a stepping stone toward healing the religious trauma that lingered from his Mormon past.

After his thru-hike, Jordan delved into his dream of flight, embracing paragliding with determination. While initially hindered by social anxiety, he overcame his fears and found a brotherhood in the paragliding community, a group that would support him during the turbulent journey ahead. Jordan's paragliding adventures reached new heights that tested his skills and resilience, including his near-death experience on that cross-country flight. Through these challenges, Jordan became a mentor, embodying the spirit of camaraderie that defines the paragliding community.

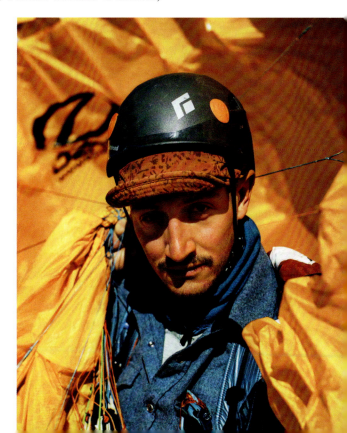

Despite the inherent risks, Jordan's thirst for adventure and the deep bonds he formed in the paragliding community keep him soaring. His thriving brotherhood echoes the love and support he lost in his departure from the church.

Now, surrounded by Sam and other supportive friends, Jordan frequents Point of the Mountain, ready to take off into the skies as his most authentic self. In the embrace of the paragliding community, Jordan has found not only wings but also a newfound sense of belonging.

PERRY COHEN

I WAS FIVE WHEN I FINALLY CONVINCED MY mom I needed to cut off all my hair and trade my feminine attire for jeans and button-up shirts to be like Dad. I genuinely thought that puberty would be when I would grow into my body and become the man I knew I was. When I reached adolescence, I didn't have the language to make sense of the changes happening to my body. When I came out as a lesbian at nineteen, the idea of being a trans man still hadn't occurred to me. I was born in 1976, so growing up in the eighties and its deleterious cultural portrayal of trans people didn't offer me any valid models for my identity.

In graduate school, I studied trans athletes through a program called Physical Cultural Studies that explored the sociology of sport and anything cultural that played out through the body. In reflection, I realized it was a peerless way to compartmentalize and intellectualize something very personal, but I didn't know how to access it on a deeper level. Through my research, however, I started recognizing the symmetries between the subjects and myself.

These realizations about my identity became transparent when I was pregnant with my twins. I didn't think about the gendered nature of it all, further suppressing my identity with these two babies growing inside me. Pregnancy is the ultimate feminization, but everything about me was quite the contrary. Even though I wanted kids more than anything, carrying them felt conflicting.

Coming out as trans at thirty-eight meant leaving the family business, a grocery distribution and logistics company. I would've been the fourth generation to run the company, but I knew I couldn't transition at work without it being a public affair. To honor my reckoning, I quit, even though I wasn't sure what I would do afterward. That's when I started hiking and backpacking again in earnest.

Shortly after I left my job, I found myself alone at the top of Mount Monadnock in southern New Hampshire. From the bald summit, I could see four different states in the incredible view I was bearing witness to. I couldn't believe that the body I had felt so alienated from my entire life had led me to this vista. It was the first time in my life I had truly felt grateful for the body I was in. I thought, "I am so happy for this body. Wouldn't it be incredible if I could help other queer and trans people have this feeling?" This was the genesis of the Venture Out Project.

While starting a nonprofit proved arduous, I had some experience from working on the grantmaking side of corporate social responsibility. In our inaugural year of Venture Out, I ran two backpacking

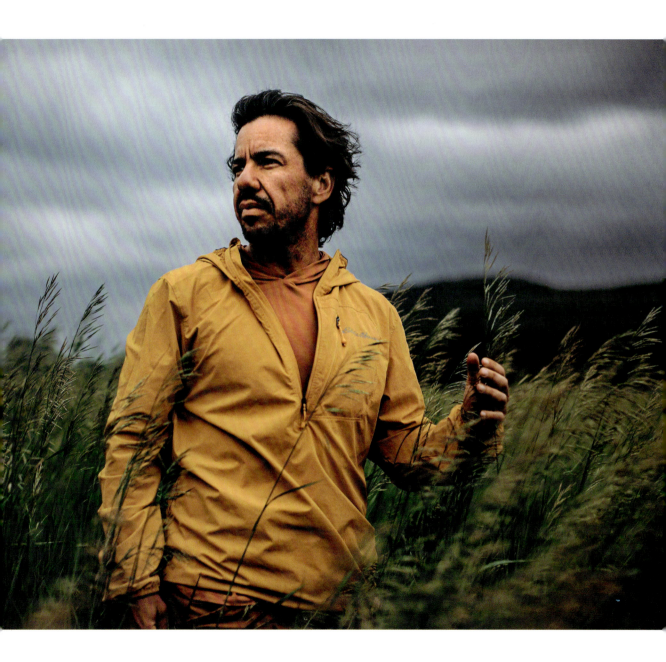

trips, filling spots through word of mouth and social media. Though they were initially planned for youth outreach, many adults expressed a strong desire to reconnect with nature in a supportive environment after transitioning, so we shifted our focus to become primarily an adult program, incorporating day hikes to ease people into the experience. By the third summer, we expanded from the Northeast to the Pacific Northwest, initiating a national growth that included a volunteer leader program.

The most stunning tree is usually the one that stands out—that's such a beautiful representation of what it means to be unabashedly, proud-heartedly, and majestically queer.

A magical experience from the program is organizing family campouts and witnessing many dads of trans kids, who initially didn't envision themselves in a queer community, discover the beauty of chosen family. Many have taken the traditional nuclear family for granted, but seeing them realize the posi-

tive impact of supporting their children is truly remarkable. Watching these dads become vulnerable and connected has been extraordinarily beautiful.

While I have been the visible face representing Venture Out, my story lies in the countless individuals who, whether in the spotlight or behind the scenes, have made this community vision a safe place to find peace and belonging. With anti-trans laws running rampant across the US, it's vital to have a place where trans and queer joy can bloom.

For me, Venture Out embodies the ability to experience delight with community and nature, proudly embracing our bodies and identities rather than hiding or feeling ashamed. The uniqueness of an animal, plant, or individual makes any sentient being *miraculous*. In nature, we, as humans, are enamored by the elements that look different. The most stunning tree is usually the one that stands out—that's such a beautiful representation of what it means to be unabashedly, proud-heartedly, and majestically queer.

KAVA VASQUEZ & MEL RAMIREZ

ALTHOUGH THEY'D HAD A FEW INITIAL encounters and admired each other from afar, Kava Vasquez and Mel Ramirez connected initially through social media. The first time they met up in person, they discussed their shared ideas and aspirations to forge their love of skateboarding into a meaningful endeavor. They cofounded Bronx Girls Skate, a women's community group that promotes and celebrates women's liberation through the sport of skateboarding in the Bronx and beyond.

KAVA VASQUEZ

When I graduated from college, I was left with two amazing opportunities to combine research, travel, and my social justice principles. First, I did a Davis Project for Peace in Maputo, Mozambique. I collaborated with the local Association to Skate Mozambique to expand their existing programming and build a skate program specifically for girls. Next, I received a Thomas J. Watson Fellowship, which allowed me to pursue a passion-driven project—in my case, one focused on how women are personally, politically, and economically empowered through skateboarding.

In addition to exploring the nuances of how women worldwide experience their womanhood in public spaces, I found that women's participation in sports varies from country to country, in part due to religious, cultural, and climate components. But no matter where I went for my research—Mexico, Germany, India, Cambodia, Sweden, South Africa—skateboarding was a grand equalizer. I didn't need to speak the language or communicate with these women to know that they all utilized skateboarding as a tool for social empowerment. I witnessed women from all over the world creatively honoring their cultures while resisting the desire to westernize or perform their passion for skateboarding in a way that was inauthentic to their roots.

MEL RAMIREZ

I have been training in taekwondo since I was six years old. My father, an immigrant, received help from my godfather to open a taekwondo school in the Bronx that ran for five years. When my godfather passed, we had to close the school. It was heartbreaking because we lost everything, even my bow—a traditional gesture of respect and courtesy—without a dedicated space to practice our art, we felt we had lost an important part of our identity.

I had been teaching youth taekwondo at my dad's school. These kids confided in me, opening up to me about bullying and other issues they faced. I got to teach them how to defend themselves against the challenges of everyday life. When the

> If you fall off your skateboard nine times out of ten, you learn how to pick yourself up, but it's better when you have a hand to help you up.

school closed, I didn't even get to say goodbye. What saved me from slipping into a deep depression was a friend who invited me to the court across the street to skateboard—and that's when I fell in love.

KAVA VASQUEZ

No one ever thinks of skateboarding as an outdoor sport, even though we are outside all day trying to find a spot or catch a vibe. Bronx Girls Skate reimagines outdoor sports by bringing people out in an urban environment.

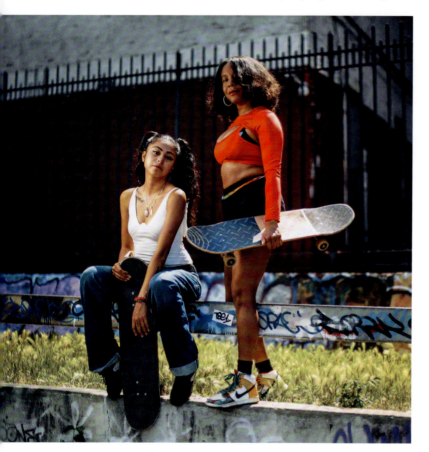

Being outside and being in nature isn't always the same thing. We've seen increased policing and privatization of public spaces. There are barely any trees in the Bronx, and it's ten degrees hotter than the wealthier neighborhood just a few zip codes over. Deepening our understanding of the outside boosts access to the outdoors, but more importantly, it fosters a stronger relationship with the outdoors.

MEL RAMIREZ

As street skaters, we're constantly making the most of outside, whether in the streets or at the park. We find nothing and make it into something; even if it's the tiniest ledge, we turn that into a spot outside.

KAVA VASQUEZ

There are so many places where people are communal, but sometimes in the United States culturally, especially in this generation, there's been a lot of isolation, especially post-pandemic. It's part of why we started our organization during the pandemic, because community was a want and a need.

We must remind people that you don't have to do everything alone.

Is anyone ever really self-made? Are we not made up of our relationships and the advice we get from loved ones? I feel like skateboarding itself is a metaphor for that. If you fall off your skateboard nine times out of ten, you learn how to pick yourself up, but it's better when you have a hand to help you up. It's important to share this perspective with the younger generation. You don't have to do things in isolation; you don't have to do them alone. When you take a chance on yourself and come into a public space in a community, you're allowing people to show up as themselves.

There's a perspective, especially among folks in urban environments, that you have to fly somewhere to access or that the outdoors is not for people who look like us. Through Bronx Girls Skate, we have an opportunity to break those barriers by encouraging women and girls to go outside and take up space—and hopefully, the next stage of that is building a deeper relationship with the environment and each other.

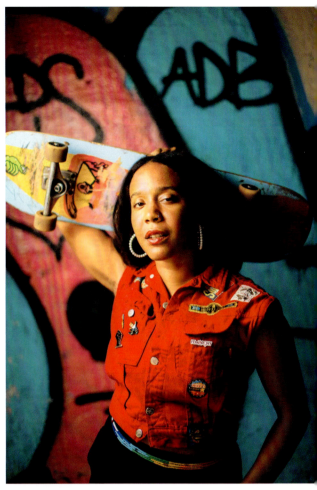

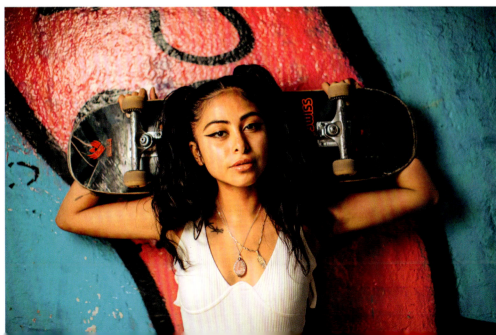

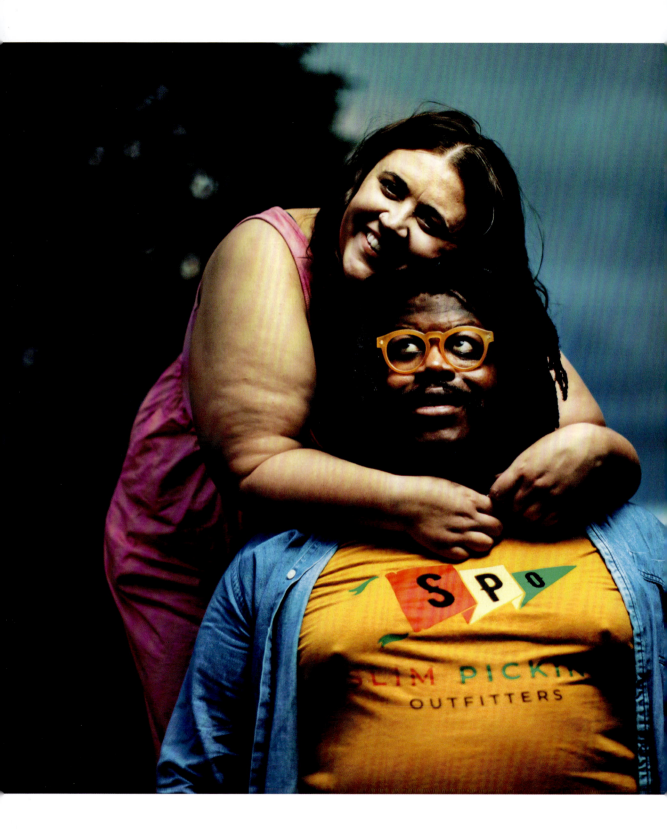

JAHMICAH DAWES & HEATHER DAWES

IN 2017, JAHMICAH DAWES AND his wife, Heather, founded Slim Pickins Outfitters, the first known Black-owned outdoor retailer in the nation. Their goal was to increase diversity not only in the outdoors but also in the giant conglomerate of the outdoor industry.

As recently as 2023, Outlandish, a Brooklyn-based company, was only the fourth Black-owned outdoor retailer in the United States. In an industry that has been passionately outspoken about diversity and inclusion, many of these statistics, unfortunately, trace back to a recent history of segregation and discriminatory laws blocking People of Color from recreating outdoors with ease.

Jahmicah and Heather, originally from Texas, opened Slim Pickins in Stephenville, Texas, about seventy miles southwest of Fort Worth. The town is adorned with open park spaces and a historical aesthetic that adds a familiar Southern charm. However, barely 3 percent of the population of Stephenville is African American, making Jahmicah a stand-alone as a Black outdoor business owner.

HEATHER DAWES

Working for himself, especially where we are located, and being his own boss and entrepreneur—it was a reclamation of his time, his identity, and even being able to express in his personality in a workplace.

WITH DIVERSITY AS his foundation for change, Jahmicah hesitates to recognize himself as a leader in the industry. Instead, he calls himself a "staircase" that includes and elevates those who come after him.

JAHMICAH DAWES

Step by step. We are working on this step, and it's hard, but it's foundational. We know this step is firm. When we move to the next step, we're going to pull you up because we know it's solid, but there's a caveat in that—when we pull you up, you have to go and do likewise.

JAHMICAH AND HEATHER'S most crucial step on this staircase is the one they are building for their two boys. Jahmicah expresses a deep-seated motivation to provide a secure future for them to feel safe outdoors and in life. The vision extends beyond personal endeavors, encompassing the journey of other Black and Brown children growing into adults with a love for the outdoors. The

commitment lies in ensuring that the upcoming generation can find safety, peace, positive experiences, and stable ground to plant their feet in collective ascent.

In emphasizing the importance of diversity in outdoor engagement, both for his family and others, Jahmicah articulates that the evolving landscape requires a corresponding shift in conservation efforts. Recognizing the changing demographics, he highlights the need to make more space for People of Color to have meaningful outdoor experiences to provide empathy for nature.

> He attributes this collective support to his community's core values of access, love, and humble service.

JAHMICAH DAWES

If we do not continue to accelerate the opportunity for People of Color to have these transformative experiences in the outdoors, then the landscape changes, the voting landscape changes. If People of Color don't have these experiences where they're connected to these places, why would they want to vote with their dollars or with their vote to protect it, to preserve it?

IN REFLECTING ON their journey through Slim Pickins, Jahmicah acknowledges the importance of the overwhelming support of family, friends, and strangers. He attributes this collective support to his community's core values of access, love, and humble service. Recalling his mother's empowering words about being descendants of kings and queens who endured significant challenges, Jahmicah shares the resilience embedded in his heritage.

JAHMICAH DAWES

My mom used to tell my brothers and sisters and me on the first day of school: "You are descendants

of kings and queens who survived. Wars to be seen, to be counted, they survived. Civil rights movements, they survived. You're a part of the descendants."

JAHMICAH'S MOTHER MADE it clear that his siblings were his best friends, but although he was never alone, he still felt lonely sometimes. However, standing among his community felt like a form of protection to Jahmicah, becoming the impetus for creating a staircase for others to stand together. Each step holds space for those who share the same love, resolve, and passion for the outdoors that Jahmicah, Heather, their two boys, and a diverse community of humans collectively share.

JAHMICAH DAWES

I never thought I was standing alone—I just knew I needed to stand.

PRIYAM PATEL

I'M A PROBLEM-SOLVER. AS A MATHEMATI-cian with a focus in geometry and topology, my job is multifaceted. I teach and train college students and write grants. The research aspect of my job is about going to the edge of known mathematics, asking a question, and then trying to form some conjecture about what could be possible and what could be true. Then, I try to prove it rigorously and make it into a new theorem—a statement of fact.

Rock climbing resonates with my mathematical mind, revealing numerous parallels in problem-solving. It's all strategy. It's moving micro-adjustments to make a breakthrough, and that's what math research is like. When I climb, I use logic regarding safety and redundancy, assessing risk in a calculative form. The breakthrough moments are so similar to when I have been working on a math problem for years. Suddenly, something clicks into place, and I see it and write down the rest of my proof. Climbing projects can take a long time to crack, but after repetition and tweaks, you can solve the problem.

When I first started climbing, I felt really isolated. I was living temporarily in California for a postdoctoral position at the University of California, Santa Barbara. When I moved to Salt Lake City, I had this inkling of creating something community-based for people who looked like me. The 2020 Black Lives Matter movement was the push I needed to start Color the Wasatch, a climbing affinity group for People of Color in the greater Salt Lake area.

More than twenty-five people attended our first meetup, stressing the mutual need for each other's presence. The motivation for my journey was the contagious enthusiasm within the community. Meeting my closest friends in Salt Lake City through these connections, encountering new faces every week, and seeing familiar ones on repeat fueled a spark that ignited my path. Although the group demanded considerable effort and collaboration from numerous individuals, it began with a shared realization that none of us were alone.

My life is centered around problem-solving. Questions like how to reach more people, spread our message, enhance community engagement, and support other affinity groups have been constant motivators. The initial impetus has evolved into a group that still meets to this day. Seeing many individuals expressing gratitude for our existence with ongoing climb nights and similar initiatives is beautiful and heartening.

Community has gotten me through life's most challenging obstacles, keeping me afloat when I

> Sometimes, you get stuck on the first move, which may be the hardest. Most of the time, someone has been there before you, working on the same problem.

thought I might drown. Being a woman and a Person of Color in both math and climbing—I value community highly because we can't make it through adversity alone. We can't be our best selves alone. Community is so meaningful for marginalized groups because the larger system wasn't built with us in mind.

My longest-running mathematical research project to date has been in progress for over six years, but it has not been the most significant. I view social barriers the same way I view climbing. Sometimes, you get stuck on the first move, which may be the hardest. Most of the time, someone has been there before you, working on the same problem. Your task is to read the rock and think of obvious ways to move your hands and feet in conjunction to get to the endpoint—and I think that knowledge parallels with inclusion.

I've learned so much from the people in my community; Black, Brown, Indigenous, Latinx, and Queer voices speak holistically about nature, which enables others to learn and feel welcomed into these spaces. There's this level of understanding between us that removes barriers so we can focus on getting better—as climbers and as humans. Sharing nature with people who mirror our own story creates collective joy and liberation, allowing us to feel connected and free. There is power in numbers.

BEHIND THE SCENES

One of my earliest childhood memories is of a yellow T-shirt my Teta (grandmother) used to wear. It was beautiful against her dark skin, even when dusted with flour from making tortillas for all of us grandkids. I chose a big yellow hat for my photo shoot with Priyam as a tribute to my Teta, who passed away a decade ago.

When I show people photos from this book, this one stops them in their tracks. Of course, Priyam's expression is stunning and the yellow plays off her radiant skin quite strikingly, but I wonder if people see more than just an image—maybe they feel the love between my Teta and me.

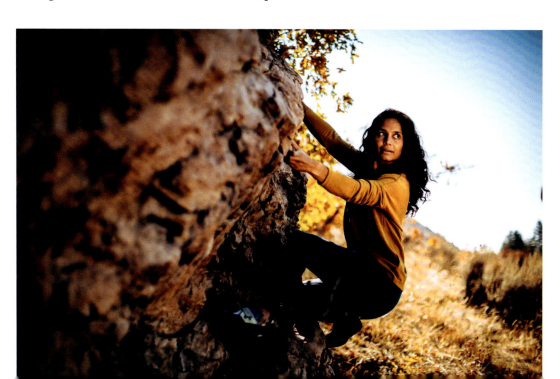

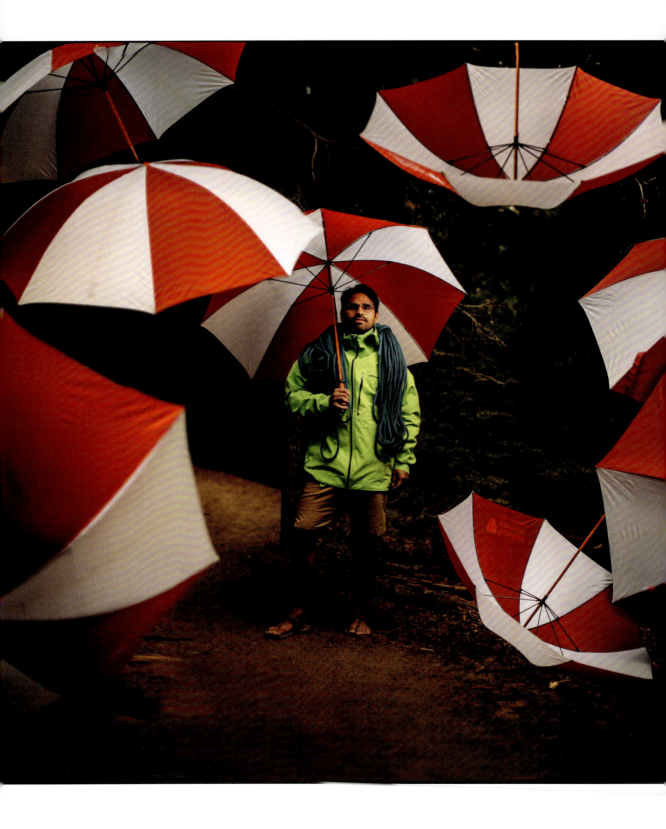

WESLEY HEREDIA

I GREW UP WITH A SINGLE PARENT. MY MOM, an undocumented immigrant, supported my brothers and me by working two jobs most of her life in Los Angeles. When I was twelve, we moved to Salem, Oregon. Laws in Oregon prevented her from legally obtaining an ID, and therefore from getting a formal job. We were on government welfare the majority of my childhood. Somehow, it was just enough for us to get by, if you can call it that.

My older brothers got in a lot of trouble during the transition. My mom tried to keep them in school and on the right path, but it wasn't easy. With me, however, she was forced to trust my decisions when I would roam the bustling streets of LA and then with my friends in the natural spaces surrounding Salem. From a young age, I was very independent, yet I was always open to care and advice from father figures throughout my childhood.

In high school, I played football, ran track, and competed in wrestling, doing any free sports I could. Through trials, challenges, and successes, these intensive sports proved key to my personal development as a young man. Sports were the platform I needed to come out of my shell and harness my potential, although I didn't do it alone: crucial male role models supported me along the way.

One of the most valuable lessons I ever learned came from my high school wrestling coach, Jason Ebbs. Coach Ebbs taught us to "leave things better than I found them." That concept has stuck with me and expanded into many aspects of my world, including my work in environmental education. Beyond just picking up trash on a trail, that teaching morphed to encompass community; how can we support people so that they can thrive and excel?

School sports can be expensive, requiring uniforms, cleats, and travel to camps and tournaments. My family couldn't afford all of that, so I had to take whatever opportunities I came across. I was able to scrape together funds, but it took the community at large to help me be a part of those teams.

Close friends' families would give me rides to our tournaments and sometimes cheer me on because my family didn't have the means to attend. Jason once gave me the wrestling shoes off his feet when mine were falling apart. The support of my community enabled me to succeed in these areas, which later on helped me become a successful mentor.

First sports and later working outdoors have led me through a lot of healing from childhood traumas. Venturing outside can be healing. There is trauma within our Latino community, and I wish for people to be active participants in their own triumphant story. Being outside in nature for so long has taught me that we humans are not separate from it. Engaging with that concept gives me the security and confidence to navigate life, success, and failure.

> **Venturing outside can be healing.**

Being a mentee guided by positive role models has helped me better reciprocate being a role model myself for the youth I work with through Vámonos Outside. Our nonprofit strives to get Latino youth outside through various outdoor recreation opportunities in central Oregon. We also help guide other organizations and businesses to better serve the Latino population. Youth can have a hard time understanding the bigger picture of this world and how we are all interdependent. I argue they don't have to just yet—that's the beauty of the outdoors and mentorship. Our responsibility is to make sure they are moving forward on a positive path. Professionally and personally, my calling is to help create healthier people by giving them access to nature and all the benefits outdoor recreation can offer.

Being outside in nature for so long has taught me that we humans are not separate from it.

There are a lot of parallels when it comes to nurturing people and nurturing nature. Mentoring youth in the outdoors can provide important skills and a dynamic mindset that helps them overcome their challenges. Taking care of our ecosystem provides opportunities for growth, restoration, and sustainability. When these two worlds collide, we create empathy for one another and foster a symbiotic relationship between humans and nature.

In my mentorship, I've come to cherish all elements of nature and people the same. A tree deep in the wilderness has equal value to a tree in a local park. I believe the same is true with young people—everyone deserves to be cared for just as I was. To me, that's leaving the world better than how I found it, and that's what it means to pass on the teachings of wise people in my life.

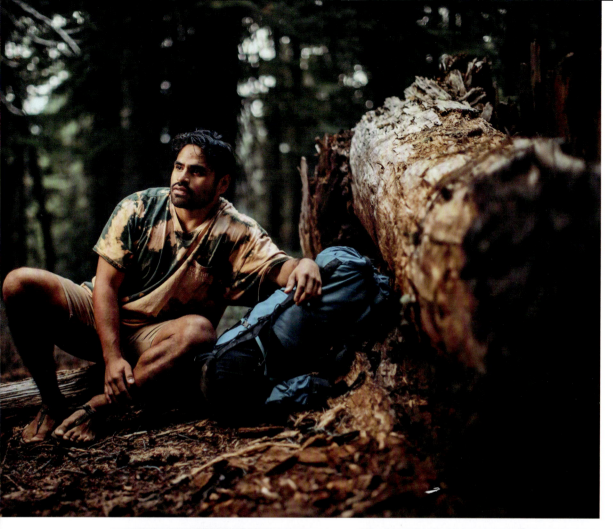
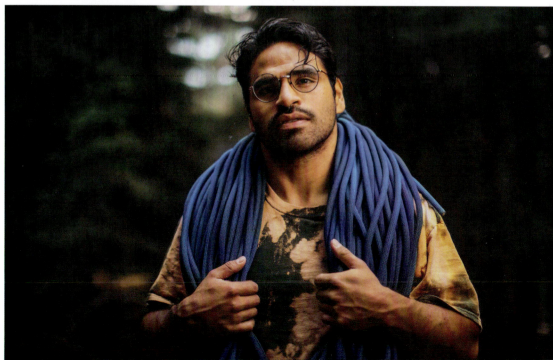

NICOLE RIVERA HARTERY

THERE'S A COMMON MISCONCEPTION THAT bees work like emotionless robots. But rather than operating mechanically, they're methodical and intentional, with an innate camaraderie. Most of these diligent workers, about 95 percent of the hive, are female bees. From the meticulous tasks of worker bees to the regal responsibilities of the queen, the hive is a testament to the remarkable collaboration driven by the innate sisterhood of its female members.

One summer about a decade ago, I had just given birth to my second daughter and was wrapping up six weeks of bed rest. Desperate to leave the house with my oldest before she went back to school, we would travel the twenty-minute trip to Philadelphia from New Jersey and explore the local museums and exhibitions. One outing led us to a beautifully showcased beehive exhibit.

The observatory guide gave me detailed accounts of the queen-making process, from stem-making queen cells to their evolution and the dramatic battles between emerging queens. This battle leaves only one queen victorious, forcing the losing queen to depart with half the hive. Utterly awestruck and captivated by these tiny creatures. I thought, *This is better than reality TV!*

Since childhood, I have been fascinated by nature. My original dream was to pursue marine biology, but when that didn't work out, I followed fashion, eventually landing in mortgages. Yet the pull toward nature was persistent. Overcome with the monotony of six years in the mortgage industry, I pitched to my husband my idea of becoming a beekeeper, driven by the desire to work with these remarkable creatures and discover a passion that would reshape my career and a sense of purpose.

Bees come into this world with a desire to work. Initially tasked with cleaning their cells so the queen can lay her eggs, they progress to become nurse bees, caring for the offspring and tending to the queen. As their hormones change, they take on roles such as house bees for cleaning and honey production, hive protectors, and finally foragers, their last job before death. This sequential progression reflects the innate work ethic of bees throughout their life cycle.

Being a keeper is like being a part of the hive. Rather than working for them, I work with them. Bees are considered domesticated, but we don't need to train them like cats or dogs. My role involves monitoring the hives, studying their strengths and weaknesses, and finding ways to support them—ensuring they are well fed or protecting against hive beetles that attempt to invade and lay their eggs. Nevertheless, I refrain from intervening excessively, as I aim to preserve their natural behavior.

> We are born with the same innate sense to be with one another in community and to work alongside each other for the betterment of our society.

My bee tours and education cater to a diverse audience, attracting individuals from various backgrounds and walks of life. It's an inclusive space that serves as a platform for learning and understanding how bees work together as a community. Starting with the bees' life cycle, I delve into their roles and migration process and even conduct honey tastings.

Growing up, I lacked representation of people who looked like me in media or pop culture. Visiting classrooms as a Black Puerto Rican woman shows young people that these types of professions are available to them. I hope this next generation will never question what a beekeeper looks like now because of my presence and education in this field.

Working alongside bees, especially the queen, has illuminated the strong parallels between their roles and my own experiences as a mom. She births, nurtures, and guards the babies like I do for my girls. The guard bees sting to ward off threats, giving their lives to protect the hive. The forager bees go out and get food and nutrients to feed the hive, sometimes looking for a

new hive better suited for the colony. As a human, wife, and mother, there isn't any one job the bees do that I can't relate to, and no job is more important than the other.

When a bee gets coated in honey and is unable to fly, the other bees will stop what they are doing, swarm her, and clean her until she can fly again. They have a natural sisterhood. One bee never tries to beat the other. There is never competition, only community. We are more like bees than we recognize. We are born with the same innate sense to be with one another in community and to work alongside each other for the betterment of our society.

The wisdom drawn from bees is profoundly enlightening: our lives, like theirs, are an interplay of interconnected roles that allow each other to find the wings to soar in our magnificent human hive.

Tommy with his father, Tim, while working on this book

BEHIND THE LENS
A NOTE FROM TIM COREY

HE'S AN ADULT NOW, BUT WHEN I THINK OF my son Tommy, my mind goes to him as a little boy. "Full of energy" might be an overused cliché, but that was Tommy as a child. And he could speak. Boy, could he speak! Some of his sassy comebacks have become family legend.

When Mikey (Tommy's younger brother) was a baby, four-year-old Tommy taught him the alphabet. Mikey was able to read baby books at eighteen months because of his big brother's teachings. Emily (the youngest) got the same treatment. Tommy also gave them lessons in swimming, reading, singing, and dancing.

Tommy's first camping trip was when he was nine months old. How can you tell if your nine-month-old is having fun camping? I don't know, but he didn't seem upset by it, and it wasn't long before he was asking to go. Our family visits a number of areas in the Shasta-Trinity National Forest. Some are very secluded and require a three- or four-mile hike, often steep, to reach a beautiful mountain lake. But whether Tommy would be able to make it there and back was never a question—he's like a mountain goat.

I got an inkling of Tommy's love of camping not just when he went on trips but around the house, too. His room, the living room, and the garage were continually draped in blankets or boxes arranged to make forts. One day, while looking for Tommy, I went to the garage and found several boxes had been moved into a corner. Shifting a couple of them, I found him curled up in his sleeping bag inside.

Part of Tommy's impetus for hiking the Pacific Crest Trail was that his older brother, Joe, had hiked in 2011. It was a big deal for the whole family, and Tommy wanted to be a part of that, too. In 2018 he did the trek, and the whole family was thrilled again. Bobbie (Tommy's mom) and I drove from our home in Northern California to within thirty miles of Canada to pick him up.

Tommy's love of photography was sparked by an old Olympus OM-1 camera I gave him. He loved taking photos of people—any people. Attractive or less so. Tall or short. Fat or thin. Any race or ethnicity. The success Tommy has had in his chosen profession comes directly from his love of people. He connects with his subjects, and they want to participate. You can see it in their faces.

This book is a labor of love Tommy has been pursuing since he was a teenager, when he created a photo series called "The Self-Worth Project" that touched lots of people. He rented a local theater and held an evening of presentations by people who were discriminated against and who bravely told their stories. One was a trans man, another an HIV patient. It was inspiring. Tommy also received an award from the Shasta County Public Health Advisory Board for his efforts to promote inclusivity.

Near the end of production for *All Humans Outside*, Bobbie and I set off on a trip to Bend to watch Tommy photograph people from this book—

not entirely sure who we'd meet or what the experience would hold. What we found was a group of people who quickly became more than just acquaintances—they became our friends.

One of the first people we met was Annika. She's a mountain biker, though you wouldn't know it at first glance because she's in a wheelchair. Years ago, she broke her back in a biking accident and lost the use of her legs, but that didn't stop her. These days, she gets out on the trails with an electric mountain bike that allows her to go wherever hikers can. It was incredible to see how determined she was to keep doing what she loved, despite the odds.

Then there's Joanne and Emmeline, rock climbers who blew me away with their strength and spirit. Joanne is quiet and thoughtful, always calculating her next move. Emmeline, on the other hand, is loud and fearless, always ready for a challenge. They've faced their fair share of skepticism. "You can't do that, you're women," people would say, but they've never let that stop them. Watching them grip rocks with their calloused hands and push through every obstacle made me realize just how resilient they are.

The story of another athlete we met, Channing, is nothing short of remarkable. When she was just three years old, a bull trampled her in Laos. Her parents rushed her to the United States, where she finally got the medical attention she needed. These days, Channing's an adaptive athlete, thriving in her wheelchair and inspiring everyone she meets with her courage and joy for life. After spending time with her, I couldn't help but feel grateful she made it through such a terrifying experience.

We also met Wesley, a guide from South Central LA whose family moved to Salem, Oregon, when he was twelve. That move was a lifesaver, a chance to escape the pressures of city life. Now, he leads groups through Oregon's forests, showing people how to connect with the wild and teaching them the tricks of the trade—even how to handle those pesky mosquitoes.

Zach is the youngest member of one of the only Black families in a small, rural town in Indiana. He's now a former park ranger who has made a life for himself in New Mexico, living off the grid on his own land. With solar panels for energy and a system for recycling water, Zach's way of life is entirely self-sufficient—perfect for him, but not exactly suited for the faint of heart.

Finally, we caught up with some friends from Bend, Oregon. Geoff, who is severely disabled, didn't let that stop him from inventing a wheelchair designed specifically for navigating the forest. With the help of his wife Yvonne and a few other friends, he's able to get out into the wilderness, where he feels most at home.

Looking back, it's clear that this trip wasn't just about the places we visited but rather the people we met along the way—each one of whom has overcome their own challenges in remarkable ways. Bobbie and I are happy to have made new friends. It gives us great joy to be able to share Tommy and these inspiring and fiercely determined people he has gotten to know with the world.

WITH GRATITUDE

FOR THIS PROJECT, MY DREAM WAS TO PHO- tograph every individual in the places they lived or in nature that they feel connected to. That meant traveling to twenty-five states across the US, a journey that was both exhilarating and financially daunting. To realize this vision, I had to rely on the very essence of this book: community.

SPONSORS

To the sponsors who believed in my work and helped bring it to life—thank you from the bottom of my heart. Many of you have supported me for years, and a few of you took a leap of faith on a dream that might have seemed outlandish. Your belief in this project made it all possible. **Sponsors include: Floqsta, Vuori, Osprey Packs, The North Face, 10 Barrel Brewing, Hyperlite Mountain Gear, Ombraz Sunglasses, FarOut Guides, Sawyer Products, TownShirt, HEST, Jolly Gear, Gossamer Gear, and The Horizen House.**

INDIVIDUAL DONORS

To the nearly five hundred contributors—strangers, acquaintances, old colleagues, internet friends, and my closest family and friends—seeing your names in this book brings me immense joy. Creating a collection like this one has been a dream of mine since childhood, and your support made it a reality.

I am deeply grateful to each and every one of you for helping to bring this project to life: Teresita Abad, Phillip Adkins, Taylor Adkins, Alyssa Adler, Alison Agresta, Marie Aleysha, Desiree Andersen, Emmy Anderson, Avery Andrews, Elle Armistead, Adriana Arreola, Jim Austin, and Chelsea Avery.

Geoff Babb, Lewann Babler, Beth Bachelor, Julie Bacon, Michael Badgett, Kristina Baker, Hanna Bailey, Monette Bailey, Michael Ball, Dana Bambino, Megan Banker, Gabe Bann, Jodie Bann, Hannah Barnett, Daniel Bartlett, Callie Bateson, Cody Bauman, Moxie Beachy, Elizabeth Becker, Rachel Beda, Annika Bee, Brian Bell, Sandra Bergmann, Julie Bergstresser, Becca Bergstrom, Ashleigh Biggs, Grace and Jerry Bird family, Paul Bird, John Black, Natalie Boggs, Trevor Bollmann, Caroline Bonds, Jake Bourque, Calvin Bovee, Molly Boyer, Mariah Boyle, Benny Braden, Suzie Brashler, Kaysen Brennan, Morgan Brosnihan, Roberta Brunkalla, Pamela Brutzkus, Laurel Buckley, Charlotte Buell, Samuel Burleigh, Tamara Burton, Marla Butler, and Brian Buttray.

Boman Caldwell, Jamie Campbell, Justin Campbell, Nina Cardenas, Dyana Carmella, Christopher Carmody, Emily Carpenter, Annie Carson, Emily Cassell, Shelby Castleton, Krystle Catalli, Elizabeth Cauffman, Jesus Celis, Natalie Celmo, Stacey Cha, Rose Chamberlin, Kelly Chang, Tasheon Chillous, Jenni Christensen, Nastacia Chubinsky, Cheslea Clark, Rachel Coffey, E Cole, Michael Connor, Angela Cook, Dani Corley, Amy Cornet, James Cornfoot, Katie Courtney, Carol "Cheer" Coyne, Ryan Craig, Ellen Crane, Summer Crider, Melanie Critelli, Heidi Crossman-Johnson, Bethany Crunelle, Leah Culkar, Megan Cullis, Melissa Curiel, Anna Curl, Jackie Curry, and Jacqueline Curry.

Sheriden Davis, Jordan Day, Ellen Deel, Kasie DeHart, Keira Dembowski, Diane DeRousseau, Karen deSousa, Theresa deSousa, Beau Devereaux, Lauren Dey, Andrea DiMaio, Madison Dinsmore, Aaron Dobson, Nicole Donnelly, Jacqueline Dorcy, Analeise Dowd, Logan Dralle, Alan Drew, John Drollette, Alexander Droubay, Caitlin Duffy, Tori Duhaime, and Kathryn Dunbar.

Justine Bona Ector, Emily Eisele, Kenneth Ellsworth, Kelsey Emmons, Amber Engel, Alyssa Engiles, and Kelsey Esquinas.

Tyler Faires, Mara J Couch Fitzgerald, Chloe Fitzmaurice-Shean, Holly Florian, Elsa Foote, Drew Foster, Monique Fourie, Tyler Fox, Kristen Francis, Kevin Frias, Jennifer Fredrerick, Jennifer "Starburst" Frederick, and Marina French.

Ashlee G, Jennifer Gadoua, RJ Gallagher, Heather Galli, Helen Ganahl, Jamarcus Gaston, Nicole Gatlin, Ethan Gehl, AnnaJoy Gillis, William Glazer, GoFundMe

353

Team, Kat Grandel, Jordan Graves, April Greenberg, Julia Goodhart, Hannah Goodman, Kelvin Goodman, Olivia Gray, Laura Grieser, Jennifer Grob, and Joseph Gunn.

Elaine Hacker, Ashtyn Haebe, Justin Hadley, Kevin Hagan, Logan Hall, Brandon Halpin, Alexis Hamilton, Andrea Hamilton, Casey Renee Handley, Laurie Harding, Linda Harrell, Lyla Harrod, Melanie Harsha, Cherisa Hawkins, Alyssa Hayes, Alice Held, Alicia Henry, Daena Hensley, Suzanne Hermann, Felicia Hermosillo, Elisa Higbee, Amanda Hignell-Rufener, Bryan Hill, Savannah Hilmer, Miya Hirabayashi, Christine Hixenbaugh, W Hodds, Heather Hoffman, James Hoher, Laura Holcomb, David Hollingshead, Rachel Holzwart, Jessica Honts, Jessica Hontz, Andrew Hosford, Katie Houston, Kaitlynn Howard, Courtney Hundley, Nancy Huntingford, and Mallory Hutton.

Alyson Ignoffo, and Miriam Intrator.

Kathleen Jacobs, Christina Johnson, Amanda Jones, Erika Jones, Katie Jonkman, and Stella Joslin.

Sarah Karner, Matthew Kastellec, Kyle Keener, Xiaoling Keller, Ashley Kellogg, Andrea Kelly, Molly Kelly, Ragan Kelly, Emily Kennedy, Jeff Kessler, Nathan Khalsa, Brandt Steven Kindness, Sydney Kleinhenz, Wendy Kinal, Katrina Kirsch, Malin Klein, Sydney Kleinhenz, Katie Kleppinger, Greg Knight, Faith Knipe, Matthew Kok, Amanda Koumariotis, Courtney Krafft, Jacqueline Krueger, Deborah Ksenzulak, Brooke Kubby, Anya Kulcsar, and Nicole Kulovitz.

Gregory Lambert, Rachel Lanman, Kyla Laraway, Gillian Larson, Keith Laurenz, Lukas Leary, Tyler LeBeau, Rachel Lee, Claire Levy, Melissa Lewis, Erica Lichty, Jesse Lieman-Sifry, Natalie Loewen, Stephanie Lorenz, Alex Lowing, Daniel Lucio, Lindsey Luebe, and Laura Lyons.

Nicholas Mackenzie, Julia Madsen, Cliffton Magee, Anthony Maggiola, Elizabeth Maguire, Sheena Manuel, Irene Marcoux, Anna Marini, Sienna Martin, Tera Martin, Feena Martinez, Shannon Marvel, Michael Masters, Hannah Mathews, Katie McClellan, Ronald McCue, Brynlee McGhee, Lindsey McKelvey, Heather McKendry, Kelly-James McKeon, Jillian McMahon, Natalie McMillan, Robyn Meacham, Ann Mecklenburg, Leah Medure, Dahlia Menelao, Mary Meisinger, Francis Mendoza, Kim Merrikin, Kathleen Meyer, Nika "Early Bird" Meyers, Kandye Michalsen, Emma Michel, Jan Michel, Margaraet Mickelson, Maya Missakian, Karen Monsen, Kaitlyn Moore, Stephanie Moravec, Maria Moreno, Lee Morton, Ghadah Mostareeh, Lissa Muhammad, Hunter Mulich, Kristen Murphy, and Tara Myers.

Shaylee Nannery, Chelsea Newton, Kathleen Neves, Neil Nguyen, and Andrew Nordhaus.

McKinzi Obaitek, Madelyn OBrien, Kathleen O'Brien, Sage O'Brien, Daniel Opalacz, Abb Orosz, and Elina Osborne.

Jessica Page, Lydia Parker, Roma Patel, Renee Patrick, Kendra Perkins, Shane Petersen, David Phillipich, Becca Moreno Phipps, Mel Pierdomenico, Jason Pluemke, Marie Poellinger, Jessica Pouchet, Jonas Powell, Lynn Preslar, Maxine Presto, Paul Priest, Judithann Prigmore, Toni Proescholdt, Hannah Proffitt, Micah Pulleyn, and Ross Puritty.

Zelzin Cedeño Ramos, Kam Redlawsk, Mandy Redpath, Kristina Reese, Michelle Reinders, Heather Reid, Bryony Retter, Josh Reynolds, Claire Richardson, John Riddle, Sarahi Rivas, Justina Roberts, Kindra Roberts, Samuel Roberts, Vivian Roberts, Victoria Rodriguez, Amanda Rogers, Jessica Rogers, Joseph Roldan, Jennifer Romaniello, Krista Rose, Christina Rosetti, Fabiola Ruiz, Kathleen and Ruland.

Chris S, Rachel Sable, Chana Salzberg, Thea Samson, Cassie Sanchez, Lauren Sankovitch, Brianna Sansing, Lawrence Schaefer, Jane Schneider, Manuel "Stallion" Schneider, Elisa Schuetz, Emma Schwartz, Ashley Schwarzer, Kala Scoubes, Melissa Scott, Renee Scott, Shaylie Seidlitz, Gregory Sewell, Clayton Shank, Brianna Sharpe, Julia Sheehan, Gina Sheets, Molly Sherman, John Shin, Francisco Silva, Gwende Silver, Elizabeth Simpson, Greg Simpson, Jackson Sims-Myers, Jarod Sleet, Jeremy Smith, Jocelyn Smith, Stephanie Smith, Johnie Smyth, Karley Standley, Carl Stanfield, Susan Stevens-Briody, Amanda Stewart, Lindsay Stickney, Snazzy Stone, Ryan Suen, Nina Suetake, Cynthia Sugden, Bryn Sumner, Tahlia Sundrum, and Rebekah Sutherland.

Danielle Tague, Wynona Taggart, Tiffany Tai, Erick Tang, Ryan Terry, Brittany Thomas, Katrina Tice, Melissa Tilford, Madisyn Taute, Annelle Tomlinson, Michelle Trame, Madison Traviss, Zachary Trecker, Julia Tremaroli, and Chris Triolo.

Kelsey Van Horn, Lizzy VanPatten, Dorothy Vasquez, Lauren Veloz, Flynn Vickowski, Erika Vijh, Jennifer Villarreal, Jennifer Vogel, and Victoria Vogel.

Angela Wade, Julie Waldeck, Robin Waisanen, Mary Walsh, Kaila Walton, Nina Waters, Madelynn Webbe, Ava Welling, Michelle Wheeler, Nina Wheeler, Sara Wheeler, Erica Whisenant, Ashley White, Emily White, Virginia White, Max Wiese, Wyn Wiley, Grace Williams, Jessica Williams, Sonya Wilson, Helena Wong, Georgia Wood, Rachel Wood, and Halleck Wrigley.

Rose Yeung, and Hillary York.

Joseph Zavala, Amy Zhen, and Bryan Zug.

I offer you all my most heartfelt thanks.

ABOUT THE CONTRIBUTORS

Zelzin Aketzalli
@zelzin_aketzalli

Anastasia Allison
@anastasia.allison

Divya Anantharaman
@gotham_taxidermy

Dani Araiz
@dasharaiz

Arthur Aston
@ourview4life

Geoff Babb
@theadvenchair

Kamal Bell
@sankofafarms

Matt Bloom
@mattbloom692

Mary Kate Callahan
@mkcallahan

Channing Cash
@allabilitiesoverland

Gabriel Chillous

Tasheon Chillous
@chilltash

Jesse Cody
@hikethegoodhike

Perry Cohen
@perrylcohen

Summer Crider
@thegivingcypress

Brandon Dale
@bdale13

Amelia Dall
@ameliathedeaf
archaeologist

Zachary Darden
@thefirst_blackbandit

Heather Dawes
@spoutfitter

Jahmicah Dawes
@spoutfitter

Virginia Delgado-Martinez
@cita_la_naturalista

DeVante Deschwanden
@iamdesch

Karen DeSousa
@karengoes_outside

Chev Dixon
@negus_chev

Ashley Duffus
@wildernoise

Shaynedonovan Elliott
@travelafterimage

Chrisha Favors
@naturally_chrisha

Jimmy Flatt
@huntersofcolor

Melody & Ruby Forsyth
@downwithadventure

Caziah Franklin
@caziahfranklin

Alvin Garcia
@whooptygoldberg

Leo Chan Gaskins
leogaskins.com

Kanoa Greene
@kanoagreene

Chris Greenwell
@xgreenwell

Autumn Harry
@numu_wanderer

Beverly Harry
@cornmush_girl

Nicole Rivera Hartery
@riveraxn

Jayne Henson
@crimson_wave

Wesley Heredia
@vamonos_outside

Drew Hulsey
@drewclimbswalls

Sarah Hulsey
@thestrongsarah

Jennifer Jacobsson-Melo
@allmansright

Jack Jones
@quadzillahikes**

Brittany Kamai
@freefloatingoceansoul

Leah Kaplan
@nubbin2seehere

Mohit Kaura
@thelostcosmicdust

Gillian Larson
@thru_rider

Anna Le
@anna_venturing

Marcela Maldonado
@behavioralromanticism

Ash Manning
@ashleysadventure

Ben Mayforth
@crushing_benjamin

Livio Melo
@allmansright

Jose Mendez
@plantsoutside_

Francis Eymard Mendoza
@roving_ranger

Dahlia Menelao
@dahliaa_spah

Kim Merrikin
@movefatgirl

Mary Mills
@onefinoneheart

Becca Moreno
@bounce_it_bec

Tara Myers
@tararubinomyers

Jordan Newton
@jnewton.parathru

Mario Ordoñez-Calderón
@marrioo

Elise Ott
@elise.ott

Erin Parisi
@erinsends7

Lydia Parker
@huntersofcolor

Priyam Patel
@priyam8186

Hector Rafael
@hec_raf
@earthie_crunchie

Patrick Ramsay
@writepatrick
@happymagpiebook

Bennett Rahn
@bennettrahn

Faren Rajkumar
@faren_wanderer

Mel Ramirez
@bronxgirlsskate

Kam Redlawsk
@kamredlawsk

Dani Reyes-Acosta
@notlostjustdiscovering

Francis Reyes-Acosta
@franciegram3

Christopher Rivera
@6solesvino

Eryn Roberts
@everywherewitheryn

Scott Robinson
@scottthepilot_

Noël Russell
@noelruss

Jack Ryan
@paralyzedtopeaks

Ricki Sanchez
@aquaholicrick

Day Scott
@thewildernessgoddess

Prince Asante Seta-Boakye
@santeprince

Josh Sheets
@soulslosher

Francisco Silva
@_travelstoomuch_

Nicole Snell
@adventuresofnik

Kyle Stepp
@kaydubsthehikingscientist

Joe Stone
@meetjoestone

Matt Tilford
@mtilford

Mirna Valerio
@themirnavator

Gabriel Vasquez
@forinjuredveterans

Kava Vasquez
@bronxgirlskate

Lolo Veloz
@radiatelolove

Annijke Wade
@geodesicome

Emmeline Wang
@emmelinewang

Dezmine Washington
@dezmineann

Whitney Washington
@recapturinglife_

Kristen Wickert
@kaydubsthehikingscientist

Ash White
@the_gentleman_lumberjack

Richie Winter
@richieisms

Joanne Yeung
@oreolard

Ann Yoshida
@annyoguava

Christophe Zajac-Denek
@christophezd

ABOUT THE AUTHOR

Photo by Matt Bloom

TOMMY COREY grew up in Redding, California. Every summer since he was a baby, his family would visit Deadfall Meadows in Shasta-Trinity National Forest. With his dad Tim, two brothers, and younger sister, he would fish, hike, and camp, creating cherished family memories in the great outdoors.

At age twelve, Corey picked up his first camera, an Olympus OM-1 that belonged to his father, sparking an undying love for photography, portraits, and storytelling. He later created The Self Worth Project, where people wrote their deepest fears and insecurities on their bodies, and then traveled the country for speaking engagements with some subjects, discussing topics like LGBTQ+ rights, domestic violence, childhood trauma, and body image. At age twenty-three, Corey received the Shasta County Excellence in Public Health Award and the 40 Under 40 Community Leaders Award.

While thru-hiking the Pacific Crest Trail, he published *Hiker Trash Vogue*, an editorial-style photo project featuring his fellow thru-hikers that propelled him into a career as an outdoor photographer. Corey then produced the Visual Podcast Series, showcasing a dozen unique individuals (including some people featured in this book) and their deeply personal connections to nature.

While attempting to thru-hike the Continental Divide Trail in 2022, Corey conceived the idea for a book narrating the diverse ways humans connect to the outdoors. *All Humans Outside* embodies his passion for people, photography, and nature. Through his work, he aspires to unite people through storytelling and a shared love of the outdoors.

MOUNTAINEERS BOOKS, including its two imprints, Skipstone and Braided River, is a leading publisher of quality outdoor recreation, sustainability, and conservation titles. As a 501(c)(3) nonprofit, we are committed to supporting the environmental and educational goals of our organization by providing expert information on human-powered adventure, sustainable practices at home and on the trail, and preservation of wilderness.

Our publications are made possible through the generosity of donors, and through sales of 700 titles on outdoor recreation, sustainable lifestyle, and conservation. To donate, purchase books, or learn more, visit us online:

MOUNTAINEERS BOOKS
1001 SW Klickitat Way, Suite 201 • Seattle, WA 98134
800-553-4453 • mbooks@mountaineersbooks.org • www.mountaineersbooks.org

An independent nonprofit publisher since 1960

YOU MAY ALSO LIKE:

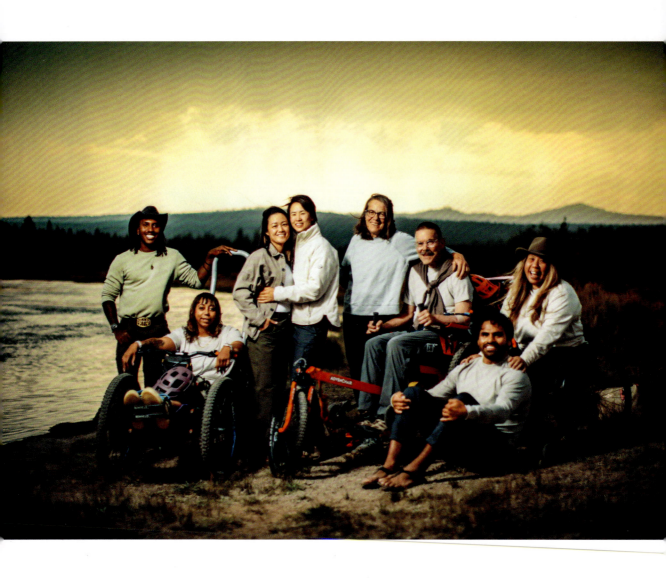